<small>Praise for</small>

KANSAS CITY LIGHTNING

"It is from Mr. Crouch, a novelist as well as a critic and essayist, that we come to see Charlie Parker in the context of his time and place in America." —*Wall Street Journal*

"A book about a jazz hero written in a heroic style . . . a bebop Beowulf." —*New York Times*

"'Bird Lives!' his followers proclaimed, as if a man as brilliant as Parker could not possibly be mortal. But Charlie Parker was a man, and Stanley Crouch's enchanting biography returns him to the soil that nourished him before he took flight." —*New York Review of Books*

"Crouch, who was a jazz drummer in his twenties, meticulously examines the musical mechanisms of Parker's genius and, in prose that veers toward lyrical rapture, conjures the inner life of the improvising artist. Following Parker on his travels through Southern circuits and to Chicago and New York, the book also unfolds, with remarkable personal nuances, a social history of black America in the Jim Crow era." —*The New Yorker*

"Will send you searching for recordings. And really, there's no more important litmus test for a music biography. Reading this book makes you want to listen." —*Boston Globe*

"Charlie Parker's story can't help but fascinate anyone interested in the most American music of the past century." —*Chicago Tribune*

"What Crouch does superlatively is capture the excitement of a Charlie Parker performance, his incandescent swing, the way he took notes to places they'd never been before. We hardly need another case made for Bird's roosting place in the jazz pantheon. But Crouch's take, combining as it does a troubled, spoiled young man in a hurry, a splendid evocation of an era, a keen ear for

the music, a tremendous understanding of black culture, and a unique prose style, takes us as close as we are likely to get to the early years of a genius-in-waiting." —*Globe and Mail* (Toronto)

"Stanley Crouch's soulful, poetic, and often graphic *Kansas City Lightning* . . . reads like the jazz version of *Batman Begins*, with Crouch detailing the raw materials of culture, class, and race that forged Parker's musical identity." —*Los Angeles* magazine

"Crouch captures with novelistic verve the excitement of that period in covering the early years of Parker's ultimately short life, which contained within it so many warring elements that he has daunted even, perhaps especially, awestruck biographers. Crouch's eyes are wide open, and he lends his considerable talents to a jazz biography that ranks with the very best." —*Booklist* (starred review)

"Crouch . . . is uniquely qualified to guide readers on this tour. . . . A story rich in musical history and poignant with dramatic irony." —*Kirkus Reviews*

"With the straight-ahead timing and the ethereal blowing of a great jazzman, Crouch delivers a scorching set in this first of two volumes of his biography of Charlie 'Yardbird' Parker, capturing the downbeats and the up-tempo moments of the great saxophonist's life and music. . . . Crouch brings to life the swinging backdrop against which Parker honed his craft." —*Publishers Weekly*

"Social and cultural critic, columnist, and MacArthur genius Crouch offers a mix of impressionist strokes, historical facts, and context in his masterful Charlie Parker bio." —*New York Post*

"Meticulous and steeped in local lore. . . . Feel[s] as urgent as a blast from Parker's saxophone." —*Kansas City Star*

"The soul of Stanley Crouch joins the soul of the legendary jazz legend. . . . Crouch re-creates 'the Bird' with his writer's talents at their peak, and the result is magical." —*Huffington Post*

"The veteran jazz writer Stanley Crouch has a store of fresh information for you in his new book about Charlie Parker (1920–55), the genius of American music universally known as Bird, and invaluable insights to offer into the meaning of Parker's achievement. It is imperative that you come into possession of this material." —*Daily Beast*

"A riveting read. . . . Crouch, through years of research, has done an exemplary job." —*Jazz Times*

"It takes a lifetime of passionate engagement to write with the intensity and depth of Stanley Crouch. He has spent more than thirty years researching and contemplating the storied life of Charlie Parker, one of Western music's greatest minds. The results are insightful, profound, and wholly original. A must-read, not just for jazz fans but for anyone interested in American possibilities." —Wynton Marsalis

"Stanley Crouch is so immersed in his material that we get a sense from his riveting, long-awaited book not only of what Charlie Parker's early years were like but also of what it meant to come to manhood in the pressure-cooker of an extraordinary time and place—the conflict of being molded by Kansas City and straining against that mold with every fiber of his genius. Here is Bird making his watershed discoveries before he fired his own lightning bolts." —Gary Giddins

"Stanley Crouch's biography of Charlie Parker is a most compelling blend of three interlocking narratives: the biographical, the musical, and the historical, all three woven together brilliantly. *Kansas City Lightning* succeeds as few biographies of jazz musicians have, explaining exactly why Charlie Parker was a musical genius while also helping us understand Parker's psychology and the larger context of his times. This book is a magnificent achievement; I could hardly put it down." —Henry Louis Gates, Jr.

"This is a memorable book, both a persuasive account of the

formative years of an elusive American genius and a vivid, kaleidoscopic rendering of all the American worlds that helped create him. Stanley Crouch takes us deep into places most of us can only imagine—including into the heart of the mysterious split-second alchemy that takes place nightly on the bandstand."
—Geoffrey C. Ward

"In *Kansas City Lightning*, Stanley Crouch not only delivers a portrait of the young Charlie Parker with a degree of vivid detail never before approached, but he also brilliantly situates the enigmatic, troubled, protean genius at the interstices of the myriad strands of history and culture that surrounded and shaped him. In the process, Crouch also manages to spin a deft, virtuosic panorama of early jazz, of the American frontier, of the complex relations between technology and art, and of the emergence of African Americans into the forefront of our polyglot culture. This is a mind-opening, and mind-filling, book."
—Tom Piazza

KANSAS CITY LIGHTNING

ALSO BY STANLEY CROUCH

NONFICTION

Considering Genius: Writings on Jazz

The Artificial White Man: Essays on Authenticity

Reconsidering the Souls of Black Folk:
Thoughts on the Groundbreaking Classic Works of W. E. B. DuBois

One Shot Harris: The Photographs of Charles "Teenie" Harris

Always in Pursuit: Fresh American Perspectives, 1995–1997

The All-American Skin Game, or, The Decoy of Race:
The Long and the Short of It, 1990–1994

Notes of a Hanging Judge: Essays and Reviews, 1979–1989

FICTION

Don't the Moon Look Lonesome?:
A Novel in Blues and Swing

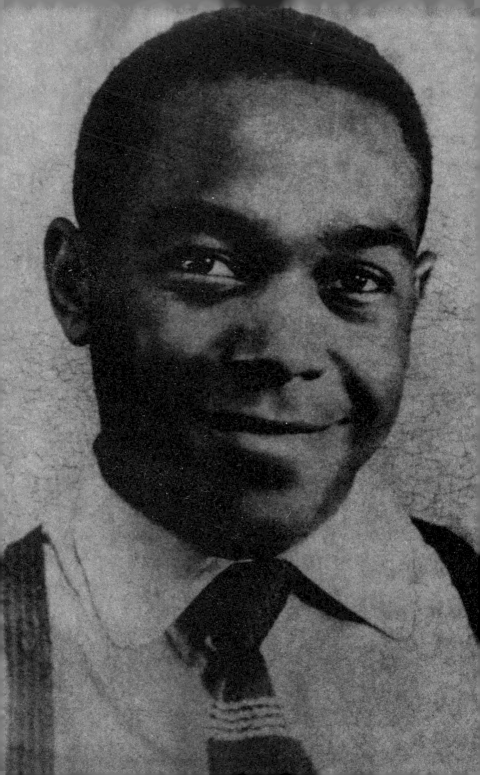

KANSAS CITY LIGHTNING

THE RISE AND TIMES OF
CHARLIE PARKER

STANLEY CROUCH

HARPER ● PERENNIAL

NEW YORK ● LONDON ● TORONTO ● SYDNEY ● NEW DELHI ● AUCKLAND

 HARPER PERENNIAL

A hardcover edition of this book was published in 2013 by HarperCollins Publishers.

KANSAS CITY LIGHTNING. Copyright © 2013 by Stanley Crouch. All rights reserved. Printed in the United States of America. No part of this book may be used or reproduced in any manner whatsoever without written permission except in the case of brief quotations embodied in critical articles and reviews. For information address HarperCollins Publishers, 195 Broadway, New York, NY 10007.

Page 367 constitutes a continuation of the copyright page.

HarperCollins books may be purchased for educational, business, or sales promotional use. For information please e-mail the Special Markets Department at SPsales@harpercollins.com.

FIRST HARPER PERENNIAL EDITION PUBLISHED 2014.

Designed by Shannon Plunkett

The Library of Congress has catalogued the harcover edition as follows:

Crouch, Stanley.
 Kansas City lightning : the rise and times of Charlie Parker / Stanley Crouch. — First edition.
 pages cm
 ISBN 978-0-06-200559-5
 1. Parker, Charlie, 1920-1955. 2. Jazz musicians—United States—Biography. I. Title.
 ML419.P4C76 2013
 788.7'3165092—dc23
 [B]
 2013015773

ISBN 978-0-06-200561-8 (pbk.)

14 15 16 17 18 OV/RRD 10 9 8 7 6 5 4 3 2 1

To Emma Bea Crouch
and
James Crouch

Birds are never far from Paradise,
when they are not singing services at its very gates,
they are caroling blithely in Nature's honor in an earthly
garden of delight or luring mortals into fairy land
by the magic of their magic notes.

BERYL ROWLAND, *Birds with Human Souls*

CONTENTS

Prologue 1

PART I

BORN IN BLEEDING KANSAS 3

PART II

INFINITE PLASTICITY 111

PART III

AN APPRENTICESHIP IN BLUES AND SWING 175

PART IV

SORRY, BUT I CAN'T TAKE YOU 259

Epilogue 327

Acknowledgments 335

Sources 341

Index 355

Prologue

*I*n West Africa, a man dances atop stilts rising more than nine feet in the air. His bold turns, leaps, and spins suggest the power of human beings to master the subtle-to-savage disruptions of rhythm and event that define experience.

In New York, on a bandstand at the Savoy Ballroom, Harlem's "home of happy feet," alto saxophonist Charlie Parker plays for the Thursday night courtship ritual of the "kitchen mechanics"—the female domestics on their night off, dressed in homespun Cinderella finery. The shine of their skin, in all its various tones, is muted by beige powder; rouge colors their lips; their hair is done up in gleaming black scrolls. They wear their dresses, solid or print, as close as sheaths; the heels on their pumps seem made of springs; they wear flowers behind ears heated by the talk of their lovers, their husbands, and the wolf packs of pimps anxious to recruit them for the bedroom mechanics of sexual theater for hire.

With the Jay McShann Orchestra shouting behind him, Parker—a great ballroom dancer himself, whose high-arched feet force him to move from his heels—choreographs his improvised melodies through the saxophone. Feinting, running, pivoting, crooning, he is inspired by the dancers and inspires them in turn, instigating them to fresh steps.

BORN IN BLEEDING KANSAS

One Sunday morning, unseasonably warm for December, a group of musicians sat on the curb in front of a rooming house in Des Moines, Iowa.

Des Moines was one of the stops on what was then known as the Balaban and Katz Circuit. If you were a musician in the 1930s, the circuits took you through different cities, different landscapes. The Balaban and Katz, for instance, took you out of Kansas City and up to Lincoln, Nebraska; then Omaha; over to Des Moines; north to Minneapolis and Saint Paul; back down through Madison, Wisconsin; over to Milwaukee; south to Chicago; then to Springfield, Illinois; moved on to Saint Louis; rolled you into Jefferson City, Missouri; and then back to Kansas City. You heard not just different music but different language on the circuits, and saw different women along the way. It was an adventure, always, but the miles and the fatigue were worth it. When you got out of those cars and stretched, spruced up if you had the time, sauntered into those halls, set up your instruments, fixed the wooden folding chairs in place, took out the music, tuned

up, relaxed, and later unleashed the nappy-necked lightning of jazz, then you came alive in a very special way; then glamour, grace, and audacity could ramble from your instruments; then your mind could shine like Klondike gold.

Kansas City, for these men and many others, was home base. For years it had been a wide-open city, thanks to the power of local gangsters and the corruption of boss Tom Pendergast's regime—and in that time the city had become a hotbed of thrilling bandstand creativity. By 1941, however, Pendergast had been fitted for a prison suit, and the vibrant glare of K.C. nightlife was in decline. Now the music was starting to drift away from the city, flowing west, north, and east with the musicians. These players had known no Depression in Kansas City, no lack of work. Throughout the late 1920s and the 1930s, they had been free to play, compete, and party around the clock. In that boomtown for jazz, mother lodes of style and gushers of swing were mined and brought in—if not nightly, then with enough consistency to make way for a newly textured pressure on the rhythm, a Southwestern swing that celebrated the soul, as well as the coos, the calls, the cries, and the lamentations of the flesh, in pulsive time.

These particular musicians, those who were sitting outside that rooming house in Des Moines, were raring to go east, to New York and the big time. But for now they were pulling tenor saxophonist Bob Dorsey by the tail. They were reminding him in excruciating detail of how they'd torn the pants off that Nat Towles band he was a member of, tore them off in Omaha *and* Lincoln.

You do remember Omaha and Lincoln, don't you?

Seem like I hear silence over there.

Cat got your tongue? Shall we remind you?

Uh, not left with a patch to cover their collective cracks?

Yes, Dorsey remembered the regret and humiliation those Kansas City players had heaped upon them, that rhythm section—meathead Jay "Hootie" McShann's piano, funky-butt Lucky Enois's guitar, thumper Eugene Ramey's bass, and never-miss-a-beat Gus Johnson's drums—was enough to draw blood by itself. Then there were those improvised-on-the-spot short repeated phrases known as riffs, jabbing like a boxer's left hand, and the sweltering combinations dealt by that alto saxophone, which had floored them for the count.

That alto saxophone had been played by twenty-one-year-old Charlie Parker, sitting out there with the rest of them, lean as a telephone wire at 127 pounds, his open face twinkling in the morning light as he laughed deeply at their ribbing. Near Parker was his running buddy, Ramey, whom he called by his middle name, Glasco, and who was easily black enough to knock daylight out of the sky with his fist. The gutter was just beyond their feet, looking like a trench or a grave. It was a mellow morning, strangely warm. Needed nothing more than a coat or a thick sweater: forget about a blanket or a quilt. The time moved so slowly it seemed to have no seconds, minutes, or hours stuck to it.

Someone ran to the door of the rooming house and pushed it open, making the sound of a radio audible from within the building.

He was hollering about Pearl Harbor. *Never heard of her*, Gene Ramey remembered someone joking.

The man at the door said he was serious, something terrible was on the way.

No one was sure, but the way things had been happening over the past few years, with all the goose-stepping and master-racing, they weren't holding out much hope for world peace.

I know some Harbors down in Austin, Ramey countered. *Maybe she's related to them.*

The messenger with the bad news didn't find that funny. Neither did most of the people they encountered after Roosevelt asked Congress to declare war the next day. In the days that followed, the musicians all heard variations on the same refrain:

You niggers better get ready to trade them horns for rifles.

THE REST OF the country may have been gearing up for war, but these musicians, known as the Jay McShann Orchestra, had been at war most of their professional lives. They were jazzmen, and that meant fighting with many a rival band for the affection of the dancers, and fighting with other individual musicians and aggregations for a place in the world of music—whether second chair or first chair, local fame or national recognition. Whatever you were after, you had to get up off your rusty dusty and do something to get noticed—something that was so much like you, it was nothing like anyone else. Oh, if you were young, you could get a pat on the head for sounding like an admired influence, but that was baby shoes. The point was to work at it and think about it and think about it until you'd produced a tone as recognizable as the texture of your voice. Just as an outstanding individual has a walk, a way of carrying the body through space, or a way of adding unique particulars to a dance, an outstanding player had to work till he developed his *own* phrasing, his *own* rhythm. Like a cook who can reinvent a familiar meal, he had to know how to mix his own musical batter, how to balance his own spices, how long to fry an idea on one side before turning it over. All those things formed your style, and style was what led to recognition. It was the difference between being an artisan and an artist.

The McShann band was thrilled that December morning because they'd just been booked into the Savoy Ballroom in Harlem, perhaps

the most famous dance hall in the nation, starting on February 13. That was where the heavyweight battles of the bands took place, where you made it or you lost it. There were no judges, in the strictest sense, working the Savoy; that work was done by the dancers who came intending to party the night away, twirling and bucking and stuffing and pivoting and bending and putting rhythmic spins on the balls of their feet for swirling combinations of steps that counterpointed the slippings and slidings of their partners, each couple a pair of torsos inspired to elasticity by the swing of the band with the strongest beat.

The McShann band's excitement was chastened somewhat by a postcard they received in Topeka, Kansas, on December 31, 1941:

> *We are going to send you hicks back to the sticks.*
>
> *Signed,*
> *Lucky Millinder*

Later for the Japanese: *this* was an act of infamy.

But that job was more than five weeks up the road. The McShann musicians would have plenty of time to talk about what Lucky Millinder *thought* his band was going to do to them when they got to the Savoy—and to think about how to find his jugular vein. Did he not know who he was talking to? Had he no idea that they were products of the swing capital that was Kansas City, Missouri? Many was the Manhattan player who'd strutted into town, only to be taught some manners after stepping in the quicksand of a jam session at the Subway, where plenty of other Eastern heads had rolled before his.

Oh, Lucky, one day soon you're gonna look for your butt and find it's done been bit off!

• • •

CHARLIE PARKER HAD been to New York before. He had ho-boed up to Chicago in the early part of 1939, escaping a marriage that had gotten in the way of his music, fighting past influences, zeroing in on his own individual voice. After blowing out every alto player in town, he'd hopped a train to New York, where he spent about a year. Just as he'd started getting work, though, and earning the respect of fellow musicians, a death in his immediate family brought Parker back to Kansas City. After briefly working with another outfit, he had rejoined McShann's new big band. Parker had been overwhelmed by the wild living he'd experienced in New York, but now he had more self-control and got back into the fold. In the next two years, he grew and grew, able to do more and more of what he wanted with the saxophone.

As the Savoy engagement approached, his mood became ever more buoyant. Finally, after a job at the Paradise Theater in De-troit, the Jay McShann Orchestra struck out for Harlem.

It was February by the time they left. They drove through snow and a landscape drained of color: the earth shifted in tone from gradations of charcoal to anemic browns; now and then an ever-green or two moved up and down to the wind's whistling tune. They all knew the importance of driving carefully as they crossed snow or the slick melts that interrupted the chill, dry austerity of winter. No one was anxious to get out and experience the tear-ful eyes, the running nose, the ears pierced by needles of cold as they struggled to push a car back onto the road, snow sliding down into shoes or the wetness seeping through, almost guaranteeing a sneezing sickness and an ebbing energy that would set in after the first night on the bandstand, since you knew you *were* going to play. This was the Jay McShann band, rough-and-tumble dance instiga-tors from Kansas City: nobody complained and risked starting a collective decline in confidence. Nobody.

They rode through the cold tar of deep evening, wrapped up tight in blankets and quilts, sipping a little liquor now and then, some coffee, all the while eyeing the pale texture of the headlights against the asphalt. The motors of the cars hummed, gurgled, or rattled, the wind squeezed through some crack in a window, and there was the inevitable snoring of someone long gone to the land of nod, head filled with dreams of such imprecision they registered only as impulses of excitement radiating about the *idea* of getting to New York, walking those big-time New York streets, and seeing those big-time New York things.

It was Charlie Parker who got there first, driving the instrument truck with the valet and trumpeters Buddy Anderson and Orville "Piggy" Minor, all wide-awake and anxious to see the big city they had every intention of making submit to the power of Kansas City swing.

They rolled through the Holland Tunnel, truck filled with drum cases, suitcases, music stands, and Ramey's bass propped up in the back, surrounded by old raggedy cushions. Parker, effusive with excitement, raved to the others about New York—its size, the buildings, the food, the music. They came out onto Sixth Avenue and moved north from lower Manhattan, the pulsation and the blare of this authentic metropolis upon them, Charlie pointing things out and joking. They saw the Chrysler Building, its art deco steeple silver in the light; the Empire State Building, where King Kong had held his last stand; Radio City Music Hall, land of the long-legged Rockettes. Parker decided to drive the truck through Central Park, telling his companions they'd never seen a park this big in their lives.

Somewhere on their way across the park, the truck was stopped by a white policeman on a big horse, his uniform dark with a long strap coming across the chest, boots rising to the knees and feet at

upward angles in the stirrups, the pitch of his voice stern, irritated, and contemptuous.

The policeman told Charlie he knew he wasn't supposed to be driving a truck through Central Park. Orville Minor recalled the saxophonist sheepishly getting out, ambling to the front of the truck, pointing at his Missouri license plate, and saying with calculated ingenuousness, "I'm sorry about that, officer. It's an honest mistake. I'm a stranger in town and a long ways from home." The cop issued no ticket, just ordered him to take the first exit and get the hell out of the park.

They checked in at the Woodside Hotel, known affectionately as the Wood House, and nationally famous among Negro musicians because of Count Basie's exuberant recording of "Jumpin' at the Woodside." It provided room, board, and a hangout for Negro talent. It was far from unusual to see buses of Negro revues or Negro baseball teams such as the New York Cubans or the Pittsburgh Crawfords, or the cars and buses of well-known and aspiring musicians in front of the hotel, with Harlem residents pointing from across the street, moving in for autographs of the ones they recognized. From late morning on, the lobby was filled with boxers, dancers, ballplayers, musicians, fans, hustlers, hot girls game to rub up against some talent, and gamblers ready to kick off a crap or card game in somebody's room.

As soon as they got their rooms, Charlie Parker, trembling a bit and with his coat buttoned up tight, took off.

THE WOODSIDE WAS on Seventh Avenue and 141st Street. This part of Seventh Avenue was known as Black Broadway, "the Great Black Way." It was the widest boulevard in Harlem and the scene of the neighborhood's famous Easter Parade, which Kansas City

bandleader Andy Kirk called "the most beautiful thing I ever saw in my life." Here was where the cream of the crop and the cream of the crooks showed off their taste and their finery or attempted to bring some polish to the scurrilous ways in which they made their livings. The bulk of those seen on that thoroughfare personified the viscous vitality of the music—a beauty so rich it stuck to the mind. The skin tones of the residents rambled the gamut, inspiring the Negro people to say of their race that it was like a flower garden, including "everything from lily-white to blue-black." There were Negroes from all over the world there, some from as far as Africa. The aristocracy of taste and individual grandeur set styles and walked heads up, sometimes in crème-colored shoes, sometimes in suede, sometimes in alligators or leather soft as the proverbial baby's ass. They seemed the royalty of their race.

Beat from two days of travel, the McShann band dropped off their bags and headed off to set up their instruments at the Savoy Ballroom, right around the corner on 141st and Lenox Avenue. The Savoy was owned by two Polish Jews, the brothers Moses and Charles Galewski, who had changed their surname to Gale. Opened in 1926, the dance hall was fronted by manager Charlie Buchanan, an uptown real estate agent who played owner and supplied the Negro mask for the public window.

The Savoy was built for continual ritual. Inside its mammoth dance hall, two bandstands stood side by side, so that as soon as one band's set was over, the next could pick up without a pause. The music went on from nine until two. The Savoy had become *the* dance hall in New York—because of the bands that played there, but also because of its customers, whose reactions to the bandstand rhythms set standards for style, giving rise to dance steps that would spread across the nation. As the Savoy grew in fame and popularity, its clientele spread to include rich whites, movie stars,

visiting Europeans, and Negroes from out of town who came to find out what all the noise was about.

The Savoy was quiet that afternoon, except for those working to get it ready for the evening's program. Even empty, though, it was still impressive with its huge maple dance floor waxed and polished to a series of shifting gleams and thick carpet covering the half of it where dancers could cool out at the tables or watch the action from settees. The McShann players started setting up their music stands and drums, got the bass in place, and soon they could hear the illusory sound of the hall—a sound that would change so much once so many bodies had crowded into the room, absorbing their notes, adding sound of their own. You had to play two or three or four times louder during a show than you did in a light rehearsal. Charlie Buchanan gave them a few snooty looks. But they knew they'd soon put his doubts to rest.

When they returned to the Woodside, McShann's men were met by a spontaneous delegation of musicians from Kansas City, there to set them straight on the ways of New York: the best eating places, the most efficient repair shops for their instruments, the cleaners who did the best and fastest work. The musicians were warned to avoid pickpockets—to carry their wallets in the breast pockets of their shirts, hidden under their jackets—and to avoid crowds, because New York was full of barracudas looking for country boys to separate from their money. "If you look like a square, they're going to converge on you," one band member remembered being told. "They sit back and watch for a few minutes, analyze your activities and your characteristics, and then they fly into you with some old kind of persuasion. The next thing you know is you're either beating off an assault or you have succumbed as a victim."

The men who greeted them with advice in the lobby that Thursday afternoon were old friends, veterans of the nightlong

Kansas City jam sessions and the territory bands. They were also part of an artistic tradition, one that had been eroding stereotypes for years by using music to express emotion in terms that were both brand-new and continually evolving. Though the music was filled with references to inside stuff—a particular person, a street corner, a club, a nickname—the penetration of the rhythm, the swing, the harmony, and the melody made it one with the external world. Once there were physical replies to the music in the form of dance, the beat had such irresistible vigor that it transcended all lines.

Travel was one of the many complications in the jazz musician's life. Performing in town after town, city after city, state after state, had taught these Kansas City players that the world wore many faces after dark and in private. They had seen the high and mighty get low-down and dirty, the low-down and dirty get high and mighty. They learned a great deal about what music did to women and what those women might do for the excitement of experiences with men of the world, these colored fellows who appeared free and drifting on a cloud of glamour, gifted with the ability to shape moods with sound. There was always a lot to find out when people gathered to pursue happiness—dancing, romancing, soaking up the atmosphere of joy.

The Woodside welcoming committee that day included some very important Kansas City musicians. There was Oran "Hot Lips" Page, a master setter of riffs on his trumpet; Walter Page, who had invented the modern way of phrasing a bass line and had almost single-handedly organized the jazz rhythm section for ultimate swing; Pete Johnson, perhaps the king of boogie-woogie piano; Eddie Durham, one of the greatest Kansas City arrangers; and members of Andy Kirk's band, an organization that had gotten national attention in 1936 with the hit song "Until the Real Thing

Comes Along," one of the first recordings of a Negro using the romantic ballad tradition, as opposed to blues. But the musician who was probably given the most respect happened to be Count Basie's tenor saxophonist, Lester Young, known in Kansas City as "Red," a Negro nickname for those light-skinned enough to change color when the blood rushed to their faces. In New York, Young had made a series of inspiring recordings with the singer Billie Holiday, and she had given him another name, one that expressed her equal admiration for Young and for President Franklin Roosevelt, who was as popular among colored musicians as he was among Negroes in general (though his wife, Eleanor, was appreciated even more for speaking out against racism). Now Young was known as "Pres," for president, and his smooth yet determined air was a bit more refined than it had been ten years earlier.

The McShann men, who were as far from fantasy as they were from Kansas City, knew they wouldn't have two years to whip their listeners into shape the way Basie had. They would either make it or break it, collapsing in defeat the way Harlan Leonard's band had when it came to New York in 1940, cow-flopping at the Golden Gate Ballroom on the corner opposite the Savoy. Yes, they were told, New York was a big town and different from Kansas City. The corruption wasn't as obvious here as it had been under Pendergast back home, but the gangsters walked softly and carried big guns. And there were other differences: integrated couples walked in the streets during the day, for instance, and it wasn't unusual to find Lana Turner, Greta Garbo, and other movie stars at the Savoy, dancing or enthralled by the motion on the floor. As they relaxed in their rooms, drinking or smoking joints rolled from the red Prince Albert can of marijuana Pete Johnson had brought, they all wondered how they would do out there on the bandstands at the end of that

shining maple floor, soon to be covered by hundreds and hundreds of Negro feet.

BUT THE THINGS his fellow band members were thinking about were of no consequence to Charlie Parker. He had his mind on other matters. Getting in touch with other musicians was high on his agenda, but first Parker had to deal with the condition of his body—to establish connections of another, more urgent kind. Then, and only then, would Charlie Parker the musician take over.

At this critical point in his development, the twenty-one-year-old Parker was possessed by his music—by a ravenous need to improvise, to learn new tunes, to find new ways of getting through the harmonies with materials that would liberate him from clichés. Once he did, his new ideas so excited him that he would play around the clock, looking for another bandstand to test them on as soon as each night's paying gig was done, and yet another if the after-hours players wrapped things up too soon to satisfy him. To McShann, Parker seemed to have a crying soul, a spirit as troubled by the nature of life as it was capable of almost unlimited celebration. But the saxophone was all he really had: it provided him with the one constantly honest relationship in his life. What he gave the horn, it gave back. What it gave him, he never forgot.

But there were plenty of other things to forget. The world had constantly disappointed Charlie Parker. For all the satisfactions of his music, for all the light jokes and deep laughs on the road, he was basically a melancholy and suspicious man, a genius in search of a solution to a blues that wore razors for spurs. And, like a tight number of younger musicians, he found it so much easier to relax, to tame his perpetual restlessness and anxiety, when he

rolled up his sleeve and pushed a needle into his vein. That winter afternoon, Parker likely walked the few blocks from the Woodside to Monroe's Uptown House on 133rd Street and Seventh Avenue, where he knew he could always taste from a big pot of food on the stove—and find his old friend Clark Monroe, who knew all the hustlers, who knew who had the dope, how much it cost, and how dependable they were.

By the time Parker turned up at the Woodside, he was ready, relaxed, and prepared to show off his wares. Those wares hadn't come easily, but through will, discipline, and his massive talent, he was approaching a point of almost absolute flexibility. Parker had worked hard for what he had; decades later, his Kansas City neighbors still remembered how the night wind used to come past his mother's house on Olive Street, pushing before it the notes of the struggling young saxophonist. Parker had spent thousands of hours listening to, thinking about, and playing music. "If there was something he wanted to work out," said Orville Minor, "he did. Sometimes you could hear him practicing when everybody else was asleep. He'd pull out his horn anytime—morning, noon, night—and the next day he'd have it together."

For Parker, as for all professional jazz musicians, the artistic problem of improvising had become clear over the years: how to create a consistent stream of musical phrases that had life of their own—phrases that were marked by fluidity and emotional power, and that were made even stronger by the surrounding environment in which they were placed. The real player invented his own line, his own melody, and orchestrated it within the ensemble so that he was in effect playing every instrument. Only a few did that. But Parker wanted to be one of the few.

Like most jazz musicians, he had started by training his reflexes. When he heard a certain chord, or a certain phrase, he knew ex-

actly what his body had to do to relate. But that was the primitive, almost Pavlovian aspect of playing. What the improvising *artist* did was something different: he experienced time at the tempo of emergency, when the consciousness understood that in order to survive—as in an accident, or when facing the threat of death— your perception had to be sharp enough to recognize every significant detail and put it to use. In that condition, everything slowed to a dreamlike pace and all was made available: the color and shape of things, the temperature, the angle from which you were looking, and a calm that transcended panic in favor of mobile decisions. It could be seen, often, in the glazing of the eyes, felt as a chill or a flash of heat, a humming in the blood.

Whether or not they thought about it, all good improvisers called upon those resources. But Charlie Parker wanted to be more than good; he wanted to be different. Part of your statement was your sound, and the one he was developing struck some more conventional musicians as brittle or harsh. Parker didn't care. He didn't want the kind of rich vibrato that characterized the sound of older players—Coleman Hawkins, Johnny Hodges—that would almost force each note in his compulsively swift phrases to seep into the next. He needed pitches that came out of the horn quicker, that were as blunt as snapping fingers when the inspiration demanded. His tone was absolutely unorthodox, as much like a snare drum or a bongo as a voice. It was assertive, at times comic or cavalier, and though often sweet, it could also sound almost devoid of pity. One trumpeter thought it sounded like knives being thrown into the audience.

When he arrived at the Woodside that night, Charlie smiled. "The sap is flowing," he said—code for "I'm going to blow my ass off tonight."

"Yeah, Bird," McShann responded, "I'm sure it is."

• • •

AS THE MCSHANN band walked the short distance from the Woodside to the Savoy, the tension began to hit them even if they didn't show it. This was the big time: Harlem, the capital of black America, a world already immortalized by musicians like Fletcher Henderson, Duke Ellington, Jimmie Lunceford, and Count Basie. The Savoy was the Madison Square Garden of the battles of the bands, and the instrumentalists who played there—Negro paragons of glamour—fought with the verve and the swashbuckling charm of matinee idols on the silver screen.

Though those Kansas City men had relaxed and ready faces, their uniforms inspired immediate derision from the dancers as they arrived and made their way toward the bandstand, under the watchful eye of the immaculate Lucky Millinder Orchestra, there to get a glimpse of the competition—or what was *supposed* to be the competition.

"Back in those days," said drummer Panama Francis, who was then with Millinder's band, "music was like sports. It was very competitive. People used to make bets. And when we were going to have a battle of music, we would rehearse *every day*, from Monday through Friday. So when McShann came in there, we was waiting for 'em. We were the big boys. We figure, Who are *these* sumbitches? . . .

"Lucky was a showman," Francis recalled. "He wasn't a musician. But he knew more about a band than most musicians did. He could rehearse a band for one week, and when he got through with them those sumbitches sounded like they had been playing together for *years*. He was a master at that. And what a showman! He would spin around and throw his arms up in the air as the trumpets popped their accents, or jump up on the piano, or do any damn thing that

looked as good as the band sounded and made things more exciting. He was something.

"James Brown is the Lucky Millinder of today," Francis remembered in the 1980s. "And, believe me, Lucky had some bombs lined up for the McShann band that night."

McShann's gang must have trembled at the sight of those Millinder musicians, with their hair parted just so, their formal wing-collared shirts dressed up with white bowties and dickies, their blue coats and tuxedo pants, and the leader confident to the point of smirking, the tails of his white tuxedo swaying beneath the buttons at the split as he jauntily headed for the dressing room downstairs. Lucky Millinder couldn't read a note of music or play a musical instrument. But to him, these McShann clowns looked like nothing but a light breakfast for champions, their raggedy old uniforms so stiff they could have stood by themselves in the corner.

It hadn't always been that way. A few years before, McShann's band had had fine uniforms: formal black coats, cross ties, and gray pants with a shiny "gambler's stripe down the side," as Gene Ramey described it. When that wore out, though, it was on to a brown uniform tailored so badly that Ramey had to lean against McShann's piano in a group photograph so his pants wouldn't fall down. Then Les Hite, a California leader whose band was backed by a rich white woman, sold them his blue uniforms secondhand. But the long weeks of road wear finally reduced half the men to wearing their blue coats with brown pants, the others to brown coats with blue pants. None of the mismatched uniforms had been to the cleaners before the Savoy gig; putting them in the day before a job, after all, risked not getting them back in time. Still, their appearance seemed to suit the McShann band, which had turned its habit of looking and acting just a little wild into a kind of informal code.

John Tumino, the manager of the McShann band, was there that night, talking to the Savoy's Charlie Buchanan. "He had already looked at me when we first came in, and he said, 'That's the scrongiest bunch of guys I ever saw in my life. Raunchy-looking outfit.' I say, 'Well, Jesus Christ, if you rode the goddam automobile all the way from Detroit overnight for two days, you'd be scrongy-looking, too.'"

"Our outlook was," Ramey recalled, "you were never supposed to be one of those walking into a place looking hankty or dicty. You got to go in there wild-like. Think wild, play wild. You see a guy so wrapped up in intellect and you wonder, 'Why don't this guy let himself go? Loosen that collar. Drop that shoulder a little bit. Relax.' That was our attitude: don't go in there and try to appear like Imperial Potentates of the Domestic Orders of the Shrine. Although music is serious, we don't want to make it so serious that we appear stiff-necked. Music is like, you see somebody you know wants to talk to you, but they're afraid to approach you. You let them know you're down there with everybody else, and before you know it, the whole dance floor is full of people cutting rugs. A stiff band will never shake the pillars of a dance hall. And we intended to tear the Savoy *down*."

The goal was the groove, which felt like effortless perfection, a rhythm so right it was a refuge from mistakes. The groove was the jazzman's definition of absolute grace: shit, grit, and the highest imaginable level of mother wit. The groove could start anywhere— one brass phrase, a drum beat, a couple of commanding chords from the piano, some notes that the boss of the saxophone unit started conspiratorially whispering through his horn and that soon swelled to take over the reed section, which attracted a counter-statement from the brass, making for a seesaw effect that insinuated itself up the spines of the musicians and the listeners. Then a

deliberate and confident intensity crisscrossed the pulsation as the band started to seduce the audience, moving at a perfect pace all the way from the tart delicacy of one moment to a passage pawing and snorting with bullish intensity in the next.

But before the McShann men could start looking for a groove, they had to get past the verbal mud pies thrown by the well-dressed and cologned Negroes who covered the dance floor, homespun and haughty in their array of styles.

That's a funny-looking cat up there.

He ain't got nothin' on that one over there. That one's real strange-looking.

Look at him: he got a scoop head.

What about the one with that head like a freight train?

Goddam! Where you tore-tail sumbitches from?

You all better keep your suitcases packed.

The second stage was occupied by Al Cooper and his infamous Savoy Sultans, who gave *everybody* playing the Savoy trouble. Oh, McShann's men remembered the Sultans, a notoriously powerful unit they'd encountered back in 1940, when Coleman Hawkins brought a big band to Kansas City and the Savoy Sultans came to play opposite them. That night, McShann had been the warm-up band. When Hootie and his men took the stage, the Hawkins musicians were paying them no attention, too busy straightening their ties, patting their pomade in place, screwing around with their horns. After one tune or so, though, they stopped doing anything but listening. Razz Mitchell, the drummer for the Sultans, came into the hall ostentatiously, rolling his drums before him and mak-

ing noise as though only the radio were playing. When he got near the bandstand, however, Mitchell stopped, and his head snapped up in the direction of the musicians onstage.

"We sent them home with their assholes blown out," Ramey laughed. "Man, they were wringing their fingers and sorry that they ever stopped in Kansas City."

SO WHEN JAY McShann takes his seat at the piano bench, he isn't worried. Tonight is serious business. He knows his boys can blow, and he knows how to motivate them. McShann knows just what to do with his musicians. He will frustrate them, make them feel upset. *How high and mighty these New York spooks think they are.*

Said the novelist Ralph Ellison, who once held down the first trumpet chair with the estimable Blue Devils at rehearsals in Oklahoma City, "We didn't care about the big bands in the East because they didn't have that Southwestern *swing*, which we then called 'stomp music.' It was dance music first and foremost. The Southwestern musicians were from many different places, from the Southwest, from the Deep South, some, like Basie, from places as far removed as New Jersey. But wherever they came from, they all developed a way to lope through the rhythm. It was fanciful and it had fervor. I remember hearing Fletcher Henderson when he came through Oklahoma City in the early thirties. He had Rex Stewart and he had the young Coleman Hawkins and they were all fine musicians—but that band did not *stomp*."

Tonight Hootie isn't stomping either, not yet. He's building up a slow pulse, the kind that creates subtle but evident responses, an unconscious nodding of the head, a raising and lowering of the toe inside the shoe, a swaying of the shoulders. McShann is taking his men through a few stock arrangements, an alligator crawl, a sweet

tune or two, maybe Bird out front, popping the corn of "Coquette." After a little while, he knows, the band will start to get mad, itching for Hootie to call one of his skull-busters. *Uh, not yet.*

Charlie Buchanan isn't impressed. "He says, 'What the hell kind of western goddam band is this?'" Tumino recalled. "He didn't know jazz from Shinola. Rhythm and blues, that's all he knew. He says, 'I'm going to get rid of these goddam bums tomorrow.' I says, 'Well, man, you got a contract. For two weeks, you're gonna suffer and die with them.' 'The hell we do. I'll throw them out on their ear the first thing tomorrow.'"

Now, finally, Hootie calls one of those skull-busters. But he keeps the rhythm section out there playing a long, long introduction, romping and slapping the beat this way and the next. Chorus after chorus comes to an end, till the customers have been dancing for a while—some of them skeptical, others consciously snapping their fingers, nodding their heads, patting their feet. The horn players are sitting up there looking stone cold dead at the market, waiting to get at the throat of that other band, ready to bust a hole in the wall as soon as Hootie lets them loose. *Not yet.* Another chorus. Guitarist Leonard Enois—who would wear a shirt four days on one side, then reverse it, who hasn't changed his socks in at least four weeks—starts patting his foot, sending blues fumes up through the nostrils of the band. Gene Ramey's humming bass notes reverberate through the rhythm. A dancer even behind the traps, Gus Johnson has his instrument tuned for dark lower drums and a high, bright snare sound, all garnished by the swoops and shimmerings of his cymbals; he's smiling and leaning into the beat.

Then McShann lifts a finger, and the unruly holler from the territories hits like ice water on a hot stove, sending steam up to the ceiling. Now the dancers aren't really dancing; they're at the edge of the bandstand, saying things like, "I don't know where you

raggedy motorscooters come from, but you sure are swinging!" They finish up that set, go into their theme, "One O'Clock Jump," signaling Lucky Millinder to come upstairs and get ready to grab the baton.

As McShann comes off the stand, Tumino pulls him aside.

"Jay, you better lay everything you got on 'em. This man [Buchanan] is gonna throw your ass right out of here tomorrow. It ain't bad enough you look terrible, you *sound* terrible to him. You got Lucky Millinder playing opposite you. Blow that son of a bitch right off the stand *tonight*."

"All right, I think we'll do that," McShann says, his cool intact.

Millinder doesn't mess around. He opens up with his roughest and most intricate arrangements, aiming to decimate the enemy right away. "We played 'Prelude in C-sharp Minor,'" Panama Francis recalled. "It was fast, full of notes, and really exciting. Then we went into Andy Gibson's arrangement of 'Blue Skies.' We dropped some thunder on them. It was like a prizefighter, looking to shake you up, let you know it's going to be your ass *very soon*." Millinder is out front, hair perfectly in place, tuxedo tails swinging with the beat, his handsome band playing that well-rehearsed music with a hard but unruffled edge.

Then those ragamuffins start sauntering back up to the bandstand next to theirs, looking unimpressed, readying themselves to play. Millinder doesn't care how they *look*; he knows his band is whipping them in grand style.

When his set is over, Millinder heads downstairs to the dressing room. After a little while, his valet comes running in.

"Lucky, you better get up there and listen to them western dogs."

"*Out!*" Millinder orders.

Back upstairs, Count Basie has stopped by to cheer on the Kansas City team. He leans over the piano, with a cigar between his

teeth, a cold look in his eyes. "It's about time to blow these mother-fuckers out of here," he tells McShann. "It's about time to get them up off that bandstand. Put them in the *books*, baby. Make 'em dig for something."

· "I'm ready," McShann answers.

"Anything you want, anything you need?"

"Well, Base, how about a couple of hits?"

"You will have them," Basie mutters through his cigar, then leaves for liquor.

McShann puts blues singer Walter Brown on them, then contrasts him with the blind balladeer Al Hibbler, who perhaps sings "Skylark." Piggy Minor kicks off "Dexter Blues" with a growl strong enough to scare the entire Millinder brass section to death. Then, when the band is oiled up and the crowd is starting to go crazy— when you can smell excitement coming out of 'em—McShann unleashes the *hot man* on the audience, making it clear that there's hell to tell the captain.

Clap hands, here comes Charlie.

When Charlie Parker stands up, lean, hair glinting from the fusion of grease and light, he has been playing the saxophone for seven years. He started playing clubs in 1935, but he didn't get serious until the following year, when Chu Berry came through Kansas City and pushed his foot through the bell of his tenor and up the butts of the roughest men in town—Lester Young, Herschel Evans, Ben Webster, and Jack Washington. From the spring to the fall of that year, Parker transformed himself from an incompetent into a real player. Kansas City bandleader Oliver Todd, who had fired Parker for his fumbling performance some months earlier, said, "When I heard him come back from a summer off somewhere, I witnessed a true miracle. He could play. Tears almost came to my eyes when I heard him then."

Over the next five years, Parker worked at a style that he was still developing that night at the Savoy: a new music built with the brass of the saxophone's body, conjured with such poise that his fingers barely rose from the keys.

BEFORE SUNRISE, the news was on the streets: a fresh bunch of Kansas City musicians was in town, and Lucky Millinder was taking a beating. It was a familiar kind of tale, part of the excitement of living in Harlem. Somebody would show up with a new way of doing it, or would do the classic stuff with such heat it felt brand-new. "It was a shock to everybody, because we had been holding our own with the other bands," said Panama Francis.

The next morning, McShann had a visitor at the Woodside: Lucky Millinder himself.

"C'mere, you little son of a bitch. I want you to go with me this morning so we can sit down and talk."

Over drinks and food, Millinder told McShann, "You know, you dirty sumbitches run us out of there last night."

"Oh, no," McShann demurred, "you know better than that."

"Yes, you did. I was going to send you back to the sticks, but you motherfuckers run us *out of there*. Look, you're in the club now. I'm going to take you around town and show you what's what. Here's my card. You ever need to know about something, you call me."

McShann was shocked. "I never met anybody like you."

"Well, that's the way it is in New York. When you bust your way in, you're in. Let's get out of here and spend some money."

McShann went along, but that didn't mean a truce; no form of friendship came before music.

In the Kansas City jam sessions, you had to be able to play either brilliantly or boldly. The following night, McShann's organization

did both. They played at just the right tempos, an essential element of swing. Half the audience was at the bandstand's edge, listening and snapping their fingers; the other half took to the dance floor, becoming what Dizzy Gillespie called "the mirror of the music." But the notes and the rhythms that caught the dancers inspired more than a reflection. There were so many different variations going on out there that the musicians were prodded into new ideas as they looked at those Negro bodies improvising on the music in time.

With their confidence all the way up, the McShann Orchestra had the corner on that dialogue. They were changing their title from western dogs to western *demons*.

"Jay's band was very special because we could play a waltz, a schottische, or whatever," observed Orville Minor. "Somebody in the band could fit it, and the brass section could sit up and play some harmony behind anybody. The reed section got to where it was that way, too. A cat would know what particular part of the chord to build his notes from. Got to be so good at it you couldn't tell what was written and what wasn't."

So McShann could send Walter Brown out there with Piggy growling behind him; then Bird would step up a chorus later, slipping arabesques of musical freshness into the gutbucket. Hibbler's sepia ballads would push the men and women together. Then Charlie would rise again, from the romantic cushion of brass and reeds, to manufacture gooseflesh with an improvised melody, a veil of transparent lyricism, in bursts as brief as eight bars that made the dancers hold each other even closer and caused his fellow musicians to shake their heads. And so the McShann band proved it could swing, Kansas City style, lolling into power, tailing behind the beat a little bit, gradually lifting the gear a notch, just a little more, until all within hearing distance knew it was *on*. Building, is you ready? 'Cause we gonna tear you *down*!

• • •

ON SUNDAY, AT 4:30 P.M., a local radio show broadcast a quick fifteen-minute set from the Savoy Ballroom. The producers allowed in thirty or forty people to give the musicians an audience, to make it more than a brief rehearsal. When they got the signal, McShann's band kicked off a blues. "And now, ladies and gentlemen, from that home of happy feet, the Savoy Ballroom, we proudly present the Jay McShann Orchestra, all the way from Kansas City! Take it, Jay."

They loped through the blues, then went into a medium-tempo song that swung nicely. They intended to take it out with "Cherokee," Charlie's feature.

But Charlie wasn't there.

Well, that was Charlie Parker. Everyone was disappointed in a familiar way, the way that those who must do business with drug addicts become accustomed to—starting with suspense, as all wonder if this will be another one of those times, then leading eventually to an exaggerated apology or one hell of a story about what made it impossible for him to get there. The men all felt this burden of potential disappointment, and the resentment that came with it. Why did this have to be the guy with all the talent? Why couldn't he be like the other guys who had it—Louis Armstrong, Coleman Hawkins, Lester Young, Roy Eldridge—able to have his fun while keeping his professional image shining? Why did his private life have to mess up everybody else's plans so often? That was the way it was, and it could seem so pitiful sometimes, make you so angry.

But then there he was, moving across the floor, case in hand.

McShann stomped off a furious tempo. "This wasn't one of those slow-trains-through-Arkansas tempos," recalled Ramey. "This was like that train between Chicago and Milwaukee. I mean *fast*!"

The rhythm section lit out. The band came in and played the

song's ensemble chorus, sixty-four bars of a tune notorious for its complex harmony, all those holes you could break your musical legs in. This was one of those times when the griddle was hot and nothing came up except steam. Arrogant and proud of themselves, the rhythm section reared back and pounced on Charlie's back when he put his horn to his mouth. And his saxophone, in turn, became a flamethrower of rhythm, melody, and harmony. They pushed and drove, chorus after chorus. Then, as professional experience had taught them, they lulled, let him get a little stronger, went back to their basic strategy, and let him dance his hot-footed dance with subtle support. Then they tore into him again, setting fire to his tail.

The rhythm section had him by the tail, but there was no holding or cornering Bird. Disappearing acts were his specialty. Just when you thought you had him, he'd move, coming up with another idea, one that was as bold as red paint on a white sheet. When the band started throwing up stock riffs behind him, Parker sidestepped the familiar shapes, issuing his responses from deep in left field. "Boy, did that man hate riffs," said Ramey. "He would do anything to get out of the way. Soon as he knew it was coming, he would duck into silence and come up squawling to kick it in the butt as it went past him."

Each chorus was getting hotter; it was clear, from the position of his body and the sound of his horn, that Charlie Parker was not going to give in. All the nights he had worked on it, the flubs, the fumblings, the sore lips, mouth, and tongue, the cramped fingers—they all paid off that afternoon. Suddenly, the man with the headphones was signaling McShann, *Don't stop! Don't stop! Keep on playing!*

That afternoon, sixteen miles away from Harlem, bassist Chubby Jackson was working at the Adams Theatre in Newark. He was play-

ing with the big band led by Charlie Barnet, who had had a hit with "Cherokee" two years before. While on break, Jackson decided to see if that new band playing opposite Lucky Millinder was showing anything special on the Savoy broadcast. As soon as he turned on the radio, a sound that was almost brutal shot out of the speaker. The song was "Cherokee," but the sound leading McShann's version was that of an alto saxophone almost completely devoid of vibrato, notes flying thick as buckshot, slapping chords this way and that, rambling quicker and with more different kinds of rhythms than his band had ever heard from a saxophone. Everybody stopped talking, fiddling with their instruments. Who the hell is *this*? Oklahoma trumpeter Howard McGhee, who was there that afternoon, chuckled at the memory: every musician standing there with his mouth open knew where he was going *that* night.

Back in the Savoy, the few people in the audience started moving up toward the bandstand as this saxophone player leaned forward, sweating like a waterfall, delivering his message as though he were on a mountaintop. Even Charlie Buchanan ambled up there, caught by the sound, the fury, the determination, the swing that had the radio man jumping. Parker, completely sparked, ran through the changes like a dose of Epsom salts, unwilling or unable to repeat himself.

Stretched out like that, with the rhythm section after his scalp and the cyclical traps of the harmonies ever before him, Bird reached down and called upon all his skills and instincts, all the gifts for perception in emergency that he had developed over the years, even at this tempo making coherent statements, playful variations, and mocking responses to the musical ideas by which he was surrounded, supported, attacked. His obsession with shifting, deceptive rhythm resulted in endless ways of toying with the beat that jelled perfectly with his desire to create melodies accompa-

nied by harmonic surprise. In his hands, a single note functioned on five levels: its individual pitch was melodic; it was a brass-balled harmony note; it was given individual texture through his control of color; its voicing was dictated by the register in which it was played; and it served a rhythmic function within its phrase. As Ramey said, "Bird knew how to dance in and out of that meter, *with* the tempo, and still get back when Mama comes home for dinner. He could take a chord that had a bastard relationship to the rest of the harmony, and, before you knew it, he has woven that bastard into the flock like it was supposed to be there all the time."

As they got the signal to take it out, the McShann band really started to roar behind Parker, and he lifted his brittle sound up over the thickness of the brass and the reeds, over the awesome marching of the rhythm section, and slashed his way home. They'd romped their way through at least forty choruses, but these weren't like the evanescent choruses heard only in backstage jam sessions or on some inspired evening at a dance in a little out-of-the-way town. These choruses had been sent out over the local radio waves, and everybody interested in swinging bands was listening. This unknown saxophone player was putting the world on notice that there was another way of looking at everything.

THAT NIGHT, MCSHANN'S men had to push their way through the crowd to get to the Savoy bandstand. The customers were tucked as close as the cylinders of paper and tobacco inside a cigarette pack. That 4:30 broadcast had drawn hundreds who hadn't already been convinced by the talk of this new band that was chastising Lucky Millinder. There were droves of musicians trying to get near the bandstand, trying to find out the name of the anonymous saxophone player who'd run all that melodic lightning through "Cher-

okee," swinging his butt off all the while. Some sort of history was being made and they didn't want to miss it.

The Lindy Hoppers, a Savoy dance group, were on the floor ready to swing, wearing out their shoes, sweating black patches in the armpits of their clothes, and humbling any amateurs who thought they might out-dance them. The young Redd Foxx was with the Hoppers, traveling the same circuit, executing the intricate steps, and getting his start as a comedian. Ready to sit in with the band, trumpet in a case under his arm, was Dizzy Gillespie; crammed in close to him was Thelonious Monk, whose intelligent eyes belied his somnolent bearing. Also in the audience, powdered and painted, were the women known as 802 Girls or Dirty Legs— those who fell in love with every band that made a strong impression at the Savoy. As the McShann gang made its way through the crowd, the women talked among themselves but made sure the musicians could hear them:

> That's mine over there.

> I want that one.

> He sure is cute. I know he wants to talk to me.

Others waited till the break, preempting the competition to get right up in the faces of the players:

> Excuse me, are you with the band?

> Hey, what's your name?

> You from Kansas City? I got a cousin in Kansas City.
> I sure do like Kansas City people!

The band was walking on air filled with perfume, cologne, and good wishes, and it was easy to see that everyone was expecting

something special. This was different from opening night. They were still as raggedy as ever, but now the Jay McShann Orchestra had a reputation to live up to, every night or often enough to convince the town that there had been no fluke: they had definitely kicked Lucky Millinder's ass.

AFTER THEY TOOK the Savoy, as Basie had, the Jay McShann band started taking in the other musicians in New York. True, they sounded good, but they didn't have that fire, they didn't have that swing, and they didn't have Yardbird. Oh, they knew better than to try and tangle with Basie or the undisputed boss of the jazz orchestra, Duke Ellington, but they didn't feel they had to take a backseat to anybody else.

"We had to get all of them out of there at the Savoy," said McShann. "We had to go in there with Erskine Hawkins's band. We had to do them in. We had to go in there with Cootie Williams's band. We had to get them out of there. We had to take care of the Savoy Sultans. At that time, Lionel Hampton was organizing his band. Down at Moe Gale's office, they said, 'Well, put Hamp in there with them at the Savoy.' 'Hell, no, don't put them in there— them sumbitches will *kill* him!' We woulda killed him. We didn't allow nobody to light in there, baby. *Noooo-body.*"

After the various musical confrontations and the string of victories, they became so indifferent, even contemptuous, toward their New York competition that they captured their swagger in a new song, "Hometown Blues," with Walter Brown out in front of the band:

> I'm thinking 'bout my hometown,
> a little place way out in the West
> I'm thinking 'bout my hometown,

a little place way out in the West
Some folks call it a hick town,
 but I rate it with the best

I left home for the big town,
 it ain't been so long ago
I left home for the big town,
 it ain't been so long ago
But there's nothing in the big town
 my small-town friends don't know

We have sessions in my hometown
 that will make you jump and shout
We have sessions in my hometown
 that will make you jump and shout
Well, the Bird is the boss cat—
 do you dig what I'm talking about?

Of course, he hadn't always been. Many things happened to
Charlie Parker on the road to becoming the boss cat. And that is
where our story begins.

In the nineteenth century, when Americans thought of the Wild West, they didn't mean California, for all the color that galloping desperadoes like Joaquin Murrieta, or the prospectors panning for gold at Sutter's Mill, gave the coast. They were thinking of towns just west of the Missouri River, towns in Kansas like Dodge, Abilene, Wichita, Ellsworth. If a drunk got on a train and asked to be taken to hell, it was said, the conductor would put him off in Dodge City. That was where the cowboys brought the cattle up from Texas, then partied with whiskey, women, cards, and pistols, daring the law to break in on their fun.

Or Americans thought of the broad center of the country, which italicized its difference from the East when three events took place in 1876: when Custer and the Seventh Cavalry got their ashes hauled at Montana's Little Bighorn; when Jack McCall blew Wild Bill Hickok's brains out in Deadwood, South Dakota, as the lawman held a hand of aces and eights; and when the Jesse James–Cole Younger gang was fed an afternoon meal of lead in an abortive raid

in Northfield, Minnesota. Cowboys. Indians. Gunfighters. Bank and train robbers.

Like all jazz musicians, Charlie Parker embodied many things: three hundred years of black American dance and music, everything from slave cabin steps and field hollers to the melodic-rhythmic revolution of improvised phrases spun out by Louis Armstrong and the arpeggiated harmonic dazzle of Art Tatum. That long march to improvised sophistication began in Jamestown, Virginia, in 1619, when African slaves were first brought to North America. But this particular western dog and innovator had his roots in that forgotten American West of Kansas and Missouri—that world of explorers, horses, wars, and settlers. His bloodline was both cosmopolitan and all-American, mingling African, Indian (which is also to say Asian), and European stock. And the Wild West in which he grew up was shaped by the same three sources that constituted his genetic line.

IN THE 1530s, colonists in the territory known as New Spain, south of the Rio Grande, were entranced by rumors that great riches had been found in a city called Cíbola, somewhere to the north. The itch for wealth raised sufficient curiosity in the local governor, Francisco Vásquez de Coronado, to persuade him to organize an exploratory team under the leadership of a Franciscan friar named Marcos de Niza. As an advance scout for the mission, they enlisted an African slave named Estevan, who had mastered the Indian sign language. Estevan is described as "an Arab negro from Azamor," a chattel Othello who had survived a Spanish expedition into Florida led by Álvar Núñez Cabeza de Vaca that cost the lives of nearly four hundred men, sparing only Estevan, Cabeza de Vaca, and two others. So Estevan knew something about Indians.

Leading a group, including the Arab Negro and some hand-picked Indians, Niza moved north, into what would later be the southwestern United States. The leader returned in 1539 with the story. Estevan had died up there, he said, for some foolish and arrogant act; the promotion from slave to scout had yeasted his head to self-destructive proportions. *You know, give them an inch.* But the discovery had been incredible: there were *seven* cities of Cíbola, not one. They dwarfed Mexico City, their buildings draped with gold, their doorways bedecked with turquoise. Estevan, the advance scout, was the only one who actually entered the cities; Niza claimed the slave was startled by the endless sheen of precious metal. Niza himself had seen it from a great distance as a glow, a golden glow.

Hoping to equal the prestige of the explorers who preceded him, in February 1540 Coronado led an experienced and tough group of men in search of Niza's seven cities of Cíbola. Yet the mission was ill-fated: two-thirds of his conquistadors were lost along the way, and when the survivors arrived at their destination, the golden vision of Cíbola was nothing more than a landscape of stone and mud houses, Niza's promise of glowing riches no more than snake oil. Armored, battle-ready, and disappointed, the Spaniards made short work of the city's Zuni inhabitants.

In 1541, on the northernmost leg of the expedition, Coronado passed through what is now the state of Kansas. Like many thereafter, he found the land oppressively flat. But he also observed that it was a very effective place to get lost, or to cover one's tracks: though he drove a thousand horses, five hundred cattle, and five hundred rams before him over the Great Plains, the grass sprang right back up in their wake, leaving no trace of their passage. It was no wonder that so many men had disappeared in the region.

Some of those horses would become Coronado's greatest gift to

the region. As Walter Prescott Webb notes in *The Great Plains*, the horses were the product of

> a long heritage of breeding and training that fitted them in a remarkable way to serve their masters. The horses of Spain were the horses of Arabia, of northern Africa, of the Moors; in short, they were the horses of the desert. This meant that they were hardy and tough, could live on scant food, on forage and grass, and did not depend entirely on grain. This Asiatic, Arabian, African-bred horse (and cattle of equal hardihood) flourished in semi-arid America. Had the north-European breed of grain-fed stock first struck the Plains, history might have been very different. The Spanish mustang, the Indian pony, became the cow horse of the cattle kingdom, and the longhorn of Spanish descent traveled from the valley of the Rio Grande to Milk River, gaining flesh on the road.

Somewhere during that expedition, as Coronado passed through the plains, he lost—or let loose—some of those sturdy Spanish horses, a move that helped give rise to a nomadic horse culture that would make the Plains Wars so fierce three centuries later.

In a spectacular loop of history, the "Indians" who confronted and tamed Coronado's lost Spanish mustangs were actually descendants of the Asians who had come across the Bering Strait millennia before—the very same people who first broke and rode horses on the steppes. The ancient Asian horsemen had brought their domesticated beasts to North Africa—and when the Moors conquered Spain, the horses went with them. From there they would

travel with the conquistadors across the Atlantic to Mexico. Within two hundred years the Plains Indians were mounted, and by the middle of the nineteenth century the Comanche were the greatest equestrians in America. The awesome horse culture that evolved under the Plains Indians would affect the lives of every race of people who came across the Mississippi and Missouri Rivers.

THE AMERICAN CIVIL War is often characterized as a conflict of "brother versus brother." Given that nearly 180,000 Negro troops fought in blue against the gray, however, that familiar description is more a romantic exaggeration than a military fact. And the black soldiers left standing at the end of the War of the Rebellion played an important role in the shaping of the Southwest.

In 1866, the year after the war's end, the Ninth and Tenth Cavalry, two all-black regiments, were formed at Fort Leavenworth, Kansas. They would soon come to be known as the Buffalo Soldiers. The soldiers in these regiments were poorly paid; the discrimination against them was obvious to the point of disdain. But the Buffalo Soldiers, who rode their horses proudly and sometimes posed for photographs wearing plumed helmets, were instrumental in the settling of the area. The Negro troops knew, through the crucibles of danger, loss, inclement weather, inferior horses, outmoded weaponry, and the injuries of racism, that they were *bad medicine*. Their units had the lowest desertion rate in the US Army. They fought in the Indian Wars of the late nineteenth century, arrested rum- and gun-runners, guarded the construction of the railroads, and contributed to the accurate mapping of the Great Plains. And their legacy includes the cities where Western jazz evolved.

The Buffalo Soldiers were not the only black people who con-

tributed to the growth of the Southwest. Negro cowboys drove cattle from Texas to the cities in Kansas where the markets existed. Some who owned land tried to bilk herders out of money or demanded tribute if the cattle were to cross their property; others became desperadoes, even con men. And the fall of Reconstruction in 1877 brought a great migration of black people to Kansas, men and women who worked hard to carve out a rough civilization that was punctuated by gunfire, lynch mobs, and jail.

The Old West was rife with such violence—a streak that would reappear with the bloody exploits of men like John Dillinger during Charlie Parker's adolescence in the mid-1930s. But it was also enlivened by the provocative tension between the thrust of individual liberty and the desire for order and safety. Out there in the West, that tension made for an improvised world. The skills that Charlie Parker brought to such visceral prominence on those nights at the Savoy were the result of a tenacious ambition that first took shape in that latter-day Wild West known as Kansas City.

EASTERN KANSAS, AT the Kaw River, is incipient timberland. In the nineteenth century, before the development of barbed wire, farms were surrounded by hedges that freshened what was often described as a monotonous landscape, a kind of visual drone.

On August 29, 1920, a brown baby, with a red undertone to his skin, came yowling from the womb. He was born not on the Missouri side, where the political machine of Tom Pendergast kept contempt for the law alive, twentieth-century Packard style, but across the river in Kansas City, Kansas. His name was Charles Parker Jr., though no one remembers him ever being referred to as a junior. His father, Charles Parker Sr., was, by his own account, born in Mississippi to Peter Christopher Parker—a second-marriage baby

for Peter, who would eventually have four wives, according to Fanny Blake, his half sister by the fourth wife. Part Negro, part Indian, with some white genes from an overcast point in the family history, Charles Sr. was light-skinned and attractive, a cook on the railroad, a well-groomed man who wore a part in his hair and combed it neatly across his head, not forward or backward. His shoes had the powerful gloss of those who earned their money on the passenger trains, his dancer's legs long acclimated to the swaying and rattling of the Pullman cars as their metal wheels turned on the tracks. He was a man of charm and wit, but his exuberance and his ability to learn quickly were tainted by an excessive attraction to nightlife and dissipation.

The consequence was that all-American heritage of Charlie's: the Asian and European blood running beneath his reddish-brown skin. Yet the forming of the Wild West in which he grew up had a much earlier start and one that was given the glory and the gore of its beginnings and shapings by the same three sources that constituted his genetic line.

Charlie Parker's mother, Addie, was from Oklahoma, the region once called Indian Territory. Like Jay McShann, she claimed Muskogee as her hometown. She was part Choctaw, her Indian blood probably the result of President Andrew Jackson's policies, which had pushed the tribe northwest from Mississippi. About five feet five, she had high cheekbones, a pointed nose, thin lips, a big bosom, and an ascendant rump. Mrs. Parker wore her hair long, in what was known as a cat-and-mouse style, with a bun on either side of her head and one on top.

The Parker family, two adults and two children, lived in a five-room frame house on Washington Avenue between Ninth and Tenth Streets. Before he married Addie, the light-skinned Charles Sr. had coupled with an Italian woman named Edith; she

gave birth to John Parker, a jolly, big-eared boy named after his peg-legged uncle, another resident of Kansas City, Kansas. Three years later came Charles Jr., and he soon became the favorite. Charlie was Addie's only child, and he became her obsession—especially when Charles Sr. made it obvious that he had no intention of giving up the firewater that made him cut the fool. When she scolded him for his behavior, he stood his ground: "I'll stop drinking," he told her, "ten years from *today*."

When he first answered her that way, it was almost funny. Charles Sr. was the kind of handsome man who got used to being funny. But he did not know when he had ground her patience and belief in him down nearly all the way. She began to lose faith in her husband as a responsible man. Over time, Addie Parker started to believe it would take a hundred years for this man to stop his drunkenness, and as she did, her eyes became hard as cherry pits. An acidic bitterness had scalded her skin. But she willed herself to do what would protect what was important. That was a sorrowful but sure thing that had its own brightness.

Edward Reeves, who lived across the street, played often with Charlie and John Parker. He remembered the neighborhood as one where everybody knew everybody else and a child seen misbehaving had to face whippings in triplicate: the first from the neighbor who saw the act; the second from Mother when he got home, or after she got home from work; and the third when Daddy arrived and found out what had happened.

"The neighborhood was together," Reeves said. "There was a close feeling. You might not like it if one of those people put a strap on you for being way in the wrong, but you could count on them when you had troubles. If you got sick, everybody was trying to help you. They got together and exchanged remedies. . . . Goose grease on your chest and a flannel over it. If you got a cut on your

leg, jimsonweed salve. It was yellow and it would damn near fight off gangrene."

Reeves didn't recall ever seeing the Parker boys' father, but he remembered Addie as sweet and friendly. The two sons were opposites: "I first met Charlie on Ninth and Washington Avenue. He must have been about eight. I was always butting around somewhere and I met John first, who was kind of a straggler, you know, looking for fun. . . . John was talkative and laughing. Charlie was different. He was a loner. Mostly to himself. John talked a lot but Charlie was quiet. Charlie didn't bother much whether he got with you or not. If he was digging a hole and you was climbing trees, he kept on digging that hole. If he was climbing a tree and you were digging a hole, he wasn't thinking about coming out of those branches. But when he wanted to, Charlie could get with us and we would do all the things that boys did back then. Just fun, but plenty of mischief, too."

They played mumblety-peg; they rolled hoops removed from the wheels of old wagons; they shot marbles; they rode sleds in the winter. There were railroad tracks, a box factory, and coal yards in walking distance, which allowed for playing in boxcars, climbing in the box factory's bins, and getting filthy with coal dust. But their bib overalls were strong enough to stand up to the pressure of boys out for squealing joy.

One of the things they liked to do was individually beg up on a few cents from a parent and go "crawdadding." "We'd get a nickel's worth of liver and those crawdaddies would cover it. They was good eating, too." On Saturdays and Sundays, the kids could buy crawdads from the crawdad man, who dressed in white from head to foot. They could hear him as he came up Washington Avenue, turning on Eighth, coming up Ninth, calling out "Craaawww-pappies! Red! They're *hot*!" "A dime's worth of red, pretty crawdads

was plenty," Reeves recalled. As it got cooler, the crawdad baskets on each arm were replaced by a tamale cart, with two big wheels in the front and a small one in the back. "Hot 'males! Red! They're *hot*!" the man sang, selling three for a nickel. The ice cream man came in the spring and summer, selling cones for three cents a pop.

Mischief surfaced on days like the Fourth of July, when the boys would go to the park on the corner of Tenth and Washington to shoot cap pistols—"Man, if you didn't have a cap pistol, you wasn't nothing!" They were free to wave sparklers, but were warned to stay away from firecrackers. Which they didn't. "They had these little things called bombs about the size of rum balls," said Reeves, "and if one of those bombs hit you on the leg, it would hurt."

The week before Halloween, Reeves set out with John and Charlie Parker and five or six other boys to celebrate Cabbage Night. They raided cabbage patches and hurled the biggest heads they could find onto porches or against front doors before running for the hills. Halloween was a bad night for outhouses, too: the giggling conspiracy of young boys would pull on masks, go up alleys, and turn over as many as they could, squawling with delight as they made their hotfooted getaway. A block away was a white neighborhood; the people there weren't rich, but they were doing much better than the Negroes. The pranksters stayed away from them.

"You could go to anybody's house and eat on Thanksgiving," Reeves remembered. "They either had a lot of chicken or a goose—greasy. Didn't have too many turkeys. They raised a lot of geese. Regularly, around the year, there was always rabbit and chicken. Rabbits cost you fifteen cents then, two big rabbits for a quarter. The children always got to clean the rabbit after it was skinned, and eventually you could do it all, skin it and clean it."

On Christmas, the white people up the way gave their children's toys from the previous year to the colored families. If the toy was a

wagon, it had been repainted and supplied with new wheels. Candy canes, cap pistols, miniature ten-gallon cowboy hats, and affordable necessities were the order of the day within the Negro families. If there had been a good snow, it was scooped up and thrown in fights, sleds were dragged into sliding positions, and rolls of expended caps rose as the hammers of toy pistols came back before striking the next dot of powder in the neighborhood western of winter warfare. Bang: you're dead. Negro cowboys.

Photographs of the young Charlie Parker taken during these years show mirth, concentration, pride. In one, he stands next to a wooden car that might have been a secondhand toy from the peckerwoods. A little girl sits in it, and he seems an almost haughty little prince. In another, Parker holds a cane and is attempting to summon a raffish expression. Twenty years later, when the saxophonist saw the second picture, he declared his younger self "a clean little Bird"—a moment of melancholy nostalgia. There were no drugs in his life then—nor, for that matter, any apparent signs of musical promise. Yet even in these early pictures Bird appears removed, almost aloof.

Young Charlie Parker was a sensitive boy, tightly bonded with his mother. Before he went to bed, she recalled to club owner Robert Reisner, he would tell her, "I love you, I love you, Mama." Little Bird also didn't suffer insult easily: Addie told Reisner that Charlie punched out a boy at school for making fun of some pimples on his face.

The school in question was a local Catholic institution—an unusual choice, since Addie, like most Negroes, was Protestant. That Catholic experience separated young Charlie from his surroundings, and he recognized early that there were ways to do things that were different from standard practice. His mother recalled him telling her that "we" didn't do things a certain way—identifying

with the way Catholics taught, thought, and lived. It was probably during this period that Parker wore the Little Lord Fauntleroy suit he often recalled when selecting details from his childhood. "Had a wide collar," said Edward Reeves, "a silk tie that you tied like a bow tie, but it came almost down to your stomach. The coat and the pants were velvet, the pants had two buttons down on the side. You wore stockings then and buttoned shoes. Some fellows had buckled shoes. You were in there when you wore that kind of stuff."

Charlie Parker was in there. Whenever he asked permission to get a pocket-money job, his mother refused, preferring to give him what he needed herself. Addie Parker reared her son as a homebred aristocrat, a young lord, and the expressions we see in his childhood photographs are probably the results of his being treated as royalty. But no one knew how heavy a crown the young prince was destined to wear.

Around 1930, Addie Parker faced what she was up against: her husband was an incorrigible whiskeyhead. Marriage had dealt her a bad hand, and she decided to throw it in. Leaving half-white John with his father in Kansas, Addie took Charlie, her only blood child, and moved across the river into Missouri. After short stints at a series of addresses, she bought a large two-story house at 1516 Olive Street. She made ends meet by doing domestic work and taking in cleaning. She rented out rooms on the second floor—there was more than enough space for her and Charlie downstairs, where there was a big parlor, two bedrooms, and a kitchen. Her young and largely silent son was enrolled for a time at Crispus Attucks School, named after the Negro who was the first person shot down by the British in the Boston Massacre, his blood a liquid finger pointing toward the American Revolution. Charlie did well there, and got his diploma from the Charles Summer School in 1933.

When he wasn't in school, Charlie was playing with his friend

Sterling Bryant, who lived up the block. The Depression was on, yet somehow Addie managed to find knickers for her son, though no others in the neighborhood could afford them. If she wanted him to stay home and be happy—unlike his father—Addie resolved that she would give him everything she could. She would make 1516 Olive Street his personal paradise.

Charlie was a little bigger than Sterling Bryant during those years, and Bryant remembers him as a buddy and a bodyguard. "We just did boy things, nothing serious, nothing really dangerous. But it was rough when we left the neighborhood and stepped into somebody's territory. Charlie used to escort me to see my girlfriend and walk me back. She lived a few blocks away, and they didn't want us around there, the other boys. They were in a gang, and they were ready to jump you and make sure you didn't get used to coming over there. Charlie wasn't scared, though. He could run, but he wasn't scared to fight. We got in a few scraps over there, and Charlie stood by me. We either won or lost together. He was a real nice boy, liked to have fun. Charlie had a good sense of humor, and he loved to prank. He just loved it, but he didn't try to hurt anyone."

Holidays were much the same as they'd been over in Kansas—except for Halloween. On that night, people would go to Eighteenth and Vine to watch the parade of homosexuals. "It was the only time they could wear dresses," Bryant chuckled, "and they put it on that night. They got on their dresses and their falsies, their lipstick. They had on their hats and their high heels, and they would strut it. That was such a good show it became a family thing. It was the highlight of Halloween."

IN APRIL 1934, trouble in a neighboring family brought change into Addie Parker's home.

The Ruffins, a Negro couple, had come from Memphis, Tennessee, to a house at 2507 Howard Street. The father, known to all as Daddy, had Madagascar Afro-Indian blood in his family; his wife, Fanny, had Cherokee and English. Their first five children—Winfrey, Octavia, Rebecca, Ophelia, and Naomi—were born in Memphis; Dorothy, the last, was delivered in Kansas City, Missouri. At that time, Edward Reeves remembered, "all the Negroes lived north. The farthest they got out to was Twenty-Fourth Street. All the big dogs lived on Twenty-Fourth Street, the ones with money and some kind of prestige." Daddy Ruffin was an insurance salesman, which was a middle-income job for a Negro at that time, a step up from manual labor, semiliteracy, and illiteracy.

For reasons no one quite remembers, Fanny Ruffin stopped sleeping in the same room as her husband and stopped cooking for him. Daddy stayed upstairs, and the rest of the family was on the first floor. The children didn't understand, but the tension between the couple was obvious, and Fanny assigned ten-year-old Ophelia to take over one of her roles. "Small as I was, I was cooking Daddy's breakfast. Mama had quit cooking for him and she would tell me and I would try to do it. Mama decided to move because she didn't want to stay there with Daddy. I think she knew a friend that knew Miss Parker, and that's how we got down to Olive Street."

On April 10, 1934, when Charlie was thirteen years old, Fanny Ruffin and her children moved into Addie Parker's house, taking the entire second floor. As the family moved their belongings up the stairs, Addie and Charlie stood at the banister, watching with fascination as the girls, the one boy, and the mother marched up and down the stairs with their belongings.

One who noticed Charlie was the Ruffins' middle child, Rebecca. To her, Charlie looked a little old for his knickers, as if he were a little spoiled. It also wasn't lost on her that he never lifted a

finger to help the Ruffins. But there was something strong about him, she thought, something in his presence and in his capacity for attention. He also exuded a loneliness, a need. At least Rebecca thought so. Rebecca was golden, thin, about Charlie's age, and her hair dropped thick and brown below her shoulders. Charlie stared at her most intently. "My eye fell on him," Rebecca said, "and I knew there was gonna be trouble. I knew I was in love with him."

FANNY RUFFIN, WHOM her estranged husband called Birdy, did *not* like Charlie Parker. First of all, he didn't go to school unless he wanted to; he'd apparently been dawdling around the house for a year. Second, he was allowed to be too mischievous for her taste. He sarcastically called his mother "Ma." He was always playing rough jokes on the Ruffin children, hiding behind the staircase and jumping out to scare them, throwing firecrackers at them, teasing, pinching, and hurling snowballs at them when winter came—or just pushing scoops of snow down the backs of their clothes. Addie Parker insisted he was just a boy having fun, that he wasn't really hurting anybody. Birdy Ruffin could put up with that to a degree. What she had a harder time with was how close Charlie and Rebecca were becoming. Knowing better than to hold hands when Birdy Ruffin was around, he and Beckerie (as the family called her) just stared at each other with the amazement of two moo cows watching choo-choo trains. But everyone could see what was happening. Rebecca had never had a boyfriend before, though she had always been very pretty.

As far as Birdy Ruffin was concerned, if her daughter was to have a steady boy, he would have to be someone better than lazy Charlie Parker, whom she considered an "alley rat." As Birdy Ruffin and her daughter watched Charlie from a second-floor window

shooting marbles in the alley behind the house with his buddy Sterling Bryant, Birdy told Beckerie that that Parker boy had no foreseeable future—unless it was living off his gullible mother and doing nothing worth anything, which was apparently his specialty.

"Mama was very strict," recalled Ophelia Ruffin. "Nobody was good enough for *her* daughters."

Birdy Ruffin's attitude may have been influenced by the nature of Kansas City itself. It was a city where corruption sprawled in comfort and a child could get the idea that right was wrong and wrong was right: the mayor was a pawn, the city boss was a crook, the police were corrupt, the gangsters had more privileges than honest businessmen, and the town was as wild with vice as you could encounter short of a convention of the best devils in hell. *Her* daughters were going to be polite, well-groomed, respectful, and arrow-straight. If they weren't, they would have to face her wrath, which could be considerable.

Ophelia remembered it clearly. "Once I went up on Twelfth Street—which was pretty wild, you know—with my friend Ruby because she was getting her lunch money from her uncle. My daddy saw me up there and asked if Mama knew where I was. I couldn't lie. He went right over to Miss Parker's and asked Mama if she knew where I was, and Mama said I was at school. He said she wasn't raising us right and told her where I was. Mama met me at Fifteenth and Olive. She whipped me from that corner all the way up to Miss Parker's, all the way up the stairs. . . . I must have bit her because she tied me to the bed, *still* switching me. She said, 'I'll teach you to go up on Twelfth Street!' That's why I hate Twelfth Street *now*. I don't have no time for it."

But even such wrath didn't sway Rebecca, whose feeling for Charlie thickened and deepened. He was different from other boys. For all his mischief, Charlie had very good manners. He

wasn't always pushing himself on her or trying to fumble his hands under her clothes. Rebecca knew the things boys would try to get girls to do. But Charlie was different. With him, she felt safe. "He was old-fashioned," she mused decades later. "He wasn't aggressive like some of the young guys." And there was something more: when she looked at him very closely, young Charlie seemed hurt. "I don't know what he was. He wasn't loved, he was just given. Addie Parker wasn't that type of woman. She always let him have his way, but she didn't show him what I call affection. It was strange. She was proud of him and everything. Worked herself for him and all, but, somehow, I never saw her heart touch him. It was odd. It seemed like to me he *needed*. He just had this need. It really touched me to my soul. He seemed like he needed someone to love him and to understand him."

With the Ruffins in the house, however, Charlie started to shed some of his melancholy. He was growing into a bigger and more attractive young man, almost as though the weight of his previous loneliness had stunted him. Charlie took to the Ruffin children and they to him. Birdy Ruffin's disdain rolled off the children's backs, though they all knew better than to argue with her. Winfrey Ruffin kept to himself, a bookworm, but Charlie had plenty of fun with the girls. Octavia, the oldest after Winfrey, had started working after graduating from Lincoln High School in 1933. She found Charlie as lovable as the rest of her sisters did, and she supported his budding romance with Rebecca.

When he wasn't playing with little Dorothy in the swing on the front porch, Charlie was doing something in the parlor to the left of the stairs—something to do with music.

Besides its large potbellied stove and the huge table where everybody gathered for dinner, Addie Parker's parlor harbored an old-fashioned Victrola in the right corner and a mahogany player

piano nearby. (Behind a pair of sliding doors was Addie's bedroom, where her possessions were guarded by Snow, her white and savage Alaskan spitz.) Charlie and the girls often got together around the Wurlitzer piano; when they weren't banging out noise, Charlie was already teaching Ophelia the boogie-woogie songs that were in the Kansas City air at the time. He still didn't talk much, but Addie's only child seemed to blossom under the influence of the Ruffin daughters, as though he had suddenly been blessed with a frolicking gaggle of sisters.

Rebecca recognized that Charlie was beginning to mature. He was an attentive boyfriend: "Whatever you talked about, Charlie Parker listened." And, under their influence, he was finally going back to school on a regular basis. The younger Ruffin children went to Crispus Attucks, Rebecca to Lincoln High; Charlie walked with them, and he started attending classes again in the fall of 1934. "He was becoming a man then, once he started going back to school," Rebecca remembered. "Of course, he didn't say why he went back. Charlie didn't talk. He talked with his eyes. . . . He was accustomed to being by himself."

Lincoln was on Nineteenth Street and Tracy Avenue. "It wasn't integrated," Rebecca recalled. "We didn't have any trouble. There was no white folks there. Negroes went to the Negro school. Lincoln was deep redbrick and took up about two blocks. My class, 1935, was the last one to graduate from there before they built another Lincoln School up on Twenty-Second and Brooklyn. Every morning Mama got all of us up. We dressed and got our lunches in pails or what have you and left, cleaned up straight and dressed. You had to be clean in those days. Your parents took pride in how you looked and how you carried yourself."

Charlie and Rebecca walked to school together. "You can believe he didn't carry his lunch to school. Oh, no. He carried my books."

But times were hard, and Rebecca was aware that her family was under more straitened circumstances than Addie Parker's. "Charlie Parker was given money because Addie Parker had money," she said. "Daddy had lost everything in the Depression, and we was on relief, doing the best we could. Not Charlie. He was taken care of— money in the pocket." She asked Charlie about his father, but "he said he didn't know anything about him. Charlie never even talked about his father. Charlie mentioned that he had a brother named Ikey [John's nickname]. He didn't talk much about his family or anything. All I felt was that he was so glad to have somebody come closer to him and try to get to know him."

Rebecca worked in the library three days a week, and Charlie waited for her until her job was over at five o'clock. Every day, while she did her two hours of work, Charlie would come to the library, collect a handful of books, and sit outside on the building's top step, reading and searching out information. He loved books about alternate universes and foreign places, some of them by Asian authors. Before he and Rebecca left for Olive Street, Charlie would put the book he read that afternoon back on the shelf.

On their walks home together, they started venturing into greater Kansas City. "We had to do something a little exciting, something [that] had a little thrill to it. So we'd come down through Nineteenth and Vine and kind of look over into the block where the Cherry Blossom and all the nightclubs were, you know. We would be holding hands and talking boy-and-girl talk."

Sometimes, the wilder side of the city came to them. In the evening, Rebecca recalled, neighbors would come visit the two of them as they sat on the front porch talking. "For instance, [our] next-door neighbor was what you call a homosexual today, but we called them sissies in those days. His name was Julius. He was tall; he was handsome, light-skinned, looked like he could have been

mixed, had almost Indian color, and he smelled good and he wore tailored clothes. Julius had a twist in his walk." As Charlie and Rebecca sat on the front porch swing, "Julius would tell us about how he was going to go to this sissy ball that they would have on Eighteenth and Vine where there was a tent and the men would wear women's clothes. Yes, they did! They wore big hats and big beautiful dresses. They wanted to be something like girls. I *guess* that's what they wanted. Anyway, that's what they *did* and everybody knew it and that's all there was to it!" He seemed unabashed about his sexuality: "Julius didn't hide what he was. He didn't have to. Kansas City wasn't like that. If you knew how to handle yourself, if you was a nice person, you had your business and I had mine. Everything was clear way back then."

Charlie's circle of friends was limited, but Rebecca found him insatiably curious. "He had to ask people questions. How else could he learn? Miss Parker didn't talk to him about nothing. She wasn't there for him in that way. . . . Charlie had to do it all by himself."

One subject of his curiosity was a neighborhood girl Rebecca remembered quite well. "This girl named Zephyr was crazy about Charlie, and she told me that he wanted to know how to do things. She lived right up the street on the corner of Sixteenth and Olive. Zephyr went to school with us and she had a big, big bust. . . . We were still girls, and she was looking like a woman—and acting like one, too! Zephyr was kind of wild, almost like the girls on the street, the working girls, you know. Well, maybe she wasn't that bad, but at the time she *seemed* like it." Zephyr filled Charlie's ears with details of the goings-on around the neighborhood. "In Kansas City they had basements because of the tornadoes, you know. You could hide down in there and get with somebody in secret. That's what she said. Yes, she *did.* You had to believe her because Zephyr was one of those that did things the rest of us didn't do, and she said Charlie

asked her about what she did. He didn't ask me." It must have been quite an education. "Charlie knew a lot about a lot of things that I didn't teach him. . . . Charlie could have learned some of that from girls like Zephyr."

Mama Ruffin watched her daughters like a hawk—as, for instance, when Rebecca asked Charlie for help with her lessons. "Charlie would look at me hard and say, 'Come on downstairs and we'll get our lesson together.' So I was down there sitting on his bed at one end with my books, and he would be at the other end with his books. Now, see, Mama knew that wasn't the place to be sitting, and she would call me right upstairs to get me *off* that bed." Rebecca might not have told her mother everything, but there were ways of knowing. "It wasn't that hard back then. We didn't have sanitary napkins. Years ago, you would see sheets cut up and hanging on the clothesline. That's what we used. So you were watched, and in those days, your mother knew if your period was regular or not. If something was wrong, your mother could look for those cut up sheets and say, 'I haven't seen anything . . .'

"So there was two things I knew not to do. One was get caught on Eighteenth Street, and the other was to mess up and miss my time of the month. Mama would have killed me for either one. Yes, she would have killed me."

The kind of killing Rebecca had in mind was no more than one of Fanny Ruffin's extreme whippings. But murder was a real possibility in Kansas City, where corruption, gangster arrogance, and a national soap opera of criminals versus lawmen formed a backdrop of graft and blood in the town where Charlie Parker and Rebecca Ruffin were falling for each other. And the soundtrack to that historical force was the music known as Kansas City jazz—a music that benefited from a regime that believed *all* money was good money, no matter how it was obtained.

Between the turn of the century and the ascent of Tom Pendergast as boss of the town in the mid-1920s, Kansas City became the hub of what were known as "the territories"—Texas, Oklahoma, Kansas, Missouri, Iowa, Indiana, Michigan, Arkansas, and Louisiana. Great musicians developed in Kansas City, and bands from all over the country passed through, playing jobs there and learning why "Tom's Town" was the central city of the territories. In the years that followed, a wide array of acts from Kansas City and

the surrounding area—the Count Basie Orchestra, Andy Kirk's Clouds of Joy, Pete Johnson, Joe Turner, Hot Lips Page, Buster Smith, Harlan Leonard's Rockets, the Jay McShann Orchestra—would alter the sound of jazz collectively, spreading the propulsive gospel of riff-based swing, and individually, by heralding solo styles they had developed in years of playing dance halls and jam sessions.

"In Kansas City," recalled John Tumino, manager of the Jay McShann Orchestra, "the joints didn't have locks on the doors. Threw them away! Didn't need them. They were never closed anyway. Whatever you wanted, you could get it whenever you wanted it—girls, liquor, gambling, freak shows. If you had the money, they had it for you. Of course, it was crooked, with the mayor in on it, the police in on it, and the public in on it. It was as wide open as you could get. No limits whatsoever. . . .

"All this meant you could have a good time morning, noon, and night. That stimulated God knows how much music—music of all kinds—and the musicians playing so much they got better than just about anybody in the country. That's where that Kansas City swing came from. These guys were playing *all* the time, long hours, and then they went out jamming and might not get home until the next afternoon. A few bucks, a little taste, and they were ready for anything and anybody! It was a good-time town, all right."

Clarinetist Garvin Bushell, who heard the city's earliest bands in the 1920s, noted certain stylistic differences between these earliest Kansas City ensembles and their counterparts in New Orleans, Chicago, and New York. "The bands in the Midwest then had a more flexible style than the eastern ones. They were built on blues bands. . . . They just played the blues, one after another, in different tempos." Bushell wasn't sure the Southwest bands were playing at the same advanced level as those he knew from Chicago. But he

"heard blues singers in Kansas City, just like Joe Turner sings, and they did impress me."

As a reedman, Bushell observed—almost in passing—one other element that would transform jazz's second generation: "They had also done more with saxophones in Kansas City." The primacy of the saxophone, paired with the local players' feeling for the blues, was central to the sound and character of Kansas City jazz. This penchant for saxophones would not only give rise to powerful reed sections that swung, shouted, and crooned the blues, but would also prepare the way for local giants of the instrument, men destined either to blow themselves into the pantheon or to arrive in Kansas City on the whirlwind of legend. After the trumpet, the trombone, and the clarinet, the saxophone was the next horn to contribute to the aesthetic evolution of Negro feeling on wind instruments.

Invented by the Belgian Adolphe Sax in the 1840s, the brass and woodwind hybrid that is the saxophone spent its early life holding down plebian roles in parade music. But the instrument made a thrilling run to glory around the time of Charlie Parker's birth in 1920. Like the other wind instruments of jazz, the saxophone was redefined in these years for virtuoso center stage action. The pioneers who used it to work out new developments in phrasing, timbre, and technique eventually elevated it to the same position in American music that the stringed instrument has in European concert work. It became America's violin and cello, America's singer of domestic song, as soon as American horn players learned to moan the blues through their mouthpieces.

First the cornet, then the trumpet, had dominated early jazz, taking the strutting, pelvic swing of the black marching bands, the melodic richness of the spirituals, the tumbling jauntiness of ragtime, and the belly-to-belly earthiness of the blues, and pulling

them together into a music that purported to soothe the mournful soul, to soak the bloomers of listening girls, and generally to cause everyone to kick up a lot of dust. But the saxophone, with its cane reed, pearl buttons, and curved body, eventually rose to champion position in jazz innovation—for many of the same reasons that the guitar, with its supple versatility, eventually became more important to blues-based Negro music than the banjo of the nineteenth century. As historian Paul Oliver notes, "The flatted thirds, dominant seventh chords, and whining notes achieved by sliding the strings of the guitar allowed blues players to copy the 'shadings, the bendings, and the flattenings' that field hands used in their hollers. The moans of their voices were imitated by sliding the strings and by the use of what later became known as 'blue notes' "—the subtly shaded "bent" notes that gave Negro music a particular kind of expressive power.

That same expressiveness, in the hands of a generation of tenor and alto saxophonists—Coleman Hawkins, Johnny Hodges, Benny Carter, Chu Berry, and Don Byas among them—had fueled the rise of the Negro saxophone tradition. In Kansas City, most of the instrument's practitioners, including Lester Young, Ben Webster, Budd Johnson, Buster Smith, Tommy Douglas, Dick Wilson, Jack Washington, Herschel Evans, and Eddie Barefield, emerged as standouts in a southwestern scene that also included pianists and bandleaders Bennie Moten and Bill Basie, trombonist-arranger-guitarist Eddie Durham, trumpeter Hot Lips Page, singer Jimmy Rushing, and bassist and bandleader Walter Page. They were the terrors of the territories—those same territories that reached back to the Indian and desperado days, to a time that preceded all contemporary danger, when the repeating rifle of the Plains Wars had given rise to bloodletting much as the Thompson submachine gun had after World War I.

• • •

BY THE TIME Charlie Parker and Rebecca Ruffin were up to their necks in adolescent romance, celluloid cowboys were clouding the air with the smoke of blanks—even as tales of desperadoes who were all too ruthlessly human dominated the press, magazines, newsreels, and radio broadcasts. Only the deaf, dumb, and blind would not have known of them. Contemporary variations on the James, Younger, and Dalton gangs of the Old West, Depression-era outlaws such as Dillinger, Bonnie and Clyde, Baby Face Nelson, and Oklahoma's Pretty Boy Floyd were pulling daring robberies and escapes almost weekly, filling the air with the rattle of machine guns in battle with the authorities, and now and then going down in bloody exclamation points. Unknown to local lawmen and the Bureau of Investigation, the outlaws sometimes hid out in rural Negro communities, where no one thought to search for them, observed local resident Emma Bea Crouch, who recalled seeing Pretty Boy Floyd and Bonnie and Clyde in East Texas when she was an adolescent there. Others found they could hide out easily in Kansas City—even have a good time of it, as a little money here and a little money there would protect their sleep and keep them free of handcuffs. By 1929, as biographer Michael Wallis observes in *Pretty Boy*, Kansas City "had become the crown jewel on a gaudy necklace of lawless havens—a corridor of crime—ranging from St. Paul and Detroit in the North to Joplin, Missouri, and Hot Springs, Arkansas, in the South. A police reporter of that time compared these cities to the imaginary bases used by children playing tag. Once a criminal with local connections made it safely inside one of these cities, he was home free. He was 'on base' and could not be 'tagged' by the authorities."

Along with every form of kickback he could work out, from construction scams to slot machine concessions, Tom Pendergast had cut a deal with gangster Johnny Lazia that gave vice a high and free rein. Between the two there existed a double bureaucracy of public posture and the dark world of graft, threat, and occasional violence. Never ones to scoff at new potential sources of income, Pendergast and Lazia ran something of an equal opportunity outfit for corruption. They recruited across the ethnic stretch: Irish, Italian, Jews, and Negroes alike functioned within the sector that jibed best with their expertise, their scruples (or lack thereof), their guile (or lack thereof)—or their willingness to accept that working in the underground world of clubs, music, and booze came at a cost. Felix Payne and Piney Brown were the two Pendergast Negroes best known by musicians, the liaisons who befriended them and made the Sunset Club hospitable to their efforts to master blues and swing.

Edward Reeves, Charlie Parker's childhood buddy from the old neighborhood in Kansas, collected a little coin himself in these years chauffeuring for the mob and serving at their parties. "The poor people loved Pendergast," he recalled. "He wouldn't let you starve. You could go right up there on Market Street and get what you needed. Cornmeal, beans, slab of bacon." In those Depression days, that Pendergast money made the machine a virtual godsend. The Pendergast machine fueled Kansas City's nightlife in countless ways—right down to its monopoly on liquor distribution. "When you opened a liquor store," Reeves recalled, "they gave you sixty or ninety days, usually ninety days, to get all the name brands off your shelf, to sell them. Then you had to start ordering Mistletoe beers, wines, and liquors. Everything in Kansas City was Mistletoe, which was Pendergast. If you tried to be bullheaded, you wouldn't have a business very long."

Behind the benevolence and the looseness, there was cold steel

and hot lead. And as the profits swelled, the competition for sections of this independent underworld economy resulted in precautions that led Reeves to understand the dangers of working as a mob chauffeur:

> They didn't drive Cadillacs then: the sixteen-cylinder Packard couldn't be beat. Engine four or five feet long. I went to pick up a Packard once and they had glass so thick the man had a little crane to put it in, bulletproof. When I looked at that glass as he was putting it in the door, I started to thinking. I realized what it was all about and knew that there was plenty of danger in there. Then was when it got clear I had better find myself another way to make a living. I didn't need to get shot down driving gangsters around.

The most famous shooting in the kingdom of Tom Pendergast became known as the Kansas City Massacre.

In June 1933, as Charlie Parker was nearing thirteen and one of his favorite comic strips, *Dick Tracy*, was in its second year, federal agents captured a fugitive named Frank "Jelly" Nash in Hot Springs, Arkansas. The agents whisked him out of a cigar store and into a car that they drove away as fast as possible. The lawmen didn't intend to become casualties of the hoodlums who ran free and easy in Hot Springs and just might miss the company of their chum. They took Nash to Fort Smith, Arkansas, and boarded a Missouri Pacific train. The next morning they would be met at Kansas City's Union Station by local police, who were to assist in whisking Nash off to the federal prison at Leavenworth, a short drive away.

Though Kansas City's telephone wires were surely humming

with speculation on where Nash was and what the arresting officers had in mind for him, legend has it that Johnny Lazia overheard the actual plans through his own private wiretap of the central Kansas City police station. When the lawmen arrived at Union Station with Nash, they were met by two federal agents and two local police officers. Handcuffed and surrounded by seven armed men, two of them carrying shotguns, Nash followed orders to walk through the station's lobby and out the east entrance, where two cars were parked and ready for the trip to Leavenworth. Suddenly, from behind a car, two men armed with submachine guns stepped forward and commanded the officers and agents to put their hands up. Then someone ordered them to shoot, and the gunmen let it rip. The chattering dose of lead rubbed out the lives of Nash, a federal agent, an Oklahoma police chief, and the two local cops. Blood ran in the gutter; bullet holes were left in the walls of Union Station; two wounded lawmen lay writhing next to the dead.

In all its shock and gore, the Kansas City Massacre was a godsend to J. Edgar Hoover, who was incensed by the romantic images criminals inspired in the public mind at the expense of law enforcement, both in the press and on the silver screen. Hoover was as ruthless as his opposition allowed; he recognized the power of the media and knew how to exploit his opportunities when he saw them. He played the slaughter for all it was worth, charging Pretty Boy Floyd with the murders, making clear that the country could not tolerate such murder in a public place, murder so bold it was done in morning light. The nation was outraged at the idea of professional killers shooting down lawmen in the bustle of a train depot. The shootout stripped the glamour from criminals once seen as Dust Bowl knights at war with the coldhearted system that had left so many homeless and kicked to the curb during the Depression. Even those who'd nearly lost all faith in society

began to reconsider the idea of bank robbers as avengers of the downtrodden, people willing to meet the ruthlessness of business on its own terms.

In July 1934, three months after the Ruffin family moved into Addie Parker's house, Johnny Lazia himself was felled by machine-gun bullets one still morning in front of a hotel. The bullets came from one of the guns used in the Kansas City Massacre. His wake drew seven thousand mourners. A few months later, Pretty Boy Floyd sent letters to friends, and to the Pendergast authorities, protesting the Union Station murder charge against him. But Hoover was already winning his war in the public eye. Soon, federal agents got the right to carry firearms. They were given the freedom to arrest fugitives in any state. Hoover got Hollywood to start investing in anticrime movies like *G Men*—which featured a fictionalized Kansas City Massacre—as well as newsreels celebrating Hoover's own bulldog tenacity. He even commended Chester Gould, of Pawnee, Oklahoma, for his contribution to law and order through the creation of the heroic lawman Dick Tracy.

And so, even as Kansas City nightlife was incubating fresh aspects of jazz that would shift the pulse of the national music, the Kansas City Massacre had changed the way the nation fought crime—and viewed its perpetrators.

Everybody was looking for fun, for a vacation from Depression conditions, for a thrill and a laugh. Many went in search of distractions—tranquilizers or stimulants, spiritual or chemical— until the country seemed slowly to become dependent on them. Especially so when faced with unpleasant realities, such as feature films, cartoons, and other entertainments that relied on the century-old tenets of minstrelsy as a way to tell the truth and create laughter at the same time. The good times were more costly to some than others.

In most places, those good times rolled in the evening when the sun went down, when the sobriety and the inhibitions of daylight rarely seemed to hold their ground. In the empire of Tom Pendergast, there was wall-to-wall sin and swing, wall-to-wall exotic entertainment and gambling. People came to guzzle the blues away, to dance the night long, to take the risk of leaving in a barrel as they laid bet after bet; and, as ever, there were those who came to involve themselves in the mercantile eroticism of the high to low courtesans.

That was how law and lawlessness, convention and opportunism, mass media and manufactured reality worked together in ways that shaped the world in which Charlie Parker and everyone else in America lived, during and after the Great Depression.

IN 1934, THE year when both Lazia and Floyd bit the dust, when Dillinger was done to death, when Bonnie and Clyde got theirs and Baby Face Nelson ended up on a slab, the good times for Charlie Parker and Rebecca Ruffin had nothing to do with gangsters or Pendergast corruption. They hadn't yet been touched by the nightlife, its attractions, inspirations, and dangers. Though the air was full of talk about who got shot and where and why, it was all very remote to them, not nearly as real as what the two of them were feeling toward each other.

The adolescent lovers were floating in a cloud of their own, trying to pursue their relationship in terms that would avoid unnerving their parents. By day they snuck kisses at the bottom of the stairs; if no one was in the house, or everyone was upstairs, Charlie might take Rebecca past Snow, the growling dog, and rummage around, showing his sweetheart Addie Parker's collection of gold coins. In the evenings they sat rocking in the porch swing, hold-

ing hands when Birdy Ruffin wasn't around or close enough to see what was going on.

As they spent more time together, Rebecca started noticing the things that piqued Charlie's curiosity. Lincoln High was just a few blocks away from the strip where the action was taking place in jazz music, and the couple, now holding hands as he carried their books, often ended up on Vine Street between Eighteenth and Nineteenth. "Wait a minute," Charlie would say, and stop in front of the Cherry Blossom, a legendary club across the street from the Booker T. Washington Hotel, where the Negro musicians stayed when in Kansas City. With its Japanese décor and the huge Buddha on the bandstand, the Cherry Blossom was an unmistakable local attraction. But it was the music that captured the young man's attention.

"We would stand there and Charlie would look in that Cherry Blossom, just him and I," Rebecca remembered. "I would ask him who he was looking for, and he was just interested in the guys who was practicing in the club. He'd be looking at the drummer or at the saxophone player. They fascinated him. I could tell by the way he was looking at them in there rehearsing their music. It didn't mean anything to me, and Charlie wasn't playing his saxophone yet, but right then something was starting to come into his mind, and now I know it had to have something to do with that music. He wouldn't miss a day looking in there if they were practicing. Charlie Parker was thinking about what they were doing."

The Cherry Blossom was like a magnet to Charlie, but to Fanny Ruffin it represented something else: danger. "We should have never been on Eighteenth Street," Rebecca recalled. "Never. Mama would have killed me. You see, she was always watching everything. Mama was concerned. She wanted her daughters to come out good. Her eye was always on you."

Mama Ruffin may have been protective of her daughter, but Charlie's mother was another story. Addie Parker was happy to slip Charlie a little money to take Rebecca to the movies, and the teenaged lovers often went to the Gem Theater, downstairs from Dominion Hall, on Eighteenth Street between Holland and Vine. They shared popcorn, and Charlie drank red soda water, which was his preference. The Lincoln Theater was where they usually showed love stories, but Charlie and Rebecca found them boring, too much talk and too little action. Could those people do anything more than swank around in beautiful clothes and say stuff nobody really understood? One grew tired of their top hats, their big ballrooms and nightclubs, their dancing now and then but mostly walking around in gowns, talking to barely masculine guys in tuxedos, flapping their lips about nothing anyone wanted to hear.

The young Kansas City couple were never bored with each other, though, and Rebecca loved to be with Charlie when he was all dressed up. "All his suits were made by J. B. Simpson," she recalled years later. "Mrs. Parker had them made. This was the Depression—do you hear me? The Depression!—and Charlie is getting tailor-made suits. It was something! But he looked good. He was handsome and clean." True, he was lazy: "Lazy as they make them. All he wore was gaiters, those shoes you didn't have to tie, just slip on. Charlie was spoiled rotten. But he was sweet, too. I don't know. I just loved him."

Their favorites—or his—were cowboy pictures. Rebecca already knew how to go along with Charlie and his enthusiasms. It gave her all the satisfaction she could get just to be there, sharing one of his private interests, getting excited along with him. Charlie and his mother were always so private about their home life; it made Rebecca feel special to be out of the house with her guy at the movies. Though they were always very well-mannered when they left

the house, Rebecca could feel Charlie growing more animated and excited as they walked to the theater for another afternoon full of "shoot 'em ups," as he called them.

Once they were in their seats, they laughed nonstop as Charlie imitated the actors on-screen, keeping up a running line of jokes about their looks, their funny names, the way they carried themselves. Yet he was captivated by every detail: ten-gallon hats, fancy cowboy boots, six-shooters, horses, woolly chaps or leather ones, big spurs they dug into the sides of their horses or that jingled when they walked down those Western streets, as ready for camaraderie as they were for a fight. Tom Mix, Hoot Gibson, Ken Maynard, Bob Steele, Buck Jones, Harry Carey, William Boyd: he could change his voice to sound like theirs, could transform his face as if it were rubber until he looked like one of them. All of a sudden the cowboy up on the screen was there next to her: no longer white but reddish brown, and still cute, tickling her until she had to laugh out loud in the theater.

To Rebecca, Charlie seemed to come alive at the movies; he was different from how he'd been when they first met, as if he'd needed something to draw him out of his loneliness. And his newfound sense of fun seemed to be aimed directly at her, inspired by his feelings for her, and how she let him love her. She wouldn't have been able to stand his mugging if it hadn't made her feel so good to be with her guy as he read the names of his cowboys off the screen or described them to her in his excited way, as she sat beside him, holding his hand as if it were part of her body.

Like any other kid growing up in the Midwest, Charlie had been fascinated since childhood with cowboys and the West. This was where so much of the drama and the comedy between white men and red nations took place, during so many of the cattle drives. And Charlie identified with something in that world, was able to

project himself into it, much as the early Western stars projected themselves into their directors' cowboy fantasies. Some—like Hoot Gibson, who got his start as a stuntman under D. W. Griffith— were former cowboys themselves. Others—like William Boyd, who played Hopalong Cassidy—were pure actors, pretending their way into the roles. One of the greatest pretenders was Griffith himself: an imitation, an actor from common stock whose father was troubled by drink, who was closer to poor white trash than not.

Griffith became big stuff in the true American way: he had irresistible talent, and he used it to drive his emerging art form toward the frontier. Griffith did not invent the close-up, but it was he who divined how to use it, mastering the art of crosscutting from image to image in a way that resembled musical composition. In this he was like Duke Ellington, the great East Coast composer and bandleader who was revolutionizing jazz music during Charlie Parker's adolescence. Though Griffith was a generation older than Ellington, the two were close in sensibility. They shared an ability to evoke the rhythms of American life and American feeling, crudely or fancifully, and each remade his medium, inventing a new artistic language that is now recognized as inescapably modern.

Griffith and Ellington mirrored America's democratic dimension by evoking the fundamental tension between the individual and the collective. They both drew broadly from the culture around them: from biblical themes, fairy tales, newspaper stories, the surrealism of cartoons, and so on. They both composed in long, broken lines that had the up-and-down sensation of a roller coaster. Just as Griffith mastered the art of resequencing individual moments of performance into compelling stories, Ellington figured out how to feature his soloists within a complementary context, placing each new improvised solo where the arrangement made it sound better, allowing the improviser to supply the special effect of

well-thought-out spontaneity to the written music. They embraced the powers that endlessly rocked in the cradle of the past, whether true or mythic or simply poetic, but never flinched in the face of modern life as it was lived, from the suites to the streets.

And yet, of course, there was a difference. D. W. Griffith's greatest personal stunt was both a technically revolutionary work of art and a misleading piece of extended-form minstrelsy: the 1915 epic *The Birth of a Nation*, truly a black-and-white mess. Based partially on an incendiary redneck pimple of propaganda shaped into a suppurating blackhead of a novel called *The Clansman*, Griffith's 1915 adaptation was the first three-hour epic. That was something in itself: audiences used to much shorter tales of love and war were glued to their seats. (As they would be, nearly a quarter century later, for *Gone with the Wind*. The antebellum South was a profitably hot, soothing, romantic topic.) It was also the very first blockbuster, running almost an unprecedented year in New York—the town where the very first blackface Irish American minstrels appeared to resounding popularity in 1843.

But what made *The Birth of a Nation* notorious was not its success or Griffith's artistic achievements. Rather, the film marked the beginning of a new way of looking at vengeful white Southerners, not as murderous racists but as radiant rednecks who started the Ku Klux Klan's campaign of murder and terrorism because they had no choice. After all, Griffith's epic argued, they were the underdogs. What to do? the film asked. What to do during that dark time when the Confederate states suffered tyrannical military occupation? What to do when those states were losing their independence due to the destructive and invasive War of Northern Aggression, commonly misconstrued as the Civil War? That was the question. What were they to do?

Griffith knew what to do—or, at least, how to tell the story,

and do it in a fashion that was unique for both its size and its one-dimensional racial message. He filled the screen with images of brave white men disguising themselves in sheets and facing down two challenges. One was the seizure of power by the North; the other was the ominous threat to white women of darkies gone wild. There it was: armed coon Union troops abusing unarmed white men on the sidewalks as a preface to drooling at the sight and the idea of bedding down—by any means necessary—with the pink-cheeked embodiments of Southern charm, gentility, and feminine grace.

Later, Griffith would back away from his huge and appalling influence. One of the most surprising of American racists, he seems, in retrospect, to have been so bothered by his massive influence on self-righteous violence and murder that he went on, one short year later, to derail his own career with another "spectacle to end all spectacles," the three-and-a-half-hour *Intolerance*. The 1916 film castigated bigotry across the ages, weaving ancient story lines over and under later material, and using counterpoint techniques still rarely attempted. Griffith even included a Negro extra in a scene—no burnt cork, no bucking eyes at all. The extra seems just another person on the street, an actor in a walk-on of less than a few seconds but unburdened by the minstrelsy imposed on Griffith's previous black characters, which would foreshadow the depiction of black people for decades. Three years later, the director would assert his Southern nobility once more, but rebound from it most obviously, in the shockingly resolute *Broken Blossoms*, in which a white woman battered by her brutish and drunken father finds a way out in a mutually reluctant and tender adulterous romance with an Asian man. With its complex visions of race, *Broken Blossoms* showed that even a white man who had made the most racist film of the time was not quite comfortable in his old shoes.

But nothing D. W. Griffith did after *The Birth of a Nation* could put the minstrel back in the bottle. The film sparked a volcanic rebirth of the real-life Klan, America's conspiratorial domestic terrorists. It served as a model for the Third Reich when it learned to use cinema to bolster bigotry, just as that regime seized on the purportedly scientific balderdash of American eugenics to explain why the white foam was supposed to be on the top. In the long run, though, surely the most devastating impact the film had on black Americans was that its enormous financial success led Hollywood to depend, for more than three decades, on variations on one set of racist images as its nearly exclusive cinematic portrait of black America. It was not evil, Hollywood would say, just business; they chose what to put on the silver screen in order to ensure the success of products that had to address the nation as a whole: North, South, East, and West. Until the emergence of Sidney Poitier in 1950's *No Way Out*, Hollywood bent down and genuflected consistently to the redneck insistence that white Southerners, old or young, be depicted as benign or cantankerous or just plain playful types, no harm intended. Black servants must be seen as uncouth clowns, as superstitious, talking work animals, male and female, small, medium, and obese. Bid 'em in, bid 'em out.

SO CHARLIE PARKER was an heir to all of that, as were all American Negroes.

For the serious jazz musicians of the early 1930s, whose ranks he would soon join as a professional, the dictates of minstrel behavior rarely extended to burnt cork. But they did include a demeaning version of stage behavior in which the Negro entertainer, or performing artist, was expected to reassure his audience that he and his fellow black men were far from the sharpest knives in

the drawer. Singing, dancing, and acting the fool were what the Lord intended. That was why darkies were born: to bring pleasure to far better folks, and to enjoy doing just that. Charlie had yet to struggle with that long, long cotton sack. But it was right there waiting for him.

The regime of segregation would last about ninety years from its point of inception in 1877. Its intent was to put the recently freed Negro back in his place, to stop him from being publicly elected, and to get the colored people back as close to where they were before the Civil War as white power could push them. And yet, as he fixed his gaze upon the adult world, Charlie Parker was preparing to join a league of dignified musicians like Duke Ellington, of athletes like Jack Johnson and Joe Louis, of generations of lay persons who were buffeted about until they got their bearings and found as many ways to be unsentimentally happy as they could. It was a league of Negro Americans who assumed a triumphant sense of life in the face of the shortcomings that came to one or to the group or to everyone, regardless of color. These men and women shared a vision of life in which vitality was powerful, in which everyone understood that it was better to learn how to make delicious lemonade—somehow, loudly or quietly—than to cry perpetually over sour lemons. This tradition was waiting for Charlie, too, just like that cotton sack.

And so, in a different way, was Rebecca Ruffin.

When she graduated from Lincoln High School in the summer of 1935, Rebecca and Charlie had been going together for more than a year. Mrs. Parker had taken a great liking to her—she was crazy about the girl, if only because Charlie was. Birdy Ruffin was somewhat reconciled but still essentially hostile.

One reason was Addie Parker's boyfriend, a deacon at Ebenezer

Church who had a wife and family. Ebenezer was on the corner of Sixteenth Street and Lydia, a brief walk away. Though Rebecca remembered him visiting Charlie's mother on Sundays and Thursdays, Ophelia Ruffin said that "he was by there practically *every* night. Mama didn't like that at *all*. Mama didn't work, so she was nearly there all the time, nearby. She knew everything. Charlie did, too."

Charlie sarcastically referred to the man as "Paw," greeting him when he visited and sometimes sitting in the parlor while the deacon made love to his mother behind the sliding doors of Addie Parker's bedroom. "I don't know," Rebecca said, "if Mrs. Parker knew how much she hurt Charlie doing that. Charlie was alone in the living room. I could cry for him when I think of how he looked. All of us would go downstairs there and play the piano with him. But when we went to bed, Charlie had to go across the hall from his mother's room, where he would sleep. Yes, Charlie was alone with all that. And they had been going together for years."

Charlie never went to church.

Still, the atmosphere at 1516 Olive was festive during Rebecca's last week in public school. She was about to join Winfrey and Octavia on the other side of high school. Everything was just fine. She was nearly a grown woman now, and she knew what she wanted.

"All I could think about was Charlie. Yes, I just loved him. Even if I had knew what he was going to do to himself and do to me, I think I still would have loved him. I couldn't help it. I really couldn't. I just loved him, that's all."

Charlie was at Lincoln High by now, too. School records suggest he hadn't gotten very far there, but no one ever saw his report cards. He and Mrs. Parker had secrets between them. You didn't come between Addie Parker and Charlie when it came to secrets. All you got was silence. That was all right with Rebecca, though,

it was all right with her. She was too excited to be bothered about anything.

As Rebecca walked down the aisle during the graduation ceremony, thrilled by the prospect of commencement, of being out of school and eventually getting married, she looked at the band—and there Charlie was, puffing into a big baritone horn for all he was worth. She was so happy to see him there in that band, having himself such a time. The two of them were so much closer then. He was her first love and she was his.

The program for Rebecca's graduation shows us that we have not always understood the recent American past as well as we might think. Conventions of this era lead many to believe that, before the 1960s, Negroes had no sense of their own history, of the battles fought to move American democracy closer to a fulfillment of its own ideals. Such was not the case at all. The graduation program for Lincoln High School's class of 1935 was informed by the work of post–Civil War Negroes, from the East and the South, bent on bringing education to the illiterate masses. The ceremony featured recitations of poems ranging from the eighteenth-century Negro poet Phillis Wheatley to the then-contemporary work of poets who had gained fame during the Harlem Renaissance of the 1920s. Those recitations made clear the substantial position of Negroes in American history and cast an unblinking eye on the social inequities of the time without defeatist moaning.

The poems delivered that evening included "Tableau" by Countee Cullen, the widely published Harlem Renaissance poet, and "America" by the Jamaican writer Claude McKay, a Harlem Renaissance novelist and poet whose "If We Must Die" was made famous after Winston Churchill was widely rumored to have quoted it during a World War II broadcast.

From Langston Hughes came "I, Too":

I, too, sing America.

I am the darker brother.
They send me to eat in the kitchen
When company comes,
But I laugh,
And eat well,
And grow strong.

Tomorrow,
I'll be at the table
When company comes.
Nobody'll dare
Say to me,
"Eat in the kitchen,"
Then.

Besides,
They'll see how beautiful I am
And be ashamed—

I, too, am America.

And from Gwendolyn Bennett came "To a Dark Girl," a battle cry of the spirit:

I love you for your brownness
And the rounded darkness of your breast.
I love you for the breaking sadness in your voice
And shadows where your wayward eye-lids rest.

Something of old forgotten queens
Lurks in the lithe abandon of your walk,
And something of your shackled slave
Sobs in the rhythm of your talk.

Oh, little brown girl, born for sorrow's mate,
Keep all you have of queenliness,
Forgetting that you once were slave,
And let your full lips laugh at Fate!

Ralph Ellison, who was born in 1914 and played a Conn trumpet in Oklahoma City's Frederick Douglass High School Band under the direction of Mrs. Zelia N. Breaux, recalled his similar high school experience with awe. "Those Negroes who taught us were both idealistic and optimistic. Theirs was a *social* world of segregation, of course. I emphasize the word *social* because they had taken it upon themselves to make sure that we never became segregated in our *minds*. We were prepared as though we were cadets fated to go into battle, battle which we might lose as easily on the basis of poor preparation and lack of will as we might lose on the basis of bad luck."

Ellison recognized in his teachers an example of forward-looking education. "We must remember that the human mind is integrative by nature, that it makes use of everything that comes before it, judging some things as more important than others, but never failing to perceive. We know that culture is at least partially about the way in which we are taught to perceive, and those Negroes were determined to prepare us to understand as much about the world as we could. They understood perfectly the challenges of our democracy, and they were up to those challenges because they were not about to allow us to have segregated visions of *human*

possibility. They had a mission, and their mission was to make sure that we never became provincial about our own race or about anything else."

In particular, Ellison recalled, the teachers at Frederick Douglass High School "made sure that we were accountable to the rich diversity of America and the world at large. We grew up hearing all kinds of music, Negroes singing the classics, Negroes singing spirituals, Negroes performing classical piano pieces in the Negro churches, and so on. We did European folk dances, and we observed jazz musicians broadening the identities of the instruments they were playing." Everything was open to adaptation. "Hell, you could learn a lot from listening to the white cornet players in the circus bands, and Negroes *did* learn a lot from them. Our world may have been segregated, but our objectives were not. . . .

"And that is one of the reasons why the music that came out of those territory bands had such a lilt," Ellison recalled. "It brought together all of the idealism, the humor, the tragedy, the eroticism, and just about anything human that could fit into music. Those Negro musicians had so much to choose from, and they didn't avoid sampling whatever they found worthwhile whenever and wherever they could."

It was in that atmosphere—of optimism and opportunity—that Rebecca Ruffin sat through the recitations, sat and listened as Charlie Parker performed with the band. Rebecca had seen Charlie at practice. "You could go and watch them in the auditorium," she recalled. "So you know it had to be that some girls would sneak around and look at the boys with their instruments. Like other girls was with their young men, I was interested in everything Charlie Parker did. He excited me. I was in love with him. . . . So there I was happy to watch him doing something.

"I was surprised, too. Charlie played *every* instrument. One time

he was blowing the bugle, another time he blowed the same one Dizzy Gillespie blows—the trumpet. He beat the drum. He beat it good, too. You know Charlie had rhythm. Charlie played that big thing you pluck and set on the floor—the bass fiddle. I was wondering what he was doing going from one instrument a little to the next and then another one after that. Charlie was looking for what he wanted to play. He needed a feeling of what he had to do. Charlie was looking for that feeling from his heart, what he couldn't express in words."

At some point, Charlie must have played the sousaphone, because Addie Parker told Robert Reisner she didn't like the way her son looked with that big thing twisted around his head. She was glad when he finally got moved to saxophone, and bought him a beat-up alto that cost more to repair than it did to buy. He really seemed to like music, she recalled, and he was always going over to see Lawrence Keyes, a local piano player he was close to at the time, to get more knowledge. As Rebecca recalled, "Sooner or later he settled for the saxophone. That saxophone did it for him. It let him speak his heart. But he didn't start with it."

Neither Rebecca nor Charlie knew what would happen to them after graduation, what the music would have to do with it all. All they knew was that they wanted to have some fun. The excitement blew into them like air into a balloon, and they swelled with it.

Charlie had never been much of a dancer, but apparently that, too, had changed. "After graduation, we went downstairs in the gymnasium, the junior/senior reception," Rebecca recalled. "We ballroomed all over the floor. He could really dance. I was surprised. Charlie Parker could surprise. You couldn't be sure what he knowed and what he didn't know. If he was interested, he would study. If there was information, Charlie would get it. I don't know where he learned, but there he was at the reception dancing just as

good as he wanted. He danced on his heels. Oh, he was so proper. He really did grow up. . . . The band was playing, and we were just out there on almost every dance, turning this way and turning that.

"It was a perfect evening. We were so in love. Cupid had shot us good."

AT SCHOOL, CHARLIE was interested only in music; by the time Rebecca graduated, he was barely attending his other classes. "I went in as a freshman," he later joked, "and I left as a freshman." But it didn't matter to Addie as long as he was staying home and letting her take care of him, and he was happy with Rebecca living right upstairs.

Edward Mayfield Jr. remembered Charlie as a difficult character. "He was kind of a bully," he told Robert Reisner. "He was kind of a mean boy. He pushed you aside and got his horn first out of the music closet in school. If you didn't like it . . . you liked it anyway. He was larger than we were. He didn't stand any kind of pushing around. He didn't pick on you, but he would pop you in a minute." But Charlie was serious about his music. "He was a good reader, both words and the dots. He managed to make his music classes pretty regular. He was that type of four-flusher. He mostly associated with older fellows. He was smoking and that sort of thing, and we didn't smoke. He was just an older type guy."

Charlie was moved up to alto saxophone by the school's demanding music instructor, Alonzo Davis. "Alonzo was really a good musician," recalled Julian Hamilton, a classmate of Charlie's. "If you didn't want to do the music right, you stayed out of *there*." Davis put Charlie on alto after he shifted all his other saxophone players to clarinet, on the theory that once they learned the clarinet, they could go back to saxophone and master it with greater ease. Hamilton, who had been playing the alto saxophone before Charlie, re-

called him as a good baritone horn player but not as accomplished as Freddie Culliver, his predecessor. "Charlie was good, now. Charlie was good. But he wasn't on the same level as Freddie." Another player who studied at Davis's knee was Lawrence Keyes. The young piano player "was coming in there still, even though he had graduated in 1933. He was playing orchestra vibes and learning as much as he could from Alonzo Davis."

Alonzo Davis was part of a tradition that dated back to the nineteenth century, when free black people started moving into the world of American entertainment after the fall of the Confederacy. While black show business was developing on the road and in rehearsals, usually in minstrel shows and circuses, another arena of preparation was coming into being that would influence the course of Negro talent after the Civil War. A legacy of photographs of serious-looking, uniformed young people holding instruments and surrounding a confident adult attests to the growth of thriving music departments at Negro colleges and public schools, headed by almost mythic figures who made sure their students learned to read, sing, or play in tune, and to negotiate material as different as Handel oratorios and Negro spirituals. Engaged in the expanding concentric circles of musical education that had begun in eastern universities early in the nineteenth century, they tattooed their knowledge on the brain cells of many young musicians who went on to shape the evolution of vernacular Negro American music. Known for rigorous discipline—they left behind many stories of thrown erasers, hands smacked with rulers, noggins thumped, backsides paddled, and knuckleheads verbally dressed down—those Negro teachers had been educated in conservatories and in apprenticeship situations, often taking over the departments at black colleges or returning home to make sure first-class instruction was available in the communities

where they'd grown up. Some of these instructors were composers; others developed crack marching bands. Many also taught privately when they couldn't find a school position; they were part of the reason that so many Negroes who were able purchased pianos and got lessons for their children.

In Kansas City, one of the most prominent of these music teachers was Major N. Clark Smith. A former military band leader and instructor at the Tuskegee Institute in Alabama, Smith had composed the music for the school's anthem, "The Tuskegee Song," at the request of Booker T. Washington before moving west to Kansas City. At Lincoln High School, he soon gained a reputation as a taskmaster who took no stuff, and he put down discipline rough enough to produce first-class players. Smith taught and inspired Walter Page, the innovative bassist who led the legendary Oklahoma City Blue Devils, and whose pulse animated the new feeling of big band swing that was nationalized by the Count Basie Orchestra, itself a fusion of the Blue Devils and the rival Bennie Moten's Kansas City Orchestra.

Saxophonist Harlan Leonard, who was a member of Moten's reed section from 1923 to 1931 and later led his own big band, Harlan Leonard and His Rockets, described Smith to Ross Russell in the book *Jazz Style in Kansas City and the Southwest.* "When I knew Major Smith he was a man past middle age," Leonard recalled. "He was supposed to have served in the Spanish-American War. After leaving the service I believe he was in show business for a while and had toured Australia with a musical group. Major Smith had a vivid and commanding personality. He was short, chubby, gruff, military in bearing, wore glasses, and was never seen without his full uniform and decorations. His language was rather rough and occasionally slightly shocking to the few young ladies who were taking music classes, though never offensive."

According to Leonard, Major Smith "*was* the music tradition at Lincoln High School. He discouraged dilettantes and time wasters and encouraged talent." Though "not an outstanding player himself," he was a skilled instructor, and "drilled the Lincoln marching bands until they were the best in the area, some said the best of their kind in the Middle West. He made music seem exciting and important, and over the years Lincoln High won a reputation for turning out a steady stream of well-prepared musicians who succeeded in the profession."

Smith was succeeded by Alonzo Davis, who "carried on the tradition," and "Lincoln High continued to turn out professional musicians. In fact, some of them were to serve in the Rockets—Jimmy Keith, Jimmy Ross, and Charlie Parker."

CHARLIE'S MOTHER HAD bought him that saxophone a few years earlier, but back then he had been so disengaged that he loaned it to a musician friend, content to fill his extra time with aimless lounging around, sometimes heading out to the railroad tracks and throwing stones at bums with an accuracy that startled his buddies. He spent most of his days eating, sleeping, pranking, brooding, and living the well-kept life of a reddish-brown prince who had no specific kingdom in sight. But sometime after he switched to alto in the Lincoln High School orchestra, probably in the summer of 1935, Charlie decided to test his mettle in another venue: the bandstand of tenor saxophonist Jimmy Keith.

All the players in Keith's band were young men; Charlie had seen them around. At least two of them, Keith and Ross, he knew personally. Like him, they were from the Lincoln band. They were a little ahead of him in this action, but that didn't matter. He intended to get in on what they were doing. Why shouldn't he? Music was

everywhere: on the radio, on phonograph records, on parlor pianos, in the clubs all over town, advertised on posters showing guys dressed up in fine clothes and posing with the jovial dignity of a homemade aristocracy soaked in confidence. It may have been his first time out, he figured, but he was doing all right playing in the Lincoln orchestra; he'd just take his horn up and get some respect the same way he'd done with anything else—back when he ran with Edward Reeves and the boys over in Kansas, or that time he stood his ground with Sterling Bryant when they took those dangerous trips into strange neighborhoods and sometimes had to fight. He figured he'd find a way to get comfortable, just as he had with the Ruffins when they moved into his house, fitting right in with the kids and becoming one of the family. A bandstand at the High Hat Club couldn't be that different from anything else. Sure of himself, Charlie Parker the alto saxophonist walked toward his next victory.

In 1950, he recalled for Marshall Stearns and Jim Maher what happened next. "I knew how to play, I figured. I had learned the scale and I'd learned how to play two tunes in a certain key—the key of D on the saxophone, F concert. And I had learned how to play the first eight bars of 'Lazy River' and I knew the complete tune of 'Honeysuckle Rose.' I didn't never stop to think about there was other keys or nothing like that. So I took my horn out to this joint where a bunch of guys I had seen around were. The first thing they started playing was 'Body and Soul.' Long meter, you know? So I got to playing my 'Honeysuckle Rose.' . . . They laughed me off the bandstand. They laughed so hard it broke my heart."

That was the watershed. From that moment on, Parker started practicing the alto with obsessive seriousness. He played from morning to night, as he told fellow alto saxophonist Paul Desmond in a 1953 radio interview. "I put quite a bit of study into the horn. . . . In fact, the neighbors threatened to ask my mother to

move once when I was living out west. They said I was driving them crazy with the horn. I used to put in at least from eleven to fifteen hours a day. I did that over a period of three to four years."

That must have been the time when people claimed you could hear the saxophone coming out of Addie Parker's house any time you passed it. Either you got yourself some discipline, Charlie had learned, or humiliation would follow. No matter how sincere the would-be musician was, technical demands were what they were. True mastery involved *learning*, not just emoting. His feelings were smacked hard that night on the bandstand—hard enough that he went home crying—but he later told trumpeter Oliver Todd that he'd decided there and then to become "the greatest in the world."

Charlie was still spending plenty of time with Rebecca, and with boyhood friends like Sterling Bryant, now Lincoln High's drum major. But it was with another friend, an aspiring trombonist named Robert Simpson, that he would pursue his musical ambitions.

The son of a union official, Simpson became something of an older brother to Charlie, a friend who was ready to suffer with him as they learned to negotiate the tempos, keys, and chords of the blues and popular songs. Charlie admired Simpson in a way that struck others as very intense in its attention and affection. Together constantly, the two worked hard at trying to get good enough to be accepted into the Kansas City jam session scene. They often went to Lawrence Keyes's house for ear-training classes, Charlie toting his horn in a blue terrycloth drawstring bag Addie had made for him. They were even thrown off one bandstand together, Addie Parker later told Reisner.

Charlie's involvements and horizons were expanding at an express clip. He had Rebecca loving him so much she almost couldn't stand it, had her female siblings as his play-sisters, and in Simpson

had a musician buddy he could run with the way he'd passed his childhood with Sterling Bryant. Birdy Ruffin may still have been looking upon him with suspicion and contempt, but otherwise things were slowly coming his way.

In September 1935, Charlie and Robert Simpson started working every Sunday in the Deans of Swing, a group led by Lawrence Keyes, at Lincoln Hall on Eighteenth and Vine. The band played teen dances there from four in the afternoon until eight in the evening. At first Charlie was just a supporting player, recalled Oliver Todd, who played Lincoln Hall with his own band, Oliver Todd and His Hot-Ten-Tots. Fred Dooley, another local transplant from Kansas, remembered Parker playing with the Deans of Swing. "He would just be sitting there by the Lincoln Hall, where he played when I would see him. I was going to high school in Kansas and was playing the clarinet. It cost thirty-five cents at the Lincoln Hall, but the place would usually be empty, or almost empty, because everybody was across the street listening to the blues.

"At that time," Dooley recalled, "he wasn't blowing that much, and he wasn't an outgoing guy. He wouldn't seek you out. If you talked with him, he would talk with you. That was it. No overtures. That's the way he was, just a pretty quiet average guy."

To Dooley, Charlie Parker still seemed to be playing in the shadows of two of his young peers. "Everybody liked John Jackson and Ben Kynard the most of the young fellows playing music then. John was much farther along than Charlie at this time. Charlie was playing more or less on the same kick as Johnny Hodges or Willie Smith, or somebody more along the conventional line. He wasn't a good reader at all." But Dooley and his gang knew that Charlie meant business. "We would be hanging out on the main drag, which was Fifth Street, out in front of the pool hall or the barbershop or what have you, just talking and messing around. Then we

would see Charlie on the way to John's house, which was on Fourth Street. Sometimes we would talk briefly but the thing on his mind was getting over to John's house to work on that music."

Charlie was starting to fall in love with that alto saxophone, and as winter gave way to spring, and he slowly became a featured soloist, there were those who fell in love with him. And it wasn't just his fellow players who were taking note. "The interesting thing about Charlie even back then was that a lot of girls liked him, but we couldn't understand why." The Deans of Swing weren't a big draw, exactly: "Ten or twelve people usually, sometimes a good crowd. We would come into town with our Kansas girls, and it was strange the way they took to him. There was a rivalry with the guys in Missouri, you know, high schools, women, that sort of thing. For some reason, *our* girls would say, 'Charlie Parker is blowing. Let's go to the Lincoln Hall.' Whatever they could hear, we couldn't. But they sure did love to go over there and listen to him."

One day in April 1936, almost exactly two years after the Ruffins moved in, Ophelia went looking for Rebecca upstairs. She was probably with Charlie. By now, Charlie had stopped going to school; he wanted only to be a musician. Anxious to find her sister, Ophelia looked all over the house. Where could Rebecca be? No one had seen her. Oh, perhaps there. Ophelia ran up to the middle bedroom and opened the door.

"I will never forget that," she recalled. "Charlie and Becky was in there. I had never seen anything like that before. It was my first encounter. It shocked the daylights out of me. Charlie told me to come in and close the door behind me. Charlie says, 'Don't say nothing to Ma. Don't say nothing about it.' I was standing there staring."

Somehow, that evening or soon afterward, Birdy Ruffin found out and wanted to kill Rebecca very nearly. To this writer, Rebecca denied that Ophelia had seen anything more than Charlie and her

doing some kissing. She also said that Ophelia told their mother. Ophelia demurred, saying that if they weren't having sex, she did not know what it was. She also remembered a fiery confrontation, with Birdy Ruffin shouting down from upstairs and Rebecca looking up from below, standing next to Charlie and his mother: "Rebecca is stubborn and tears are in her eyes. Mama wants to beat her to the ground. Miss Parker is defending the both of them. She says they was in love and can live right here in the house. 'Everything will be all right, dearie.' Mama didn't have no time for none of that."

Winfrey Ruffin interceded, saying that his sisters would be ruined if they kept getting such harsh whippings. And so Birdy Ruffin decided to move. Soon they were off to Sixteenth and Olive, leaving Addie Parker's house behind. Birdy Ruffin made it very clear to Rebecca that she didn't want her setting eyes on that Charlie Parker ever again. Her daughter, whom she still called Beckerie, was grounded, not to be trusted. Rebecca knew that she was no big-busted Zephyr, sneaking up under houses to teach boys the female things they wanted to know. She wasn't trying to act grown, or be mistaken for a street woman. But her mother would not have her falling in love with that "alley rat" Charlie. Instead, she'd keep her in a cage like a parakeet, force her to sit down and listen to her mother's admonitions—and never "cut her eyes" at her mother, for one look of insolence or indifference could get any of the girls knocked to the floor with instant fury, Birdy standing over them until the offending daughter begged for mercy.

Rebecca could only pout within, feeling as though she were breathing air through a straw, trying to figure out how to penetrate the glacier of misunderstanding her mother had about her relationship with Charlie. She knew her mother loved her, re-

membered the radiant pride Mama Birdy showed as she put her daughter into the organdy dress and gleaming shoes for Lincoln High graduation, even told her she was beautiful. She could still see her mama sitting there in the auditorium, happy that the girl had shown all of Kansas City that she was good enough to get her certificate of education, her diploma.

Rebecca had clearly represented herself well; she had no intention of remaining in the mud unfair people always wanted to push the Negroes into. Birdy's daughter was clean and neat, and she had respect for people, wanting no more in return than what she gave. But she was head over heels in love with Charlie—and she could do nothing about it, because her mother refused to understand that kind of pure love.

Rebecca's older sister, Octavia, liked Charlie, and she knew how the young couple felt about each other. And, after the Ruffins flew the Parker coop, she became a willing coconspirator in the cause of their romance.

Mama Ruffin may not have trusted Rebecca, but she never worried about Octavia doing wrong or getting messed up with any lazy, spoiled, low-class Negroes. With Octavia acting as Beckerie's chaperone, Mama Ruffin could relax into a placid confidence, could shake the anxiety that overtook her to the point of terrifying violence whenever she began to suspect that one of her daughters was at risk of becoming a misled, loose, and vulnerable street woman. As a religious woman, she was grateful to be able to trust her oldest daughter to look out for her middle daughter.

That's how Octavia managed to deliver Rebecca to Charlie. Birdy Ruffin never asked any questions when the older and younger sister left their new home together. On Saturdays they arranged to meet him at the movies, and on Sundays the sisters always went to hear him play with Lawrence Keyes and the Deans

of Swing, either at Lincoln Hall or Paseo Hall. That became their regular habit.

Keyes, however, broke up his band in early 1936. So did Oliver Todd. But a local booking agency made Todd an offer to start another one. And when Todd started holding auditions for the new group, at a home on Brooklyn Avenue between Fourteenth and Fifteenth Streets, the first person to show up was Charlie Parker. "Shouldn't you be in school?" Todd remembered asking. "His answer was, 'Do you want this to be a quiz program or are you interested in a saxophone player? But since you asked, I'll tell you. The teachers think I was a bore, and I thought they were bores. So I think the best thing I could do is leave them alone so they could leave me alone.'"

Soon Todd was building his new band. Robert Simpson joined, as did Jimmy Keith and James Ross, two of the Lincoln High musicians who had laughed so hard at Charlie when he sat in with them. After rehearsals, the new band would head out in Todd's car to see what was happening at the many Kansas City jam sessions. By now, apparently, Charlie had been around enough for the professionals to know just who he was—if not to welcome him into the fraternity. When Todd and his gang came in, the musicians did something so extra, it was clearly special. They all stopped when they saw Charlie. Todd was startled by the contempt these older musicians showed the young alto saxophonist. "It irked me to see these guys get up because the man walked in," Todd said. "They'd say, 'Well, if this guy's going to play—forget it!' And this happened so many times."

Other than music, Charlie Parker had one more thing on his mind: Rebecca Ruffin. She'd been sneaking out to see him faithfully, month after month, and Birdy Ruffin hadn't caught on at all. Then, on a Friday evening that was a bad summer night for the

Negro race, June 19, 1936, the young star-crossed lovers made a decision.

THAT NIGHT WAS the night of the first fight between Joe Louis and Max Schmeling.

Joe Louis was the Alabama masterpiece of boxing, a black man who regularly whipped white men in the ring and walked the streets of Negro America with a handsome brown-skinned charisma. Who moved through the world telegraphing, with his very posture and easy confidence, that it hadn't seen anything yet. Who thrilled Negro boys and girls as they sat near radios listening to the blow-by-blow descriptions of his bouts, watching as ecstatic adults hooted holes in the roof at each new victory. Whose photograph, torn from magazine articles and newspaper clippings, was as basic to Negro homes as Christian iconography.

Joe Louis, whose parents were both children of freed slaves, was a symbol of what Negroes could do when they got a fair chance, not a favor. His story belied the fiction that all Negroes were weak-willed buffoons, as they were depicted in advertisements, in novels, in movies, in nearly all popular entertainment. He stood as a combination of Nat Turner and John Henry, a latter-day truth that could not be denied: proof beyond denial that black people could rebel with quality.

What sealed Joe Louis's role as a completely modern hero, however, was his relationship to electric technology. His individual achievements were caught on film as they happened, taken beyond the context of the present and recorded as a timeless presence that could be stopped and repeated, if anyone should require confirmation of what they'd just seen. He fought first as a man,

then as a part of the public record, a record that was functionally indifferent to racist practices or beliefs. Each new document gave Joe Louis's fans a chance to admire his talent, his grace, the example he laid before the world. Yet it also offered an opportunity to study that example, to admirers and opponents alike. And one of those would-be opponents was a German national named Max Schmeling.

Benefiting from technology, Schmeling had studied the "Negro people's champ" through his fight films the same way jazz musicians studied the recordings of the competition. He picked up on the details of Louis's style and developed a perfect strategy for counterattack: when Louis unconsciously lowered his left hand after throwing a jab, as the films showed he sometimes did, Schmeling would throw him a hard right. Louis would never see it coming. And on that June night in 1936, just as Ethiopia was being slapped silly by Italy, Max Schmeling was using everything he had learned in those films to batter Joe Louis nearer and nearer to unconsciousness.

Those German rights kept landing in the ring at Yankee Stadium, and the Alabama wonder began coming apart, round after round, three minutes each—the same length as a 78-rpm record, all a jazz band needed to make a complete musical statement. Such technology could open a sonic world as it was right then; it would no longer be heard in isolation from other ideas and feelings. Isolation was losing the upper hand in modern life. Everything— accurate, inaccurate, fanciful if not distorted—was moving up front in a hurry. Three minutes was a long time—and it seemed even longer if you were being mysteriously pulverized in the middle of your ascent to a championship that had been off-limits to black boxers for nearly thirty years, since the days of Louis's wicked predecessor, Jack Johnson.

Or that's what some people had thought he was—wicked. On December 26, 1908, the boxer Jack Johnson, a figure who incensed a generation of white men because he was arrogant enough to consider himself a man just like they were, who had traveled from his chosen hometown of Chicago to Australia to measure his fate, nailed a career coffin closed for an Australian fighter named Tommy Burns. In defeating Burns, Johnson became the new heavyweight champion of the world, and the crown he won bestowed some real athletic royalty upon him. The man who wore it could feel and perhaps live like an emperor, the roughest scrapper in the world, come one, come all.

Johnson won that crown in a fight that was promoted in the press as a battle between a man and a huge ape. The insolent, panther-black Johnson seemed willing to thumb his nose at white men with no apparent fear of losing the digit. He was the king of the white man's blues, wearing a royal crown that added an ominous shine to his hairless head. As if loving all the deep notes of a particularly lowdown gutbucket song, this uptown ruler barreled downtown behind the wheel of an aggressively stunning car with mufflers loud enough to wake the dead. He draped his big presence in expensive duds, gold in his teeth and diamonds encircling his fingers. He did not seem to care that he was a brunette in a blond town that had rules and a place for him. Culturally hard of hearing, perhaps deaf, Jack Johnson went his own way, as if he were composing a strange new tune called the "Infuriation Blues."

Johnson retained his crown for more than six years. And he became a legendary, challenging figure on the American landscape. He partied night and day with white women, plenty of wine, gourmet food, and songful jazz music in which he even played the bass and conducted bands in a turning style, slowly spinning around

and doing dance steps with a baton in his hand. And he became more than obliquely important to the aesthetic world of blues and swing—most directly because he owned some expensive sporting rooms, and when he sold the one in New York known as the Club Deluxe, the sizable four-hundred-seat room was remade into a swank imitation of a plantation with log cabins and renamed the Cotton Club.

Under its new moniker, the Cotton Club became a high-society upstairs hideout way up in Harlem. But it was off-limits to Negroes, who were not allowed to cross the color line of segregation—Jack Johnson, of course, being one of the few exceptions. The club became a showcase for the hoary tropes of the minstrel tradition, maintained by Negroes entertaining white folks while in tattered plantation attire, or other, equally noxious costumes if the routines called for them. One favorite was a titillating skit about hero fly-boys lost after crashing in the jungle of the cartoon dark continent, reveling among attractive, light-skinned, comely, savage, and sexy women ready to have at it with a light-skinned or a so politely tan, tall, and terrific flier—while other, more frightening men lurked nearby, grunting in rhythm: dark brown savages growling while they waited to devour the fallen sky boys. It was a place where white customers could experience so-called "jungle nights" in Harlem, full of what they thought to be the darkies' "natural" behavior—authentically imbecilic, if not amusingly or intriguingly subhuman, much like the thug-and-slut hip-hop world of today.

In 1927, that sort of show business muck was undercut by the music of Duke Ellington, who beat out Louis Armstrong's New Orleans mentor, King Oliver, to become leader of the Cotton Club's house orchestra. The still-budding but soon to become formidable Ellington used a wide variety of music—some written by

others, but much of it arranged and composed by him alone—for his nightly shows at the club. This allowed him to meet the demands of the assignment and refine his own style, as had so many black musicians before him. As his early film appearances reveal, Ellington was still working in a milieu that included less enlightened Negroes. But Ellington never spoke in the broken-up way some black entertainers did—a voice that Armstrong lampooned to answer the dialect-dribbling explanation delivered by Lionel Hampton on their 1931 recording of "You're Driving Me Crazy."

Though Ellington's roles in film demonstrated that he wasn't above or beyond humor and bandstand enthusiasm, he never submitted to the happy fool imagery of the time. He learned how to keep his cool and move respectfully and respectably through his job at the Cotton Club. For the easeful quality of his bearing, for his special brand of elegance, Ellington became an inspirational example of deportment to upcoming generations, who would soon become impatient with any kind of minstrel demand, within or outside of show business. The Cotton Club served him well: the pay was good, the suits the Duke and his men wore to work were plenty all right, and the gangsters who owned the room, led by the English-born Owney Madden, kept others from bothering them in town and on the road—or else the others would have to pay a slapped or gushing fine, red and slippery. After hours, Ellington and his drummer, Sonny Greer, played private parties for Madden as a duo, rendering requests for the popular tunes of the day, sometimes crooned by the percussion player to Ellington's accompaniment.

Ellington took his Cotton Club fame and parlayed it into international status through the medium of recorded music. By releasing records of sophisticated compositions such as "Black and Tan

Fantasy" and "Creole Love Call," he did the same things for his art that D. W. Griffith had done for film (racism aside), and that Joe Louis would do for the world of athletics: his recorded work revealed exactly how the game should be played.

Ellington's cool and elegant refusal to conduct himself like a cooperative buffoon made him a hero to black musicians. Singer Billy Eckstine, who became an important sponsor for musicians of Charlie Parker's generation, has pointed out that much of what has been said about the supposedly revolutionary bebop movement is wrong because it overlooks Ellington's importance to the young men who made the new music, all of whom began paying close attention to his distinctive music and his equally distinctive demeanor on and off the bandstand.

Eckstine saw Ellington's conduct as a rejoinder to spectacles like one he saw in the Howard Theatre in Washington, DC, where the band of Fess Williams was presented as "monkeys in trees playing saxophones." The display nearly killed Eckstine's enthusiasm for show business—until Ellington played the same venue a few weeks later.

As Eckstine recalled, "The way he looked when the curtain went up, the way he walked to the microphone, the beautiful clothes, and how he talked were all so charming, and so far away from that other shit, he brought me back to my dream of getting out there with Cab Calloway—except in my own way. That's what a truly bad motherfucker will do for you; he will inspire you to keep reaching for your own shit until you get your hands on it—if you are lucky enough to have something that is your own."

As Eckstine made clear, younger Negroes were beginning to resent the impositions of minstrelsy while keeping an eye out for possibilities that could lead them in other, more promising directions. None of them, old or young, had ever been quite what some

would call happy in the face of their names being scandalized so casually and so consistently. Another future conspirator for a fresh, swinging interpretation of the jazz aesthetic, Carolina country boy Dizzy Gillespie, was almost hypnotized when he saw Ellington in a short film, with Sonny Greer sitting behind a big set of drums. The duo, and the whole band, gave the little Southern boy correctly named John Gillespie a very special early dream of becoming a professional. And his influence was even more pronounced on Charlie Parker than on Eckstine or Gillespie.

"Dizzy and I were known to have short tempers," Eckstine recalled. Sometimes, when you were out on the road, "you had to stand up behind your own talent." To a live wire like Billy or Diz, that might mean "knocking an ignorant motherfucker out, don't make no difference if he black or if he white. . . . A hard right might wake him up and let him see the error of his ways." One day, they were in a Detroit bus station men's room. "I sat in a chair to get a shine. I got comfortable. It was a nice high stand. The next thing I know is, a white motherfucker done jumped up and snatched me by my tie talking about he was next. I told him I was sorry and if he just would back up an inch or two I would get up for him. He did, and then I hit him with a right and he fell into the urinal, out cold.

"Charlie Parker went over to the man and said, 'Now this is a shame right here, mister. You called this man a nigger and didn't know a thing about him. Not a thing. You messed up then. Now you got to go home to your wife and explain to her how you broke your glasses and why your face is red and puffy and your lip is all cut up. I bet you feel like a fool right now. Perhaps I can say it better. You probably feel like an elephantine anus. You sure look like one.'"

That was the Ellington effect. "Bird was totally influenced by

Duke: he could say things in a classy way and they worked. Duke made everybody want to have more class."

ON THAT SAME June evening that Joe Louis was facing Schmeling, and Charlie Parker was sinking pleasurably deeper into the mush of adolescent romance, walking along hand in hand with his first love as they listened to the radios broadcasting the fight through the windows of home after home, Jack Johnson put another kind of hot mess on his own head.

Like Duke Ellington, Jack Johnson was never one to radiate the qualities of minstrelsy in demeanor or appearance. But unlike Ellington, Johnson was neither able nor inclined to charm the bigger sharks of racism until they moved to protect him from the others. By 1936, he was in retirement after losing his crown and weathering a trumped-up federal case against him for violating the Mann Act, written to protect young women from "white slavery." (Johnson was married to white women three times; some whispered that he had a kind of "hypnotic power" over white girls.) Though Johnson's alleged crimes had predated the act, he was convicted, but he left Chicago, that toddling town, before authorities could send him to prison.

During that period, the champion fell out of favor with American Negroes. The black press, black educators, and black clergy saw his actions as a shame on the entire ethnic group, a hindrance to its moving on up to greater freedom. Black Jack could have married one of his own ethnic group, but he wouldn't, or didn't. He fell as hard and as far as his appropriately demeaning symbolic twin, King Kong, a big ape losing everything over a white woman, brought so concrete-low by what he thought was beauty but was actually doom. Maybe so, but as far as the fighter was concerned,

it was nobody's business what he did and whom he did it with, as long as both were cooperatively enjoying themselves. When Johnson lost the crown in 1915 to a Kansas man—Jess Willard, formerly a working cowboy but nicknamed the Pottawatomie Giant for his punches—some may have chosen to believe that the champ laid out down there in the baking air, faking unconsciousness on the canvas, finally submitting to white men by throwing the fight; but they were understandably wrong. Sometimes the coldest truth cuts in at least two ways. Johnson's day as a national black hero was done, his conduct considered despicable. He no longer represented an acceptable kind of individual freedom.

Twenty years later, however, Joe Louis did. And as Louis prepared for the fight of his life, Jack Johnson—never one to be comfortable in the shadow of any man or any institution—visited his training camp and offered to coach him for the Schmeling fight. He was turned down. Johnson was still considered poison for any Negro about to move to the top, which is exactly what Louis was: the first black man in a generation to be headed for a world heavyweight championship, now one fight away from a title bout. Louis, like Johnson, had moved north to Chicago, but unlike Johnson he had recently married a colored woman with a fine brown frame. The aspirant champion and his camp chose not to allow the former king of the white man's blues even to stand next to the new colored man who was now such a terror within the square dimensions of the ring. It was not the time to risk maddening the white people with the turbulent memory of that period two decades before, that time when the black thumb was so arrogantly jammed into the white eye. Not this time, not that memory.

Johnson did not take the rejection of his services lightly. Like Schmeling, he had watched Joe Louis, had seen his weakness. And

he started predicting, loudly and widely, that Louis would lose. As Geoffrey Ward documents in his highly detailed biography of Johnson, *Unforgivable Blackness*, Johnson even offered his knowledge and insight to Schmeling.

When the German started landing his padded rights in the face of that chosen hero known as the Brown Bomber, neither Louis nor his corner could figure out what that thirty-year-old boxer from Europe was doing, that man who should be losing his skills in the swift decay of professional fighting, but was instead getting stronger and his punches no lighter. When Joe Louis finally fell, so—at least for that evening—did the entire black, brown, beige, and bone ethnic group, knocked cold, dropped to the canvas. That was a sad Friday night. Poet Langston Hughes saw Negroes weeping in the streets throughout Harlem—grown men, grown women, adolescents, and children. The unexpected and shocking knockout affirmed the sense of universal frailty so basic to the blues sensibility, the tragic recognition that made the blues such a perfect tool against sentimentality, if not against pain itself.

But defeat can lead to thoughts of revenge. In the hours that followed, five white men in New York were beaten by Negro mobs uptown in response to Louis's loss. And old black Jack, reaching for a bucket of hot mess like a suicidal Napoleon crowning himself with solid stink, almost instigated an interior ethnic riot, a sort of violent heaving, after he chose to go through Harlem bragging about how much money he'd won by betting on the German.

IN THE FUNEREAL atmosphere of that evening, Negro sadness filled the darkness. Duke Ellington's band played the Loews Theater downtown that night, but the leader may have made it up to the Bronx to see the fight. Back in Kansas City, Charlie Parker

walked Rebecca Ruffin past Crispus Attucks School, listening to all those radios blaring in the warm night.

"You know what?" Charlie said. "Miss Ruffin's gonna kill you if she knew we was slipping out. So let's get married."

He had finally said it. It made absolute sense. And Rebecca agreed. She would pack her things and come to 1516 Olive the next day.

Floating on the force of a romantic attraction that they both thought, deep in their hearts, was invincible—the real thing in a world filled with so many false things, so many masks and so much deceit—Charlie and Rebecca decided they deserved more than getting away with seeing each other secretly. They were through with a life where romance happened only when they were beyond the eyes of the pretty girl's mother. A beautiful and public future was theirs for the asking.

The next afternoon, with her clothes and toiletries in a suitcase, Rebecca told her mother that she was ready to go, that she was going to become Charlie's wife. "Marry Charlie, huh?" she said. "Okay, Beckerie. You'll need me before I'll need you." It was that abrupt. Addie Parker was more welcoming: when Rebecca arrived at the Parker house, Charlie's mom told her to get her wedding dress together, and instructed Charlie to stay with his friend Sterling across the street until the wedding.

On Saturday morning, July 25, 1936, Addie Parker gave Rebecca a white Bible; put her in a white hat, a yellow blouse, and a white dress; told her son to wear his brown suit; and took them both by trolley to the justice of the peace. When it came time for the ring, Addie Parker took off her two wedding rings and handed them to Rebecca, who slipped the marital symbols on comfortably.

The young couple, newly reinvented as man and wife, returned home to a small reception. Charles Sr. was there, with his brother John and Charlie's half brother, also named John. There were also

friends and relatives of the young married man, friends of his wife, and a few others. The groom stuck the end of a napkin in his collar and walked around the parlor eating ice cream and cake, pausing only to wash them down with punch. Everybody was in good spirits, the family and the rest, including a few female friends of Addie Parker. They all looked a bit like Parkey, as Rebecca called her, and also seemed somewhat out of breath, as if they had run up and down the stairs to relax themselves before the celebration started. That night Rebecca and Charlie moved upstairs.

After the wedding, Charlie settled into a new rhythm, going out to play or listen to music every night and not returning until the next morning. Rebecca, who got a job working half days as a governess, spent a lot of time with Charlie's cousin Hattie Lee Boxley. Rebecca remembered the household vividly: "When Charlie and I got married in July, Hattie Lee was there. Hattie Lee worked 'out south,' which meant they were working out in the wealthy district— domestic stuff, you know." Another resident was Marie Goldin, who lived in Winfrey's old room on the second floor.

Rebecca went on, "Marie and Hattie Lee and I played bid whist downstairs. Marie and Hattie drank. They were the only ones Addie Parker let drink. You see, Addie Parker made her rules in her house the way she *wanted* to make them. Before her blood kin come in there, there was no drinking in that house whatsoever! Now that's Addie Parker and that's Charlie Parker: they do things the way they want to do. You don't tell them about contradiction. Oh, no. You don't do that. You just live with it. Hattie Lee and Marie smoked, too, down there puffing on Camels. They had me smoking, too, but I never inhaled. I think Charlie got started on the Camels around then."

Charlie was still spending a lot of time with his buddy Robert Simpson, the trombone player from Oliver Todd's band, who was

dating Hattie Lee Boxley. As Rebecca recalled, "Robert Simpson was fair-skinned and *tall*. He had to be because Hattie Lee was tall as the sky. She didn't have any womanhood on her in any kind of a fine way, she was just tall. Robert came to see Hattie Lee up in her room. Robert Simpson was the *only* man that Mrs. Parker ever let come in the house around us. Charlie himself told others to stay out in the car when they came to get him. Like Clarence Davis—when they was working in the Ozarks, Charlie said, 'Man, you don't need to meet my wife. Stay out in the car.'

"But Robert Simpson was different. Charlie really liked him. He was like a brother to Charlie. Charlie looked up to him. Hattie Lee was close to Charlie. Charlie would talk with her in the parlor or he would get up out of our room and go in her room and talk with her and Robert after he got up to go to work in the evening, about nine o'clock. The three of them were very close. Robert Simpson helped Charlie grow up some more. He had somebody to learn from in the way of being a man."

ONE DAY IN the middle of August, Rebecca came home. When she climbed the stairs and opened the bedroom door, she found Charlie lying in bed, butt naked and asleep, with his penis standing straight up and wrapped in a handkerchief held in place by a small knot.

Rebecca ran down to find Charlie's mother. "Parkey, come upstairs," she said. "Charlie's in bed with his worm all tied up."

Addie Parker rushed into the room, closing the door behind her. Rebecca remained in the parlor. After a while, Charlie came down for dinner, then left for the evening.

When Rebecca returned from work the next afternoon, Charlie wasn't in their room. She went to the kitchen, where she could hear Addie Parker humming.

"Parkey, where's Charlie?"

"Dearie, I had to take him to get a cure."

"What kind of cure?"

Addie Parker said nothing, merely went back to humming and fiddling around the kitchen. After a bit of silence, Rebecca left the kitchen.

Charlie had been gone for about two weeks when Rebecca came home one afternoon and found him sitting on the couch in the parlor. He looked as though he had been extremely ill; his dark skin had an ashen cast, his eyes were weak, and he was so thin that he seemed much taller. When Charlie saw her, he leaped up and ran behind the large potbellied stove that was in the middle of the room. He stood there staring at her, his clothes hanging loosely on him and fear in his eyes. When Rebecca moved toward him, he went to the other side of the room.

"Charlie, what's the matter?" she asked, trying to get close to him. There was no answer, only a frightened stare. Puzzled, Rebecca went up to their room.

Charlie remained downstairs for nearly a month, never sleeping upstairs, never going out to play music, never speaking to Rebecca, only staring at her in silence. Then, in the middle of September, Rebecca heard a saxophone as she lay on the bed in their room.

"I ran down those steps, eased open the door, and he was blowing himself to death. Charlie was standing there next to the piano. Oh, he was blowing. I have never heard him blow like that. And I've been to the dance halls where he'd blow, you know, but I had never heard this kind of music before."

Rebecca sat on the couch for about seven minutes and listened as he played. At first, he was playing along with what she thought was

Fats Waller's "Stealin' Apples" as it spun on the Victrola, answering phrases as they came through the speaker. But he continued after the record was over, exhibiting an authority and intensity that were new to him, the sound alternately strident and tender, the rhythms bubbling or disruptive. When he finished, Charlie opened his eyes and saw Rebecca.

"Hi, Suggie," he said.

"Charlie, why do you blow so long and hard? Why don't you rest a while?"

Charlie smiled at her and sat down to the piano, fingering something that sounded like what he'd been playing after the record stopped spinning. Rebecca was shocked at how well he executed the phrases. This wasn't boogie-woogie, but he was rolling his long, pretty fingers over the keys as though he'd been doing it for a very long time. At one point, Charlie seemed to hit upon something and played it a few times, straightening out the melody and the chords until it was complete. Then he turned to her and said, "I think I'll call that 'Rebecca.'"

They then spoke pleasantly for a bit, as though nothing had happened. That night, however, Charlie still slept downstairs. He wouldn't return to his room with Rebecca until the evening of Thanksgiving, after some startlingly bad luck took place.

PART II

INFINITE PLASTICITY

It is practically the only question of the age, this question of primitivism and how it can be sustained in the face of sophistication.

JEAN RENOIR

You could look at Bird's life and see just how much his music was connected to the way he lived. . . . You just stood there with your mouth open and listened to him discuss books with somebody or philosophy or religion or science, things like that. Thorough. A little while later, you might see him over in a corner somewhere drinking wine out of a paper sack with some juicehead. Now that's what you hear when you listen to him play: he can reach the most intellectual and difficult levels of music, then he can turn around—now watch this—and play the most lowdown, funky blues you ever want to hear. That's a long road for somebody else, from that high intelligence all the way over to those blues, but for Charlie Parker it wasn't half a block; it was right next door.

EARL COLEMAN

Ａs the young Charlie Parker practiced and practiced, his life began to dovetail with the long story of Negroes in American music, dance, and show business. More and more often, even though it wasn't working for him yet, he was going out there into the night of the professionals, where there were joys and dangers, potential regrets and moments of imperishable triumph. As he packed up his horn and left Olive Street looking for music—showing up to play with Oliver Todd or to attempt a jam session victory, never sure whether or not he was going to be laughed at again—Charlie was beginning to hear the call of a world that respectable parents worried might chew up their children and spit them out as drunkards, hopheads, perverts marked up by venereal disease. Even if their health wasn't destroyed by wild living, those who aspired to be performers were always at risk of joining the ledger of statistics documenting the violence of ruthless police or jealous locals—or of being mutilated or burned to death in some cheese box of a dance hall as an evening of drunken revelry turned calamitous.

Even if he'd been warned, though, there was no stopping Charlie. The nightlife of those Kansas City joints he and Rebecca used to stare into, and the feeling he got from the men who collaborated and competed on the bandstands there, were too far and wonderfully removed from the regular world for him to ignore. Charlie, no matter his faltering, was on the verge of becoming a Kansas City musician, one more young man drawn from the straight and narrow into a universe of nearly mythic sensation and extraordinary invention.

It is understandable that Charlie Parker would find himself awed by all this, for though a good number of myths are as porous as Swiss cheese, there is no more deservedly mythic city in the jazz story than Kansas City, Missouri. After the smoke and dust storms of exaggeration and outright lies blow away or settle down, the facts of Kansas City rise so high in the national artistic pantheon that it proves the wisdom of Hermann Broch's axiom: "The civilization of an epoch is its myth in action."

In jazz, the myth in action was the discovery of how to use improvisation to make music in which the individual and the collective took on a balanced, symbiotic relationship, one that enriched the experience without distracting from it or descending into anarchy.

As the youthful Charlie Parker absorbed the performances he saw in the clubs every night, he was watching his hometown in the process of becoming the swing capital of the land. Kansas City was a kind of experimental laboratory where the collective possibilities of American rhythm were being refined and expanded on a nightly basis. Musicians were learning to navigate a constantly shifting context of complex harmony and propulsive rhythm, to absorb and respond to it within split seconds. This was long before the digital age; before technology revealed how the mind and body could serve the sensitized aesthetic response at such

high velocity—in seconds and milliseconds—allowing musicians to create high-quality jazz, an improvised creation of form and response. But it was happening. In Kansas City, in the 1930s, the blues got shouted, purred, whispered, and cried in such inventive style that the city became the third great spawning ground for jazz, after New Orleans and Chicago.

THE FIRST MOVEMENT in that revolution had occurred a few decades before, down in the tropical southern nexus of superstition, panache, gumbo, street beats, and cultural complexity known as New Orleans. From roughly the turn of the century up through World War I, New Orleans musicians initiated the most revolutionary conception of ensemble music in the twentieth century. After the red-light district of Storyville was closed down in 1917, the first generation of New Orleans jazzmen moved north to Chicago, the midwestern home of a harsh wind that was as legendary as the city's favorite thug, Al Capone. In Chicago the substance of the new ensemble style was made most obvious by King Oliver, whose cornet playing was considered golden and full of light.

Oliver had been a triumphant local hero in New Orleans from 1910 to 1917, but his most influential band was formed when he sent home for Louis Armstrong to join him in Chicago in 1922. With the arrival of young Armstrong on second cornet and Baby Dodds on drums, Oliver had seven pieces, and the circle of charismatic effect was complete. The band's performances at the Lincoln Gardens dance hall were the recipes of legend, sparking and romancing the dancers while drawing musicians from all aspects of the business, each come to hear that marvelous ensemble swing one tune after another.

In 1923, King Oliver's Creole Jazz Band went into the studio and

recorded the material that would largely determine Oliver's reputation. As a blues player of seminal eloquence, Oliver brought to his music a melodic sense, and an expressive clarity, that captured the elements of mood and feeling that were central to blues: contemplation, celebration, lament, wit, eroticism, and ambivalence. Those blues phrases, and the heroic dignity they served, influenced the young Louis Armstrong, and others, in elemental ways. Oliver's innovative uses of mutes provided the template for timbres that would later become signatures of the Ellington brass section and were then passed on through Cootie Williams to Jay McShann's trumpet player, Piggy Minor, for use when McShann and his men were dropping coals of fire down the pants of Lucky Millinder and his fellow victims.

But what contributed most to Oliver's position in the music was his authority as a bandleader. In Chicago, where the partnership of the mob and Mayor Big Bill Thompson made sure there was a hot time in the old town every night, King Oliver brought everything he had learned in New Orleans—in the years he'd spent amid the city's marching bands, funeral processions, street-level musical battles (often conducted from dueling horse-drawn wagons), and bandstands in Storyville, where the soundtrack of the tenderloin had a drive that satisfied the musicians and drove the customers to peaks of excitement. Oliver possessed a brilliant understanding of how to make improvisation and composition work in the balanced way that became the foundation of jazz. His recordings were exquisite collages of polyphony and solo statement, punctuated by shifts of rhythm and stings of percussion so well coordinated that they never give the impression of anarchy.

And those achievements affected the players themselves, created among them a feeling of elite identity, however down-home and greasy that identity was. That elite feeling existed behind all

the public masks—even those of comedy—and was central to the way black show-business performers came to see themselves, especially as their achievements were captured and confirmed in objective recordings. In *Jazz from the Beginning*, reedman Garvin Bushell remembered talking to clarinetist Johnny Dodds and drummer Baby Dodds, who were working with King Oliver and Louis Armstrong, about the place their work had earned them in the jazz landscape: "They felt very highly about what they were playing, as though they knew they were doing something new that nobody else could do. I'd say they regarded themselves as artists, in the sense we use the term today."

Bob Redcross, who later became a friend of Charlie Parker's, also perceived how surely the performers of the time were driven by that appetite for recognition. Born in 1913, Redcross grew up in Chicago, where his mother worked as a hat-check girl in a club where King Oliver and Louis Armstrong played. As a child he would sit in the coat room, draped inside his mother's coat, as the musicians and customers filed in and out every night, and his ears were filled with music from the bandstand. Seeing, meeting, and listening to so many performers—veteran and upcoming comics, dancers, singers, and instrumentalists—from such an early age, Redcross learned how the musicians saw themselves and the world in which they lived:

> You wanted to be known by your name, not "that nigger over there." To be an individual was the most important thing in the world to you. People [knew] who Bert Williams was—the funniest man who ever lived. Later on they knew who Louis Armstrong was, who Duke Ellington was, and everybody else that broke through. That was the goal, and competition

made for a whole lot of invention, you can believe
that. Somebody would get mad at all the attention
some other sumbitch was getting. He would get as
green with jealousy as your finger does if you wear-
ing a cheap ring. All he can think about is, How can
I get some attention? What will make them notice
me? I'll walk like this, I'll sing like this, I'll dance
like this. Pretty soon—if he's got what it takes and
he puts in the homework—people notice him, they
see something different, something nobody has
done before. After all, how are you going to make
any headway if you only do what somebody else did?

As they pursued their craft, of course, the black show-business
people weren't confined to friendly towns like New Orleans and
Chicago. Their work took them into the redneck South, and as
they traveled through that unfamiliar territory, they must have felt
much like their counterparts in the unsettled West of the nine-
teenth century. As the onetime minstrel performer Tom Fletcher
noted in his impeccably informative *100 Years of the Negro in Show
Business*, in those early days "a colored man with a banjo would draw
almost as big a crowd as an elephant in a circus"—and the Negro
professionals often saw their audiences as dangerous hicks who
might be elevated above their barbarous ways by the experience
of black entertainment. "The old saying that music hath charms
to soothe the savage beast worked fine for us," notes Fletcher, who
was born in 1873 and was on the road with Negro minstrel shows
by his adolescence. "In our minds most of these people did every-
thing the savages did except eat humans. We also found that they
had the same weaknesses as savages. . . . I have never quite figured
out whether it was the music or the shows which made the people

gradually get a little more civilized." To Fletcher, that question was "central to understanding the difference in the thinking of committed minstrel figures from all contemporary stereotypes," often "men who were up to passing on the kind of insights inspired aspirants were looking for."

One of the talents these wise men passed on was a knack for registering subtle cues of danger. Negroes learned to read such signals as soon as they began to enjoy freedom of movement, and they learned to protect themselves the best they could. Those who showed even a playful contempt for such constraints—like Jack Johnson, always willing to break the speed limit and thereby break the bigot's rules of order—became true symbols of sedition. Black Jack became the most overt and imposing Negro variation on rebellion since the American Revolution.

The men young Charlie Parker was starting to admire as he became more and more serious about the saxophone, seeing them as local legends or watching them as they arrived from out of town to play a dance, to thrill the local ladies, and to sip or guzzle the flowing good times of Kansas City nightlife, had learned well the savage ways of their own patrons, the Italian and Jewish and Irish gangsters who paid them for their services. Those musicians also knew the parallel dangers of white police who became progressively more irritated by the attention given these horn-tooting coons—and even the anger of local wallflower Negroes, who could grow sullen and dangerous as their sisters and girlfriends stared with mounting admiration at the men on the bandstand.

"They didn't like seeing those Negroes looking so good," as fellow musician Gene Ramey recalled. "Guys would be on the road in their new cars, and they would stop outside to take out rags and wipe off that dust, change their clothes, and come on in looking like they ruled the world. That's one of the reasons they smoked

marijuana, some of them anyway. The police would be looking for something to bring you down, any excuse to show you were no more to them than one of the local niggers. Prohibition was going on, and you didn't want any alcohol on your breath. Then they could get you. Arrested for drunk driving or drunk and disorderly or drunk and drunk! You couldn't have that. And then at those dances you had to stay on your p's and q's to keep some local lug from going crazy over the idea of losing his girl."

The implications of a muttered comment or gesture; the way a voice rose, lowered, or broke; the look on a powerful gangster's face as he entered a room; the way a policeman adjusted his hat or cap, pulled up his gun belt, or put one foot up on the car's running board; the way a rowdy Negro surveyed the dance hall from one end to the other: these were all signals the musicians learned to recognize and accommodate as seamlessly as a silent cue from the bandleader. As professionals, the jazz players learned that the friendly and the hostile live next door to each other, that they stand shoulder to shoulder and sometimes even dance together.

KANSAS CITY TOOK its position in the development of jazz for the same reasons New Orleans and Chicago had: there was a community crazy for the music and a regime that let the good times roll. The city provided plentiful and steady work for professional musicians and those aspirants who could learn and develop on the many jobs necessary to satisfy the party-hungry customers in various venues. Jazzmen combined the refinements of high-society instrumental music with the stronger stuff they employed in those cauldrons where the patrons came to boil the blues out of their flesh, to begin the ritual of courtship on the dance floor, to reduce

every chaotic element in life to a series of elegant gestures, steps, turns, and embraces.

That democratic stretch of sources, always connected to dance, had been rising in the oven of the culture for some time, its ingredients reaching back much further than the young Charlie Parker knew or even sensed. As he went out into the Kansas City night, listening, sitting in, being thrown off bandstands, getting a little better, intensifying his resolve, and practicing even harder, Parker was preparing for the day when he would have it together enough to join the royalty of those bandstands where only the best playing was accepted. Yet everything he would do as a musician was the result of a long creative evolution that we must examine in some detail if we are to understand what happened in that moment when he became entranced by the activities inside the Cherry Blossom.

The road to Kansas City probably begins with the popular nineteenth-century Philadelphia bandleader Frank Johnson, whose career predicted the vistas of later Negro big bands and represented the combination of the sophisticated and the primal that would be central both to jazz and to ragtime, its immediate predecessor. Johnson embodied large cultural shifts that were taking place in America in his time, as African dispositions were absorbed into the context of public joy. Much attention has been paid to the loss of specific tribal traditions that marked this era, but that was less important than the set of attitudes that replaced those traditions. As Eileen Southern has documented in *The Music of Black Americans*, Negroes were influencing dance rhythms in America as early as the late eighteenth century, through their reinterpretations of the popular music of the time. As this writer observed in the anthology *Considering Genius*:

> . . . those black people who played fiddles during

bondage or as free citizens were the result of a so-
cial crucible that produced perhaps the most influ-
ential synthesis of Western and non-Western ideas
since the indelible impact of the Moors on Spanish
and southern European cultures. They were a new
people—some mixed with European blood, some
with that of the American Indian, some with His-
panic tributaries in their family lines. Above all, the
raw impositions of slavery ironically liberated them
from the tribal enmities and religious conflicts that
still bedevil contemporary Africa, allowing for a
richly distinctive Negro American sensibility of re-
markable national consequence. . . .

What existed within the ritual confinements of
polytheistic African cultures and has been dubbed
"an affinity for distortion" was transmogrified into
what I call a sense of infinite plasticity. In Africa, this
sense of plasticity has been observed in the stretch-
ing of necks with rings, the extending of lips with
wooden plates, the filing of teeth, the elasticizing of
slit earlobes so that they could hold large wooden
discs, and so on. The plasticity of stylization in Af-
rican singing allowed for a scope that included fal-
setto, whistles, tongue-clicking, shouts, plaintive to
joyous slurs, growls, and enormous changes of regis-
ter, rhythm, timbre, accent, and intensity. That the
shifts of meter, tempo, and accent in African drum-
ming reflect this sense of plasticity almost goes with-
out saying, as should any observation about dancing
that demands independent coordination of the
head, shoulders, arms, trunk, and legs . . . [And]

> this disposition . . . had an impact on professional
> Negro musicians at the same time that it was func-
> tioning in a folk context.

One of those musicians was Frank Johnson, who led marching bands up and down the East Coast in the early nineteenth century. By 1819, Southern notes, Frank Johnson's Colored Band was observed "distorting a sentimental, simple, and beautiful song, into a reel, a jig, or country-dance." Johnson was a prototypical jazz musician, rearranging familiar music around surprising new rhythms. Like the golden age Negro jazz bands that played for dances across America in the first half of the twentieth century, Johnson and his band traveled the country—as far south as Richmond, Virginia, where one planter wrote of his ensemble, "who ever heard better dance music than this?" In 1838 he even toured England, receiving a silver bugle for his efforts when he played a Buckingham Palace command performance for Queen Victoria. Clearly those in power, down south or abroad, didn't allow their own bigotry to prevent them from having some dancing fun, or from getting the chance to hear a superior performer work his hard-earned skills and disciplined charisma on familiar instruments.

One hundred years would pass between Frank Johnson's success and the Kansas City swing scene that young Charlie Parker wanted so badly to join. In between came a parade of Negroes in American show business, emerging from rural and urban communities where local and traveling performers heard music inspired by belief in God, by the need for rhythms to get people through monotonous work, and by the desire to tell tales of love, blood, sex, blunder, mystery, disaster, and wonder. As soon as the Civil War ended, with the Confederate weeping and the Union rejoicing at Appomattox, the country started to win the west in earnest, and Negroes redoubled

their efforts to develop a rich body of original music, dance, and humor—much of which reached its audience through the crucible of minstrelsy.

Those with a flair for performance and a will to invent, as well as an attraction to chance and adventure, took advantage of the thrilling mobility that their new physical freedom allowed. In the eyes of the law, at least, Negroes were no longer like children; they did not need to be taken care of; they did not need to be protected. To those who went into show business, the options seemed suddenly limitless. If they could not handle something, they could learn how; if they couldn't do that, it was still nobody's business what they did. They were as ready to take their lumps as any free person was. If one stumbled, that was too bad—but not bad enough for him to step away from the choices that came whenever one could make them. The right to fail was a fresh choice and one that they did not take for anything less than what it was. Being able to choose *yes* or *no*, *up* or *down*, was what it was all about. It was the ethos that mortared the bricks of the music they played and the way they chose to live, with an abiding respect for human individuality.

Before the South fell, a few minstrel shows featuring black performers had roamed the country, though none lasted very long. Only two Negroes are thought to have performed in the very popular burnt-cork revues: one was a dwarf, and the other was William Henry Lane, known as Master Juba. Juba was the greatest vernacular American dancer of his age, proving his superiority when he defeated John Diamond in an 1845 competition that presaged the dance band battles that came to prominence in the late 1920s. Juba introduced percussive patterns to the rhythm of the jig that might have been the first *professional* examples of Negro innovation in

American dance. When he traveled to London in 1848, one dance critic wrote that he had never seen such

> mobility of muscles, such flexibility of joints, such boundings, such slidings, such gyrations, such toes and heelings, such backwardings and forwardings, such posturings, such firmness of foot, such elasticity of tendon, such mutation of movement, such vigor, such variety, such natural grace, such powers of endurance, such potency of pattern.

Juba set precedents both for black show business and for the attitudes that would later make jazz what it was: a music ever in pursuit of vigor, variety, elasticity, mutation of movement, and potency of pattern. A music, that is, inclined to infinite plasticity.

Like Juba, the new black show-business people who emerged in the wake of Appomattox had moved beyond the slave condition of prized livestock that provided entertainment: they were *paid*. Audiences could see and hear *them* sing and dance. Though they used the convention of blackface, it was clear to all who paid more than superficial attention that their creative energy was coming directly from the authentic source—the same source the white minstrels themselves consistently recognized. The Negro minstrels took great pride in what they did, and for good reason. The material they performed was almost always their own; they took care with their own self-presentation, crafting individual costumes that conveyed their personalities; and they used their roles to create personal reputations. They wanted to be the best entertainers in the world.

By the turn of the twentieth century, the most ambitious of these performers were setting their sights higher: they wanted to become some of the best artists in the world.

• • •

THE WORK OF the Negro band and private instructors, so important after the Civil War, brought a new emphasis on tone and discipline into music departments and homes. When Negro musicians were well taught, however, they were as often as not removed from the aesthetic bite and the sarcasm of the street life, where ribald satire, as well as the terrors and hurts of life lived hard and fast, found their ways into rhythm and tune. But the unexpected amalgamation of these two attitudes—the discipline of instruction and the salty posture of the streets—led to the creation of ragtime.

Ragtime was a turn-of-the-century craze that went national, then spread through the Western world. At heart it was an extension of Frank Johnson's habit of turning those lovely airs into reels, country dances, and jigs. Initially a sophisticated piano music, ragtime was first performed in honky-tonk situations where Negroes as low as snakes in wagon tracks were the rule—pimps, hustlers, whores, gamblers, thugs, and murderers, either primped up bright and gaudy or as soiled on the outside as they were in their lowdown, froggy-bottom souls—and the music that emerged in their midst was a remarkable combination of high and low. The very fact that ragtime was first played on the piano means that it was a city music, not a collection of rural tunes performed on banjos or guitars by folk musicians.

The ragtime masters brought folk elements to celebratory, highminded refinement by taking tunes they heard in the street and mixing them with the formal elements they had learned from private teachers and in schools. Another element in the mix was the era's marching band tradition—a part of street culture that was as respectable as it was popular—and the pioneers of ragtime borrowed both the exuberance of march music and the form's tra-

ditional three- to four-part structure. Since many of the original ragtime pieces were premiered in the red-light districts, and since the music lent itself naturally to the steps of the cakewalk, it's no surprise that much of the music was marked by a bittersweet joy. Gloom is bad for business and doesn't do much for courtship in the mobile environment of the dance hall.

There's another reason the music was so joyous: it was created in recognition of freedom. Ragtime represented people doing what they wanted with everything they liked and understood. The jaunty rhythm, syncopated and moving fresh ideas about the beat into piano music—the left hand a drum, the right a lyric, breakaway dancer— was not only fine for cakewalking, it was the contemporary myth in action. Slavery was behind Negroes; the cities were ahead, on the horizon, open to them in ways they hadn't been for their chattel forebears. The implications of this newfound freedom of choice were not overlooked or misunderstood by a people for whom choice had been the least available aspect of their experience. And black people in show business drew on that sense of liberation, every chance they could get, to define and direct what they did.

To the musicians, the prospect of available travel was a revelation. Even if the cars on the trains were segregated, that fact was secondary to the excitement of seeing one town after another, smelling the air affected by nature and local industry, hearing the accents of speech as they shifted from one place to another, coming to know the delicious specifics of recipes and seasoning in home cooking, and recognizing the characters of various towns, counties, and states as expressed in the tunes, jokes, and tales. They noticed the ways each town lived one way during the sun's reign and another when the moon, the clouds, and the stars took over.

For these musicians, there were palpable dreams as well as good times to be had, private property, apartments, fine clothes, and

pay—any salary at all, but enough to wish for with all one's might. One has only to look at the photographs of Scott Joplin and the others who wrote the music—at the confidence and mischief in their faces as they pose around a banner heralding their social club, suits and ties pressed, shoes gleaming, heads under derbies cocked at the angle of aristocracy—to see the sweetness of city life as they experienced it.

Like the upbeat movie musicals and screwball comedies of the 1930s, ragtime was welcomed by a public that recognized its national spirit acted out in the music's tartly elegant melodies and banjo syncopations—which had risen from slavery through the minstrel shows—creating that enjoyable tension between the steady and the unpredictable that is so essential to the American soul. It also offered the same kind of antidote to resigned dejection that the popular art of the Depression did. Ragtime was "the gayest, most exciting, most infectiously lilting music ever heard," as Rudi Blesh and Harriet Janis wrote in *They All Played Ragtime*. "When the first instrumental ragtime sheet music appeared in 1897, no costly, high-powered promotion was needed to put the music across . . . and within a year it seemed as if it had always been here. [It] was as healthily overt, as brimful of energy, as the barefoot American boy."

Beneath that energy, though, there was piquancy and pathos. Ragtime was much more than an audible happy pill; at its best, it conveyed messages about standing up to life, taking its indifferent or intended blows, and learning to move forward with the indispensable grace of vitality. In it we hear the realization of folk potential, technical skill, and the technology of the day—the development of material from an oral culture into an art that was thoroughly conceived, arranged, and transcribed for the sheet music

that was increasingly being printed, distributed, and stacked up in living-room piano benches across the country. It became a music for home entertainment in the time before radio, in the days when American music was more like a democracy that was enjoying a high level of active participation.

At the forefront of ragtime was Scott Joplin, born in Texarkana, Texas, in 1868. Joplin, who had shown talent from childhood, took instruction from a German teacher before going out on the road as a teenager, making his living in one bawdy situation after another, picking up every kind of song and fragment of melody or rhythm that was out there, working what he could into his nightly repertoire, and storing away the rest. Joplin's travels foreshadow the life of professional musicians up through the 1950s: "His whole orbit of saloons, honkytonks, pool halls, poor restaurants, and the Forty-niner Camps—the traveling tent shows depicting the California gold-rush life and featuring the cancan dancer and the roulette wheel—was a world near the soil," Blesh and Janis observe, a world where "Civil War songs, plantation melodies, jigs and reels, country dances, ballads, hollers, and work songs were still current coin."

In 1894, after eight years in the ragtime bustle of Saint Louis and one in Chicago, Joplin took a job playing second cornet with the Queen City Concert Band of Sedalia, Missouri, while also playing piano and singing around town. The Queen City Concert Band was known for musically whipping the heads of any Negro bands willing to compete with it—a tradition that echoed the 1845 contest in which Master Juba defeated John Diamond, and that would still be in effect when the musicians who awed Charlie Parker "went out there and sliced up so much ass with that Kansas City swing there was ass waist-deep all over the floor," as Harry "Sweets"

Edison bragged of the Basie band's unfortunate opponents in the rough-riding battles of the 1930s.

Joplin also benefited from the city's culture of early jam sessions, gatherings where ragtime piano players exchanged ideas, fingerings, harmonies, and rhythms, sweating and grunting, or cooling it and slyly smiling, over the keys as they made spontaneous academies of their private moments. Beginning in 1896, Joplin studied harmony and composition at Sedalia's George R. Smith College for Negroes. His own band, and his social position in Sedalia, changed local attitudes toward ragtime; it was clear to those who heard his music, and to those who observed the eggplant-dark, self-assured Joplin, that his example proved the adage, "It's not where you come from or where you learn, but where you go and what you do with it."

The refinement of Joplin's music, and its lyrical celebration of rising above circumstances while retaining its spark, gave his ragtime its impact, in both his original solo keyboard versions and the marvelous full-band arrangements that were soon putting heat on the traditional repertoires of nationally famous bandleaders like John Philip Sousa. Joplin was the first of a succession of pianists who would set standards and aspirations for Negro music as it expanded. His work exhibits a pensive but active melancholy that counterpoints the joy of the beat, a precursor of the double consciousness so fundamental to jazz: the burdens of the soul met by the optimism of the groove—the orchestrated heartbeat, tinkling or percussive.

THE NEXT SIGNAL combination of high and low took place around 1900 in New Orleans, where jazz seems actually to have

been born. The legendary figure who apparently first brought to-gether the elements that became jazz was Buddy Bolden.

In his exceptionally well-researched *In Search of Buddy Bolden*, Donald Marquis describes Bolden in terms that would also apply to the men who made ragtime: "He was born twelve years after the Civil War, and if his mother remembered the days of slavery and the aftermath of Reconstruction, being a little uncertain of just what emancipation meant, Buddy was of a generation that didn't know or particularly care what the rules had *been* and saw life as an open challenge instead of a restricted corridor." Bolden was never recorded, and his legend is at least partially the result of tantalizing stories surrounding the "open challenge" of jazz improvisation and what he did with it.

Bolden became a professional in an era when there was a great deal of tension between the light-skinned Negro Creoles of New Orleans, who were trained in European music, and the city's intui-tive, self-taught "ear" musicians, who made up the core of the early jazz innovators. Bolden himself was one of the so-called "fakers," who would sometimes substitute imagination for memory and who developed a reputation for playing embellishments that struck his audiences as exciting, surprising, and sometimes even superior to the original compositions.

Bolden did more than challenge the primacy of written music. He also pioneered an equally profound revolution by changing the instrumentation of conventional groups, combining elements of brass bands and string ensembles, and reversing orthodoxy by giv-ing the wind-blown instruments the leads and the strings the sup-porting roles. In Bolden's day, the brass bands performed marches and some rags, while the string ensembles played dances and par-ties. Bolden did them all, but he was primarily a leader of a dance

band—smaller than the norm but, by all accounts, possessed of tremendous power. He himself was capable of playing with a volume that not only expressed his passion but also advertised his presence, often "calling the children home" from outdoor concerts where other bands were performing. The strings couldn't project with the power of the brass in those preamplified days, nor had Negro musicians begun to approach their instruments the way Bolden did his cornet, incorporating the vocal intonations of black speech and song, and bringing a moan to his sound on the blues that touched listeners with a power akin to that of church music.

The only known photograph of Bolden shows him with a six-piece group: cornet, trombone, two clarinets, guitar, and bass. With groups of that sort, he worked at remaking familiar material. As Marquis writes, "Given Bolden's personality we can be sure he was looking for a novel approach—something to gain the crowd and sway the applause his way when he competed with other bands. His efforts took the form of playing 'wide-open' on the cornet and of playing in up-tempo or ragging the hymns, street songs, and dance tunes to create a musical sound that people were unfamiliar with."

Bolden was not an immediate success; indeed, at first his new ideas caused friction with other musicians. His "style did not catch on immediately and the Creoles scornfully called it honky-tonk music," Marquis notes. But Bolden's sound "had an appeal, especially to a liberated, post–Civil War generation of young blacks," and Bolden eventually became king of the uptown New Orleans musical scene. He helped set the standards of performance the Creole musicians had to absorb when the Black Codes of 1894 forbade them from performing in the downtown white community, breaking their dominance of the musical jobs across the city.

That edict, an extension of the laws that took black artisans

out of competition in the post-Reconstruction South, had nothing to do with artistic advances. Ironically, though, it helped bring about a new convergence between the music of the drawing room and the sounds of the dance hall. The most popular bands in the lower-class black community were like Bolden's, setting a communicative standard with their hot rhythms and the timeless awe and tragedy of the blues. The Creoles, meanwhile, discovered that their formal training, their "legitimate" techniques, meant nothing to an audience that had grown fond of the guttural lamentations and sensual celebrations of King Bolden. And slowly but surely a remarkable synthesis took place: as the Creole bands migrated back into the black community, and encountered the competition of the Bolden-style black bands, the two Negro classes—long separated by skin-color prejudices promoted in the Haitian community—underwent a gradual musical integration.

The uptown arrival of the Creoles marked the beginning of the transition from ragtime and marching band music to the art later known as jazz. As the sophistication of the Creoles fused with the earthy innovations of form and technique pushed into the air by men like Bolden, the uptown musicians learned in turn from the Creoles—commencing a musical exchange of profound cultural import. Aesthetic integration is what it was; it came through the mutual respect that can happen when people are forced to deal with one another—to like or dislike one another as individuals, not as good or monstrous myths told at a distance.

Bolden's aspirations were not as lofty or wide-ranging as Joplin's; it's a notable democratic truth that it was the Texas honky-tonk piano player who elevated Negro music to new heights of precision. Joplin, who was highly mindful of his artistic individuality, was also one of the many Negro entertainers who counted themselves as members of an elite, who shared the common scars left by their

shared ethnic gauntlet and the satisfactions that came of facing the invisible mystery of music and the human world they traveled through.

And that human world could take its toll. King Bolden became a statistic in the fast life of big spending and heavy dissipation, playing "like he didn't care" and making great demands on himself and his instrument. The strain of playing might have been the cause of the headaches he started to experience shortly before he began to go mad, suffering from advanced paranoia and, later, alcoholism. Marquis concludes, "He took an unrouted, sometimes hedonistic path, and unfortunately he did not have the benefit of learning from others how to handle this situation; no one of his circumstances had been there before." In ways both musical and personal, Bolden was truly a precursor of the young Charlie Parker.

Even before the ragtime craze of the 1890s, Kansas City had been a music town. One of the central hubs of the cattle trade, it was a place where mixtures of taste and passion arrived regularly, and the range of customers demanded that professional entertainers be capable of everything from elegance to sentimentality, from trendy dance numbers to broad humor and stunts. Bands performed outside in parks and at dance halls, traveling in from every direction, succeeding or failing on the basis of whether they got to the feet of the listeners, made those feet pat or do steps. Popular songs, marches, novelties of every sort—including the saxophone player's trick of playing two horns at once—were common to these traveling bands, which played endless variations on the conventions their audiences expected. In such a stratified society, the bands had to be ready to play for tea drinkers in one setting and hooch sippers or guzzlers in another. Their music had to possess a democratic stretch, no matter the color of the players.

When clarinetist Garvin Bushell first encountered the music of

Kansas City in 1921, he had already heard the Chicago work of Joe Oliver and Johnny Dodds, musicians who shook up the jazz world. To Bushell, it seemed as if those early Kansas City musicians were still catching up. "[In Chicago] we felt we had the top thing in the country," he recalled in his memoir, *Jazz from the Beginning*, "so the [Kansas City] bands didn't impress me. It may be, now that I look back, that I underestimated them."

The two godfathers of the Kansas City jazz scene, bandleaders Bennie Moten and Walter Page, are excellent examples of the broad experience, training, and imagination that underlie so much of jazz history. Born in 1894, Moten was a piano player who worked his way up through the broad spectrum of popular music that entertained audiences in the late teens and the twenties. Though he was linked with the blues from the very beginning of his recording career in 1923, Moten was working toward a sound and a beat that evolved with his bands and with the ever-expanding frontier of jazz, where composers, improvisers, and bandleaders were influencing one another almost by the day, in person and through the sheet music, phonograph records, and radio broadcasts that became their common language.

Moten's bands, starting with three pieces and moving up to twelve, detailed the evolution of Kansas City dance music and the arrival of blues as an element strong enough to supplant the sentimental foam of sweet hotel tunes commonly served up for audiences who weren't yet attuned to the swing, humor, and stark feeling basic to Negro art. Yet Moten admired the sophisticated arrangements that characterized the best of sweet music, and he was intent on combining that skill with the sound shaped in the streets and at the Negro gatherings where musicians were starting to adapt the blues shadings they heard in the work of singers like Bessie Smith.

In *Jazz Style in Kansas City and the Southwest*, Ross Russell writes of the kind of instrumental insights that Moten—like all serious bandleaders thinking about jazz—derived from his players:

> The golden link that bound the jazzmen to the blues tradition was the concept of vocalization. When the jazz musician understudied the blues man, observing the great variety of devices at the disposal of his model—vibrato, variable pitch, microtones, fast turns, and the many sliding, slurring, leaping effects—he found it only natural to try to reproduce these efforts on the instrument of his choice, whether it was a trumpet or trombone, or a member of the articulate reed family, the clarinets, alto or tenor saxophones. . . . If the experiments were favorably starred and a right road had been stumbled onto, the jazz musician might arrive at an interesting personal style and one reflecting an accumulation of Afro-American vocal procedures.

Moten's ambition was to assemble a band whose music made it larger than the provinces where it played. At the start of his recording career, his ensembles were clearly influenced by King Oliver, including references to some of the trumpeter's famous improvisations. By the end of the twenties, Moten was reflecting the influence of Duke Ellington, in one case even lifting a riff directly from the Eastern bandleader. This was not unusual: the Midwestern musicians measured themselves against the sounds coming first from the Chicago work of Oliver, and then from the bands in New York, which everyone rightly considered the jewel in the crown of jazz. It was in New York that the complexities and subtleties of show music were combined with the instrumental and compositional innova-

tions of Oliver, Louis Armstrong, Sidney Bechet, and Jelly Roll Morton.

Yet the musicians of the Midwest were doing more than merely aping either the New Orleans musicians or the Easterners. They were nurturing ideas that would reshape the very thrust of the music. Moten was in the middle of it all, struggling upward as his reputation grew, and he became ever more ambitious. In almost every photograph one sees of him, Moten is dressed beautifully; he has the look of a well-fed man enjoying the elevator ride and dreaming of the view from the penthouse.

Moten's archrival was Walter Page, whose band, the Oklahoma City Blue Devils, had developed a reputation by the late 1920s for musically removing the scalps of the opposition and leaving their bodies for the buzzards. Page's background touches on nearly every element in the story of pre-bebop jazz. He studied under Major N. Clark Smith at Charlie Parker's Lincoln High School; Ross Russell reports that Page switched from bass drum and bass horn to string bass at Smith's suggestion. Russell also says that it was after hearing Wellman Braud's powerful bass tone, during an engagement of the Elks and Shriners Circus in Kansas City, that Page had a kind of epiphany about the instrument's potential. He went on to gain a degree in music from the University of Kansas in Lawrence, a city that had been burned to the ground by Quantrill's Raiders during the days of the Civil War renegade. Page was a student not only of the bass fiddle but also of piano, voice, violin, composition, and arranging.

By the time Page got to Oklahoma City, he had already spent time on the road, alternating between tuba and bass but also playing baritone saxophone and sousaphone. Intrigued by the challenge of how to use the lower reaches of sound in a jazz band, he was working on a beat that would change the pace of jazz time,

one removed from the windblown percussion of the brass band yet capable of bringing fresh harmony to the percussive thump so fundamental to jazz.

When he joined the band that eventually became Walter Page's Blue Devils, the bassist's conception began to crystallize. Supplementing the band with an array of talented players—Buster Smith on alto sax, Hot Lips Page on trumpet, Eddie Durham on guitar, Jimmy Rushing on vocals, and Bill Basie at the piano—Page surrounded himself with musicians who were both trained and natural talents, players whose experience included blues bands, theater bands, tent shows, minstrel units, circuses, and every possible situation where music, dance, humor, the exotic, and the mysterious were welcomed, south to north, east to west. Basie told Jo Jones that he had prepared as a straight man for Jelly Roll Morton in a vaudeville number. It was like that.

With the Blue Devils, Page managed to close in on what he had to work out on his own, since there wasn't yet any tradition of using the bass the way he wanted to play it. He knew that the percussive qualities of the usually strummed banjos suggested a blend of percussion and harmony; big enough to handle the string bass, Page had an ingenious sense of the new beat needed to melt the pulse from, perhaps, a fervent stiffness into what would be known as the relaxed heat of Kansas City swing. That would come once he had taught enough players what he was hearing. The man had a vision of the rhythm section as a unit whose capacity went beyond what the piano, banjo, tuba, and drums contributed to the New Orleans sound. The rhythm section had to be *balanced*. It had to phrase with an even feeling that simultaneously anchored the tempo while creating a forward pulsation. Then the swing of the horns would be coordinated with the percussion and the percussive harmony of the rhythm section. A sound like that would be a good weapon in

the dance-band battles of the 1920s. Slick, big-boned Bennie Moten knew that was the way to go if he had the choice and the luck to find the musicians who felt what he knew would work, what would lift the bandstand through the roof.

By the way, Mr. Moten declined to be bloodied by those damn Blue Devils in a battle of music. Oh, no. Instead, he acted on an old show-business adage: *If you can't beat 'em,* hire *'em.* His efforts to lure musicians away from the Blue Devils were helped along by the downward economic rush of the Great Depression, which led to the collapse of many venues. As with the fall of the manor system that led to the rise of the city-states in Europe when the serfs and the vassals left, taking their skills to town, the Depression intensified the overall quality of music in Kansas City. Many of those who'd been whipped down by the road, and by the lack of money in so many other towns, came to Kansas City, where there was plenty of work and the party refused to stop. Bennie Moten was proof of that. He had engagements, fine clothes, and recording contracts galore. All you needed to do was let old Bennie know you were ready to step into some success, and if he liked the way you played, you had it made.

Once the Blue Devils started to defect, an important fusion took place. It would remake Kansas City jazz. Basie told Albert Murray about what he, Rushing, and Durham were looking to transplant into Moten's band:

> After Jimmy had been in the band for a little while, he and Eddie Durham and I started a little more larceny [trying] to get Lips Page in that trumpet section. We wanted somebody in there to play the kind of get-off stuff we felt we needed for the new things we were adding to the book. Of course, before Eddie and I began bringing in our arrangements, that band had

its original Kansas City stomp style. It had a special
beat, and it really had something going. . . . I really
don't know how you would define stomp in strict mu-
sical terms. But it was a real thing. If you were on the
first floor and the dance hall was upstairs, that was
what you would hear, that steady *rump, rump, rump,
rump* in that medium tempo. It was never fast. And
you could also feel it. . . .

But it was not the kind of jump band or swing
band that the Blue Devils band was. The Blue Devils'
style was snappier. They were two different things,
and we wanted some of that bluesy hot stuff in there,
too. So we needed Lips, and Bennie brought him in
for us. . . .

With that four/four beat undergirding it all, Moten's latest band
started developing a new approach based on spontaneously gener-
ated riffs. One player—often it was the dependably inventive Hot
Lips Page—would initiate a propulsive, memorable phrase, which
would then be picked up by the entire trumpet, trombone, or reed
section. That, in turn, would be countered by riffs from the other
two sections. This layering of riffs gave the music a polyrhythmic
quality, as if the entire band were one big set of tuned drums. It was
something like a large ensemble version of the old New Orleans
front line of trumpet, clarinet, and trombone, with the phrasing
stripped down for another kind of thrust and momentum. Because
the riffs were so often improvised, they functioned as spontaneous
elements of support—spur and saddle alike for the cantering or
galloping improviser.

Oliver Todd remembered the thrilling effect of a riff, the incre-
mental power it took on as a simple set of notes traveled from one

person to the next at an early morning jam session, changing gradually with each new chorus. "It is a feeling that you build," he said. "You build and keep building. Guys coming in from one o'clock and building that riff, drummers changing, and that riff still goes on. It might hit some moments where it might diminish, but then there's a certain surge and that starts it up again. Just along about two o'clock, it's still winding up and it's still going strong. It's more of a true feeling of music. It's simple. It's just whole, natural, spiritual, building up—*jam*, flow, and somebody is always supporting it."

Then there was the innovative style of bass that Walter Page finally pioneered. Page jettisoned the tuba that was still often heard in bands of the time, replacing it with his string bass and working out a two-bar, eight-beat rhythm cycle in four/four (1-2-3-4-5-6-7-8) that gave the time a flow that bass players use to this very day. This new rhythm removed the earlier music's feeling of choppiness, allowing the pulse of the rhythm section to breathe every two bars, switching gears on the ninth beat to start the cycle again. Along with Basie, drummer Jo Jones, and eventually guitarist Freddie Green, Page forged the self-orchestrating ensemble-within-an-ensemble that is the jazz rhythm section. The development of the improvising rhythm section separates jazz from both African and European music, because the form demands that the players individually interpret the harmony, the beat, and the timbre while responding to one another and the featured improviser. To play such music demands superfast hearing—a component of genius that is one of the greatest stands against the mechanization of pop music, in which the players send in their parts to be mixed by producers and engineers.

And yet, as original as the Kansas City and Oklahoma City musicians were, they still drew on the basic model of New Orleans, just as countless works of Western literature have drawn on the

complex situations and the search for home drawn so indelibly in the *Iliad* and the *Odyssey*. In Hot Lips Page, one heard King Oliver, Bubber Miley, and Armstrong clearly; in Lester Young, the Armstrong of "Mahogany Hall Stomp," floating beat and all, was personalized and passed on to younger players—notably to Eddie Barefield, whose alto saxophone improvisation on the 1932 "Moten Swing" must surely have touched Charlie Parker. With its crooning and shouting, its speechlike phrases and unexpected runs up to wailing ends, Barefield's feature sounds like a primitive version of what we would come to hear from the younger man. And Charlie Parker was also taken by Buster Smith, the alto saxophonist, clarinetist, and arranger, who was prominent in the Blue Devils when Young was there, and who eventually found himself in blues-based cahoots with Basie coleading a band at the Reno Club—after the shocking 1935 death of Bennie Moten that followed the collapse of the Blue Devils.

IN 1936, WORD finally got out about Kansas City.

By then, Tom's Town was so thick with musicians it caught the fancy of one of the princes of the East Coast recording industry: professional jazz hound, record producer, critic, and promoter John Hammond. While driving through Chicago in a car whose radio had been wired to pick up waves from great distances, Hammond had heard Count Basie broadcasting from the Reno. The swing caught his ear as something unlike anything in New York. As he wrote in *Down Beat* that September, the experience flipped his Vanderbilt wig.

In the article, headlined "Kansas City: A Hotbed for Fine Swing Musicians—Andy Kirk & Count Basie's Elegant Music Spoils City for Out-of-Town Name Bands," Hammond raved about the city and

its musicians: "Descriptions of the place as the hotbed of American music are in every way justified, for there is no town in America, New Orleans perhaps excepted, that has produced so much excellent music—Negro, of course." Hammond couldn't believe that so much talent could be found swinging and shouting in one place outside New York. His public proclamations sent agents and producers scurrying to Kansas City the way oilmen had hit Oklahoma at the turn of the century. Suddenly, white men intent on finding new black stars for the sky of success were going from one joint to the next, collaring musicians, plying them with promises and watches and pulling out exclusive contracts.

In 1936, Charlie Parker was working with Oliver Todd's orchestra, but he wasn't yet on anybody's list of potential new stars—not Hammond's, not even Kirk's or Basie's. His problem wasn't weighing competing recording contracts but screwing up his big chance with a collapsing saxophone.

Somehow, sixteen-year-old Charlie had lost the screw that held the neck of his saxophone in place atop the long, curving body of the horn, and for some reason he refused to replace it. While he was playing with Todd's band at Frankie and Johnny's, the neck would slip away from his mouth as soon as he finished a solo or a riff, the mouthpiece flapping back and forth like the waving tail of a moo cow. Kinky, the Italian who owned the joint, was infuriated by the spectacle and told Todd he should fire that guy—first because he couldn't play, second because he didn't have respect enough to fix his saxophone. When Todd passed on the complaint, Charlie replied, "You want to be my daddy? Well, why don't you go and get it fixed?" The owner refused to pay Todd for the sorry saxophonist, so the bandleader had to split his salary with the young knucklehead.

At first, Todd refused to fire Charlie over the missing screw, on the principle that no one should be able to tell a musician whom

to hire and whom to fire. Eventually, though, Todd decided to let Parker go, caught between an angry club owner and a sideman who wouldn't even help the situation by getting his horn fixed. If he was determined to play by his own rules, he would have to bear the consequences. Charlie's friend Robert Simpson, who had been ill with pneumonia, rose from his sickbed and took a streetcar across Kansas City to reason with Todd. "Please don't get rid of Charlie Parker," said Simpson, shivering with his illness, his eyes shining and inflamed. "Charlie Parker is going to be a great musician. Charlie has an inferiority complex. He can play."

A few days later, Robert Simpson died.

Charlie Parker had lost his closest friend. No longer would he have someone to talk with the way he and Robert did, to suffer the embarrassment of being thrown off bandstands together, to work out new chords at Lawrence Keyes's house, to share experiences in the Deans of Swing like two peas in a pod, as they were frequently called. Simpson gave him the feeling of having an older brother, in spirit and ambition. Charlie was a pallbearer at Simpson's funeral, which took place in the rain.

For Charlie Parker, confronting Simpson's death was like drinking a cup of blues made of razor blades. People who knew him at the time remembered Charlie suffering profound grief; for quite a while he seemed lost, alone out there with his ambition, struggling for recognition in a music world not yet hospitable to him. "That tore Charlie up," Lawrence Keyes recalled. "He and Charlie took to each other, and Charlie had a lot of trouble getting over that, a lot of trouble."

Rebecca never even knew that Robert Simpson had died—not from Charlie. He was strange that way, closemouthed. No one knew what he was thinking, what he was feeling, not if he didn't want them to know. And if what you were saying to him didn't keep his

interest, he would just walk away. Sometimes, when he did that to Rebecca, she would follow him and ask why. "You ain't saying nothing," he would reply. "Why should I stand there and listen to it?" He could be nice to her, too. But he still slept downstairs, and at night he still went out with his saxophone, that same old raggedy Conn that Addie Parker had bought him at the pawnshop. Ma Parker may not have known much about saxophones, but she was still committed to making life as pleasant as possible for her son. If it got to the point where he needed more in the saxophone department, his mother would figure out how to save the money that was necessary.

Perhaps Charlie's strange behavior was as much a response to Simpson's death as it was to the "cure" Addie Parker cryptically referred to after Rebecca found him tied up in his bedroom. Things were going bad for him in a number of ways; young Charlie was at risk of buckling under the weight of his disappointments and his shocks, the rejection of his fellow musicians and the sharp, metallic loss of such a close friend so soon. And his musical aspirations still seemed out of reach. "At that time, Charlie Parker was trying to work up on something," recalled his friend Clarence Davis, "but he didn't know what he was doing. He was fishing, but nothing was biting."

Even so, Charlie kept going out into the Kansas City night of affirmative blues and swing. The music was a refuge, a world of memory and dreams, a field of aristocrats, of aesthetic wizards and sorcerers' apprentices. One of the places he went was the Reno Club, on Twelfth Street and Cherry. It was perhaps fifty by one hundred feet, with a fifteen-foot bar to the left as you came in the door, then tables on either side. Beyond that was a small dance floor, with a gallery overhead for those who wanted to party and drink above the flow of customers, music, and hustlers. At the end of the room was the bandstand, and behind it a door that opened

into a yard where prostitutes sat on benches in the summer, waiting to be called into action by a pair of code words: "walk one" meant there was a single john looking for action, while "walk two" signified that there was a duo ready to slump into what might be some polluted pudding.

The house band at the Reno was Count Basie and His Barons of Rhythm. With the exception of Carl "Tatti" Smith, a former member of the great Texas band led by Alphonso Trent, the musicians were the best of the warriors from the Kansas City–Oklahoma City battles of music, veterans of Bennie Moten's Orchestra and the Blue Devils: Oran "Hot Lips" Page and Joe Keyes, trumpets; Buster Smith, alto and clarinet; Lester Young, tenor; Jack Washington, baritone; Walter Page, bass; Jo Jones, drums; and, on piano, Bill Basie himself. Basie led the band without ever mentioning it; his direction was clear from the moment he landed one of his unforgettable piano introductions—sometimes giddy, sometimes insinuating—and followed it with a series of hot, well-placed chords and riffs, provocatively fine stuff to build an improvised dream on. He and the band were *in there*, swinging all night, playing for the featured dancers, sailing and stomping along with the excruciatingly clear blues and the ballads sung by rotund Jimmy Rushing, taking breathers and laughing when the comedians were on, and waiting for the end of the job, when the jam sessions would start at the Reno, then move to the Subway or the Cherry Blossom.

During breaks, the band cooled it in the lot behind the club. Basie, Young, and Jones engaged in a lingo they had developed that no one else understood. Others nearby took nips, smoked cigarettes, wandered somewhere to light a reefer, joked with the whores, talked shop about their instruments—new refinements and mouthpieces—admired a suit, a pair of shoes, a tie, dreamed of futures in music, recalled some incident from the days of the

Blue Devils or Bennie Moten. To younger musicians like Charlie Parker and Robert Simpson, Count Basie and His Barons of Rhythm were symbols of glamour and victory. Everything they did, no matter how simple, had the glow of authority. Those men had been around, had proven themselves out on the road and up on the bandstand. They made that lot and those benches, the cigarettes they smoked, the liquor they drank, the clothes they wore, the colognes they rubbed on, and the instruments they played all part of a myth turned radiantly active through their music, which they summoned into the air with consistent confidence.

Silent but observant, Charlie hung around the yard behind the club, his horn in a sack, his appetite staved off by chicken from one of the local chuck wagons. When his nerve was up, young Charlie would cadge a cigarette and stand off to the side with his hand in his pocket, one leg forward and bent a little, trying to give off the look of an older player swimming deeply but easefully in the nightlife. He spent many a night at the back door listening to the Basie rhythm section's superb introductions, to the blend of the saxophones, the stinging brass.

Blues was the lubricant that opened up the music. It let you get the feeling in. Lips Page could speak blues words with his trumpet, chorus after chorus, covering the bell with his hand for more precision or with a glass to color each note with expression. Buster Smith rambled over his alto, quick and deceptive, then pushed forward moans that called up melody with a personal but clarion lyricism. Lester Young had an odd sound, part light, part dark, and could work his notes with the skill of a pitcher who could land the ball anywhere he wanted within the strike zone. Jack Washington's baritone was a dancing bull ever ready to bloody its horns. Often placing the blues in the foreground, sometimes letting it

play in the shadows, edging the sound of a popular song, the band gave Charlie lesson after lesson. It was always graceful, easy in the rhythm, capable of cheek-to-cheek romance, a smoldering lope, or the running joy of an up-tempo celebration. Yet the celebration was always tempered by the shocks of the piano chords and the smacks of the drums, the odd yelp of a horn, the blue pinch that was always in the story, no matter its exuberance. Basie's music traced the roller-coaster fate of the human heart: rising high, falling low, singing, joking, sobbing, reminiscing, dreaming, cursing, bragging, praying. Everything was *in there*.

Charlie was simultaneously awed and inspired by what he heard. He came every chance he got, staying through the night when he wasn't working a gig of his own, or heading over immediately after he got off. Sometimes, he was found sleeping in the yard come early morning after the jam session was over, having succumbed to fatigue while listening. Eventually he became recognized as a regular, sometimes seen coming through the front door in the company of a young white piano player and sitting down before the band with his horn, as if he was hoping to be invited to play. Everyone knew who he was.

No one ever invited him to play.

The early-morning Reno jam session was the big time, and if you weren't ready, you didn't come expecting to do anything more than listen. It was highly competitive, a place to out-think, out-execute, and out-swing the opposition. This, as Ralph Ellison has pointed out, was the jazz musician's "true academy," where the novice learned his trade, developed the ability to negotiate various materials, adjust to the beats of different rhythm sections, manipulate the harmonic demands of unfamiliar keys, and eventually take a position as one of the professionals, a player whose individuality

and flexibility combined for an artistic personality worthy of serious consideration.

Gene Ramey was there on the night in the summer of 1936 when Charlie Parker finally made it up onto the bandstand. The bassist had come to the Reno with Margaret "Countess" Johnson, a piano player and rival of Mary Lou Williams, who—with her almost roughhouse virtuosity, her intelligent compositions, and arrangements—became the extremely beautiful, dreamy-eyed brain trust of Andy Kirk and His Twelve Clouds of Joy. Ramey loved going to the Reno jam sessions to watch the masters at work, to see them demolish musicians from out of town, black or white, famous or not. Sometimes Ramey's mentor, Walter Page, would say to him, "Baby, come hold my bass." Then Page would tell Basie to kick something off in the key of C, forcing the terrified Ramey to play. Then, afterward, Page would give Ramey pointers, explaining how to shift the flow of the beat, build tension, relax it, how to work under an improviser, spark him, seek an even beat to fit with the drums and fill the space between the drummer and the piano. Ramey took in everything Page said, but he was glad when he got off that bandstand. It was too hot up there, and those guys—if they had blood in their eyes—would run through the keys on you without mercy. "You'd have to be ready," he said. "Because they're not going to wait and give you a chance to brush up on this thing."

One of the most popular musical venues of the era was *The Original Amateur Hour*, a nationwide radio broadcast hosted by a music promoter known as Major Bowes. If you did well on Major Bowes's *Amateur Hour*, you got a prize; if not, however, they let you know by whacking a gong or ringing a bell—a gesture that got picked up and turned into verbal and musical slang in the jazz world of Pendergast's stronghold. "We got so in Kansas City that even if you were talking and you said something that I didn't believe," recalled

Ramey, "I would say, 'Ring the bell.' That means I'm telling you that I think you're lying. And so we had that thing in playing. If a guy wasn't playing too much, or their beat was goofed up or something, you'd ring the bell." At the Reno, Jo Jones would hit the bell of his cymbal—*ding, ding*—to tell a novice to back down and try on another night. It became a source of suspense: would you or wouldn't you get the bell?

And so it must have been for Charlie that night when he went up there with Gene Ramey and Countess Johnson looking up at him on that bandstand, where the blood of the vanquished flowed when drumstick hit cymbal. He was a skinny teenager with a horn held together with rubber bands and cellophane, and he was surrounded by men twice his age or more. They were merciless, and they didn't mind making you look like a fool. If you didn't know what you were doing, you might be force-fed a lesson that would make you sick to your stomach. No matter how much you had practiced, the only thing that would save you was functional knowledge. Things you practiced alone wouldn't necessarily work in the mobile situation of the improvising band, where coordinated call-and-response was all. But come soft praise and acceptance, or jeers and disgust, he was up there, and the only thing to do was play.

The instrument seemed heavier, the reed almost the size of a tongue depressor, the buttons on the keys slippery. He could feel his every breath, almost the flow of his blood, the indifferent presence of his nervous system. It was warmer on the bandstand, the lights and the shadows more intense. Everyone seemed to be staring at him, looking at no one else. What tune would they call? Would he know it? He knew he would know it. Would they give him any mercy? He didn't *need* any mercy. He'd listened to them plenty. He was sweating. Everyone was relaxed except him. They were smiling. Were they laughing at him already? His stomach was

fluttering. It was hot up there. What tune would they call? He knew better than to suggest something. You didn't do that, not unless they asked. Why would they ask *him*? All he could do was wait, every sound in the club, every color, every smell more vivid than he had ever known. It was a long, long wait. Then they called the tune and he was in the middle of everything, the piano vamping in the song, the bass humming out the harmony, the drums setting a pulsation of metal and skin. He knew it! He knew the key, too. Charlie could hardly hold himself back. This evening he would get it right. This was it. Now was the time.

But it didn't come out that way. The boy wanted to blow, but instead he blew it. "Bird had gotten up there and got his meter turned around," Ramey remembered. "When they got to the end of the thirty-two-bar chorus, he was in the second bar on that next chorus. Somehow or other he got ahead of himself or something. He had the right meter. He was with the groove all right, but he was probably anxious to make it. Anyway, he couldn't get off. Jo Jones hit the bell corners—*ding*. Bird kept playing. *Ding. Ding.* Everybody was looking, and people were starting to say, 'Get this cat off of here.' *Ding!* So finally, finally, Jo Jones pulled off the cymbal and said '*DING*' on the floor. Some would call it a crash, and they were right, a *DING* trying to pass itself as under a crash. Bird jumped, you know, and it startled him and he eased out of the solo. Everybody was screaming and laughing. The whole place."

Humiliated once again, Charlie walked casually over to sit with Ramey and Countess Johnson, his face a mask of coolness fighting to hold back the frustration.

"You got ahead of them," Johnson said to Charlie.

"Yeah, I got messed up. I just ran my cycles wrong, and I must have rushed it or something."

"We've got to get with that," said Ramey. "But above all, you've

got to stop playing like you're so anxious, because if you're so anxious like that you're sure to get ahead of them."

"It's all right. I'll be back."

But Charlie Parker didn't come back—not for a long time, not until he was sure he would never be so wrong again.

SOMETIME DURING THAT summer, Charlie later told John Jackson, he had a breakthrough. One night, as he was listening to Lester Young jamming at the Subway, he began to understand what the tenor saxophonist was doing, and he broke out into a cold sweat. From that point, Charlie Parker came under the sway of that tall, light-skinned man, who held his horn out to the side and pumped his ideas into the air of his usual job, at the Reno, and from there to the nation at large.

Born in Woodville, Mississippi, on August 27, 1909, Young was part of a cluster of Virgos who created the environment that inspired or supported Charlie, including Addie Parker (born on August 25), Buster Smith (August 24), and Chu Berry (September 13). In Kansas City, Young was the local demon, a handsome and easy-speaking man whose style was individual to the point of sedition. Not for him the brusque call of Coleman Hawkins, whose vibrato bristled gruffly against his tone. Hawkins had developed a distinctive, arpeggiated style after he heard the piano of Art Tatum and realized the breadth of harmonic color that broken chords could give to the saxophone. Though the thrust of Hawkins would rise into Young's music every great once in a while, he had something else going on in his mind; drawing on influences quite different from those Hawkins put together, he arrived at an approach that liberated the spirit of his imagination.

Young's attitude toward the tenor saxophone was an example of

the democratic freedom artists took while on the aesthetic frontier of the 1920s, when everything American touched everything else, sticking or seeping in and inflecting the personal style of any musician who was talented and willing. Jazz musicians, like their counterparts in the other aesthetic arenas of the period, were working to develop a common language of technique and style that could serve as a vehicle for individual expression. Though the richest and most charismatic synthesis came from the Negro community, no one spent much time worrying where something came from if it worked as a compositional device, added tang to an arrangement, or showed you something about your horn. For all the regional pride that is so essential to the story of this country, no one seemed overly concerned where the raw material came from—the north, the south, the east, the west, the academy, the street, the social palaces, the ethnic provinces—as long as it sounded good.

As a result, the aesthetic parentage of early jazz was as complex as the miscegenated identity of the flesh-and-blood culture. Musically speaking, an artist could have a Negro father, a white mother, a Negro sister, a white brother, and cousins who were Christian, Jewish, Indian, Italian, Irish, and so on. The phonograph was particularly important in closing the gaps among regions and races, and a number of Negro saxophonists—like Young's early running buddy, Eddie Barefield, and Buster Smith, his fellow Blue Devil—listened closely to the recordings of Frankie Trumbauer and Jimmy Dorsey, each an important figure during the pioneer days of reed mastery. This was one of the first moments since the advent of printed books—and, later, newspapers—when a new technology offered a wide audience equal access to information. Logic, sensibility, and technical skill took precedence over social or racial differences.

Lester Young—a light-skinned Negro—took the smooth tone of

the C-melody saxophone as played by Trumbauer—a white man with Cherokee blood—and remade it into a sound of deceptive understatement. Himself a dreamer, Young heard in Trumbauer something kindred to his own preference for a world of romantic fantasy and joyous humor. Yet that wasn't enough for Red Young either. He took Trumbauer's high-minded timbre and used it to serve up the low-down options of the blues. Fusing that tonal color with his greatest influence—the floating swing and melodic logic of the most liberated and daring Louis Armstrong—the tenor man with the light sound gave birth to an approach of chameleon plasticity and cool elegance. Stubbornly unique, Young was a melodist partial to shock effects: sudden descents into the lower register; repeated single notes given melodic variety through alternate fingerings that switched around timbres; slithering ideas that arrived in phrases of unpredictable lengths; maneuverings of tonal color for drama; rhythms that jumped inside the beat or held it at bay to create exquisite tension, until the suspense was released with a sweep of lyric defiance or jest or dreaminess, often bowing out with a muffled howl of ambivalent passion.

Young had plenty of road dust in his memory by the time he became the central saxophonist in Kansas City. Reared in Algiers, on the West Bank in New Orleans, he had heard jazz when it wasn't yet twenty years old, listening to the street bands as he passed out leaflets for upcoming appearances. His father, Willis, led the Young Family Band, with Lester playing drums before he switched over to saxophone. They traveled through the South and through the Dakotas, Kansas, Minnesota, and Montana, performing with circuses, on fairgrounds, at dances. The repertoire was popular songs, waltzes, jazz tunes, and blues. Even in short pants Lester was a musical battler: one veteran remembered him bloodying an equally young Louis Jordan, and another saw him jump up on a

bandstand to show up a cousin, who had to be restrained from leaving bruises on his young antagonist.

In 1928, Young joined Art Bronson's Bostonians. He started on alto but went to tenor, he later claimed, because the band's regular tenor player was always holding up the band by taking his sweet time before a mirror, primping almost to prissiness while souring everyone else to the edge of murder. The deeper and broader voice of the tenor immediately appealed to Young, and the style he'd been cultivating—one rooted in swift execution—became an alternately startling and mellow approach on the throatier tenor horn, one wielded so inventively that Young baffled almost all comers in jam sessions, their dreams smothered with transcendently songlike passages the whores called "silky saxophone." His tone replaced the conventional vibrato with a sound like a light streak; a sense of rhythm that stuttered, balked, and swooped unexpectedly; and a decidedly melodic imagination.

In the late 1920s and early 1930s, Young divided his time between Minneapolis and Kansas City, playing briefly with Walter Page's Blue Devils, King Oliver's band, and, briefly, Count Basie's first band. He was often seen roaming the streets of Kansas City, long after dawn broke, in the company of fellow tenor saxophonists Ben Webster and Dick Wilson. Carrying their instruments like rifles—the necks crooked over their shoulders, the body held in one hand—they were constantly on the lookout for another place to go and do battle with their musical imaginations, blowing to goad and challenge, inspire and devastate. There was only one rule: however hot and sparkling one of the others played might be, you couldn't imitate it. You had to find a way to make it a part of your own identity.

John Hammond heard Young in 1934, when the jam session

demon came east to replace Coleman Hawkins in Fletcher Henderson's band; the producer sang Young's praises to Henderson, but the saxophonist was rejected by his fellow band members, none of whom seem to have recognized that his style represented a new—and extremely good—development in the horn's power to project feeling. Henderson, brilliant and well aware of Young's talent, wasn't strong enough to back the tenor saxophonist against the protests of his musicians and those of his wife, who got the new man out of bed every morning and played Coleman Hawkins records for him, hoping to remedy what she considered the repulsive lightness of his sound. Henderson was said to have tears in his eyes as he reluctantly agreed to push Red out of his band, but even as he did, he insisted to his bandsmen that the tall, yellow, soft-spoken tenor player was the best musician among them.

Young returned to the Southwest, to Andy Kirk's band and then back to Basie's, dejected but still in possession of his individuality, uncompromised and ever ready to speak and swing his piece in his own way. He quickly became the lead demon among the Kansas City musicians, one of the warriors who lay in wait for traveling jazzmen to appear in town expecting to get through a jam session without losing slices of scalp and butt to the locals. Young's position was determined by the steadiness of his imagination. The longer he played, the better he sounded. His ideas didn't stop. They were fresh and aesthetically waterproof. Lester Young was not a man successfully pissed on; he'd cut your head for trying.

As the mystery of Young's style began to reveal itself to Charlie Parker, he began to conceive a new set of goals for himself. Not only would he have to get command of harmony and tempo, he would also have to reach for the level of fluid expertise Young exhibited night after night, jam session after jam session. Charlie

couldn't quite have broken through the code of Young's playing just by listening to him on bandstands—he would certainly have known the tenor player's records with Count Basie—but he would have recognized the older player's taste for long melodic lines, the linear inventions that gave lyric quality to his playing. The shape of Lester Young's playing would have a formative effect on Charlie Parker's work.

In its own swinging way, Young's style was a compelling saxophone variation on the legendary improvisations of Louis Armstrong, recordings Parker had been hearing coming out of windows all over his neighborhood since childhood. Those Armstrong records formed an accumulative epic of the imagination; musicians thrived on their ideas, lifting them for their own improvised features, slipping phrases into their arrangements, and emulating their rhythms in order to arrive at the nub of swing.

Eddie Barefield, who worked with Young as part of a two-saxophone band, recalled how profoundly those three-minute recordings could inspire even the most idiosyncratic musicians. Barefield and Young traveled around the Midwest playing dances, with one of them improvising while the other sat nearby, keeping time and stomping out the rhythm. Many have noted how much Lester Young absorbed from Bix Beiderbecke and Frankie Trumbauer, but Barefield remembered that something else was just as important to his partner: Young had learned the Armstrong improvisations from the Hot Five and Hot Seven recordings of the twenties, and he was also taken by the melodic majesty of the records Armstrong made in the 1930s, when he started expanding the jazz repertoire by appropriating Broadway tunes. Charlie Parker may not have recognized Young's connection to Armstrong's work, but he certainly noticed the rhythmic fluidity of Young's tenor.

After a Halloween dance in 1936, Count Basie and his band left Kansas City on a series of jobs that would lead them, permanently, to New York. Their time as regulars in the sin-for-sale kingdom of Pendergast was over. It was a turning point for Charlie Parker: no longer could the young saxophonist listen to his idol on the bandstand at the Reno Club or in those relaxed but electric after-hours jam sessions, picking up a scrap of music here, a scrap of music there. He would never have the moment of direct communion that fellow saxophonist Frank Wess did a few years later in Washington, DC, when he and a buddy went to Young's hotel to pay their respects—and were called up to his room, where the tenor saxophonist greeted them in his long underwear, hat atop his head, cigarette case filled with reefers, and his horn out. As the young musicians sat rapt before him, Lester Young shared a lifetime's worth of lessons: alternate fingerings, breathing techniques, advice on tone production, the great man a light-skinned oracle right before them.

No, none of that for young Charlie. His unrequited apprenticeship ended when Basie took Pres off to New York City. He would have to find another mentor.

Around this time, Charlie Parker secured a place in another Kansas City group. Trumpeter Clarence Davis—who would later run an after-hours situation in his home, complete with whiskey and gambling—was a running buddy of his at the time. "When I first heard Charlie Parker, we were both working in a WPA band," he recalled. "He had got a union card through old man Simpson, Robert Simpson's father, who also played the trombone." For Charlie and Clarence, any gig was welcome. "But since it was a government band, the money would stop and go. They'd have a contract for so much time, and you played, then you'd be off. It was unpredictable."

In the fall of 1936, Charlie and Clarence headed east from Kansas City with the band to play at a club called Musser's Ozark Tavern, part of a resort complex owned by Clarence Musser, whom Davis called "one of Pendergast's henchmen." The tavern was "a drive-in thing," he recalled. "They had little castles where you go to fuck, and [they had] a tavern or something in the middle of it."

The band was slated to play Thanksgiving, and it was snowing. "The car that Charlie Parker was riding in was behind us," Davis recalled. "I was riding with Musser in a Cadillac, and the bass fiddle player had a little old Chevrolet following us. We hit a little spot of ice, and the car slid like crazy. I looked back and I said, 'I sure hope they don't put on brakes.' Just as I said that, the car hit that ice and did a tumbling thing. That car rolled over like a toy and rolled up an embankment."

It was a bad accident. "Charlie Parker broke his ribs and broke his saxophone up. Another guy, Ernest Daniels, he busted his drums all up and broke his ribs." But the worst of it was reserved for the bass player and bandleader, George Wilkerson. "That guy that owned the bass fiddle, the neck was laying across his head; he was asleep. Just broke his neck and killed him."

The mess was cleaned up, courtesy of the Kansas City machine. "Old man Musser gave us all a couple of hundred dollars, paid for this guy's burial, paid for his car, give his wife a car, and made the insurance company give everybody two or three hundred dollars, too. . . . Pendergast was in power then, and they could bend things the way they wanted them bent. It was a lot of money to us, but wasn't nothing to them."

Rebecca heard about the accident when the hospital called, and soon Charlie was home again with his ribs taped up. That was when he started sleeping with her again upstairs. He sat up at home all the time, smoking some stuff she found in a bag. Smelled like burnt bacon. Rebecca didn't want none of that. He could have it. But he was back, and they were in love . . . and as soon as he got better—thanks to the attentions she and Addie and Marie and Hattie Lee were lavishing upon him—he was back up and out the door, off to play that music.

Charlie and Clarence Davis worked Ozarks jobs all winter. "We had

a nice little swing band," Davis recalled. "Nothing but a small combination. Me on trumpet, Charlie, Ernest Daniels, a woman piano player who was an older person, and a bass player. When we come back after the accident, Musser bought us a big old seven-passenger car to go back and forth from Kansas City to Eldon, Missouri, on the weekends, which is when we worked. We played from eight o'clock to about eleven or twelve, dependent on how many people were there.

"We had everything we wanted down there, beds to sleep in, a stove, plenty of food. We didn't want for nothing. We slept in one room, in bunks. The woman played piano slept in a room by herself." Whatever Charlie was smoking back at home with Rebecca, in the Ozarks he seemed to be living clean. "Charlie couldn't have been on that stuff then because there wasn't no way he could get it. That had to be later, after we come back from there." Even to a friend like Clarence Davis, he was something of a cipher. "Charlie was very quiet, didn't have nothing to say at no time, unless you were very close to him. He was never talkative or nothing. Only time he talked was when he picked up his horn."

IT WAS EARLY afternoon on Monday, April 6, 1937, and the sun was still high in the sky of Kansas City, Missouri. Charlie Parker's new alto saxophone was in the soft blue terrycloth drawstring bag, downstairs on the piano bench in the parlor, next to his mother's room, where he always left it. In a few hours he would be walking up the street to get a ride back to the Ozarks, where he worked from Monday through Friday night. But at that moment Charlie Parker was climbing the stairs to see his wife of nine months. She was slim, golden and beautiful, with long, heavy brown hair, her still-adolescent but maturing features enriched by a heritage that was part British, part Indian, and part American Negro.

He opened the door to their room, which contained a big brass bed, a light oak dresser against the right wall, and an adjustable mirror with tie racks on either side. In the center of the room was a potbellied stove, small but strong enough to heat the room. When it was winter, the head of the bed was pointed south, toward the stove, but in spring, summer, and fall it was pointed north. Rebecca, whom he also called Suggie, was lying on the bed and looking out the window at the sun, which was still heating the pleasant breezes of April. He crossed the room and lay his body next to hers, but with his head at the foot of the bed.

"Suggie?"

"Yes, Charlie."

"You know all of the men I work with have children. I'm the only one who doesn't have children. Give me a son."

"Well, I haven't had any yet. Maybe we can't have any children."

"Ma knows. Ma knows how," he said, and left the room.

He returned shortly, holding a white-capped bottle with an orange label. It was Lydia E. Pinkham's Vegetable Compound. "A baby in every bottle," as the old people said. When the cap was removed, a strong smell, like that of today's vitamins, came forth. Now they were sitting next to each other on the bed with their legs crossed.

"We both have to drink this, Suggie. You want some first?"

"No, you drink it first. Then I will."

He took a swig, winched, and passed it to her. Now that he had done it, she did the same, believing it was safe. After two swigs apiece, they placed the brown bottle with the orange label on the small night table next to the lamp. They then made love, still something of a new experience for the couple of nine months.

Later that evening, Charlie got up. He put on his dark, tailor-made J. B. Simpson's suit and suspenders, which gave him the look

of a man much older than sixteen, and pushed his bad feet, with their high arches, into some slip-on shoes, his gaiters. When Rebecca woke up a few minutes later, she looked out the window and saw her husband hunched over, horn under his arm, walking with his feet splayed out, digging into the pavement for all he was worth, back for five more nights in the Ozarks.

In the beginning of May, when the Musser's gig was over, Rebecca had something to tell her husband.

"Charlie?"

"Yeah."

"I guess you're going to have a son."

"What? You mean a baby?" he asked, shocked as a sleeping pet doused with ice water.

"You wanted a son. I guess we're going to have a son. It's my time of the month, and I haven't seen anything."

With that, the young saxophonist changed. The mantle of adulthood he'd been seeking to conjure through his clothing and manner got under his skin a bit when he heard he was going to be a father. Though he'd been known to lay about the house, aimless—especially in a month like May, when it often rained—now Charlie started to hit the street, looking for gigs in earnest. No longer did he seem content to float along, playing the saxophone and the part of Addie Parker's spoiled only son. Now he meant to shoulder his responsibilities, or appeared to.

In June, two months pregnant, Rebecca Parker got up and went downstairs to the parlor. She opened the sliding doors and entered, passing the big potbellied stove, the mahogany player piano, the sliding doors that led to Addie Parker's room. Her eye took in the old-fashioned Victrola standing in the right corner, and the oversize mantel where Parkey kept her collection of knickknacks. As Rebecca stood before the picture window, she peered through

the lace curtain, watching people passing on the street. Then a cab rolled up. In the backseat were three people: two men and a woman between them. One of the men was Charlie Parker, who leaned over and kissed the woman before getting out and walking up to the door.

When he entered the parlor with his horn, Charlie was surprised to see his wife.

"Hello, Rebeck."

"Charlie, who was that woman I saw you kissing?"

"I wasn't kissing any woman."

"Charlie, I was looking out this window and I saw you. Who was she?"

"Rebeck, I said I wasn't kissing any woman."

"Charlie, I don't care. I told you I saw you kissing her."

He slapped Rebecca.

"I still say you was kissing a girl." Her cheek began to redden from the blow. Charlie picked up a pan of cool water that had been standing overnight and started patting it on his wife's face.

"Suggie, I'm so sorry," he said, going to his knees. "Please forgive me."

Seated now, Rebecca said, "I still don't care. Who was the girl, Charlie?"

Charlie left the parlor and went down the hall to the kitchen, looking for something to eat. Nothing more was said.

The following month, as Charlie was getting ready to go out one night, Rebecca was downstairs talking to Parkey when she heard her husband's voice.

"Suggie, come upstairs."

When she went into their room, all the shades had been pulled down. Charlie, who hated to cross the upstairs hall to bathe, was standing next to the tin tub he used to wash up.

"Yes, Charlie?"

"Go over there and sit on the bed."

She had no idea what Charlie was doing—was he going to give her a gift? Some kind of surprise? On the windowsill, there was a small mirror Charlie used to pick ingrown hairs from his face. Charlie was out of her line of sight, but when she looked in the mirror, she saw him put one foot up on a chair, remove one of the ties with the tight, small knots from the rack on the oak dresser, put it around his arm, and pull it tight. Then he removed a hypodermic needle from the dresser and pushed it into the crook of his arm. When Rebecca saw the blood rush up into the needle, she screamed and ran over to him.

"Charlie, what are you doing?"

He smiled, removed the needle, wiped the blood from his arm, loosened the loop, and put the tie on. Then he took his coat from the closet, looked at his wife, and kissed her on the forehead. "Suggie, I'll be seeing you," he said, then went downstairs, got his saxophone, and was gone.

After he left, Rebecca opened the dresser drawer and found a kit with a hypodermic needle, a twisted piece of rubber, a spoon, and a small, white packet. She took it downstairs to Parkey, telling her what she'd seen and asking her if she understood it. Parkey said nothing, merely looked inside the kit and took it into her room.

The next morning, when Charlie returned, he was met by his wife and mother in the parlor.

"Charlie," Addie Parker said to her son, "I'd rather see you dead than use that stuff."

Charlie looked at Rebecca, set his saxophone on the piano bench, left the parlor, and went to the kitchen.

Shortly afterward, Rebecca began to notice a change in Charlie. When he got home, a shuffle of companions would come into the

house and head to his room with him. When he emerged to leave for the evening, he would be aloof, distant, descending the stairs as if he owned the world, speaking to no one in the family and listening to no one. Before too long, Rebecca noticed that things were starting to go missing. All of Rebecca's good clothes disappeared, suit by suit, then her rings. Charlie started acting frantic, and as his own tailor-made suits disappeared, he began looking more and more haggard. He was in the streets almost all the time and seemed on the verge of losing his mind—nervous, irritable, and always preoccupied. Rebecca wouldn't see him or hear from him for three days; then he would return, eat like a horse, and sleep as if dead for twenty-four full hours. One morning he came to his wife.

"Suggie," he said.

"Yes," she answered, looking at him and feeling a sorrow she had never felt. This wasn't her Charlie, this man who looked as if he'd slept in the street, who'd dissolved into a nightlife she knew nothing of and was now aging before her eyes; he was as much a ragged stranger as he was her husband of nearly a year.

"Why don't you get an abortion?"

"No."

Charlie said nothing else, but that evening he borrowed Parkey's Model T Ford and took Rebecca to the movies. For that evening, at least, he seemed more like the old Charlie. He could still be fun. Maybe all this trouble would pass. She prayed it would.

One evening in the middle of August, after Charlie had left, Rebecca was cleaning up their room. While she was making up the bed, she found an envelope addressed to Charlie under the pillow. The letter had already been opened, and she sat down to read it.

It was a love note from a woman named Geraldine, and it detailed her physical experience with Charlie Parker in no uncertain terms. The letter ended with these words: "Rebecca sure is a very

lucky girl. I wish I could be in her shoes." Had she been knocked down with a bat, it might have hurt less.

She turned the letter over and found another page behind it.

> *Geraldine*
>
> *Nobody will ever walk in Rebecca's shoes.*
>
> *Charlie*

Charlie's wife put everything back under the pillow where she'd found it. Knowing the condition Charlie was in, she decided not to cross him, not to ask him about it. But why would he leave letters like that under the pillow? Was he toying with her? Was it his way of apologizing for kissing another woman right outside the house? She didn't know. There was so much she didn't know about Charlie. Even Parkey, who used to have so much influence on her boy, couldn't get him to stop what he was doing. And Parkey was starting to seem tired, as if she was giving up trying to win back the control she'd had over her son for so many years. Out there in the Kansas City night, Charlie Parker was doing whatever the hell he wanted to do.

A few weeks later, in early September, Rebecca was downstairs talking with Parkey when Charlie called her from upstairs. She went to him—she always did—but this time she wondered, *What will it be now?* When she opened the door, Charlie stood before her, aloof, clearly full of that stuff. He seemed as if he were all the way across the street, even though he was right in her face. His eyes empty, he spoke to her in a dark and imperial fashion.

"Go sit on the trunk and look out the window."

She did. She heard a click; cold metal was pressed against her temple. *Oh, my God*, she thought.

"Rebeck, where is the letter?"

"Charlie, I don't have the letter."

"Rebeck, where is the letter?"

"Look in the drawer," she answered, not knowing why.

As he removed what must have been Parkey's pistol and turned away, Rebecca reached for a flatiron that was on the floor. Sensing something, Charlie slipped through the door just as she threw it, barely missing his head. The flatiron hit the door. She picked it up, pulled open the door, and threw it at him, missing his head again, and this time sending the iron through one of the long, slender windows flanking the front door.

At the bottom of the stairs, Charlie turned and stared up at her.

"The next time you pull a gun on me," Rebecca cried, "you best to kill me!"

"What's the matter, dearie?" asked Parkey from the parlor.

Charlie said nothing, but a sudden calm came over the house. In a moment he was himself again, as if nothing had happened. But Rebecca would never forget.

The difference between fact and fiction was now more than superficially important to Rebecca and Charlie. She was being punished for standing up to a falsehood, instead of letting it pass—a decision that was not always available to her community.

Charlie Parker and his young wife had grown up in circumstances where *all* Negroes were presumed to conform to a false portrait—that primitive image that had dominated print and stage depictions for more than a century. They were presented as simple beings, never humanly complex—except perhaps in newsreel snippets, one of the main ways Charlie and Rebecca would have learned about the larger world. Those newsreels brought them stories of world leaders and national criminals, tragic fires and startling floods; they featured film shot on faraway grounds that were soon visually familiar: royalty in Europe, merchants in Asia, Jesse Owens at the Berlin Olympics. None of whom the conspira-

torial couple, or most others in the theater, could likely have imagined alone. It was surely a smaller world, now; looking up at those giant bodies and giant faces—some of them exotic figures with wild makeup and strange tattoos, with wooden discs or metal rings stretching their bodies in surprising and unaccustomed ways—it became easier to imagine the world beyond Kansas City, as Charlie had been doing ever since his days sitting on the steps at the Crispus Attucks library, reading about foreign people and odd ideas. The cinematic images made available by technology told truths that made viewers more sophisticated, more curious, more skilled at facing problems.

Not long before, in 1934, the Harlem Renaissance painter Aaron Douglas had put a determined, if fanciful, image to the dreams Charlie Parker was already starting to have. One of the figures in his landmark triptych *Aspects of Negro Life* was the silhouette of a black man standing athwart the skyscrapers of the city with no more armor than a saxophone held to the sky, radiating light, a beacon but also a weapon. Like Billy Eckstine, younger Negroes such as Douglas were starting to reach beyond the injustices of minstrelsy, which scandalized their names so casually and consistently.

Yet back at 1516 Olive it was Charlie Parker who was doing the scandalizing, threatening Rebecca for calling him on the deceitful life he was living right before her eyes. That gun to her head was no movie gun; it was not filled with blanks, not as far as she knew. That was the injustice Rebecca was struggling against, and she was ready to go down for the truth. She could only wish that her husband would somehow return to the way he'd been not too long ago, when the two of them were conspiring to deceive her mother and sneak down to the movies to get acquainted with the larger world.

PART III

AN APPRENTICESHIP
IN BLUES AND
SWING

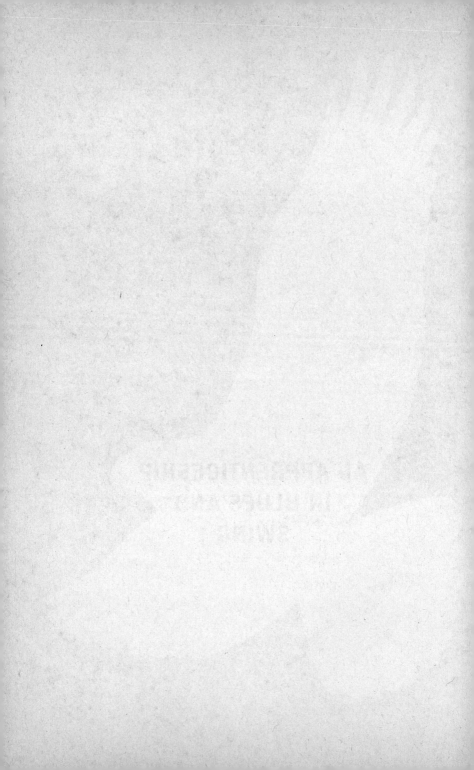

*O*ne master jazz musician said to a young player, "It's not magic, but it should seem like it is." He was referring to the way professional improvisation felt to the listener—the sort of improvisation in which intellect, passion, and technique all conspired to create a mysterious and irresistible momentum, perfectly formed, no matter the tempo. The master also said that the role of the jazz professional was quite close to that of the magician. No matter how much labor had been put into working out all the aesthetic details, the appearance or disappearance of material, the manipulation of form, the apparent creation of a new reality—all were supposed to seem like the work of a musical prestidigitator, one so in touch with the very chemistry of the moment that he or she could pull love potions or explosions right out of the air. And yet improvisation was never truly accidental, never the result of the hot mess that was ignorance.

Once he achieved his position as a thorough professional, Charlie Parker wasn't one to talk in musical detail about what he was doing. He rarely raised technical specifics in his conversation, and when he did talk, Parker sometimes gave the impression that he was largely a natural, an innocent into whom the cosmos poured its knowledge while never bothering his consciousness with explanations.

The facts of his development were quite different. He worked for everything he got, and whenever possible, he did that work in association with a master.

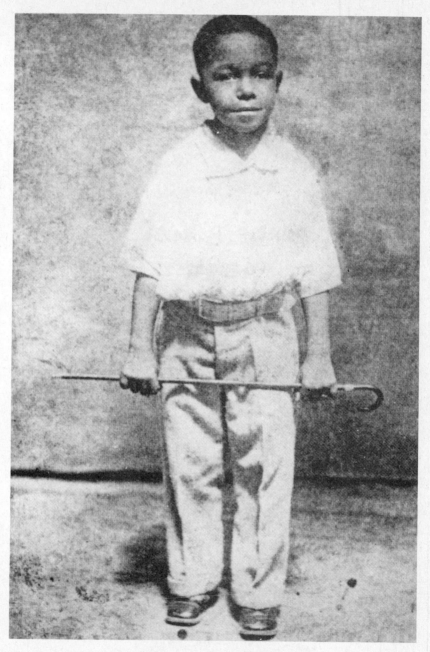

"A clean little Bird": Kansas City, Kansas, early 1920s.

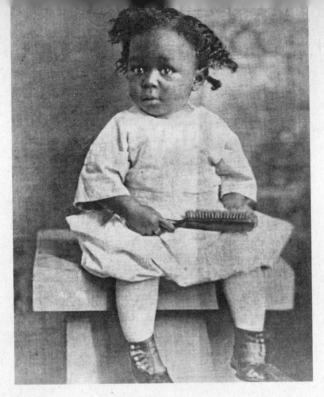

Charlie Parker (above), the young lord of Kansas City, and his mother,
Addie Parker (below), who spoiled and protected him—even after he married,
when he and his first wife continued to live under her roof.

Charlie with his half brother, John "Ikey" Parker (above), and with a neighbor, before the move across the river to Missouri.

Rebecca Ruffin, who moved into the Parker house in 1934. When she first laid eyes on Charlie, she said, "I knew there was going to be trouble. I knew I was in love with him."

Lincoln High School (below), where Charlie played several instruments in the orchestra before taking up the saxophone. "Charlie was looking for what he wanted to play," Rebecca remembered. "He needed a feeling of what he had to do."

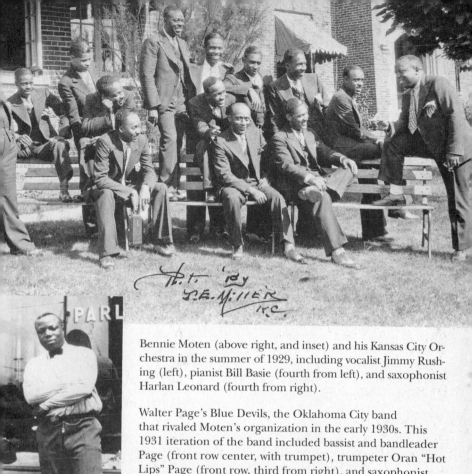

Bennie Moten (above right, and inset) and his Kansas City Orchestra in the summer of 1929, including vocalist Jimmy Rushing (left), pianist Bill Basie (fourth from left), and saxophonist Harlan Leonard (fourth from right).

Walter Page's Blue Devils, the Oklahoma City band that rivaled Moten's organization in the early 1930s. This 1931 iteration of the band included bassist and bandleader Page (front row center, with trumpet), trumpeter Oran "Hot Lips" Page (front row, third from right), and saxophonist Buster Smith (back row, second from right), who became Charlie's mentor.

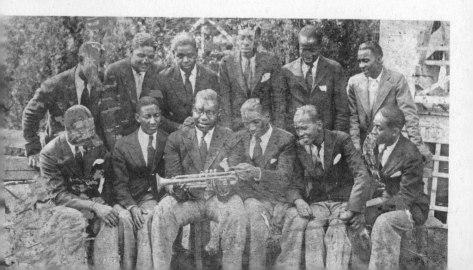

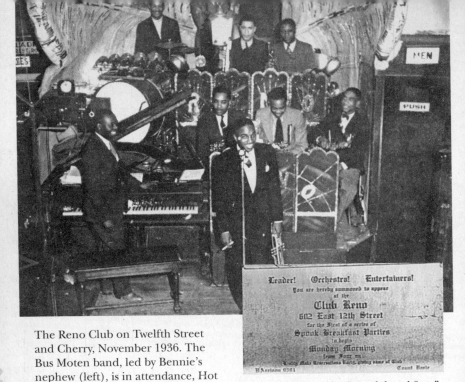

The Reno Club on Twelfth Street and Cherry, November 1936. The Bus Moten band, led by Bennie's nephew (left), is in attendance, Hot Lips Page at the microphone.

An invitation to the "spook breakfasts" at the Reno. Count Basie presiding.

By 1938, Count Basie and his Orchestra had made it to New York. Here they are at the Famous Door on Fifty-Second Street that July: (left to right) Walter Page, Jo Jones, Freddie Green, Count Basie, Benny Morton, Herschel Evans, Buck Clayton, Dicky Wells, Earl Warren, Ed Lewis, Harry Edison, Jade Washington, and Lester Young.

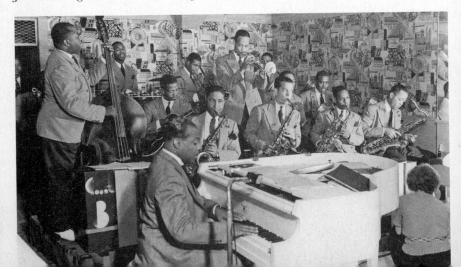

Jack Johnson (above), whose tenure as Heavyweight Champion of the World was complicated by his disregard for other people's opinions, and Joe Louis (below), who cut a different figure when he claimed the title thirty years later, on the night Charlie and Rebecca were engaged.

Four saxophonists who paved the way for Charlie Parker (clockwise from top left): Coleman Hawkins, Lester Young, Chu Berry, and Buster Smith, Charlie's mentor.

Other influential figures include (clockwise from top left) bandleader and saxophonist Tommy Douglas; trumpeter Roy Eldridge; pianist Art Tatum; and guitarist Biddy Fleet, who helped Charlie map the harmonic terrain of bebop.

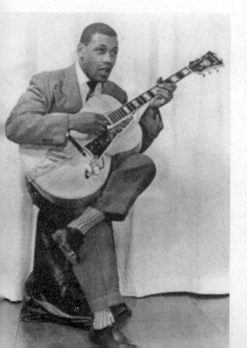

Duke Ellington in 1931. "Bird was totally influenced by Duke," said singer
Billy Eckstine (below). "He could say things in a classy way and they worked. Duke
made everybody want to have more class."

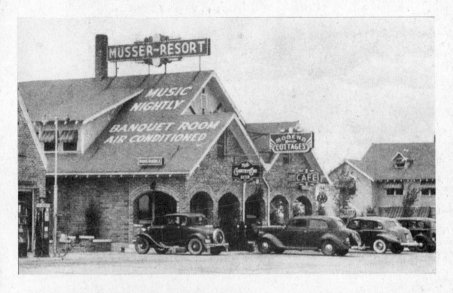

Musser's Ozark Tavern, the Pendergast-backed resort where Charlie worked several stints starting in late 1936. It was while working in the Ozarks that Charlie started to transform his sound.

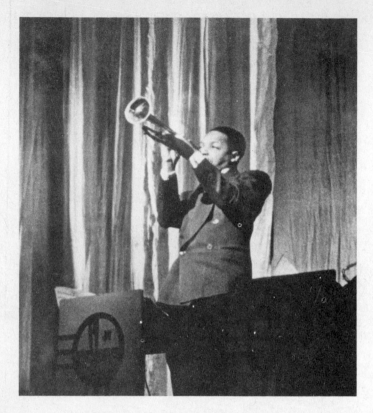

Trumpeter Orville "Piggy" Minor, who observed Charlie at close range through-out his Kansas City years. Together they played in Buster Smith's band at the Antlers Club (below), where the musicians would take in the "freak shows" upstairs after hours.

Skinny in his high-waisted pants, just turning eighteen, Charlie (right) clowns around with drummer Jesse Price, who helped persuade Buster Smith to hire him.

Charlie with Gene Ramey, his frequent bandmate and traveling buddy in the Kansas City years.

Jay McShann, photographed on his trip through Chicago in 1939. Charlie had blown through town not long before; locals were still talking about him when McShann arrived.

The McShann sax section at the Savoy Ballroom, New York City. Left to right: Bob Mabane (tenor); Charlie Parker (alto); John Jackson (alto); Freddie Culliver (tenor).

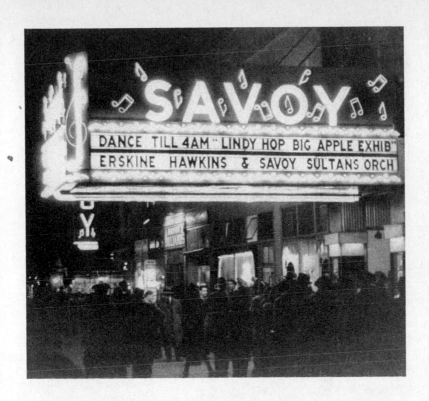

The Savoy Ballroom, the "home of happy feet" and the beating heart of Harlem, 1940.

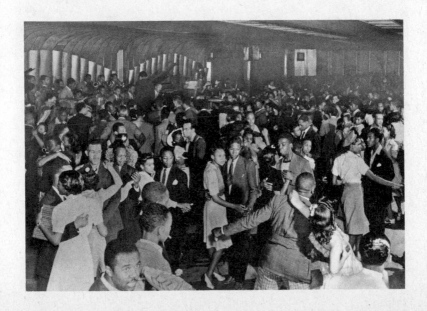

Charlie Parker in a photo booth in Kansas City, 1940.

It was during his stints in the Ozarks that Charlie Parker began to work on his art with real diligence. The jeering and the rejection back in Kansas City must have lingered, but they were probably less important than the challenge of synthesizing all of the things that had touched his musical sensibility. Now he could start to live by what he heard Jimmy Rushing sing on Count Basie's "Boogie Woogie," right in there with Basie and Lester, floating on the airwaves that spring of 1937:

I may be wrong, but I won't be wrong always

It was a maxim for the life he intended to live, not desperately, but with iron resolution.

Like so many before him, he was learning primarily by ear, and now he was beginning to hear more clearly. He had known something of the piano since the days when he'd played around on it at Sterling Bryant's, and it was through the piano that he started to find his way around the concept of harmony. He had an appetite

for those combinations of tones known as chords, combinations that had their own laws according to the order in which they were placed and the keys in which they functioned. They were fundamental to the mystery of the music he was trying to learn.

At Musser's Ozark Tavern, Charlie and the rest of the band played from eight o'clock until perhaps midnight, but they had the days to themselves. There was a schoolteacher who lived nearby, and every so often the musicians paid a visit; now and then they even went to watch the water pouring through the nearby Bagnell Dam. They went to look at the lake, but they never fished. Driving was risky in that weather, as they knew all too well. Not a lot to do.

Once, Clarence Davis and Parker went rabbit hunting in snow that was nearly waist-deep, the trumpeter armed with a double-barreled shotgun, the saxophonist with a German Luger, perhaps one of the weapons brought back from World War I and still floating around.

Stopping at a hole, weapons at the ready, they waited for the prey to come out. They were prepared to leave it doornail-dead immediately and then pick up the carcass on the way back to Musser's to be stewed up as part of the dinner menu.

When the rodent showed, Clarence turned—and almost shot Charlie, who damn near squeezed off a slug into his buddy. They had fired too fast, but not fatally; the split-second judgment that was at the core of their burgeoning artistic success had not betrayed them out in the field. So they looked each other in the eye and burst out into laughter, almost crying. Eventually they transformed the near-tragic accident into an adventure story, a supple joke they would revisit over and over as they traveled back to what they should never have left, changing its texture, its meaning—even the outcome—along the way. By then, the two aspirant woodsmen had decided they best let others do the hunting.

When they did get hold of some rabbits later that day, Charlie and Clarence were perfectly prepared. These Western boys knew how to dress the animals, slicing into the carcasses, peeling away their coats, chopping off the heads and feet, and then cutting up what remained to make a tasty dinner, the taste and texture of the fresh meat still vital and gamey. Unlike their more urban counterparts, who had spent their childhoods dressed up as movie cowboys and Indians, Charlie and Clarence weren't at all squeamish about dressing a dead animal killed to be eaten. Later, as he was moving through the big time, that country boy side of Charlie Parker would shock those who knew him for his urban sophistication, his literate speech, and his artistry.

The musicians holed up in their modest Ozark accommodations, cooling it out, practicing or studying their interests before or after work. The band's female pianist mostly kept to her own cabin, but the men in the band all bunked together, some of them smoking reefers as they listened to radio broadcasts. And it was through the broadcasts that Charlie picked up on another mentor. Coming out of Chicago every night from the bandstand of the Three Deuces was the music of Roy Eldridge, the most powerful influence on the trumpet after Louis Armstrong. Like Lester Young, Eldridge was working on creating something different from the sound that dominated his horn. For nearly a decade, Armstrong had been like a monumental wagon wheel: his style was so rich that scores of individual trumpeters took out one mighty spoke and bent or carved it into a personal style. Armstrong's imagination was given to the grand gesture and the floating beat that lifted up over the tempo and moved through songs with the freedom that defined jazz. His improvised melodies evolved in stark structures, surprising bursts of rapid-fire notes, sometimes coming off like internal obbligatos, as if he were making asides in response to his own statements. His

influence had reigned over jazz from the middle 1920s into the middle 1930s, when other elements began to offer a counterbalance to Armstrong's influence. These younger voices were building on what he had laid down, taking his principles in new directions, and Eldridge was among the most prominent figures intent on finding his own way.

The virtuosic Eldridge brought a fresh technical proficiency to the trumpet and expanded the expressive possibilities of jazz in the process. Born in Pittsburgh in 1911, he was an Eastern musician whose early style ignored the transmutation of Negro vocal styles that was so prevalent among the playing of titans such as Armstrong, Red Allen, and Bubber Miley. "I came up playing the horn real straight," Eldridge said. "I didn't bend notes and growl like the guys did out west. When I first heard them in Saint Louis, I didn't know what to do. They had something else going on that was foreign to how I did my playing. They made me think a little different. Over the years, I put what they did in with what I was already doing and my sound came out. Eventually, it all became me."

Eldridge initially came to Armstrong the back way. As a young man he was swept up by the style of Coleman Hawkins, learning the feature part the tenor saxophonist improvised on "The Stampede," a 1926 record with Fletcher Henderson's big band. That brief solo was Armstrong processed through Hawkins, delivered with the bravura and rhythmic surge of the trumpeter. Eldridge was drawn to such flashy playing—so much so, he later admitted, that his early work often had more to do with showing off his fast playing to impress listeners, and showing he could rout the opposition in cutting contests, than it did with true content or invention. "When me and Jabbo Smith went at it one night, we played a whole lot of trumpet but not much music, maybe none at all, but, again, a whole lot of horn was played that night." When he finally did

hear Armstrong at New York's Lafayette Theater in 1932, though, he was amazed at the logic of his playing. This was what jazz musicians meant when they said that someone "told a story." The units of music that Armstrong invented evolved seamlessly, one into the next, his ideas perfectly shaped and balanced. Listening carefully to Armstrong's music, Eldridge learned how to pace himself, how to relax and build a statement. It was this epiphany that transformed Eldridge the virtuoso into Eldridge the artist.

Even so, Eldridge didn't really want to phrase or breathe like a trumpet player. He often commented that he leaned toward the longer, swifter lines of saxophonists. A harmonically oriented musician, he wanted to play through the changing chords with the authority he heard in Hawkins, Benny Carter, and Chu Berry. His daring style shocked its way up into the highest range of his horn, using high notes not just for drama or tonal percussion or to draw a little applause from the crowd, but as organic parts of his work. Eldridge was full of heat; his stamina allowed him to play in the upper reaches of his instrument for set after set, then go out scouting for jam session battles, which could inspire him to punch and counterpunch with his trumpet until late the next morning, even into the afternoon. He had the confidence and the gladiator spirit to seek out the best trumpeters wherever he traveled, always intent on wiping them out, bruising their self-esteem. At home he was a great irritation to his Harlem neighbors, practicing four to six hours every day. By the time Charlie Parker and his fellow musicians started tuning in to his broadcasts in their winter haven in Eldon, Missouri, in early 1937, Eldridge had put together the style that would be a dominant force in jazz for several decades to come.

Eldridge's playing combined ease with urgency, lending the motion of his lines a fresh, shimmering energy. His work echoed the industrial confidence of the culture, the disdain for heights that

led to the skyscrapers, the energy that laid the railroad tracks, that dug the subways, that rolled car after car off the assembly lines, that lit the American night. It was the sound of steel, electricity, and concrete made lyrical. Young musicians like Clarence Davis were as stuck on Roy Eldridge as their predecessors had been on Armstrong ten years before.

In Eldridge, Parker probably heard more elements, more pure information, than he may have been aware of. He was still a young man, with only limited knowledge of how complexly things moved in jazz, how invisible threads of influence connected each musician to other players they may never have paid much attention to, may never even have heard. Eldridge combined the schools of melody and harmony that were represented by Armstrong and Sidney Bechet on one hand, by Hawkins and Art Tatum on the other. Like most New Orleans musicians, Armstrong and Bechet were fundamentally bluesmen. Hawkins and Tatum, by contrast, were impassioned intellectuals whose music introduced another aspect of consciousness into the art. In time, Charlie Parker would combine both orientations—melding the visceral with the intellectual, the freedom and force of swinging the blues with an extraordinary conceptual appetite and capacity for intricacy.

The towering figure of the intellectual school was Art Tatum, the piano genius who had influenced Coleman Hawkins so profoundly in the late 1920s, when the tenor with the big sound traveled to Toledo with Fletcher Henderson's surging, twirling big band and heard the local keyboard wonder. Hawkins would never be the same. Tatum was perhaps the greatest of all jazz virtuosi, admired by the young Vladimir Horowitz, who could re-create one of Tatum's improvisations by reading a transcription but scoffed at the notion that he could invent anything of Tatum's brilliance in the moment. Tatum sprinted through his material, dancing over

broken chords while inserting chord substitutions that allowed for more intricate connections within the harmonic foundation. Hawkins, a trained cellist and classical student, could hear how Tatum combined the European technique of harmonic motion with the New York stride piano school led by James P. Johnson, Willie "The Lion" Smith, and Fats Waller.

So when Eldridge put his horn to his lips, he was bringing together styles that seemed, at least on the surface, contradictory. Though Armstrong's influence had transformed everything in a manner that had no precedent—making him the first figure in Western music to raise a revolutionary flag with a single-note instrument—a new generation of more harmonically adventurous jazz musicians was joining the conversation. From the early thirties forward, wind and keyboard players would maintain a dialogue of influence, pushing their instruments into fresh areas.

Charlie had been following Roy Eldridge for a while; Rebecca had already heard him playing along with Eldridge and Chu Berry on the Fletcher Henderson record "Stealin' Apples." On those late nights in the Ozarks, Charlie must have been impressed by the trumpeter's Chicago broadcasts. Eldridge offered some of the same pleasures as Lester Young: He was uncanny, devoted to an individuality that forced him to invent his own way. You never knew what kind of a phrase he would play or how long he might keep it going. The trumpeter embodied the audacity of jazz music, the combination of moxie and technical command that gave him freedom in every direction—in his range, his conception, his coloring of notes, and his rhythm. All of those elements Charlie Parker would eventually work into his own style, steadily achieving greater and greater comprehension of the details every jazz intellectual has to master, then *feel*, in order to attain greatness.

While at Musser's Ozark Tavern, Charlie and his compatriots

also tuned in to station W9XBY, broadcasting from the bandstand of a Kansas City club located on the Kansas–Missouri state line. It was on these broadcasts that Charlie first homed in on the sound of the alto saxophonist Buster Smith.

Charlie would have known Smith from the Kansas City clubs. Smith had been a major figure in the Oklahoma City Blue Devils, a formidable bluesman on the alto saxophone and the clarinet; he was one of the players who had coaxed Lester Young into the Blue Devils, and a member of the reed section John Hammond heard at the Reno Club after the Blue Devils had blown their last note and their former members joined the best of Bennie Moten's men under the guidance of Count Basie. At first they led the band together, Smith and Basie, but the easygoing and likable Basie seemed born to lead. This was clear from the moment he landed one of his unforgettable piano introductions—sometimes giddy, sometimes insinuating—followed by hot, well-placed chords and riffs, provocatively fine stuff to build an improvised dream on. Bill Basie—from Red Bank, New Jersey—knew how to find that groove, putting his arm around it, slapping that thing silly, or playfully grabbing its throat.

What distinguished Buster Smith in the Basie band was his writing and arranging prowess, which earned him the nickname "Professor," or "Prof." At first Charlie seems not to have noticed his playing. Perhaps it was only after Young's departure for New York that he turned his attention to Smith. Certainly Young still loomed large in his mind; Gene Ramey recalled him memorizing Young's solo on his 1936 recording of "Oh, Lady Be Good." "Oh, when Charlie came back from the Ozarks, he had gotten that Pres solo on 'Lady Be Good'—which we called 'Lady Be *No* Good.' He had it down. Charlie played that solo all over town. He played it so much, almost everybody else memorized it!"

It was when Charlie started listening to Buster Smith, though, that he began to recognize what the alto saxophone could do. Tall, slim, dark, with his hair combed back and his mustache thick, Smith was a figure to be reckoned with. He had the sound of the Southwest in his quick speech, a swift way of talking that almost duplicated the zip of his saxophone playing, and that was punctuated by the gallows wit and Olympian laughter so often heard from those Negroes closest to the tragic-comic sensibility of the culture, a perfect human mirror of the democratic soul of American life. Smith had learned the craft of composition almost entirely by himself, and he spent his afternoons sitting at the piano, texturing the air of empty clubs as he worked on his pithy arrangements.

Though Smith had been one of the infamous Oklahoma City Blue Devils before he settled in Tom Pendergast's town, no musician had a higher position in the pantheon of Kansas City. Born near Dallas, Texas, in 1904, he took an early interest in instrumental music, playing an organ in his mother's house at the age of four or five. He later told journalist Don Gazzaway: "Yeah, my brother would get down and push the pedals to make the notes come out, and I was up above playing the keys. My grandfather made us get rid of that old organ because he told my mother it wouldn't do anything but lead me into the worst of sin." He was in his seventeenth year, still living at home, when a clarinet in a shop window caught his eye. Young, very dark brown Buster knew he wanted one, and knew he wanted it quick.

As soon as he got home, he told his mother about the clarinet. She told him he could have it if he picked three hundred pounds of cotton every day. That neither changed his mind nor sent him running to hide under his bed. He soon earned the $1.50, and Smith was off, untethering his family from sanity as he learned the instrument through squeaks that slowly but surely abated under

the sweating force of the patient boy's determination. Before long, young Buster was getting jobs playing that music in what he called "pig iron" houses, where pork was served, liquor was drunk, and the bands played blues all night in the keys of B, D, and E. The Negroes there danced on the dirt floors through the night, kicking up dust until they left the next morning, soaked with perspiration as they stepped into the welcome fresh air, no more moon at all. Walking home, the men laughed at the sight of one another, their sweating faces covered with so much danced-up dust that they looked like they were wearing pancake makeup.

Smith discovered that he had a special aptitude for the instrument and swiftly became a member of the local musical elite. This was before the virtuoso wind-playing era; emulating the Negro voice was plenty, especially if the player had good rhythm and could project his sound. In that respect, wind players were a distance behind what the Eastern piano players were putting together. And since Smith was self-taught, there was no reason for him to aspire to anything beyond what he heard on recordings of the day and witnessed in the work of local musicians or the traveling bands that performed in Dallas. Getting with the kind of sound blues singers were putting in the air was a job in itself, and meant encrusting notes with nuances that reached back to the field hollers, moans, and hums of the shared Negro memory—the elements that took music beyond the tonal precision of the piano, opening the door to what might have initially seemed like guttural exhortations or cries of pain, even ambivalence, but were actually the foundations of a language that was expanding the expressive power of Western music.

As young Buster Smith mastered his clarinet, then, he was bent on getting with the rough music of the barrelhouses, the places where joy came in muscular or soft packages but could surely ar-

rive the hard way. He hoped to speak to those who wanted their secular experience expressed with the same intensity they felt in the churches and camp meetings, where the spirit could arrive with the force of a hurricane, throwing believers this way and that, taking possession of listeners, forcing unintelligible sounds from their mouths, pushing tears from the eyes of witnesses, terrifying children who had yet to learn the vocalizations known to the believers as the language of God, sounding that way to deceive the devil, who, just like the savior, was everywhere. Buster was finding out, as all bluesmen had to, that the audible route to success was through creating subtlety and fire in the tones and timbres of Negro American speech and rhythm and song. You had to be able to soothe the people or insinuate them into reverie; you had to be able to make them rise up, stomp, kick, spin, and caress; you had to remind them that the sandpaper facts of human life could be smoothed over if met in the close quarters of courtship or celebration, where the sun going down at the arrival of evening promised recognition of something far inside the soul and right under the skin. None of the sweet, sentimental music white folks listened to was for them. They needed stuff played that was as tough as they knew the world to be, and that was as compassionate as they wished it could become. The kinds of voices they heard in their daily lives had to rise out of horns; the intervals they liked had to be rolled or trilled or boogied out of the piano; the backbeats they liked to set their dance steps to were expected of the drummers. And, working in his little trio with pianist Voddie White and drummer Jesse Dee, Buster Smith met the demands of Dallas.

Sporting his new shirts and pants, his polished boots, smoking his stogies, Buster Smith soon began loving the life he had found for himself. It lifted him up into another stratum, allowed him to go about picking up musical information from every cor-

ner. He didn't miss the big acts that came through Dallas, either: the appearance of some famous Negro musician at the L. B. Mose Theater or the Hummingbird was an event of importance for professional and lay alike. At the stage shows, audiences saw comedians, jugglers, contortionists, torch singers, now and then an animal act, and the main attraction. But what struck Buster Smith most was the local crowd, coming out to see those boys who worked with territory bandleaders like Troy Floyd and Alphonso Trent, wearing all that expensive stuff and carrying themselves as if they were recognized for sitting right on top of the whole world. They had cars, shiny ones, their shoes gleamed, and they traveled around, making names for themselves. It was easy to see that this music business could be very good to a man if he worked on it hard enough, if he got so he could be reliably good, be depended on to touch the people.

Buster Smith was the reliable type. If he got a job, he was there and ready to perform. He was ready, too, to learn anything you threw at him. Quick. He paid close attention. Boy wasn't stuck up, was not the backbiting kind. You didn't have to worry about him getting drunk and embarrassing anyone. He was a young man on the go, looking for ways to better himself as a musician, fast to learn and gifted with a powerful memory. The musicians liked him, and whenever something came along that could fit his talents and help him out, they told him about it. He had a kind of light coming out of him that attracted people to his side and that neutralized distrust. Above all, Buster Smith didn't abuse the popularity that came to him; he was solid and proud, liked him a laugh, was a good friend to others, and could be counted on for loyalty once he declared himself.

Smith wouldn't back down from something he wanted to do just because it took a whole lot of work. This characteristic helped him

understand that Charlie Parker boy when they later met. Good man Buster knew personally what some ironclad determination could do. But he also wouldn't do anything he didn't want to do. At one point, some guys from New Orleans who'd heard about him came in and got him up on the bandstand for their engagement in Dallas. When they tried to get him to go out on the road with them, though, he wasn't interested. He didn't feel like traveling out with the circus and medicine-show bands that came through, the ones where musicians just blew as loud as they could, nothing connected necessarily, just what it took to attract people over to where they could be transformed into suckers by the men selling remedies for everything that ailed anybody on the face of the earth.

Smith later concluded that jazz, for him, had begun with his reaction to those medicine shows, to the way those gawking, gullible customers were drawn into the fly trap by those complicit musicians. Buster didn't mind standing around blowing on his horn in the open air, his tone getting stronger, testing his instrument's abilities, noticing the power music had to bring people right up to where he was playing. But he was satisfied with that—with the instrument itself and its power to draw the people in. He didn't feel the need to go any further, to keep them there while someone else picked their pockets. After all, he was now working things out on a new alto, one he had gotten from Jesse Dee, his trio drummer. The horn came out of Jesse Dee's closet or somewhere, green as a new leaf. It fit him pretty good, and he didn't know many other players who had one. He needed to clean it up, show that it was being cared for by a professional musician. It gave him another something to add to the list of what he could do. And he was getting with it, getting with it fast.

The tempo of things picked up in 1925, when the Blue Devils came into Dallas from Oklahoma City. Now *those* musicians had

something appealing to Buster Smith. It seemed like they all had something about them that they got from being out there on the road, moving around, finding out about things. The Blue Devils were full of fiery stuff, and they played music like they meant it, every note. Crackshot McNeil was on drums and he excited Buster Smith in a way that was different from anyone else he'd ever heard. McNeil had spark, and he could get around his drums well; he knew how to get the rhythm up under you and make the stuff you were playing come out better. He would make you want to play. It didn't matter how you felt when you got there, once he started putting that rhythm on you, you had to execute something good just to satisfy yourself. Then old Walter Page could pluck you into something with that bass, the notes booming out low and close to the drumbeat. If the piece called for it, the man would put his bass down and pick up the baritone saxophone, or take off down low on a sousaphone he'd perched nearby on a scaffold. It was as if he knew he had to punch the band forward, and one instrument just wasn't enough to do the job.

It was the punch and the verve of the Blue Devils that got to Buster Smith as he played with them around Dallas. They stood and talked with pointed assurance; they held their instruments as if nobody else could play them; the power that came out when those men got rolling, and the feeling of being there with them and having to get up over all that fire, gave him a steaming thrill. These were young men, too, musicians of his generation, cocky and ready to go anywhere there was a job. Once they arrived, well, it was *on*—and that was how it was at the last job, and that was how it was about to be at the next, and they weren't bashful about letting anyone know it. A strong new buzz saw had no cause to apologize for splitting a log in half.

Once Smith had spent a little time with those musicians, leaving Dallas didn't seem like such a bad idea. There was suddenly an inevitable quality to imagining being out on the road with musicians like the Blue Devils. You went to a gig, you did good work with your instrument, you got paid, you divided up the money evenly, and you moved on. The Devils were still being led by Ermir Coleman, but the band would soon come under new management as Walter Page's Blue Devils. Whatever the moniker, it was really a collective organization. Smith later called it "a commonwealth band," all for one, one for all.

When they asked him to join the band and hit the road with them, Buster Smith was ready. He bade good-bye to his family, packed up his clothes, got his instruments together, packed everything into one of the Blue Devils' cars, and was gone. No more a local boy, he was about to become a shaper of the sound of the territories, and eventually an instigator of innovation.

As Ross Russell wrote in *Jazz Style in Kansas City and the Southwest,* "The Blue Devils was just another ambitious, young, brash southwestern territorial band when Buster Smith joined in 1925. The average age of its members was around twenty-three. Page, at twenty-six, was looked upon as something of a patriarch. In the next four years the Blue Devils became one of the best and certainly most feared in competition of all the bands in the Southwest." As Russell notes, their core players included half a dozen future pillars of the Kansas City scene, including Bill Basie, Eddie Durham, Lester Young, Lips Page, and Walter Page. "These talents were recruited by a team project of sifting rumors, bird-dogging leads picked up over the musical grapevine, and a systematic series of auditions, evaluations, offers, sales talk, raids, and cajolery—all part of the infighting of the dance band business. The process took

place in much the same way that a major baseball team is brought up to championship level by the acquisition of stars and superstars to field its various positions."

As in all human teams, personnel, craft, and spirit separated the journeymen from the good, the good from the great. The bands of the Southwest were intent on becoming great if they could, and the elements that would make them great included repertoire, technique, and rhythm. They would learn from the mass technology of print, from the phonograph record, through the reactions of the audiences they played for, and by conferring and competing with other professional musicians. Each of them would learn things about music on his own, as well as with others—mulling over a piece of material, practicing in a difficult key, making and listening to suggestions at a rehearsal, meeting the challenge of a stranger's imagination at a jam session, or plotting the sequence of tunes at a bandstand battle the same way a baseball manager would select the pitcher and pick the order of batters. It was all about the audience: Pull them right in, let them lull awhile, build back up with some kind of surprise, scoop up their attention, get all eyes on the bandstand as things start twirling pleasurably in unexpected directions, until the tension is tighter than Dick's hatband. Then the hot man, whoever he is, stands up and lays down more of a good-sounding time in rhythm and tune than the law allows. This lifts the band, the dancers, and the room itself into an invisible carnival of joy, up there somewhere, up there. That's where they want to go—up—and your job is to get them there if you can. The people want to feel as if they were made for joy, and joy was made for them. Why not be celebrated for the ability to do that? Few can, very, very few.

Ralph Ellison was from Oklahoma City, the Blue Devils' home base. As an aspirant musician, he saw the Blue Devils walk the

streets with the sheen of local celebrity. Working in the local drugstore, he mixed up citric acid with two or three eggs in milkshakes for musicians, pimps, and laymen looking to stand in bed after a long night. He knew Buster Smith, and remembered seeing Lester Young coolly strolling around in a white sweater, carrying an old silver tenor. He also saw the Blue Devils when they performed at Slaughter's Hall. That was where the Negroes gave their dances, though the band headquartered itself at the Ritz Hotel, a white place. As Ellison noted, the sensibility of an era isn't always what we assume in retrospect: "What gets lost when you overstate race is the fact that people aren't always thinking about race. They might be thinking about style, about technique, about information that would allow them to do whatever it was that they were trying to do. Hell, when you went to the record store, you were looking for anything that could help you achieve your own aspirations; you weren't concerned about seeing yourself in the limited terms that someone else might."

Ellison perceived something essential about the musicians of the 1920s and 1930s: that they saw music as an opportunity not just to entertain, but to express something of their shared situation. "There is a wide-open sensibility in jazz, and that sensibility made it possible to express so many of the essentials of the national character in the sound and feeling of the music. You hear the wanderlust, you hear the hopes and the dreams; you are given a feeling for the inevitable disappointments and the equally inevitable humor. That is why those bands swinging that music had such significance. They existed in a ritual where the highly demanding aspects of the musical imagination—and the dancing imagination—frequently met, pulling together techniques and expressions of elegance from anywhere they could."

Like all the Negro bands, the Blue Devils played for every-

body who gave them work, and that meant that they performed in many segregated situations. To meet the demands of their white audiences—when those demands fell outside of their jazz tunes and original material—they would stop by music stores and buy stock arrangements of the popular songs of the day, sometimes playing them straight, but sometimes treating them to the creative reinvention that's known in music as arranging. That is how Buster Smith started expanding his skills at composition. Smith had learned to read music in Dallas, but he hadn't made much of it. In the Blue Devils, he started writing music—a process that involved a small parade of revelations.

From early on, Smith knew he had things in his head that could sound good coming out of other people's instruments. As he studied those stock arrangements, though, he noticed something that would change his understanding of how music worked. Until now, the bands Buster had worked in followed the New Orleans style, with each section either playing the same note—in unison—or freely improvising obbligatos to the theme. The trumpet, the clarinet, and the tenor saxophone were all B flat instruments, playing the same line, with the saxophone an octave below the others. The alto saxophone and the baritone saxophone were both in E flat, an octave apart. And the trombone was in the bass register, down there with Walter Page. The New Orleans units achieved counterpoint purely through improvisation—which could come through very clear, with one voice rising above the fray, or very thick, in a dense cloud of polyphony, but was always vital if the players were capable of more than hopped-up, ignorant noise. Somehow, in those years, audiences seemed able to separate the melody line played by the cornet or trumpet from the improvised responses of the clarinet and the trombone—and to enjoy the new music.

What Smith discovered, in unpacking those stock arrangements, was that there were other, more complex ways to write music for a jazz band. In these professional arrangements, the horns were not only playing different lines, they were also playing different notes. This turned Buster around; it introduced him to harmonizing and pointed him toward a way to give the music his own stamp. Armed with this new knowledge, he sat down at the piano and started working out the chords he would voice in new arrangements for the Blue Devils.

Voicing chords was a whole other kind of business. To master this, Smith would have to study music theory, but he recognized the power such knowledge could give an arranger. Once you understood harmony, you could change your band's entire sound a gang of ways: you could change the intervals you used, switch up the voicings, and with each change the band would take on a different color. "There were many, many nights—stayed up all night studying that stuff," Smith recalled. "Sitting down at the piano, sitting in the night. I went to sleep at the piano, writing."

This new approach to harmony made the Blue Devils sound bigger, gave their music more of a snap. It put something extra on the ballads and lifted the waltzes up from the pedestrian: it provided an escape route, a getaway from the ordinary, the expected. The music Smith wrote was so naturally good it also gave the men something else to ponder, to be interested in. You could surprise them with it, help them find out what range made them sound best. If a man had a good, strong high note, use it; if he had a powerful low note, use it. If one of the musicians sounded good in every register, Smith could achieve different effects by shifting that player's notes around—high, middle, low—as the chords progressed through the tune. Over the next few years, with Eddie Durham,

Buster shaped the sound of the Blue Devils, directing a fire hose of intensity—and, often, a garden hose of finesse—that washed away untold competitors.

This knack for rearranging popular material led the band to expose its bumpkin hindquarters one night when Fletcher Henderson came in looking around and listening, as he was known to do. Out there, dancing in a suit looking as good as material spun from gold, he handled the attention he got from the local yokels with good humor, class, and charm, seeming every inch the nice guy.

Then, when the band started in on a certain tune they'd learned by ear off a record, Henderson danced over to the bandstand with his date. "I wrote that," he told Basie. "Very good, but it's in D flat. You guys are a halftone off."

Basie apologized and claimed he'd told Buster the same thing himself.

Prof was having none of it. Rising from behind his saxophone, he answered the apologist. "I had to call him on that, because we both knew old Base wouldn't know a note as big as a house." Like many of the Kansas City musicians, Basie and his band tended to stick to certain friendly keys. "He got quiet then, and we shared the shame of being that wrong in front of a musician as top-flight as Fletcher Henderson, who was not scared of any keys. None. The four or five keys most bands used meant nothing to him, and I learned to think like that. That was why so many who had played with him were extremely rough customers—the roughest. Louis Armstrong, Coleman Hawkins, Chu Berry, Lester Young, that's four aces right there. You put in Roy Eldridge, and he will show how wild a joker can be, all night long."

The musicians also kept up by studying the music they were brewing up back east. Listening to those recordings, Smith and others sometimes transcribed arrangements as they heard them—

though it was easy to get the key wrong, because phonographs were unreliable when it came to speed. With each new arrangement, though, the Blue Devils sharpened their skills, bringing such a cutting edge to their music that they were able to keep a competitor like Kansas City's eminent Bennie Moten on the run.

The other key to the Blue Devils' ascent came from working dances like those Ralph Ellison went to at Slaughter's Hall. The antiphony, the call and response, the exchange of rhythms between the musicians and the dancers was part of the excitement, and that electric byplay surely influenced the Buster Smith style that later touched Charlie Parker so indelibly. Ellison recalled one bold, quick-stepping dance, popular in Slaughter's Hall, that had much in common with the double-time playing style that Smith was known for. "It was a dance step called the 'two and one,' or the 'two *in* one.' It was a brisk rhythm in which they would dance with and against the rhythm of the bands. There was a lot of improvisation going on out on the dance floor, and these Negroes would go into quite a series of steps that carried them very rapidly from one end of the hall to the other, almost in one huge sweep of feet and bodies in motion. Then they would turn and come back down just as fast as they had gone.

"Buster Smith then had that strange, discontinuous style that one could see was also a reaction to what he was looking at from the bandstand. That discontinuity was later heard in Charlie Parker. But it could easily have some of its roots in Slaughter's Hall. You see, this was where the swing really started, not the East. Out there in Oklahoma City and over in Kansas City something was happening to the rhythm of the music. It had a certain thrust that was different, and when Basie, who was an old, ex–Blue Devil, took that feeling east, it revolutionized the sounds of the bands back there. They hadn't heard anything like that before. . . . But *we* had heard

it and we had heard it often. . . . Not only did we hear it, we *saw* it, because you listened to the band swing the dancers and watched the *dancers* swing the band. It happened all the time, this trading back and forth, and old Buster Smith was right up there in the middle of it, working on that style of his and writing music."

But the good times for the Blue Devils were short. By 1929, even with all the battles of music won and the quality of their players obvious, things went bad. The Depression dried up the free flow of gigs and the pickings soon grew slim. Then Bennie Moten started pulling the best of the Devils away to Kansas City—Jimmy Rushing, Hot Lips Page, Basie, Eddie Durham, even Walter Page himself.

Buster Smith and Lester Young remained, blowing with the diehard verve and defiance that gave the band its reputation. In Cincinnati, Fats Waller heard them and invited the entire band to accompany him on a radio broadcast. A founder of the New York stride piano school, Waller was a monumental force: a composer of many hit tunes, a gourmand who lived up to his nickname, and a mentor whose influential model touched many players. To show them how much he respected their skills, Waller went out and bought a whole lot of gin, placing a half pint in front of each Blue Devil on the bandstand, then raised his eyebrows, putting his bulbous charm in their faces with a wink, smile, and chuckle. But Waller wasn't offering enough money, so the last of the Blue Devils took off for an ill-fated tour of the Southeast.

They were in Virginia when the stranding came, full stop. It was a familiar situation for the band, getting into unknown territory and being unprepared for failure. Sometimes that was all it took, if the audience turnout was low and the promoters reneged on the band's pay. Smith and his men worked around Newport News, Martinsville, and Blue Point for three months, eventually running out

of money, having their instruments confiscated, and finding themselves thrown out of their hotel. A few of them made it home with money sent by relatives, but the others had nothing to help them get moving. They decided the only thing to do was hop a train and ride until they made it back to Oklahoma City.

A friend from Dallas gave Smith $2.80, which he used to buy some Bull Durham tobacco, some rolling papers, and a bag of cold cuts. The friend drove Smith and the seven others to the railroad yard, where they caught a train that seemed to be three hundred boxcars long. Unable to get inside, the last of the Blue Devils had to ride home in the open air, lying down in the coal cars, digging themselves holes and covering up to keep the wind and cold off them as best they could. Smith had started the trip in a black tam and a gray suit. By the time they got to Ohio, his suit was the same color as his beret.

Somewhere along the way, Smith and his men hooked up with some white hobos who took them into a boxcar. One of them wedged a stick in the door to make sure they weren't trapped inside, which could be fatal. There were twenty-one of them, all huddled around a fire built inside the boxcar, their occupations, their skin tones, their education and class backgrounds, their dreams, their fears, and even their individual takes on the Depression and the blues were secondary to the all-American shake, rattle, and roll of the iron horse, whose rhythms were captured in the beat of swing and the drive of the shuffle blues.

At Cincinnati, the train stopped. The white hobos told the Blue Devils they'd better stick around the railroad yard and not go out looking for food. As Smith remembered, though, they were also told not to worry; they'd be taken care of. The white guys went off bumming for grub and soon they were back with pieces of steak, ham, cold cuts, and bread for the Blue Devils. Then the white men

took them to a hobo camp where they sat on a rug under a tree and ate a meal cooked in a pot on the ground, with all the necessary dishes and cutlery waiting for them under a sign reading "Leave It Like You Find It."

With his Bull Durham and his food in a box around his neck, Buster Smith, along with Lester Young and a few of the others, finally made it to Saint Louis, where Bennie Moten sent a car for them. Before the car arrived, someone stole half of Smith's music. *That* was the blow. Buster knew he could write more music, but having his music stolen—that was another nail in the Blue Devils' coffin, another sign that the evening sun was going down on their small empire of swing, insouciant lyricism, humor, and spunk. This last stretch had been long, it had been hard, but it was typical of what was starting to happen as the Depression destroyed a whole world of entertainment and employment the way a prairie fire did a field.

The only way to outrun the fire was to go to Kansas City.

Shortly after they got there, Buster Smith joined Bennie Moten, putting himself back in the regional big time, a member of the hottest jazz orchestra for a thousand miles in any direction. Buster Smith was right at home—and there he would stay until April 2, 1935, when thirty-nine-year-old Bennie Moten died on the operating table while his tonsils were being removed.

It was a shock to everyone. Pudgy and confident, Bennie Moten had been carried forward for years on the steam of pure gumption. By diligently pulling new talent into town, he had made himself essential to the Kansas City musical scene. Moten was a builder. Along the way he had grown his band from three pieces all the way up to a jazz orchestra, battling every band he could. His greatest victories had been pulling in old Walter Page himself and then stepping away from the piano to let Bill Basie get that rhythm going. He

knew who belonged where. He wasn't just a damn paymaster; he was a leader with big dreams for his music and for his men.

There was no better symbol of what Kansas City was about than the sight of tack-sharp Bennie Moten and his musicians. Always exquisitely dressed, the bandleader could be either cheerful or as serious as an open straight razor. Moten always had his eye on the East; they'd fallen short on the first try, in 1932, but he planned to go after victory there one more time, one more once. Someday, he knew, Bennie Moten's Kansas City Orchestra was going to raise its flag on the musical hill of Manhattan. Under his leadership, the men in his orchestra would have followed.

But it wasn't to be. After Bennie's death, his nephew, Bus, tried to take over, but he wasn't the same kind of man as Bennie. Bus was too quick to anger, too argumentative; no one could get along with him. Everything fell apart quickly, ending any sort of Moten dynasty.

Buster Smith had gotten to know Kansas City as a Blue Devil, and his reputation for taste and craft made an impression. As Jay McShann said of him, "We all knew what we were saying when we called him Prof, and the people before us knew, too. It's just what the man should have been called. He was a professor. . . . He knew a lot of music and he knew how to write his music, and he wrote so great and he could *play* so great." Trumpeter Orville Minor saw the same thing in Smith: "He wasn't a rough-edged guy. Any time you saw him, he was a tie-and-shirt man. He didn't talk a whole lot of foolishness and all that. Buster Smith was the kind of a man you would look up to. If you didn't, Prof could show you why you *should* look up to him."

McShann recognized that Smith was one of those players who brought virtuoso skill to the blues. "Buster had a good bringing up. He played correct. He played piano correct, wasn't no wrong

chords, and he played *good*. He played clarinet, he played all the saxophones, he played violin. Buster played bass. He was just one of those kinds of musicians." Even early on, he displayed a proficiency that would be an obvious influence on Charlie Parker. "If you had a chance to hear Buster stretch out, it would have sounded something like what Bird did later on. It's just that Buster didn't care about stretching out. That guy was phenomenal. I think he was so much of a gentleman that he didn't really want to be bothered with what you had to go through to become a star. He knew what he could do." And that was enough.

But there was also something cautious about Buster Smith, something that kept him in the background, away from the footlights. "He wasn't one to chase after anything. No, Prof just laid it back cool. You had to push him to find out what he could do." After Moten's death, he teamed up with Bill Basie, at the Reno Club. When John Hammond came along to lure Basie's band back east, though, Buster opted out. Perhaps he was reluctant because of his experience with the Blue Devils, but just as likely it was because he knew how badly Moten's band had done on that eastern tour in '32. They made some great records in New Jersey during that tour— "Toby," "Moten Swing," "The Blue Room"—but as good as they were, those sides were cold comfort after the painfully heavy dues they paid along the way, plenty of rocks in their pathway. Plenty. By the end of the trip, they were reduced to eating a rabbit stew off a pool table. The road was fickle, success as fragile as those shellac discs. If two bands as strong as Moten's and the Blue Devils could run into such trouble, why should Basie expect anything more? Buster Smith was skeptical and stuck around Kansas City, safe and sound but ready for whatever came his way.

Orville Minor, who played with both Buster Smith and Charlie Parker, remembered seeing Buster at a jam session before Basie

pulled up stakes and rolled on out. "One night Benny Goodman got his horn out and came up on the stand with Lester Young, Jo Jones, Herschel Evans, Buck Clayton at the Reno. Benny Goodman started playing—and that was a night when Buster chewed him up and spit him out! I think it was that John Hammond [who] brought him down there. Benny wanted to hear Basie because the white men knew that if you wanted to learn something you went down there to hear what those colored musicians have to say. He learned something that night. . . . He found out what a whole lot of people found out when they got to messing around in Kansas City. Benny Goodman found out how it felt when being a star didn't mean nothing. You needed to be more than that to stand up against that rough stuff they had for you in Kansas City."

Buster Smith made short work of Goodman that night; he seemed to pop out of the ground with two guns of imagination, hungry for bear. "That night was the Buster Smith everybody respected. Prof was cool about what he could do, but when he got to doing it, he could start spinning and spitting that stuff out. He could run a cyclone of fire up your butt."

BY EARLY 1937, Buster Smith had his own band going. He was working at the Antlers Club, in a section called the West Bottoms, right down on the state line, about a half a block from Kansas. The Antlers Club wasn't far from the stockyards; Swift, Armour, and Cudahy all had meatpacking plants nearby. The Antlers was owned by Bus Pasler, a slender man who "looked Jewish" to the musicians and never hired any white bands. "Colored people was right down his alley," recalled one of the musicians who worked the Antlers in many different bands. "A white man couldn't get a job from Bus Pasler even if he was paying himself."

Pasler's club was a beer joint, with one of the longest bars in Kansas City. There were stairs near the entrance that led up to the second floor, where the topsecret after-hours activities took place—but the Antlers didn't serve Negroes, and the musicians couldn't come in the front door. The bandstand was in the middle of the room, surrounded by some space for dancers and then tables that went to the wall.

They played from about nine o'clock to two in the morning, mostly for dancing. "We were playing a lot of things like 'I Got Rhythm' and blues things mixed in with that," Orville Minor remembered. "Prof wrote a tune called 'Blues in D,' and it was a hard key to play but we were down there playing it. Things like 'Liza' and whatever tunes the dancers liked best were what we were playing. That was for the regular customers. When they were gone, we did the other shows upstairs."

The time Charlie spent in the Ozarks paid off. One evening, after his little job at Musser's was over, he took his horn down to the Tap Room, where his old buddy trumpeter Oliver Todd was leading a group. Charlie was in good spirits, laughing and joking, reminiscing about how Todd had split his wages with him when they worked together at Frankie and Johnny's and the owner wanted him fired for refusing to get a screw to fix his saxophone. That was only a year ago, back when he was still being laughed off the bandstand at the Reno Club. But Charlie wasn't crying now. There was a new feeling of confidence in the way he stood, the way he pulled on a Camel cigarette, in the cast of his eyes and the feeling he had about music. Now Charlie wanted to play, and over the scowling protests of the band, Todd invited him up onto the bandstand after the break. It was about 11:30. Todd looked at his friend and asked him what he wanted to play. Charlie Parker chose "I Never Knew."

The tempo kicked off. Everyone was looking at him, lying in wait

and listening. It was warm up on that bandstand, invisible waves of red heat dominating the air. His shirt was beginning to stick to his chest and stomach. As the music floated into the air, Charlie took aim and played what he knew how to play. It might not have been a lot, but it was what he knew. He had struggled for it, and it was right.

That didn't change the hostility in the air. It was there, thick and hard as a mature oak, disdain not about to budge. This kid had him some nerve to step up there with them again, disrespecting the music with his ineptitude and his desire to be seen in the company of professionals. Todd was making a mistake, letting this guy come up there. He was nothing but a drag—a mutilator, not a musician. Charlie had to play through all that animosity if he was to stake his claim for some respect.

The only thing Charlie Parker had now was what he had learned, what he knew he knew, what the sweat and frustration had led to, how the time he'd spent playing had been shaped into the sound of a young saxophonist who clearly felt himself in the presence of his enemies. All he could do was play. He reached for what he knew and held on.

"Before the thing was over," Todd said, "all the guys that had rejected him were sitting down with their mouths wide open. I had seen a miracle. I really had. It was something that made tears come down my face."

Playing with Buster Smith had been a dream of Charlie's since he'd started listening to the former Blue Devil's broadcasts out in the Ozarks with Clarence Davis. "When you got up there on the bandstand with Prof Smith, you knew you were somewhere," Orville Minor recalled. At one point, Charlie passionately asked Oliver Todd, "Please get me in that groove," meaning Smith's band. But the deal was actually sealed after the Ozarks job, later in 1937, when Smith heard Parker play. In effect, he got himself hired through the quality of his playing.

At that moment, Buster Smith was almost all Charlie cared about. He wouldn't allow his mind to set on anything else for very long. His mission was nearly sacred to him, and he went at his apprenticeship with the resolute intensity of one converted through revelation. Buster Smith knew that saxophone, and he wasn't afraid of it. There was something in his work that lay close to Roy Eldridge; it took on the instrument and made things come out no one expected. Smith's ideas turned corners at a fast clip, and his

knowledge of the piano gave his chord structures solidity. There were also the distinctions that writing music gave his playing. The discontinuity that Ralph Ellison observed is also a way of thinking in more than one line at the same time, a way of creating something like a contrapuntal effect on a single-note instrument, playing one voice up here, answering it with another down there, starting an idea at either end of the instrument and taking it all the way to the other extreme, sailing through the ballroom of the music with the audacity of those Oklahoma City dancers in Slaughter's Hall. All those effects—that internal dialogue, that contrapuntal effect— became basic to Charlie's mature style.

During his apprenticeship with Buster Smith, Charlie drew on everything in front of him. After putting in his time in the lower grades of learning, now he was in musical college, doing an independent study with a master who also allowed his student performing space right next to him. In Charlie, Smith found himself with a musical son. Wherever Smith was, Parker was sure to come. Charlie studied Smith's fingering, watched how his mouth worked when he was executing his passages. He listened for every element that connected one thing to another, asked questions about how to shade individual pitches, and worried over his tone. Smith even agreed to practice with Charlie. Master and apprentice sat down, saxophone to saxophone, playing through the lines and improvising on fast-paced pieces like "Dinah," "Oh, Lady Be Good," "Sweet Georgia Brown," and "After You've Gone." Parker stopped by to see Smith as he worked at the Antlers during the day, walking his stooped walk across the floor to join Smith as he worked out chord progressions on the piano.

For the musicians on his bandstand, Smith set an inspiring example. "He liked to sit down and play some chords and talk about things in the world," Minor recalled. "He was an intelligent man.

As a saxophone player, he was something. His technique was very good. Buster had the good sound of a lead alto, but he played like he had been schooled good somewhere. Buster was playing all of the modern changes, the chords the advanced people knew. You had to pay attention to him when he was playing."

Smith took care to usher his young charges into the jazz fraternity. "Prof wrote notes big enough for you to read a block away," Orville Minor remembered. And he extended himself to Charlie in particular, telling him how he, Lester Young, and Eddie Barefield used to study Frankie Trumbauer, listening to the recordings over and over. He told Charlie how impressed he'd been, in those early years, by the virtuosity of players like Jimmy Dorsey, with his control of the alto saxophone and his ability to execute difficult passages. He was startled at how quickly Charlie picked up on what he was shown.

As Orville Minor remembered, Smith's protégé could be a playful troublemaker. Now and again Smith would admonish him— "Don't be practicing on my bandstand"—when Charlie started wiggling phrases on his horn between songs or tried to push something through a hole in an arrangement. "Charlie Parker was a guy who didn't like anything according to Hoyle, and if he could bend it, he would bend it quick. He was full of mischief and was one of those people hated a dull moment." Yet with Smith he generally behaved himself. "Bird was under a microscope with Prof's band, because Prof was a real professional and didn't put up with something if it wasn't right. Buster Smith laid the law down, and Bird paid attention to it. He stayed on Bird's case every night. Buster was somebody he respected. You had to respect that man: he knew too much music, and when he wrote something, he meant for you to read it right and for you to come in when you were supposed to— no missing, no messing around."

Though Charlie was the soul of attentiveness and manners when he was in Buster Smith's presence, once the job was done he was more than ready to stay out all night long. Those long nights included running over to Fourth and Main, where an Italian woman known as "Moms" sold marijuana, four reefers for a quarter, a full red Prince Albert tobacco can measured into a paper bag for three or four dollars if you had it. Since the automobile accident, Charlie had learned how to clean out the seeds and the stems, pinch off the sometimes gummy marijuana into a cigarette paper, lick it, and inhale the smoke with the loud viper puff that was more a theatrical gesture among reefer smokers than a necessity. The smoke in his bloodstream slowed things down; it brightened the sound of music, the textures of voices, the songs of birds, the industrial noises of city life. He even put his digital virtuosity to work on the party trick of rolling a cigarette with one hand. He also started experimenting with the stimulant Benzedrine, which allowed him to go on and on, practicing, jamming, walking the streets and looking in windows, talking of his dreams with friends, and remaining out until those who'd gone off to bed hours before were awake again and ready to play.

Once everyone else went home, Charlie sometimes stayed in Paseo Park, alone with his saxophone on a bench that had been filled with musicians a few hours earlier, all of them swinging the blues and going through hard tunes, neither the people in the neighborhood nor the police bothering them. Popping more Benzedrine whenever he found himself about to fall asleep, Charlie stayed out until his mother came and took him home. He later told his third wife, Doris Parker, that if not for Addie he might never have gone home; staying out was too exciting.

Sometimes it would be two or three days before Addie found him, nearly muttering in a hoarse and tired voice, mouth dry, lips

white, eyes ablaze, joints in his knees and arms aching, his body smelling from not having changed his clothes, but his soul feeling as satisfied as his body was exhausted. It was during this period that Charlie began to notice that his appetites were larger than those of others, that he started to sense that he was somehow a danger to himself.

On the job, Charlie Parker was punctual, and at first Smith had few real problems with him. Now and then Charlie nodded off, but no one really understood what was happening with him. Hard drugs were still novel then; most musicians either drank or smoked reefers. Parker later told fellow heroin addicts that morphine was the first high that pulled him down into the tiger trap of addiction. It was strange: morphine was an upper-class high, one that moved through the decadent world of casual substance use that Cole Porter wrote of in "I Get a Kick out of You." Though many claimed to have influenced Charlie musically, no one seems to have taken credit for the first time he was shown how to prepare the powder and shoot it into his arm, for the moment when he was introduced to the slowed-down, drowsy world of sedation and chaos.

Still, there are tales that shed some light on Charlie's darkness. According to one Negro hustler who ran an after-hours gathering spot called the Happy Hollow, heroin didn't come to Kansas City until around 1940, when he went north and got permission from the Chicago mob to bring it in himself. If he is to be believed, then, the only thing Charlie Parker could have scored in 1937 was morphine stolen from a pharmaceutical dispensary or a hospital. This connection to the medical world is highly possible; some of the old heads from the time remembered a woman known as "Little Mama" who worked as a nurse or in some similar capacity at a Kansas City hospital, and who, legend has it, introduced the young musician to hard-core dope. Little Mama is said to have been small, dark-

skinned, nicely proportioned, and vivacious. If Charlie's drug struggles began with her, that would make her a female counterforce to the power of Addie Parker, nurturing the gummy darkness that would stain the course of his life. Whoever the culprit was, bassist Buddy Jones told Robert Reisner that Parker himself described the beginning to him: "Getting high at fifteen, Bird told me what he felt. He pulled out $1.30, which was all he had and which was worth more in those days and he said, 'Do you mean there's something like this in the world? How much of it will this buy?'"

Charlie's curiosity about narcotics may even have been related to his affection for Sherlock Holmes mysteries, which he read during his teenage years. Arthur Conan Doyle's tales had the kind of intellectual materials that would resonate with a curious but introspective young man like Charlie. The detective Holmes was no average person. He was gifted to a superior extent, but alienated by his peculiarities and his focus on elements missed by those who moved more casually through life. Parker wouldn't have had to read very far into the Holmes stories before encountering the second of Conan Doyle's Baker Street tales, *The Sign of Four*, with its startling opening:

> Sherlock Holmes took his bottle from the corner of the mantelpiece, and his hypodermic syringe from its neat morocco case. With his long, white, nervous fingers he adjusted the delicate needle and rolled back his left shirtcuff. For some little time his eyes rested thoughtfully upon the sinewy forearm and wrist, all dotted and scarred with innumerable puncture-marks. Finally, he thrust the sharp point home, pressed down the tiny piston, and sank back into the velvet-lined armchair with a long sigh of satisfaction.

If Charlie Parker the fledgling professional was looking for ways to rationalize his burgeoning dependence on drugs, he could easily have found one in the example of Holmes, who goes on from that passage to exhibit incredible powers of detection, a mastery of large implications divined through small details. If Charlie read the story before encountering the sweet haze of morphine, his curiosity is understandable. Each Doyle sentence is a road leading into a world where calculated or desperate destruction became comprehensible through the heightened gifts of a great detective. The Holmes stories transcend constraints of race or class, since any brilliant young person in the modern world might identify with a detective solving the riddles of the universe.

The Holmes stories, of course, were narrated by his friend and helpmate Dr. John Watson, and there was something further about the narcotic lifestyle to be learned from Watson's reaction in the very next paragraph of *The Sign of Four*:

> Three times a day for many months I had witnessed this performance, but custom had not reconciled my mind to it. On the contrary, from day to day I had become more irritable at the sight, and my conscience swelled nightly within me at the thought that I had lacked the courage to protest. Again and again I registered a vow that I should deliver my soul upon the subject; but there was that in the cool, nonchalant air of my companion which made him the last man with whom one would care to take anything approaching to a liberty. His great powers, his masterly manner, and the experience which I had of his many extraordinary qualities, all made me diffident and backward in crossing him.

Watson's attitude toward Holmes's behavior—troubled, yet guilt-ily indulgent—anticipated the attitude of many of Charlie Parker's admirers as his career grew. When Watson does question the great detective about his drug use, noting its potential danger to his health, Holmes responds: "I suppose that its influence is physically a bad one. I find it, however, so transcendently stimulating and clarifying to the mind that its secondary action is a matter of small moment." Pressing Holmes further, Watson mentions not only the drug's effects on the body but also the "black reaction" that comes over his idol under the sway of the drug. "Surely the game is hardly worth the candle," the doctor urges. "Why should you, for a mere passing pleasure, risk the loss of those great powers with which you have been endowed? Remember that I speak not only as one com-rade to another but as a medical man to one for whose constitu-tion he is to some extent answerable." Holmes almost welcomes the doctor's questions, but his answer is hardly comforting: "My mind rebels at stagnation. Give me problems, give me work, give me the most abstruse cryptogram, or the most intricate analysis, and I am in my own proper atmosphere. I can dispense then with artificial stimulants. But I abhor the dull routine of existence. I crave for mental exaltation."

It would take a while, though, before Charlie Parker's com-rades even recognized what was affecting him. To Buster Smith, he seemed no more than a somewhat fatigued but enthusiastic fellow when he took his place on the bandstand at the Antlers. "Son, don't be sleeping on my bandstand," Smith said whenever he caught Parker's head starting to droop forward. "Sleep at home. Get yourself some rest, son. No sleeping up here."

But Charlie didn't let anything get in the way of his work—at least not yet. He was too impressed by Buster Smith, so much so that he was starting to call him "Dad," which was hardly surprising,

as he was trying to learn everything he heard Smith play. Somehow, he managed to keep his wild side in check around his first flesh-and-blood mentor. Smith had no idea what made Charlie seem to need so much sleep, and Charlie was able to keep him guessing: all he had to do was snap his head up, open his eyes, and become attentive, smiling slightly as though acknowledging that he just needed a long night's rest.

Once he got back out onto the street after the show, Charlie kept up his other apprenticeship—in the codes and activities of the nightlife, the solid rules of the evening. Those rules were segregated, at least during certain hours. During those hours the musicians and the people in positions of service appeared and did their jobs, the former using instruments to turn the smoky air of a nightclub into a paradise of rhythm, lyricism, and blues, while the waiters appeared and disappeared at the tables with an elegant balancing of drinks, food, and advice for the evening—much as the white train passengers of the time were served by other graceful Negroes, among whom spillage and accidents were as rare as the appearances of intelligent Negroes in American films.

If a Negro musician hit it off with a white woman, there were ways of pursuing that interest, too. Later, the musician could have a light-skinned guy take a cab to her neighborhood, pick her up, and bring her to one of the whorehouses on Tenth Street, or to an after-hours spot where he could get a room for the night. Of course, there were still limits—one of them being that the woman couldn't be attractive. It didn't get *that* liberal: as long as she was stringy-haired or old and shapeless, the club owner would turn away if he saw boudoir looks being exchanged. At some of the clubs, Negro musicians were allowed to sit at the tables with customers; this was tolerated almost exclusively in rooms owned by the Italian gangsters, who were so powerful that

they did whatever they wanted and allowed whatever they felt like allowing.

After hours, yet another set of rules played themselves out at the "spook breakfasts," which began after everything else was over—starting at four or five in the morning, often extending till noon. At the spook breakfasts, held at a different club each week, musicians played while obliging locals served up hot dogs, hamburgers, and chili—quick food, nothing that took too much time. The spook breakfasts were wide-open racially. When white customers felt comfortable rubbing shoulders (and whatever else) with Negroes, they could come and live for a few hours in a world of ethnic diversity after dark. White musicians who had heard about Kansas City swing brought their horns if they felt they were ready, their ears if they felt they weren't. Everybody in the nightlife knew about the spook breakfasts, and they were never at a loss for customers.

Even more private than the spook breakfasts were the kinds of after-hours shows given at the Antlers on Saturday nights. Admission to these shows was restricted, more or less, to those who knew Bus Pasler personally; they might be rich, they might be politicians, they might be black or white, but if they were tight with Pasler and could pay the price, their way was cleared to the upstairs room where the "freak shows" took place. "In the freak shows they had freedom the backwards way," one musician recalled. "Everybody [was] looking at something strange, or they was up in front of people *doing* something strange."

The shows, also known to the musicians as "smokers," generally involved sex acts presented in an almost vaudeville style, with the band performing musical backgrounds for different kinds of erotic exhibitions. Men in dresses were seen performing oral sex on other men, or being mounted by men after being lubricated in a slow, sensual preamble. Women had sex with other women. Some puffed

cigars with their vaginas; others had sex with animals. On those secret Saturday nights, playing third alto in Buster Smith's band, sixteen-year-old Charlie Parker had his eyes opened yet further to the difference between what went on in the conventional world and what happened when people chose to reject the laws of polite society, to satiate their appetites, whatever they might be. It was a spectacle to erode one's confidence in rules and laws, in anything beyond the pursuit of mutually agreed upon satisfaction. Morality had its peaks and valleys, and in Kansas City, those down at the bottom seemed as confident in what they were doing as those on the top.

The world of the musicians themselves, however, rose high above the corruption that surrounded it. There was a feeling of community among them when they were out in the streets after their jobs were done, or as they prepared themselves to look their best for the next engagement, some dance or college date at home or not so far away. It was a world in which the smell of barbecued ribs, chicken, and chili; the feel of new shirts; the fresh scent of leather shoes; and the nosegay of soaps, pomades, and colognes added up to expressions of excellence and visions of glamour.

"Musicians were strictly following rib joints and chili joints after work," bandleader Jay McShann recalled. "Guys would have them a taste or two or three or more through the night; some might take some drags off a reefer; either one or both would make you hungry. Your stomach would be crying out for *something* to arrive and come on down there and get to filling it up. None of this has stopped you from continuing to have a little taste between shows, out in the alley behind the club with guys, that sort of thing. One more sip and just a little bit more hunger. So the hours are passing, you're up there sweating and swinging, and your stomach is still crying the blues, louder by the minute. With all this activity, you knew you had

to get something down in your stomach, and by the end of the gig, you wanted it to be hot, it had to be a solid, and it better be *right*.

"So we'd give Smith's barbecue and chicken and Gates's chili and Harris's barbecue a rough time. That kind of food would counteract that alcohol. If we was working downtown, by the time we got to Twelfth and Vine, we was straight. Didn't make no difference what you did, you held on to a quarter so you could get some of that chili. It would straighten you out. . . . Smith, Harris, and Gates, oh, they were rough. Walk in on one of those three and that woodburning smell mixed up with that meat would hit you and you knew good and damn well you was in the right place. No mistake had been made. None."

McShann recognized men like Smith, Harris, and Gates as comrades. "All of those men were proud of what came out of their kitchens. People were like that then. They worked hard to do something right. That's how everybody expressed himself, putting in that little extra. You had to get it right. Oh, yes, you had to get it *right*. It would be your signature, you might say. Then people knew who you was. Wasn't no confusion. You were *good*. The facts spoke up for you. That's right. They sure did. They spoke loud and clear."

And looking good was as important as eating well. "In those days, wasn't no looking like bums, none of that. You tried your best to look as good as you could. Musicians used to buy their clothes at one place on Eighteenth and Vine and another across from it, both run by Jewish fellows. One or the other got your money. They had the quality, the look; they knew what they were doing. Those Jewish fellows were tops. They had everything a musician needed. Cats like George E. Lee used to stay sharp going in there. Those two places sold shoes, suits, shirts, everything, because all a musician wanted was to be sharp. When we played these one-nighters, we'd set the styles of how people dressed and how they wore their hair."

As McShann recalls, nightclubs and restaurants weren't the only places where the Kansas City musicians crossed paths. "All up and down either Eighteenth Street, near Vine, or up and down Twelfth Street, near Vine, were the barbershops. All the news and the sports averages and that sort of thing, people with their political opinions and what not, like the neighborhood Senate or Congress, you might say. Arguments. Lies. Who shot John. Bloody murder. Oh yeah. You never could tell what the talk would be, but it would be loud and strong, and you'd get yourself a laugh while they was fixing up your look. Cat go in there with his hair looking funny one way, and he'd come out of there looking all good, smelling all good, hell, *feeling* all good. In the barbershop he'd get the hot towel on his face, get the hairs picked out of bumps, get the sideburns right—sideburns were big then—put on some cologne, and then he's *ready*."

CHARLIE PARKER'S FIRST stint with Buster Smith lasted only a month or two, and soon Charlie was out looking for other work. In the summer of 1937 he got another job in the Ozarks, with George E. Lee and His Novelty Singing Orchestra. Lee had been a rival of Bennie Moten's in the late twenties, but hadn't been able to maintain the quality of musicians that would have allowed him to hold a position in the upper reaches of Kansas City instrumental swing. He had also been guest leader of the Deans of Swing, when Charlie was getting his professional feet wet at Lincoln Hall, and is thought to have helped the young alto saxophonist with some union business at an early point. Regardless of his troubles keeping a good band together, Lee was still a very popular Kansas City singer, proficient in both ballads and the kinds of oddball comic tunes that were rooted in minstrelsy and vaudeville.

Lee's work reached into the repository of American show business, reflecting the popularity of the arias that spun on so many turntables, regardless of race, when the recording industry started to roll. The sentimental ballad went all the way back to the minstrel shows, the tunes of Stephen Foster and the overweening moments of mush when the white men—yellowed up as Creoles—sang of, or to, their objects of affection, who were also white men, but in drag. Negroes didn't have much of a tradition of singing slow, lyric material that wasn't religious or blues, but the long shadow of Enrico Caruso stretched across America; almost everyone heard his ringing tenor, including Louis Armstrong, who recalled enjoying the singer's recordings when he was still a child in New Orleans.

Caruso's sound brought a melodic sexuality to the American drawing room, and his material projected the fascination with death that arose over and over in opera. Over time, his image slowly transformed into that of the patent-leather-headed Latin lover, he of the tango and the desert tent, which moved into the American sensibility in the form of Rudolph Valentino on the silver screen, and in phonograph records in the form of handsome popular singers who appealed to the female need for romantic recognition that could be dangerous, elegant, scalding, or tender in so many transcendent ways that they took on a masculine majesty. By working in that musical tradition, George E. Lee was one of those who took a path that led away from the blues—the same path that Billy Eckstine eventually followed all the way to the position of matinee idol. With his fine clothes and his ensemble of musicians, traveling in an eye-stopping team of luxurious Hudson automobiles—one pink, one blue, one green—Lee was inclined in that direction himself.

Lee was an entertainer all the way, a showman who made a win-

ning combination with his singing sister, Julia, who also played the piano and could drink and gamble with the best of them. For laughs, George Lee even made a show of puffing into the tenor and baritone saxophones onstage, prolonging the instrument's minstrel identity even as everyone Charlie admired was ushering it into more sophisticated territory—including Buster Smith himself, who joined the band around the same time as Charlie. Another member was the guitarist Efferge Ware, and it was Ware who taught Charlie how to run cycles of fifths and resolve different kinds of chords. He gave the same lessons to Gene Ramey, who remembered jamming with Ware and with Charlie, all three of them trading insights about their craft while tightening their harmonic precision.

Between Buster Smith and Efferge Ware, the first half of Charlie's summer was perfect. In the second half, Buster Smith launched a new big band at the Club Continental that included the piano of Jay McShann, who had landed in Kansas City earlier that year. It was McShann's introduction to the musical aristocracy of the swing capital.

"I first met Buster Smith when I came to Kansas City in 1937 and Basie had already left," McShann recalled. "Buster was playing with Dee Stewart's band at the College Inn, which was then called Club Continental. They needed a piano player, and I was working with a drummer named Elmer Hopkins, just the two of us, and the cats come and got me. . . . They hired me on a short-term basis until their regular player came back. When he came back, the guys still wanted me to stay. I couldn't go. By then I was working at this place called Wolf's Buffet, where they had me and a drummer and sometimes Joe Turner came in there and sang the blues, and we had one of those girls who could dance by the table corner and put that twat up there

and take the money off—so she was valuable, bringing in those tips, which we split three ways. We were doing just fine. I had my wife to take care of, so I had to take the best paying job I could get.

"I made the next gig, though, which was Prof's big band at the Club Continental. His big band didn't last very long, because then there wasn't much business for a big band in Kansas City. It couldn't have lasted more than two months. We would have been lucky if it lasted three months. Things were over and it was gone. Situations were moving very fast then. We all loved the band, but it didn't work enough for us to be able to do anything with him for very long."

Smith's big band played college dances, fraternity socials, and the like. "After those dances, we would have sessions somewhere on the campus or near. . . . There were always some kids who still wanted to swing. We worked in places like Missouri University in Columbia, between Kansas City and Saint Louis, practically almost in the middle. We played our jazz book, just what we had. Those white kids wanted to swing, and we knew how to give them all the swing they could stand. Yes, we did."

When Charlie wasn't studying with Buster Smith or listening to the latest records from the East—Roy Eldridge, Chu Berry, Jimmy Dorsey, Benny Carter, Johnny Hodges—he hung out with some of the guys at the Castle Theater on Twelfth and Paseo. They sat in the balcony, drinking wine as they watched the afternoon's fare— two serials, a feature, and a comedy—and listening to the ways the chords in the movie soundtracks moved and resolved, how the scores went into relative majors or minors. They listened to everything over and over again, analyzing and debating what they heard until it was time to leave for the job. When they actually watched the movies, which they didn't always do, the musicians noticed how different tempos and colors were associated with

various moods and actions. In the grand democratic tradition of technology in American life, they were scouring other art forms for elements that could serve them in their own, which helped them to increase their control of the craft through which they could express their individual identity.

One night at the Club Continental, while the big band was swinging, Benny Goodman came in. He wanted to hear Buster Smith again. Jay McShann remembered the night well:

"Now Prof, [with] all that saxophone he could play, you never could get him to play. He'd take one chorus, whet your appetite, then he'd stop. It was frustrating because you always wanted him to stretch out. Buster would play short, then he would let Charlie play, let me play, whoever else, *somebody*. Everybody but himself. Buster didn't care about it. He drove us crazy. We wanted to hear that music come out. That wasn't his style. Give you a little bit and sit down. That was Prof.

"But the night that Benny Goodman come in, we wouldn't settle for that short stuff. We wanted to hear Prof open up. . . . We started to calling out, 'Go 'head, blow, Prof, blow.' I guess we made him feel it. He let it go. Oh yeah, he let it go, but he let it go with all that control that kind of musician has. When you hear that, man, that really is something. It really is. . . . It starts to build, and it starts to build some more, and it keeps on building; each one of those choruses comes right on in there, *perfect*, just like a coupler snapping those boxcars together. It starts to rolling and you have to feel it, you can't resist it. That groove is in there and you can't get over it, you can't get under it. You *got* to swing. We're still calling out, 'Blow, Prof, blow,' and we're swinging hard as we can now, with Prof out there letting it get just as rough as he wants it to be. . . . This is do or die right now. This is the master in action. This is Kansas City swing, strong as it gets. This is the whole kit

and kaboodle coming out red hot. You couldn't hardly stand it he was sounding so good. Prof got to playing so much he leaned over and his glasses fell down to the end of his nose, just hanging there about to fall. It looked funny but you couldn't laugh; you couldn't laugh because he was *playing* so much. Benny Goodman just sat there shaking his head."

IN ANOTHER OF the quick leaps from one bandstand to another that were so common in the lives of professional freelance musicians of the era, Charlie also spent time with Kansas City jazz legend Tommy Douglas. Like Walter Page, Douglas had been classically trained at the Boston Conservatory, and he had a strong reputation in Kansas City. Though his specialty was the alto saxophone, he was a master of more than one reed instrument and stood confidently within the ranks of Kansas City musicians. In photographs, Douglas projects a pert dignity and has the imperious posture of a man who was both a disciplinarian and a rumbler. One photo shows him standing in front of his band bus, a few feet above a line of squatting musicians, holding a clarinet and staring at the camera with the low-keyed but baleful intensity of Joe Louis.

With Buster Smith, Charlie had been given enough improvising space to try out new ideas almost instantly. Douglas was a different story. As Clarence Davis pointed out, "When Charlie Parker worked with Tommy Douglas, you can believe that he was playing third alto, because Tommy Douglas was going to be the star. Tommy might have let him get off now and then, but Tommy Douglas was going to do almost all of the playing. Buster Smith and Tommy Douglas was the two best around here. Tommy Douglas knew how to play them high notes way up there. They used to get him. He was one of the ones they would wake up if somebody came through

town blowing. He'd get up out of his bed and come over there and put something rough on him."

Douglas took a more authoritarian attitude toward Charlie than Buster Smith had—especially after he realized that the young man had started hocking his saxophone for drug money. As Douglas told Robert Reisner, he saw Parker's problems and promise very clearly:

"Charlie Parker was playing with me when I cut the band down to seven pieces. He was on alto. He was about fifteen then, and he was high then. I told him he was in trouble, and I used to have to go and give a taxi driver ten or fifteen dollars to get his horn out of hock because he was high on that stuff. Finally, he lost the horn and I got mad and wouldn't get it for him. The taxi driver soaked his horn and wouldn't tell him where he had it.

"When I was blowing, he'd be sitting there smiling and tapping his foot, and I figured he was just high off that jive, but he was digging. I took a Boehm-system clarinet (I played both Boehm and Albert) over to him one day, and he came back the next and played all the parts; he was that brilliant. It wasn't long before he was playing all the execution, and it was that clarinet that started him soloing."

Apparently, Douglas was thinking beyond the harmonically commonplace. His style pointed in the direction of the bebop movement that Charlie would pioneer, with Dizzy Gillespie, in the 1940s. "I was playing almost the same way, way out. What caused me to do that was studying theory and harmony. I made all passing tones and added chords, what we call intricate chords today. I was doing all that then in 1935, and in order to get that in, it called for a whole lot of execution. Naturally I couldn't just run notes, and I had to figure out a style, but nobody understood it."

Douglas may have been overstating the gulf between himself

and his peers. He was a highly sophisticated musician, but he was also very popular, as Jay McShann confirmed: "When Buster Smith or Tommy Douglas came in a club, *musicians* would sit down and listen. They knew there was learning to be done."

So did Charlie, who was taking in information like a vacuum cleaner and challenging himself in more inventive ways. By now, he had long since mastered the physical challenges of playing—the pain of the lips, the tongue, and the teeth; the fatigue of the fingers; and the limitations of the lungs—and become preoccupied with the coordination of mind and muscle necessary to make his own way.

That coordination allowed musicians of Charlie Parker's era to create a new experience of time, an innovation in performing consciousness that was fresh to Western performing art. It amounted to a kind of *control of the present*. Unlike the European concert musician, who could be compared to an actor, a person who used the subtleties of interpretation to bring vitality to material created in the past, the jazz musician wrote and interpreted his own script on the spot, right in the middle of the chaos of the moment. Charlie Parker's mind moved faster, and had a greater command of detail, than that of the merely gifted. And in order to serve his quicksilver consciousness—and the montages of passion that it demanded—he had to address not only his own physical limitations, but those of his instrument.

From the start, one of Charlie's goals had been to refine his tone, to get rid of that goddamn vibrato and create a sound that was built for speed. To further his cause, he took a Brilhart mouthpiece—an uncommon brand at the time—and experimented with its shape, filing it down in an effort to control the sound even further. In doing so, he was ignoring the advice of older musicians, who warned him about the possibility of brass poisoning. Players such as Tab

Smith, an alto player with Lucky Millinder and Basie, had gotten infections when the sharp edge of an altered metal mouthpiece cut into their lips as they played. As was his way, Parker listened, said nothing, and then went on with what he was doing. Parker became such a proficient reworker of mouthpieces that he was soon filing away on those of his fellow band members and of any other saxophone players who trusted his skill. He was also trying out all kinds of different reeds, those shaved cane strips that rested between the mouthpiece and the lower lip, providing the quiver that created the sound when a player blew wind past its sharp edge. Parker singed his reeds with matches, sanded them, and scraped away almost invisible layers with a knife. He was trying everything he could think of to push his pitches through the horn quicker, to make them as blunt as snapping fingers when the inspiration demanded.

But the physical world was distracting him, too. His troubles with hard drugs were increasing, and they brought his relationship with Tommy Douglas to a sour end. Soon he was back looking for another job, his saxophone always one step away from the pawnshop if his need for drugs outran his opportunities to make money playing. Charlie's musical education was accelerating, but sorrow and confusion were entering his life at the same high rate of speed. He was starting to experience the discomfort of repeatedly disappointing people he admired. It was a feeling he didn't like, because for all of his shyness, he was a proud young man. But pride and drug addiction are forever at odds. If pride wins, the person escapes the tragedy of addiction, while gaining an understanding of human frailty at its most harrowing. If addiction wins, however, pride takes that hard, mutating fall, boiling away in the bent spoon where the dope is cooked.

Charlie's relationship with Rebecca had changed since their violent altercation after she found the love letter from Geraldine. A

chill set in, her disappointment matched by his aloof indifference. The situation took on its own rhythm, and Rebecca weathered it with the sort of stoicism she had always observed in the women around her, most of whom accepted the bittersweet particulars of domestic life and made their homes what they could by immersing themselves in work and through their dedication to their families. Rebecca knew she was isolated—shut out by her mother, only fitfully in contact with her siblings, considered an interloper by Mrs. Parker, and little more than a witness to Charlie's dissolution.

Nothing she had ever heard of or seen had prepared the pregnant young woman for what was happening, and there was no one to give her counsel. She had to make it day by day and stand up for her rights if they were trampled too harshly. Charlie knew it would be dangerous to abuse her again—that flying flatiron wasn't lost on him—but he didn't seem capable of telling her what was happening to him, what could make him want to go through the same thing over and over, falling into a pit of drugs and whatever else, climbing out exhausted and looking like a bum, then diving in again and again. Rebecca didn't know if he was ashamed or just secretive, but it was clear that this was the new order of things and that they were handling a great burden very early in their marriage, neither aware of what catastrophe would happen next. The only thing that gave the household any feeling of consistency or direction was the fact that Addie Parker still handled all the washing, all the cleaning, all the cooking. Only in the evenings, as they sat and listened to the radio after dinner, did the two of them feel together, like family. At least that is how the younger woman felt, what lifted her up inside, as long as she could continue to believe it, just a little. A little was a whole lot when she worried that nothing was coming at all.

Now that Charlie had dedicated himself to his career as a musi-

cian, and was growing more confident about his career, it became normal for him to appear and disappear almost continuously, leaving early in the evening and arriving home the next morning. Rebecca had a job working half a day way out on Prospect Avenue, where the rich white people lived at the time. When Charlie got home Rebecca was at work, and when she got home he was asleep.

The couple she worked for was Jewish; they owned markets and vegetable stands in downtown Kansas City. Rebecca took the streetcar to their house and did her work down in the basement—household laundry, washing the baby's diapers, and ironing—from early morning to noon for fifty cents. The lady of the house made dresses at home and would give Rebecca one of whatever was sewed into form—suits and dresses, often very pretty. If the lady of the house had a feeling to do it, she even gave Rebecca new shoes. The gifts made the job very good, allowing her things that were far beyond her salary. One by one, however, Charlie stole all these gratuities and sold them for drugs.

In January 1938, when Rebecca was fully swelled with child, Charlie told her, "Rebeck, don't name the baby if I'm on the road when he's born. I'll name him."

When the labor pains finally came, Rebecca called out for Mrs. Parker, who came upstairs to help. Calm and completely in command, she soothed Rebecca, braided her hair, and got her dressed. They went to General Hospital in Parkey's car. As delivery time came, there were three sharp pains, then Baby Parker, eight pounds and nine ounces, was born, naturally, no drugs, nothing. It was seven o'clock in the morning on Monday, January 10, 1938. Rebecca had been there no more than an hour.

About a month and a half later, Charlie returned home in the morning around ten o'clock. Rebecca was upstairs with the baby, who was in a bassinette. Charlie came in the room and kissed

Rebecca on the forehead. He was happy. Charlie stood there staring at the sleeping baby. Even as new to the world as he was, he looked exactly like his father.

"Rebeck, his name will be Francis Leon Parker. Francis is for Francis Scott Key, and Leon is for Mr. Leon 'Chu' Berry, the greatest saxophonist that ever lived."

Charlie seemed to feel he had done something great in fathering a son. In the springtime he took to sitting outside with him for hours, playing with the child. Now and again Charlie took the baby, whom they called by his middle name, in his basket and put him in the swing on the porch where he and Rebecca had once held hands in secret. The new father pushed the swing back and forth, taking care that nothing went wrong. People came around to see the child: sissy Julius from next door, Sterling Bryant, some of the white people in the neighborhood, a few of Charlie's musician friends, some of Rebecca's friends.

To Rebecca, Charlie's feelings toward Leon seemed less like a father's love for a child than like a child's affection for a toy. Perhaps he was too occupied with the drugs and the music, the needles that took him upstairs and the saxophone that sent him out into the street. He and a friend named MacDowell were still sneaking off upstairs to his room on a regular basis, pulling out the needles, and then staying there until they were ready to come down and head out for the night. When he came home, he didn't say anything to the child—none of the usual childlike phrases, teasing questions, or funny faces, the sorts of things babies absorb rather than literally understand, that make them feel they are the objects of a secure affection. No, it wasn't in Charlie to act the way Rebecca knew men to act if they loved their children. He was proud and happy about his child, but he held himself at a kind of a distance— exactly the way Addie Parker acted toward her son. No matter how

warm the outside seemed, the filling was ice water. His ways insti-
gated a wariness in Rebecca, a feeling that she couldn't trust him if
she should ever need him to stand up for her or their baby, and it
lended a sting to the sadness spreading inside her.

Rebecca was wary of him in other ways. The letter from Geral-
dine, which included references to oral sex, made her reluctant
to kiss her husband, lest she catch anything from him. When she
began to itch and notice bugs in her pubic hair, Rebecca asked
Addie Parker what to do. Parkey got her some medicine and told
her how to clean herself and kill off the intruders. Only later did
Rebecca realize that the bugs were crabs she'd caught from her
husband.

After the baby was born, Rebecca went back to work out on Pros-
pect. While she was at work, Parkey took care of the baby. Then, in
March, Rebecca became pregnant again.

This time it was a surprise, and it worried her deeply. The way
Charlie was acting with the drugs, the things he was stealing from
the household, and his refusal to talk with her except through his
eyes, she knew another baby could be a burden their fragile mar-
riage couldn't handle. There was nothing she could do; she was
trapped with another birth, another child Charlie would treat like
a toy, interested at first, then indifferent.

One day, a few months into her pregnancy, when Rebecca was
at work, she went outside to put the baby's diapers on the clothes-
line to dry. Later, when it was almost time to go home, she got the
diapers to bring them inside and fold before leaving. On the way
inside, her foot got caught, and she fell down the stairs; years later,
she couldn't say for sure that she didn't jump. She did know that
she went down that entire flight of stairs before she could take a
breath, landing so quickly she felt as much pain as surprise. As she
rose, surrounded by clean, wrinkled clothes and a partially empty

basket, she was already worried about cleaning up after herself. Then she felt something tearing inside her. She seemed to awake for the second time that morning.

Certain that something was wrong, Rebecca alarmed the lady of the house when she asked to take the streetcar home, saying her workday was almost over and she needed to sit down somewhere. She worried all the way to 1516 Olive, rolling slower than ever but getting there. Once inside the walls on Olive, she examined herself and found her underwear bloody. Her urgency overcoming her reluctance, Rebecca rushed to tell Parkey. At first Addie Parker chose "not to touch the wire," to let anyone know what had happened. Eventually, though, the young mother managed to call Kansas City, Kansas, for J. R. Thompson, the doctor who had delivered Charlie.

Thompson told her to come to his office immediately.

Rebecca took a streetcar to a place where she could catch a cab and then went to Dr. Thompson's office, which was up on a hill. Because it was an emergency, Rebecca was taken in immediately. Dr. Thompson was a handsome, light-brown man with gray hair, tall and thin, older than Mrs. Parker. He looked to Rebecca like an individual of mixed race, his Negro blood mixed with white or Indian, like a member of her mother's side of the family.

Oh, God, her mother, Birdy, whom she missed more now than she ever knew she could. But in that office, looking at that man, even upset as she was, Rebecca felt better, not so alone, in the hands of someone who knew what he was doing and cared about how she felt.

Dr. Thompson examined Rebecca and told her she was about to lose the baby. He packed her with medicated cloth and then told her that she would abort normally, for the baby had broken off from the umbilical cord. She was instructed to go home and let it happen there. Dr. Thompson gave her a bedpan, explaining that

she would soon abort in her bed and that Charlie should take her to the hospital right after the fetus came down, for the bleeding would be profuse and needed to be managed by medical professionals. Then he asked her how Charlie was—and if the young man he had delivered into the world almost eighteen years ago was still using drugs. Dr. Thompson had apparently found out about his addiction from either Addie Parker or Charlie himself. Rebecca told him that her husband wasn't working, that he was still using drugs, shooting up with needles, and running around like he was out of his mind.

Dr. Thompson looked Rebecca in the eye. "If he keeps using that stuff," he said gravely, "I give him only eighteen to twenty years at the most."

From Dr. Thompson's office she took a cab to the streetcar line. By the time she was walking up the steps of 1516 Olive, she had calmed down somewhat. She had made it that far. Rebecca told Addie what Charlie was supposed to do after the baby was stillborn and then went to bed, relieved that it hadn't happened on the street.

When Charlie got home, he went upstairs to see Rebecca. He was obviously upset; Rebecca noticed him pushing his tongue against his lower lip, the way he did when things troubled him. Yet to Rebecca it seemed as though he was about to cry. She felt as if there were no air, only emotion pushing at them from every direction. That emotion on her side turned to pain, and she began to wince as a large clot of blood made its way out with what was not a distorted baby but a string of flesh, not yet developed enough to be recognized as an unborn child. There was no time to think about that; within moments, the immobile string of flesh was followed by a gushing. Charlie was moving to assist his wife. He took the clot, dropped it in the bedpan, perused it very quickly, and stepped to the toilet. Then it was gone.

Coming out of the bathroom, Charlie was fully a man somehow; in the moment of crisis he summoned full authority, shouting to Parkey that Hattie Lee had to call a cab *now*. Terrified or not, he rode with Rebecca, trying to soothe her as she continued to bleed. At the hospital, he told the staff it was an emergency and signed his wife in.

Rebecca was in the hospital for four or five days. Charlie never visited her there as she was mending, nor did he touch the wire.

When it was time to go back to Olive Street, Addie Parker came with Francis Leon and took her daughter-in-law home. There Charlie treated her just as he had before, never talking with her about what had happened, not even with his eyes.

Surrounded by the familiar and the mysterious, Rebecca was relieved. Already nearly driven crazy, she realized now, clear as a bell, that she never again wanted to have another child with the sort of man Charlie Parker had become. Not with all she had gone through, with the signs and the pain of her body's aborting, the strip of flesh and the blood clot, the gushing, the cab ride to the hospital, and all the days to think that followed. Not in this life would she allow that to happen, the good way or the bad. So help her God.

In April 1938, Jay McShann took the first Negro group out to Martin's-on-the-Plaza, a club where particular white people congregated—the rich. It was a small unit that had come about in the way that things often happen in jazz, when McShann, who'd been playing around town for a little more than a year, learned that Walter Bales, a wealthy white man, wanted him to come to his home. Without knowing much about what Bales wanted, McShann made the trip, hoping another job might come out of it—another opportunity to keep some grits and gravy on the table. It turned out that Bales had made some money backing Count Basie, and he was interested in hearing whether McShann might have what it took to follow in Basie's footsteps, to become more than just a good piano player, to take those giant steps. No one knew who would. Any chance to get somewhere was better than looking down the throat of a potential gift horse. Walter Bales did not have the sound of jive in his voice. That was good enough.

The meeting was fortuitous. It began with playing. Nothing else

for four hours except sipping a bit as they went along, becoming re-laxed enough to drop some suggestions. Bales played well enough himself that he felt able to give McShann some advice, to counsel him to calm down and not pound the piano. He could slip into his ideas gently, controlling the pace, avoiding the temptation to rush. Then he could pull more colors out of the keyboard by refining his touch. All of that sounded good to McShann, who recognized in-formed talk when he heard it. This rich fellow had a real feeling for the art of jazz, for how to inspire professionals who wanted to take their playing down as many corridors as they could effectively run. And McShann was certainly a buoyant guest; he could have been having as good a time as Upper Crust Walter, the one accustomed to hearing this new guy from Muskogee, whom some were already calling a meathead, as he sat there playing all night in the clubs, try-ing to hold up the swing and keep the groove in place, and dealing with all the boredom he had to triumph over; anything that helped expand what he was trying to do, he would listen to quick, in a hurry.

Like most, high or low, Bales took a liking to McShann, and the two men started getting together regularly, either at Bales's home or in Kansas City proper, where he would rent two pianos at Jen-kins Music Company. Those sessions, with the liquor, the jokes, the talk about who came from where and who had seen what, edged into the music itself, keyboard conversations in which familiar phrases and tunes were approached respectfully or with parody. Bales would show McShann something he had picked up from Basie; McShann would show Bales things he had heard or figured out for himself. Together they swung, romped, and put down the rhythmic figures that defined the pulsation of their world, in Kan-sas City and across an America full of people who spent their days looking in store windows, peering up at movie marquees, listening to radios, watching the forward march of technology, and feeling

the melancholy of the Depression challenged by the musicals, the dances, and the tall-tale dreams of the era.

It was through Bales that McShann met Count Basie—a thrill, to see the master of Kansas City piano right there in the brown flesh, his clothes store-bought, the ragged days behind him, the dry humor and appetite for ribs and good spirits all intact. And it didn't stop at one meeting. Soon Bales was renting three pianos when Basie was in town, so they could all go at it together until they were satisfied. "Walk three," as the order used to come at the Reno Club.

Bales started hiring McShann for private parties. And he started suggesting that this relatively new Kansas City musician start thinking of himself as a bandleader, not just as a member of pickup duos and trios. McShann liked Bales, he could see that he was a white man who enjoyed picking himself a Negro to groom and help, to present and push. Profit wasn't part of the deal; it was the satisfaction of taking one's money and adding something, separating from simple, flatfooted privilege, and moving forward as a member of an aristocracy, insiders sensitive to blues and swing as they were right there, right then.

Walter Bales, and those like him, were patrons of homemade art. They were as natural as the musicians they often loved. In some extraordinary way, these people sensed the wonder of a music that had no academic credentials, no long history, and was being made up day by day, tune by tune, on bandstand after bandstand, in one dance hall or nightlife joint after another, disappearing into the air more than 99 percent of the time or else leaving a short stack of recordings to speak for thousands of hours of effort, struggle, dismay, excitement, and success. Those like Bales were part of the tradition of true believers, often wealthy, who have stepped in with assistance when an art form needs them—as they did for George Balanchine when New York City Ballet was built, or for the Museum

of Modern Art when it was planned and formed. True believers arrived, sometimes just in the nick of time, to bring a new movement in the American arts to fruition. Patrons were often reaching down from above, but they just as often knew how to pick up the dice, blow their hot Olympian breath on those bones, and roll them.

At that point, Jay McShann had made no recordings at all. He was just a man who had come into Kansas City after roaming the territories in second-string bands, and who'd gotten a bit of local experience in Buster Smith's small group and big band. He was jolly, round-faced, and loved him a chance to sip until he was mellow. But there was something else there. McShann could swing, could swing very hard. He knew how to accompany a singer, how to support, nudge, lay back, underline something, hold a groove, and help somebody get out of a song if things got knotted up. Bales heard promise in this young man with the flat Oklahoma accent, the spiraling light in his eyes, the big laugh, and the feeling of anticipation that always purred under the skin of musicians who could swing. Walter Bales intended to see just how much promise stood right before him, and he started testing McShann immediately.

When Bales told McShann that a friend of his wanted to bring a band into Martin's-on-the-Plaza, McShann put together a group for the occasion, but its personnel kept changing as the gig went on. One evening, McShann was listening to the Sunday broadcast from Lucille's Paradise, where Buster Smith was working. Smith was whipping up a hurricane of swing, spinning through those tunes and turning them into splinters. McShann shook his head in wonder at his old bandleader's work, and when he saw Smith a short time later, he was delighted to tell him how much he'd enjoyed the broadcast.

"That wasn't me," Smith said. "That was Charlie Parker."

McShann was shocked, but it was true. Smith had refused to per-

form that night after some hassle over money. Charlie had played in his place.

"That's when I woke up to how much Buster was in Bird," McShann said.

McShann encountered Parker when he took a small group to do battle with Harlan Leonard, a veteran of Bennie Moten's band. Charlie was among the opposition. Another alto player, Leonard had made his way up through the Kansas City system, had gotten his early discipline at Lincoln High from Major N. Clark Smith, had solid command of his horn, and wasn't about any foolishness. He was a sophisticated player, with one blind spot: he wasn't very good at setting tempos, which kept his repertoire from swinging as much as it could—but he had a sense of how the music should go. Leonard had first shown his independence in 1931, when he and a group of musicians broke away from Moten, convinced that he was getting too much of the money from their jobs—and that he had become too enamored of the eastern style. Leonard and company thought the band should stomp, stomp some more, and keep on stomping. As the leader of the saxophone section with his alto, he brought a big sound, precise reading abilities, and a willingness to become a tonal part of the rhythm when a riff was set.

In an interview with Ross Russell, Leonard made it clear that he understood what made jazz the force that it was. "You could divide jazz musicians into two classes, the trained men, like myself, and the people I call 'naturals'—those with *natural* ability, who were usually self-taught and used unorthodox fingering, embouchures, reeds and so on. You needed both kinds in a strong band. For example, Basie later on had to hire trained men like Ed Lewis and Jack Washington to steady his sections, even though he had great natural players like Buck Clayton and Lester Young. A band's intonation and sound quality depended a great deal on accurate sec-

tion leadership. I always thought of myself as a trained man, a good sight reader and section leader, not as a hot soloist or highly gifted improviser. Some of the great naturals were Prof Smith, Eli Logan, Snub Mosley, Fred Beckett, Lester Young and Charlie Parker."

Harlan Leonard may have understood band dynamics, but Jay McShann knew how to swing and find the right tempo for it. McShann's six-piece group, with Gene Ramey on bass and Gus Johnson on drums, ran over Leonard, swung him against the wall. The force of McShann's rhythm section held up, showcasing and inspiring the featured players. The pianist knew how to get down into the cracks of the blues, using a groove so rich it popped the right notes out like slices of bread in a toaster.

Charlie was startled by how good they sounded. He was sounding good himself, playing with a hard, intense sound that wasn't yet satisfying him, but that kept his fast passages from running together, turning to mush. Clarity is what he was after, all of the notes coming out right, none getting lost. Charlie was looking for his way to say it. He had something of Chu Berry's snapping attack, but there was a different urgency in his playing. Young and skinny as he was, with mysterious bags under his eyes and an appearance just short of an unmade bed, he was the biggest force up on that bandstand. When he put the saxophone in his mouth, his music seemed to fill quickly with light. Harlan Leonard looked at him with appreciation and disdain, a cold respect.

Before the gig was over, Charlie came up to McShann. "I like that rhythm section! Can I join you?" McShann knew big talent when he heard it, but he didn't want to be bothered with Charlie Parker's problems—problems that were already all over the Kansas City grapevine. The word was, Charlie was great as long as he was blowing his horn, but once he put it down—bad news. McShann

declined to bring him in. He was trying to build something solid, and he didn't want anything to do with unreliable musicians. Charlie Parker sounded fine, but he would have to keep sounding fine somewhere else.

On those spring evenings when Charlie was working with Harlan Leonard at the Dreaming Club on Cottage and Vine, a younger kid named Junior Williams used to wait for him to get off, and they would walk the streets together. Sometimes Charlie bought a quart of orange juice, nearly finishing it before passing it to Williams for one last gulp. Sharing didn't come natural to Charlie, but Williams didn't care. He wanted to play the alto saxophone, and he'd been following him ever since word started getting around that Charlie Parker was turning into a hot force, just a step or two below Buster Smith and Tommy Douglas. Williams recalled passing Lincoln High after school, back when Charlie was still a student there, and seeing him going over some music lesson with Miss Marson. That was only a short time ago, but now it seemed a small point on the rearview mirror of memory. Charlie had whizzed right up out of the gutter of disrespect to take a real place in the ranks of local musicians. Little crowds of younger men like Williams would follow him as he strolled the streets, deciding where he was going to jam. There was something miraculous about it all.

Though not yet a king, Charlie was a prince of Kansas City, and his dominion extended as far as his sound carried. To those who heard him at this point, it seemed clear that some sort of serious crown would someday rest on his head. He was still shy, but there was something both charming and lumpy in his demeanor. Though he still displayed the nervousness of his youth—and his condition—the young man was starting to walk with a different feeling, no longer the jerky dig of the kid who left home every night

wondering if he would be rejected before the night was over. He was starting to hold his saxophone case with the confidence of a young doctor carrying his medical bag, one who knew well that his skill and what he did with his tools could keep pain at bay.

There was a certain majesty to this young man, but also a delicate misery, a flitting turmoil in his eyes, an ache and terror that he managed almost to hide in the variety of voices he used to express himself and to amuse or surprise his listeners. With his natural gift for mimicry, he was starting to take on a hint of the theatrical, an attempt to sound absolutely unwounded by experience. He waxed rhapsodic about the voices of British actors like Charles Laughton and Ronald Colman, who had the ability to spike a sentence with subtle venom, to declaim exasperation in the face of clumsiness, to create a scalloped rhythm of lyric hope or stoic heartbreak. Friends recall Charlie mocking the minstrel coonery of popular entertainment. And he laughed with an intensity that drained anything less than joy from a situation. Yet his reputation still pushed away as many as it attracted.

To Junior Williams, the attraction was Charlie Parker's music. Charlie favored the younger man with the fatherly smile he would give with increasing authority throughout his career. The saxophone prince stayed out all night, Williams by his side, and in the morning they went to the younger guy's house, where his mother would fix them pancakes and eggs. Charlie talked about becoming a father, and how proud he was of his son, but he also confessed to Williams that he was having problems with his wife. He loved her, but she didn't understand what he was doing. She wanted him to get a job and work for the family like the people who went to bed at night. Charlie had other things going on in his head. Music was everything. And at that point in Charlie Parker's development, the musician who meant everything to him was Chu Berry.

Charlie was overwhelmed by Chu Berry. He told Williams that Berry was the greatest saxophonist who ever lived, that his first inspiration to play the saxophone had been Berry.

Berry was one of the first *fast* tenor saxophone players. He loved to sprint across his instrument, kicking clouds of harmonically rich notes at his listeners and executing difficult passages with a cautionary fire, a tip to potential adversaries that was a measure of grace. With Coleman Hawkins in Europe and many skull-cracking jam sessions in Washington, DC, under his belt, Berry was the stateside tenor saxophone man of the hour—at least on the East Coast. He was a large guy with a large horn, but his mustache and metal-rimmed glasses gave him the look of a college professor, maybe a dean partial to swatting discipline into place. He looked like a man who settled things. A veteran of Fletcher Henderson's band, he learned quickly that the bandleader wouldn't stick to those friendly keys jazz musicians preferred—B flat, C, F, and G—and learned to play in all the hard keys.

It's easy to understand, then, how Berry must have impressed Charlie Parker. The tenor man's work had the hard sheen of virtuosity; it was focused on logical musical statements, and there was something in his sound that answered the industrial clamor of the times with the same sort of human power that had conceived and built the machines making all the noise. In that sense, he was kindred to Roy Eldridge. His strength never apologized for itself.

Charlie may have been introduced to Berry through his recordings with Henderson and Eldridge, or through his broadcasts with Cab Calloway. If he wasn't there himself, he probably heard Buster Smith's story of what had happened in 1935, when Berry came through Kansas City with Fletcher Henderson and went out jamming his horn up against Lester Young, Herschel Evans, and the other locals who were always in the mood to rough up some eastern

star eager to gamble his reputation and possibly the suit on his back. According to Smith, Berry stomped off a medium-fast ride through "Body and Soul," blowing combative chord changes with such sudden ferocity that Lester Young started heading for one door and Herschel Evans another, leaving a handful of lesser saxophonists to close their horn cases and creep out behind them. Smith stood up, laughing, and shouted, "I *told* you not to mess with that man!"

WHENEVER CHARLIE WAS having musical problems in those early years, some figure seems to have stepped up to help, recognizing his talent and reckoning that the music he could produce was worth the expense of keeping him in line. Charlie might bring disorder to your border, but then he could turn around with disheveled grace and pull a mother lode of what everybody was looking for right out of the air. That was how it was, and the bandleaders of Kansas City had to decide if they could put up with it. Many would not; many would.

Gene Ramey, McShann's bassist, kept after the leader to hire Charlie. McShann could tell what was on Ramey's mind by the way he walked—could tell what he was going to ask, and what he thought Charlie could do for the unit. No matter where they were, what time it was, that damn jet-black Ramey would not let his bandleader rest until he went ahead and hired that boy from Olive Street. Finally, McShann made his bassist an offer: he would hire Charlie Parker, but Ramey would have to take responsibility for his friend the bad but irrepressibly shiny penny. McShann didn't need an alto saxophonist who showed up at a job without a horn, making the situation worse by telling one of the endless sad stories that had led to his being fired all over Kansas City.

McShann wasn't alone in his contempt for Charlie's raggedy

excuses. Kansas City jazz musicians were accustomed to counting on one another, to being able to take a man's word, and they were galled by the lies Charlie told in order to get drug money or to laugh off the tardiness that came naturally to the addict. Of course, Charlie's world was constrained by a simple imperative: he either got the money he needed or suffered the pain of withdrawal, which terrified him. McShann would take a chance on him only if Ramey was willing to deal with that knucklehead and his habit, so that he could keep his attention on developing the band. If Ramey was willing to babysit, he could go right ahead.

Ramey accepted McShann's terms. He picked Parker up every evening before the job, took him home, and kept his alto until the next day to make sure he didn't sell it in a moment of weakness. Parker always implored the bassist to let him play just a little before taking the saxophone. Ramey usually agreed, which meant that he had to stay out with Charlie on many nights, waiting for him to blow himself out. Sometimes he drove Charlie down to the Missouri River, where marijuana grew tall, and waited while the saxophonist picked what he needed before bounding back to the car. When he got Charlie home, his mother always seemed relieved to see him strolling up to the door. "Take care of my baby," she urged Ramey before they left every night. "Don't let him get hurt. Please watch over him."

Despite Ramey's precautions, Charlie kept finding ways to get his morphine high. By this point small glass vials of morphine were starting to be available for two or three dollars, stolen pure from some warehouse, hospital, or drugstore and making their way into the hands of local dealers, who were beginning to multiply. Yet the trouble McShann expected didn't materialize, at least at first. "When Bird came in my band, Bird was making time," the bandleader remembered. "I did notice a few sleepy symptoms some-

times. As a rule, the cat sitting next to him would tug him. He stayed happy, and he was moving all the time when he was with the small group."

Charlie and the rest of the band were still studying what Count Basie and Lester Young were serving up from the East Coast—live, when they could get it. "We'd always keep up when Basie and them was on the broadcast so he could hear Lester Young," McShann remembered. "He'd say, 'Man, what time are you going to take intermission tonight? Basie and them are coming on at such and such a time. Why don't you take intermission so we can hear this?' I'd say, 'Okay.' We'd switch the intermissions around so we could run out to the car and tune Basie and them in. . . . He loved Lester Young, boy."

When Young did something new or exciting, Charlie either memorized it or remembered enough to filter it back through his alto when the McShann Orchestra returned to the bandstand. There Parker would toy with Young's phrases, bending them, stretching them, stripping certain things away, and mixing the compressed version with bold ideas of his own. But even when it was almost recitation, Charlie could tell his story with a shrill savagery you never heard in Young. That squawling side of Charlie's sensibility became part of the excitement for the rest of the band. No one ever knew what Lester Young was going to play when that radio knob was turned, and neither did any of McShann's men have a clue what Charlie Parker was going to do when he returned to the bandstand after the latest radio master class.

Those Basie broadcasts seemed to get Charlie thinking about broader horizons. "He decided then what he wanted to do," Ramey recalled. "He told me he wanted to go to New York, that he was going to look over New York. Just wanted to go there and look."

Charlie told Gene Ramey his troubles, just as he had back when he was still Charlie Parker the laughingstock. He told Ramey that

Rebecca had called the police on him through the courts, that she had him charged with lack of child support, that he was arrested and had served time in jail. That seems implausible. Rebecca was living with the Parkers. Neither she nor Leon was suffering, except perhaps from loneliness. Charlie did get into some kind of jam with the police during this period, but Addie Parker described it to Robert Reisner quite differently: "Charles got into serious trouble one night when he kept a taxi for six or seven hours and ran up a ten-dollar bill, which he couldn't pay. The taxi driver tried to snatch his horn, and Charles stabbed him with a dagger. They took him off to the farm. I told the police, 'How dare you treat my son like that? Bring him back!' He came home the next day."

But Ramey's story suggests a deeper truth: that Charlie was starting to think ill of Rebecca, enough that he would fabricate a story about a jail term in which he was a victim at her behest. The air on Olive Street was starting to lie heavily against his skin.

Buster Smith, too, had become interested in the possibility of doing more than he was doing in Kansas City. Since that Halloween dance in 1936, when Basie's band had said farewell to Tom's Town, Smith was shocked to realize that they'd actually made it big. It seemed as though they were just as strong now in New York as they had been at the Reno Club. They'd added new members, and you could hear over the radio that the boys had gotten smoothed up without losing that Kansas City beat; they still had that lope and punch in place, swinging the blues. Some of that stuff was his. And now they were playing his tune—"One O'Clock Jump"—and people were eating it up. But nobody knew Buster Smith wrote it.

Now that there was a piece of bad luck. The original title was "Blue Balls," but that was a little too raw for the radio in those years. They had to change the name so it could get announced. The professor couldn't believe it. Basie was a hell of a musician—

newly recognized as a master of the introduction, the vamp, the setup, and the groove—but he couldn't read a note. Still, New York had wrapped him in success. Maybe New York wasn't as bad as it had been in 1932. It had to be different from the way it was back when Bennie Moten's band had suffered through that starvation tour and the Blue Devils had folded the year after, before they'd even made it up there to see what it was like. Whatever the circumstances, sometimes a musician had to travel. He had to get up and dust his broom, move on farther down the road. Trying was better than sitting around wondering what might happen.

So in the summer of 1938 Buster Smith decided to move to Manhattan. Why not? Plenty of time had passed since John Hammond and those white fellows had come through, signing this one and that, and no one had come running home with his tail between his legs. It was time for Buster Smith to see how much hell he could raise in New York. He was the same man he had always been, only a year older and knowing a year's more stuff, which made him ready to get back with those boys and bring the swing up a notch. That was it. He told Charlie he would be back in town soon, that he was only scouting the place out. If things got right, he wouldn't mind sending for Charlie, if the boy thought he could handle himself. For now, though, he was gone.

This didn't make Charlie happy. Charlie wanted to go with him. He told Smith he wouldn't be any trouble. He'd earn his keep. Smith said no; all he could take was his wife, his saxophone, and his clarinet. But he assured Charlie that he would be back.

New York wasn't as easy as Smith had expected. There were musicians all over the place, and he didn't blend in the way he expected to, the way he had when he first came to Kansas City. People didn't really know who he was. Basie and the guys were doing fine; Buster Smith met him every afternoon at the Woodside, going out

back to talk music and drink gin, cigar smoke floating up to the sky. They were two aristocrats, one brown, the other as dark as an eggplant. But Basie was at home in New York; he was from New Jersey, after all, down the road in Red Bank. Once upon a time, Bill Basie had left the East a wide-eyed novice besotted by Fats Waller. He returned home a conqueror, sporting a style that stripped stride piano down to its poetic essences and fronting a band that many thought had no rivals in swing. He had the feel of a man who had done something and knew it, but he was still the same warm guy, no walls standing between him and Buster. They could have been hanging out behind the Reno. Basie didn't have any open chairs in the band, but he did what he could for his old buddy, asking him to write him some new tunes and arrangements.

Every day, as he and Buster were having their white liquor, the same peculiar thing happened. A rich-looking white woman drove up, took a wad of money from her purse, and gave it to Basie before driving back downtown. Basie gave a wink and smiled, put the loot in his pocket, and carried on. Buster Smith was learning that there were things going on in the East that he hadn't seen in the West—and he'd seen a good number of things in that wild Pendergast town. The white woman wasn't what she looked like. She was the madam of a whorehouse, a fancy one, and Basie was her pet—though she handled the tricks. This was another kind of town all right. Negroes could get away with more than they could out west—that is, if living like a freeman whenever one could was defined as "getting away" with something. Bill Basie wasn't a particularly aggressive type; he was known for going with the flow, not against it. His good judgment was always convincing. He had a good nose for freedom and could always get a whiff if any liberation was lurking nearby, advertised or not. If he had figured out how to become the pet of a white madam who hired a limousine

every day to bring him money uptown at the Woodside, well, it must have been all right.

There was no place like Harlem, not that Buster Smith knew about. Even people who could pass for white when they worked downtown were anxious to get back uptown, where there was high style and know-how everywhere. They were white for their money, and they were Negro for their good times. There was a code to all of it, as there always was.

CHARLIE MISSED BUSTER Smith. Nothing floated back from the East: no letters, no telegrams. Smith's young protégé was still attached to the older man; he had felt secure in his presence and missed having a more experienced figure around to inspire him the way Prof had. Lester Young was gone. He didn't get along with Tommy Douglas. He was playing with Harlan Leonard, who was starting to promote him as a "saxophonist supreme," but in private the bandleader hated him. Jay McShann was great, but Charlie had run himself out of that band, falling down on his discipline, giving his position the aspect of a suspense serial: *Would he appear or wouldn't he?* Finally, McShann let him go.

As Charlie Parker began to see what might be available to him in the world of music, Kansas City itself increasingly felt like a closed town. He was far beyond what he had been, but still a long distance from what his ambitions were. Even so, the command he was developing over the saxophone was raising his sense of himself. Charlie Parker could be one of those people with his picture in a magazine, with his records in the shop, with fine clothes, cars, and crowds waiting for him to arrive in town. He could have them lined up begging for his autograph. Above all, he could sound great. The desire to get there went past every other thing—above and beyond the public,

above and beyond the gig. It was a drive shared by musicians every-where, a feeling that came whether they were alone or surrounded by listeners snapping their fingers, patting leather on the floor, danc-ing, or just sitting there happy to be getting in on something special. He could be one of the cats, up there with Lester and Chu Berry, Johnny Hodges and Benny Carter. It was all within his reach.

The saxophone told him so, every time he picked it up. The horn no longer treated him like a stepchild; it had begun to submit to him. That alto gave him things. When he had it in his mouth now, the reed and the mouthpiece seemed more natural. His fingers fell into place almost automatically. His embouchure was just like the one in the book, a dimple on either side of his mouth. The weight of the horn was no longer heavy. The keys and his fingers were getting along better and better. Sometimes something would jump out of the in-strument and almost scare him: it seemed so much like a revelation. This music was his life when he was living exactly the way he wanted to live. It was on him all the time. Passages and rhythms went through his mind. He was hearing something different now, though it was still foggy, the notes and the tone indistinct. That was his style, still hiding from him, flitting up and disappearing. Every now and then he snatched a piece of it and held on until it was settled in his saxo-phone, locked in his soul, committed to a life sentence in his memory.

Somewhere along the way, he had taken to kissing his alto saxo-phone, to calling it his "baby." It was surely his true love, for he had no other honest relationships. The saxophone was the only thing that gave him exactly what he wanted and he gave in return.

IT WAS LATE one morning in early 1939, maybe ten o'clock. Charlie came in with his horn and set it down on the piano bench. He called up to Rebecca, who was with Leon, now just a year old.

"Rebeck, come on down."

She had been lying in bed, but she rose at the sound of his voice, wondering what Charlie wanted from her. You could never tell. His moods were mysterious. It also depended on how much of that stuff he'd been using. She walked down the stairs, and there he was, heartbreaking because he was still getting more handsome, looking a little weary, but his eyes very intense—that stare she knew so well was upon her, but there was softness too and a sort of sadness. She came down the stairs expecting nothing, but ready for anything.

"I want to tell you something," he said, taking her hand as he always did when he wanted to speak with her.

She looked him in his eyes.

"Rebecca, you are a good person, and I want you to take good care of our son. I love you. But I believe I could become a great musician if I were free. Rebecca, please free me. Please free me, Rebecca. I have to have my freedom."

She didn't say anything. She just looked at him. Rebecca wasn't raised to ask questions. She just took it in.

"Ma," Charlie called out. "Ma, come in here."

Rebecca still looked at him.

Charlie grew impatient. *"Ma!"*

"I'm coming, Charlie."

Breathless, as usual, Addie Parker stood looking at Charlie and Rebecca sitting at the dinner table, her hand in his.

"Ma, Rebeck is going to free me."

Rebecca was looking at him. She had said nothing.

"I want you to promise something, Ma."

"I promise."

"Promise, Ma!"

"I *promise,* Charlie."

"I want you to do something for me, Ma. For as long as Rebeck

and Leon live, I want you to make sure that they have a roof over their heads and food in their mouths."

Then he rose and was gone.

Emotion replaced the air with invisible gutting knives: Rebecca was in shock, feeling as if she'd been cut open and hung from the ceiling.

AT SOME POINT, probably at night, Charlie Parker made it to the railroad yard.

As a boy, he'd been good at throwing stones, and he'd go down there with buddies to smack bums with rocks. Now it was a different story. He was going to bum his way to New York. He hadn't convinced anyone else to go with him, though he had tried, telling them it was just another adventure, nothing to be frightened of, nothing at all. Now, though, it was good-bye to Kansas City for real. His horn was in a pawnshop, so all he carried with him of his struggle with music was inside, out of sight: what he had taught himself, what he had picked up from Lester Young, the things Buster Smith and Tommy Douglas laid on him, the splattering fire and intelligence Roy Eldridge emanated through recordings and his Chicago broadcasts, the brusque harmonic complexities Chu Berry executed so easefully. He wore some old clothes, having sold everything else to provide himself with a grubstake. His pants were far too big, held up by a long piece of cloth; worn workman's shoes protected his feet; a threadbare suitcoat covered a rumpled shirt. Over it all he wore a ragged topcoat, buttoned all the way up to limit the cold pushiness of the wind that had been getting colder since October.

Nothing could reduce the anticipation and the fear of being caught in the railroad yard. Everyone knew that the guys on the lookout for hobos could get brutal, could lay something on your

head, have them some fun whipping on you. Charlie had surely heard the train-hopping lore from Buster Smith; he knew to carry a stick that could keep the boxcar door open so he wouldn't get closed up in there and starve to death. For the time being, he held his morphine habit in check, knowing it would be foolish to run the risk of withdrawal on these freight trains. Nothing could be worse than going through that sickness in a boxcar or on some siding—or out in the woods where he would be helpless prey to whatever came his way. Charlie might be mischievous and act a fool, but he wasn't anywhere near crazy.

Soon 1516 Olive would be behind him. Soon he would be riding the rails and moving on out into another dimension of his life. Once he got to New York, Buster Smith would surely take him in, and he would start working his way up the ladder the same way he had done at home. It might be hard, but it couldn't be any harder than it had already been; he couldn't imagine any humiliation more painful than that Kansas City laughter when he made his naive little mistakes. Not long from now, he would be up and out of here. Everything getting smaller and smaller as the train put on the distance. Gone, gone, gone.

Sure, he knew that his mother wanted him to stay home, or at least in Kansas City, forever and forever and forever and forever. Rebecca didn't want to be without him, either. Leon was just getting to know who his father was. He wasn't doing bad locally, not anymore. His reputation was spreading in Kansas City, and he could get up on a bandstand now and demand respect through his playing. People wanted to hear him blow his saxophone. Of course, he didn't have a saxophone now. He didn't even have an address.

In just a few days, his very first love, lean and golden Rebecca, and his son, Francis Leon, would sit somewhere away from him, not knowing where he was, just as he was unaware of what they were

doing. It had been so long since he had first seen her that day the Ruffins moved into 1516 Olive, since Ophelia had caught them upstairs, since he'd waited after school for Rebecca on the steps of the library, whiling away the time with a book. Geraldine would be behind him as well. All the joints on Eighteenth and Twelfth Streets; the Ozarks; the spook breakfasts; the barbecue and chicken gathering places, where chili was slurped early in the morning; the freak shows upstairs at the Antlers, where Charlie's innocence took a longer and longer hike; the barbershops, the shine boys, the clothes the Jews sold in competing stores on Eighteenth and Vine; Lincoln High, where he had been such an incorrigible truant; the alleys where he and Sterling Bryant had shot marbles down on their knees: these were almost no more than memories, connected to a place he was leaving on that railroad, the clatter of the rails a percussive accompaniment to his ambitions, which were so much stronger than his fears.

It was almost time to take off. He was up to the risk, or thought he was. He'd nearly been killed already on the way to the Ozarks; he had flushed down the toilet his aborted second child; he had suffered the damnation of trying again and again to reclaim the thrill of that first high, until he had become addicted; and he had known the good times that came when the music actually worked and the lifting feeling of swing took off, everybody functioning like the miraculous engine of a finely tuned car, but with that extra spark that comes of human emotion. He had known sorrow and terror, sensation and frustration, learning by surprise or mistake how tenuous were the lines between the extremes of life and health. He had seen so much pain, so much disappointment. Now was the time to find out how it felt if dreams could come even a country mile close to the mark.

Charlie Parker was leaving Kansas City, and he was damn sorry he had no one to go with him.

SORRY, BUT I CAN'T
TAKE YOU

*T*hough Charlie Parker would never ride in the luxury compartments of American trains, never stand out on an observation deck in a smoking jacket, martini in hand, he was as familiar with the truth and myth of railroads as any young man his age. It was an era when America still knew the world of trains firsthand, but also when the toy electric train was rising to its high position in the mind of the American boy, a fixture of newspaper and magazine ads full of bright ovals of miniature track, cyclopic eyes of light, quarter-size wheels powerful beyond fatigue, a mesmerizing universe of precision machinery. Model trains captured how the American people had become interwoven with the technological imaginings of its inventors, transforming from two-dimensional engineering drawings into three-dimensional reality in a far-flung support system of mines, lumber camps, foundries, and factories, of gargantuan parts and tiny screws, all of it functioning as a magnificent puzzle, a mighty exemplar of modernity given to unprecedented velocities and metallic percussion.

The train and the stations, the engines and boxcars, the rattling aura of faraway places and the stories told by those who had ridden in the wheeled and coupled lines of coaches out to and over the blue horizon: all these put fresh images—some true, some glowingly embellished—into our pantheon of fancies and reservations. The train made distances seem less real; it also intruded upon the American desire to be left alone, to seek peace and respite and rural seclusion. In its size and its constancy of motion, city to city,

its loud whistles and rapid clanking and clattering, the train was both a machine and an almost breathing monster of transportation, escape, kidnap. The train seemed to go everywhere, and it meant everything.

It pushed us back into the Wild West, where the black-smoke-puffing iron horse had begun as another of the mysteries the white man sprung on the Indian in the wake of the wagon trains, another force that interrupted their already harsh lives from a world so far away it was infinitely mysterious. That same iron horse would eventually carry the brutal and legendary Apache chief Geronimo and his people from the Southwest to Florida. It would become a target for the bloody derring-do of robbers like the James Boys, who came over the hills in their peaked hats, six-guns blasting, tails of their long, dusty store-bought coats rising behind them in the midwestern wind.

The abolition movement, too, was described as a kind of engine-pulled locomotion: the Underground Railroad, that creature of false-bottomed wagons, treks through swamps, and points of seclusion known as safe houses. That train rolled in one direction: north, to the heaven that lay above the lower, hellish quarters of the national map. Its goal was to evade the white men on horses who would return its passengers to the world of chattel depression, full of metal traps set to snap the rails of human bones, lanterns carried in the night chase, black and sometimes Indian trackers galloping behind baying dogs as they hounded the chattel with the gall to risk a long, long, danger-thick breakaway from the plantation. On that virtual railroad, the black smoke was replaced by woolly hair, the chugging by furious human breathing, the promise of luxury by the possibility of freedom, the points of refueling by the homes of those whites who were willing to risk tar and feathers—or worse—to commit a sin of conspiratorial humanism.

These trains, real and symbolic, redefined the American landscape and the American place, each town or city's identity at least partially the result of how close or how far it was from an important railroad stop. The trains, and the laying of the track, brought a steady influx of the Asian workers known everywhere as coolies, who may well have been linked

to the American Indians through a bloodline broken by the Stone Age migration over the Bering Strait, from the Eskimos all the way down to those Darwin encountered off of Tierra del Fuego. Those workers could only dimly have understood how their hard labor under the command of white men would help to connect the boundaries of the country with a brace of railroad steel; their presence would be felt decades later even in Kansas City, where Charlie Parker learned to love the Chinese food their descendants prepared.

The railroad and railroad men also inspired the legend of Casey Jones, the engineer whose unwillingness to stop his hurtling mass of steel and boxcars reworked the sentimentalized gallantry of the Light Brigade into a folk American celebration of the meaningless destruction generated by a man too stubborn to brake his locomotive, rushing full face into death as his whistle steamed all the way. That colossal wreck took its place beside the mythic six-gun and the steel-driving hammers of big, black John Henry, who died in futile rebellion against automation. The suicidal arrogance of a Casey Jones, hypnotized by the power he controlled with his hand, is but one railroad spike rising sharp amid the bed of nails every technological civilization lays its mattress of customs and good behavior across, hoping never to be awakened by the pressure of too much weight on too many dangerous points.

In time, of course, those fears were put to rest. The train became more and more a vehicle and a dream source. Its sound, and the stories it inspired, became a signal aspect of the national excitement of modern life. Railroad life would add an industrial lyricism to the music of the earliest blues musicians, who celebrated the big cities that terrified so many European artists. The hard, unsentimental sound of the blues, evolving from the rural guitar and the rural voice, mimicking the shuffle of the train in a rhythm that pulled together the march and the waltz—that blues sound took a stand for the human heart in the factory-made American world.

Blues musicians sang of the trains as ways of getting out from under burdens of woe; they sang of them as the Yellow Dog and Empire State vehicles so cruelly responsible for taking that man or that woman so, so many miles away from the head-over-heels lover. Forever gone, forever gone.

The Underground Railroad had clearly evolved into a system of very real trains that solved problems of distance with speed—much as Charlie Parker would do years later, pulling into his horn an industrial edge of breathless rhythm and attack that gave as much flight and fancy to urban life as the metal taps on dancers' shoes, remaking the drag of gravity into an engine of rhythm ever ready to send out signals of elegance. On those real trains, Negroes like Charlie Parker's father showed off their stuff as waiters, filling glasses almost to the top and moving from car to car without spilling a drop. They served with so much style that their deportment and skill were part of the definition of luxurious travel.

When they came home, they brought clothes they'd found on sale in slicker towns, carried records not yet released in their own part of the country, introduced fresh slang, talked blue streaks in the barbershops about the way people cooked food from state to state, county to county, city to city, and gave the word on exactly how red necks faded to pink and almost to pure white from town to town. The trains allowed a colored man such a wide berth he sometimes almost felt as free as those whose only privilege was white skin, not money or class. The Negro railroad men smoked cigars as often as cigarettes; they wore their clothes mercilessly pressed, wore shoes so well-shined that the gleam told onlookers that they were men who knew of faraway places and felt comfortable all over the country—that same gleam that told Rebecca Parker that Charlie Sr. was a porter on the railroad as soon as she first saw him and saw it. Every one of them attending the reception at Addie Parker's house knew that Charlie's father was somebody, in the way only accomplishment makes possible.

What took Charlie Parker hoboing out of Kansas City on those trains was just that: his blues to be somebody. When he left everything behind and headed for Chicago, he was shadowing the migration of Mississippi Negroes who had done likewise—and made the blues a basic part of the spiritual background of the city's South Side.

Chicago was as famous for the formidable stench of its stock-yards as for the cold wind that came in like a razor off Lake Michigan, the wind Negroes called "Mr. Hawkins." The smell of all those animals would have reminded Charlie Parker of the vile odors wafting from the much smaller stockyard in Kansas City, near where he'd sat on Buster Smith's bandstand at the Antlers Club, night after night, learning tune by tune under his mentor's paternal watch.

There was no Buster Smith here in Chicago. There was no one here he knew. As Charlie came off that last freight train, Chicago's fall was stalking toward winter. All those K.C. haunts tainted or maintained by the Pendergast machine, places he'd known so well, would have seemed a world away.

This Chicago was a really big town, second only to New York, the train tracks themselves suggesting an intricacy beyond what it was like back home. Here was where merchant families had long since floated into palaces on the blood of slaughtered hogs, cattle,

and sheep. Here was where Roy Eldridge had broadcasted from the Three Deuces as Charlie sat hunched over a radio with Clarence Davis in the Ozarks, listening to him bristle through those tunes. Here was where Eldridge had ridden around in a convertible with a blonde—one of the things that proved how very, very different things were outside of Kansas City. Here a Negro had a wider range of motion; he could stretch out his habits a little more. Roy Eldridge may have been gone by now, but the Three Deuces was out there somewhere. Probably.

That wasn't all. Charlie had heard the Kansas City musicians talk about Chicago, and the traveling musicians who came through had their stories, too. There was a lot of hot and bloody folklore about gangsters, about Chicago and the nearby town of Cicero, where you walked down a long corridor in one place to hear Louis Armstrong and when you looked up there were gangsters lined up in gray hats above you, machine guns and shotguns in their laps.

Charlie had heard the talk about all the modern things they had up there: about the elevated train called the El and the section known as the Loop, about the fine clothes and shoes in places like Marshall Field's. It was a city of big, tall buildings, standing high in the distance, calm and magisterial above the city, visual introductions to the skyscraper modernity of the day. Traffic was thick as freckles on the face of a redheaded cracker.

No matter how different the city looked, though, Charlie knew that Chicago would have its day life and its night life, the code of honest men and the slick, crude games of the devotedly crooked. He was no hick, not exactly. He was quick to pick up information about places he knew he would see someday when his career as a professional led him there.

The Chicago wind sure lived up to its goddamn reputation. Still, Charlie was happy to have ended the first leg of his journey. By the

time he turned up in Chicago, he had learned how to hobo, how to get along with guys who were down, though far from out. There is no record of exactly what route he took, or where he stopped; there was no schedule for those who got around by hopping trains, tramping along illegally in a dangerous environment. When you were hoboing your way out of town, you didn't necessarily know the path or destination of any train you took; it wasn't hard to get lost or have to change direction when left on a sidetrack, or an unexpected spur where goods were packed or unpacked onto the boxcars—or to be run off by railroad men with clubs and saps.

Charlie never said where he stayed between trains, either— whether he found a place to flop in town, or how attractive a hobo camp might have been to this young musician, a place where he could get some food and java in exchange for helping out however he could. He later told his third wife, Doris, how impressed he was by the men he'd met riding the rails: men who'd been out there since the end of the World War; or who'd lost everything in 1929 and said the hell with it, leaving their families following the big crash in search of a fresh start; or who'd gone out on the lam for some intentional or unintentional crime; men who had chosen to live in motion, to make it by working, begging, or stealing.

Charlie's personal skills—his charm and his curiosity, his ability to learn by asking good-natured but meticulous questions—could only have helped him in that side world of train-hopping and hobo jungles. Nobody knew who he was and nobody cared; neither his past life nor his present intentions meant as much as whether he could be trusted, whether he would lend a helping hand in an-other man's interest. Once he was in there, riding the rails with the veterans, Charlie learned all kinds of new tricks: how to hop a train properly and avoid being pulled under to dismemberment or death; how to leap off one if you had to; how to peep the intentions

of rough homosexuals who might be out to force their appetites on inexperienced young tramps; how to sleep comfortably on top of your possessions, just in case somebody deficient in respect wanted to steal from you; how to end your thirst by licking the accumulated "branch water" from leaves early in the morning.

Like Buster Smith and Lester Young when they hoboed out of that last Blue Devil gig in Virginia, he was given a lot of help along the way. He fondly remembered to Junior Williams the exotic feeling of sitting around a pot of hobo stew, eating with men of different colors, and hearing their different tales from an America that was in its last years of Depression. What Charlie liked most about that itinerant life, he told Doris, was the insignificance of race. To the hobos, color meant nothing. Men were only men; they helped one another or grumbled away from those they distrusted. In this cold, they wore pants over pants, shirts over shirts, and coats over coats. A hot cup of anything was a splash of heaven.

NOW, IN THIS city second only to New York, it was another world. Winter separated those who had to go outside from those who didn't. When the chill was seriously down in Chicago, snow in the streets and Mr. Hawkins furiously flapping out more cold, people found every excuse possible to stay home: drinking hot milk, coffee, and spirits; holding card parties; doing crossword puzzles, listening to radio broadcasts; huddling around radiators, fireplaces, and open ovens to talk. Those who left the oven on sometimes blew up, but it was god-awful cold enough to take the risk.

Charlie already knew how to shrug off such difficulties and focus on what he wanted. He started to make his way to the city's South Side: the Negro section, the black belt. But a serious chill was getting there, and he could definitely feel it. He was starting to miss

his pawned horn; he was anxious to rekindle his burgeoning mastery as soon as he could. Once he got to the South Side, something would work out. Somehow he would get a mouthpiece between his lips and get his fingers on that alto saxophone, and there would be musicians there, and they would understand him.

Charlie was searching for music in a town already made famous by the desperadoes who died there and the gangsters who ruled. The Indiana Kid, John Dillinger, had pulled off all kinds of nonsense running around the Midwest, robbing banks, escaping jail, shooting his way out of police traps. But when he came to Chicago in the summer of 1934—his fingertips healing from the acid he used to try to destroy his prints, his face lumped up and scarred from a botched plastic surgery job—he got his comeuppance outside the air-conditioned Biograph Theater, where his ghost left through FBI bullet holes.

In the city of the big shoulders, another outlaw was the flip side of the immigrant dream. As biographer Laurence Bergreen has documented, Italian émigrés had come north, fleeing a wave of lynchings in New Orleans—and a broader, almost hysterical contempt down south—that paralleled the treatment of Negroes at its worst. But those refugees from an old country of arias and honest labor would find themselves lampooned in a stereotype of Italian lawlessness held in place by one pudgy ex-bouncer from New York named Al Capone, who embodied the complex of ruthless ambition, upward mobility, sensual appetite, and desire for public approval that often drives the ruthless and charismatic into seats of crooked empire.

Capone made his mark on the Second City by stoking its tendency toward corruption. By the time he arrived, the spirit of Chicago was already covered with the coal dust of dishonesty and a cynicism born of overcrowding. It was ready to be bullied, bought,

and sectioned off into racketeer turfs, and Capone was happy to oblige. Much spilled blood put him in silk underwear, which he enjoyed laying out for the admiration of reporters eager to shed ink, like hot sauce, on this latest iteration of the urban bad boy. Capone was an irresistible character, a jovial Neapolitan who smoked Cuban cigars and loved the Chicago sun at a baseball game, but also had a stare so filled with rage that it could burn the paint off a tank. Even after the Feds got him for income tax evasion, his appetites—his love for opera, jazz, the best food and drink, the best clothes and watches, the best cars, the best tobacco—cast a long, complicating shadow over America's rags-to-riches mythos.

CHICAGO BETWEEN THE wars was a strange place. Among other things, it became a seedbed for paranoid conflict between the weirdest Irish American politics and Islamic Negro cults. Irish politicians, exploiting the romantic whiffs of IRA rebellion, ranted their way into office huffing and puffing about British plots against the United States and the Irish in particular. At the same time, leaders in the city's Negro mosques, convinced that Christianity had pulled the wool over the eyes of black people, waged a strange jihad against fez-wearing Negro factions from Detroit. The city's Irish, Poles, and Italians were all held together by the religious dictates of Rome, while Negroes were overwhelmingly Protestant; some surely believed, as one black preacher said, that Catholicism was "a beast in the wilderness."

Among musicians, Chicago was famous as the town where Louis Armstrong had come up to from New Orleans in 1922 to join his mentor, King Oliver, for a red-hot engagement at the Royal Gardens Café on Thirty-First Street. The King Oliver band played the blues fast, medium, and bunny-hug slow as young Negroes

danced—and equally young white jazz musicians came to hear the real thing. Armstrong became a center of attention, and he soon received an offer from Fletcher Henderson that took him to New York, which he shook like a box of loose screws in a buckboard on a bumpy road. But he soon returned to Chicago, recording ever more imposing trumpet improvisations with his own small groups and in duets and ensembles with Earl Hines, the piano revolutionary whose line had much in common with the inventions of his trumpet. Armstrong was long gone by the time Charlie Parker got off his freight train, empty-handed, but Hines was still there—held hostage for ten years by gangsters, broadcasting with his big band from the Grand Terrace Ballroom, unarguably challenging the New York outfits, and making records, but denied mobility under threat of death.

Charlie's first stop was at Thirty-Ninth and State Street, where he hung around at the black musicians union, Local 208, trying to get into the scene. There were jitneys everywhere, ready to carry people to clubs farther into the South Side, and the El made stops where the clubs were, at Thirty-First Street, Thirty-Fifth, Forty-Third, Forty-Seventh, Fifty-First, and Fifty-Fifth. The union was only a few blocks from the DuSable and the Morocco, the two hotels on Cottage Grove at Thirty-Ninth Street, where local artists like Hines congregated and traveling Negro entertainers took rooms. But that was the big time; Charlie wasn't ready for any of that, not yet. He had plenty of nerve, but he also understood protocol. For now, Local 208 was good enough.

With no horn to blow, looking like any other ragamuffin, he wasn't exactly shunned at the union, but no one really knew what he could do. Still, it was warmer in there than it was outside, and he could bum a cigarette or watch the guys playing tonk, telling stories, and waiting for jobs to come in over the phone or some

bandleader to walk in or send a man down ready to hire. On any given evening, some gig might need a bass player, another a drummer, another a piano player, a rhythm guitar, or a small group to do a job. If you didn't have a job, the union was where you got in line to get what was coming.

Harry Gray was the head Negro at the 208. He was about five nine and one hundred and sixty pounds, light brown, and always well dressed, his clothes carrying the scent of cigar smoke. When you saw him, even if you didn't know who he was, you could quickly tell he was in charge of something; Gray had the unmistakable demeanor of one who decided the fates of others from a position of absolute security. His eyes were compassionate, but his temperament had sharp angles; if pushed too far, he might unashamedly become one of those Chicago Negroes who would shoot enough holes in you to guarantee your horizontal position in a funeral parlor. In the teasing atmosphere among Negroes at the time, everyone knew not to bump Harry Gray too hard.

By his second day at Local 208, Charlie knew the only thing that would get him anywhere was to go out and jam, to borrow someone's horn and see if he could break into the scene. He had no intention of staying in Chicago; he just wanted to play. Then, when he felt rested up enough, he would make that last hoboing stretch to New York and find Buster Smith. Some of the Chicago musicians remembered Buster from the time he'd spent in town after Basie went east—played a whole lot of good saxophone, they said, could run you crazy on the blues— but there wasn't much they could find for Charlie until he found a horn and some clothes that prevented him from looking as though he put the big T in tramp.

That was it: Charlie had to find a place to play. The music would smooth his path. For the moment he didn't have much choice about how he looked, but when they heard him play they would know

what choices he had made, how'd been spending his time. Not too long ago, people had been following him around the streets of Kansas City, waiting for him to decide where he was going to pull out his horn. Now was the time to get that kind of respect in this man's Chicago.

NEGROES IN CHICAGO had their own excitement going; they weren't always that thrilled about musicians coming in from other places. They were proud of their town; the feeling seemed to steam out of their clothes, evident in the way they stood waiting for public transportation or drove their cars or walked the streets, wrapped up in overcoats, complaining about the weather or listening as someone told them a story, their eyes wet from the wind. They existed in that perfect American intersection where the first-class machinery of the Northeast turned and reached all the way down to the cultural bass notes of the South. If you weren't heading as far as New York, but you wanted to know what it meant to get next to something modern, you went straight to Chicago.

The Negroes had come, up from the Mississippi Valley mostly, delta moons and limber vitality in their looks, gazes filled with impenetrable solitude and humor; their speech rhythms could be as swift as the Chicago piano of a machine gun or as thick and oily as homemade peanut butter. They were answering the call that went up with World War I, when the city's mass production businesses could no longer rely on the dirt-cheap immigrants who'd been arriving from the East for decades, ready to work in the stockyards; to pour, forge, and cool steel; or to make their way up into the higher grade of American poverty by drawing their pay in the packing plants. Now all those European workers were back across the Atlantic within the battling nations, or

heading back to war, leaving plenty of work behind them. Down yonder, a generation of country people—black, brown, beige, and bone—looked north for another chance to get in on the promise of the land.

These Negroes saw a new chance to rise up from under the blood-encrusted glare of home, to pack their lives and savings into a cheap suitcase, tied up with a rope or a belt, climb on up those train steps, and watch the Delta country get behind them. They filled the colored sections of the trains, carrying biscuits dipped in molasses, fish sandwiches, ham sandwiches, fried chicken, preserves, cornbread, jars of greens, and the delicious pot liquor they drank after the greens were slurped down.

Some arrived looking as country as the mouth of the Mississippi. Others wore their down-south Sunday best, causing the red caps to laugh and the hustlers to lick their chops. However they looked, whatever they thought, their arrival in numbers changed Chicago—and Chicago changed them.

The participants in the Great Migration were met by much of the same hostility their immigrant predecessors had experienced in the second half of the nineteenth century. The rejection, the violence, and the crowding didn't stop them, any more than it did those Europeans, any more than those industrial skyscrapers stopped Chicago from being a hometown to the blues. They became part of the energy of the city, earning their positions in urban life through their factory and trucking jobs, their work packing meat or making household gadgets, and their hours on assembly lines knocking out one tool or product after another in that town where stores were as large as dreams.

And there were other kinds of work in Chicago, in the homes of white folks who needed their floors mopped, their windows cleaned, their rugs walloped, their dishes made spick-and-span,

their floors polished, their beds done, their laundry washed and ironed. When the blues craze spun off of turntables in the twenties, some white women tried to forbid their colored cleaning girls from listening to that indecent music while on the job—only to see the girls throw their heads up and walk out. But most of them kept their jobs, working through the impossible summers, the heat held in the concrete, and the winters that put white mounds in the streets, forcing them to wade through snow up to their waists. Spring was sweet, and during July or August you dreamed of autumn.

It was late autumn when Charlie Parker sidled up to one of the guys standing outside the 65 Club, on Fifty-Fifth Street at Michigan Avenue, and no one thought he might be dreaming about music. They gave him a look that was short on contempt but long on experience. These were night people, men in possession of the electricity, the anarchy, the pride, the suspicion, and the doubt of the times. They knew how it went. Whatever it was, they saw it coming. They lived in that part of the night known as after hours, when the streets were wandered by only the most intrepid party spirits, by musicians looking for someplace to pull out their instruments and jam, by johns ready to barter with some whores, and by the homeless, who had to keep in motion to hold back as much of the cold as they could.

One of the guys out in front of the 65 Club was a young Negro named Bob Redcross. Redcross, at that time, was a hustler by his own description. He worked hard at moving whatever he could and had a gift for clothing design that would come in handy later when he started suiting up entire dance bands. Light-skinned, thin, about five feet nine, Redcross had the spark of wit in his eye, but it was matched by an iciness that could be unnerving. When he went to New York in 1937, hustling the backside of the Apollo The-

ater with the notorious ruffians and desperadoes of 126th Street, people were heard to say: "Leave him alone. That's a Chicago nigger. He'll shoot you."

Redcross also loved music. He was a serious collector, the kind who was there to help out famous musicians who were looking for a recording they'd made back in the day but which was no longer in print and was scarce on the ground. If it was good, chances were Redcross had it tucked away carefully in a brown paper sleeve inside a record-album book, practically brand-new. Records were easy to break back then—they were made of shellac—but in Bob Redcross's collection, everything was in order and protected with a do-or-die attitude.

Though he was only in his mid-twenties, Bob Redcross had show-business roots going right back to the start of serious jazz in Chicago. From the time he first heard King Oliver and Louis Armstrong, sitting inside his mother's coat in the Royal Gardens checkroom, he'd known them both on stage and in private—the musicians and singers, the dancers and comedians. A curious man, a voracious reader and conversationalist, who consumed Will Durant's *The Story of Philosophy* as a young man, Redcross was also a sociable type who liked playing tonk with the guys at the 208, though he later admitted he didn't always love hanging around with the unemployed.

When Charlie Parker approached the guys outside the 65 Club, looking to bum a cigarette—this kid's pants would fit three people, Redcross thought—another who noticed him was Redcross's buddy Billy Eckstine. A twenty-four-year-old singer from Pittsburgh whose good looks and high cheer masked a willingness to knock a joker out if necessary, Eckstine had a honeyed glow that was almost irresistible to the opposite sex. Eckstine could easily have been a pimp; he had plenty of street women offering to go out and lay down

some love for sale on his behalf, content to do the sweating and squealing for a Negro *that* pretty—high brown with almost oriental eyes, with those football player's shoulders and that good hair lying down like that. But: forget it. Too much hassle. Music was on his mind. He didn't avoid street-corner banter about dancing the poontango, but the pimp walk wasn't for him.

Eckstine's show-business mentor from a distance was Duke Ellington, but his singing model early on was the bandleader and showman Cab Calloway. Eckstine used to imitate the Hi-De-Ho Man, whose perfect diction and high-powered Harlem jive sold many, many records, and even broke into the world of Betty Boop cartoons, where figures like the Old Man of the Mountain were animated to emulate Calloway's dancing style. But now the young Eckstine was starting to close in on his own sound, a personal way of crooning that was rising out of his body more clearly every day. His real dream was to become a romantic balladeer, to use his low, dark baritone to liquefy the hearts of the ladies. There was no place for that in the musical landscape of the time—not produced in the dark side of town, anyway—but that was what he wanted, and he sensed he could get it. Good male singers, from opera to pop, became the romantic force throbbing in the hearts of women. Young Billy Eckstine knew he was a good singer and was always ready to prove it.

Charlie stood there quietly for a while with Redcross, Eckstine, and the others, taking in the surroundings, looking for his opening. When the guys went back inside, he followed them. It was swinging hard in there, very hard, trumpeter King Kolax's band riding through the air in musical triumph, laying down that Chicago momentum of strut and shuffle, colored by the taint of true blues. Charlie sized up the landscape in an instant, all that Kansas City groove within reach of muscle memory. He might have

looked like something time forgot, but Charlie was in no way afraid to ask to play. When he told the guys in the band he played the alto saxophone, Goon Gardner, who was at a table flirting with a girl, turned around in his chair and slid a horn across the floor to Charlie, its neck and mouthpiece twisted safely up off the ground. Charlie picked up the instrument and turned the neck so that it was ready to play.

IN JANUARY 1939, Jay McShann and Gene Ramey went to Chicago for a two-week engagement that ended up lasting six weeks. A friend of theirs, a *Down Beat* writer named Dave Dexter, had heard them with Jay's small group in Kansas City; he loved their sound, gushing about them in print and paving the way for them to nab one of the magazine's awards. Soon they were called on up to Chicago, where McShann and Ramey put down a heavy line of Kansas City groove, giving the beat enough personality to lift and rock and swing the room.

Dexter had also met Charlie Parker in Kansas City, though he saw him only as a liar, a pickpocket, and a spoiled, selfish boy. To Gene Ramey, however, Charlie's name meant something different. Almost as soon as he and McShann got to Chicago, he later recalled, they started hearing about this skinny saxophone player from Kansas City who had come in there and shocked the hell out of everybody who heard him. In no time, this Kansas City nobody had come into the South Side jazz world and blown everybody out. He had a stump to fit anybody's rump.

According to Eckstine, Goon Gardner was so impressed by Parker that he invited him to come live at his place—though that ended soon enough, with Gardner short some of his belongings and Charlie gone off to God knew where. But Ramey was proud of

what Charlie had done, bringing the Kansas City message to Chicago and letting those men up there know that swing hadn't died when Basie left for New York. He didn't know where Charlie had gone to, but he was getting used to the fact that mystery was part of his young buddy's story.

Nineteen thirty-nine, while a very good year for jazz and for Charlie Parker, was also the year that Adolf Hitler finally pushed the globe into another world war. Negroes were well aware of what Hitler represented; they had welcomed, with whatever misgivings, the sight of Jesse Owens and Joe Louis triumphing literally and symbolically against European fascism and the junk science of eugenics. Trumpeter Jacques Butler, who was from Washington, DC, and had played with Jelly Roll Morton in New York, remembered how Negro jazz musicians in Harlem made a joke of Third Reich philosophy by calling any light-skinned person with autocratic tendencies "Master Race."

The odd position of black people in America was made quite clear in January 1939, when the Daughters of the American Revolution refused to allow the world-renowned contralto Marian Anderson to sing at Constitution Hall in Washington because she was Negro. First lady Eleanor Roosevelt—who had invited Anderson to sing at the White House three years earlier and was the hot force

for Negro rights in the presidential circle, constantly urging her husband to use his authority to enforce a greater degree of racial justice—found the DAR's decision not only racist but also a personal insult, resigning from the organization in protest.

The Constitution Hall concert was eventually supplanted by an event that took on far more importance than the recital it replaced. It made the movie house newsreels, so we can assume that anyone who wasn't dead or buried must have seen it. On a cold Easter Sunday, in front of the Lincoln Memorial, Anderson was introduced by the secretary of the interior, Harold Ickes, with these words: "In this great auditorium under the sky, all of us are free." Then, brown and dignified in a mink coat, Anderson thrushed forth her gifts before an integrated audience of 75,000, not a ragtag type visible in the photographs. As she often did on the other side of the Atlantic, Anderson sang both European concert selections and Negro spirituals, the music of the Old World and the New. The Philadelphia contralto resurrected the dream of the country by kicking off her twenty-minute recital with "America" and encoring with "Nobody Knows the Trouble I've Seen." It was one of those great American days.

And yet this was also the year when *Gone with the Wind* premiered in Atlanta, just before Christmas, and swiftly became the highest grossing movie of its time. Starring Clark Gable and Vivien Leigh, this paean to the plantation South offered a sentimentalized vision of its destruction in the Civil War—the second instance, after Griffith's racism-mottled *The Birth of a Nation*, in which Hollywood busted the bank wide-open with a period tale in which the rapacious Negro, foaming at the mouth, was central to the narrative. Though Hattie McDaniel would win an Academy Award for Best Supporting Actress the following year—the first for a Negro—*Gone with the Wind* was proof, in many ways, that the nation had not yet been reborn.

* * *

BY THE TIME Charlie Parker arrived in New York that winter, he'd been wearing his shoes so long that his feet and legs were swollen out of shape. He had come the hard way, freezing in boxcars between towns, getting a roof over his head and breakfast from the Salvation Army, then taking to the rails again. But he took the bumps, scrapes, and pricks of his journey in stride, because he'd finally gotten to the place at the far end of the country where he wanted to be. Slight or acute, pain was a traveling partner by now. He'd learned the weight that hypocrisy and chaos brought to his sense of life; how it felt to be alone and the target of contempt; how to bear the soreness that came with mastering his instrument. He'd discovered the almost intolerable excruciation that went with his drug habit, with loving Rebecca but losing her and little Leon to the saxophone and the magnetic demons that so easily drew him in, chewed him up, and shat him out, drained, remorseful, and filthy.

He knew he had to be willing to suffer for what he wanted, and it was starting to look as though he were earmarked to suffer, whether he was willing or not. All the exaltation of Kansas City was far behind him now. In that Manhattan winter, walking the streets on those very sore legs and feet, he went in search of new adventure as a form of illumination that simultaneously muted his hurts and neutralized his anxiety.

He couldn't have arrived at a better time. The New York World's Fair was to open in April, with its theme, "Building the World of Tomorrow," and word of the event was everywhere: on posters, on broadcasts, in newspapers, in magazines, filling the newsreel screens of the movie houses. The country's insatiable appetite for innovation and sophistication—the flip side of the American

love for the pastoral, the down-home, and the steel-wool cocoon of the conventional—was about to be given its head. Thousands upon thousands would soon be driving their cars, grabbing buses, or zooming in the subway out to the exhibition fairgrounds in Queens, where the newly completed Triborough Bridge connected the borough to Manhattan and the Bronx.

Come springtime, pavilion after pavilion would be swarmed with visitors, stunned or thrilled by the grand industrial promises of a sterling tomorrow. It was the era of bigger, better, and faster— the perfect moment for a young musician entranced by things mechanical and the mathematical laws behind them, which had nothing to do with race, class, religion, or the various bugaboos that made life dangerous and unnecessarily irritating, if not humiliating. As a boy in Catholic school, before he moved across the river to Missouri, Charlie was drawn to the purity of modern machinery. He was fascinated by the physics, electronics, and technological secrets behind modern life in the late 1930s: radios, automobiles, skyscrapers, elevators, bridges, dams, airplanes, traffic lights, rapid transit—all the inventions that were pushed at Americans by competing manufacturers. He even foresaw what we know today as *sampling*: In 1952, he told pianist Walter Davis Jr. and some fellow musicians, "Someday in the future, they'll be able to put your music in a can. Then, whenever they want to, they'll do it just like they were using a spoon to take out as much of you, or as little of you, as they need. After they have done whatever they want to do with you, with your sound, they put you back. Your future, my dear fellow, is in a can."

When Charlie Parker got to New York, however, he had a much more immediate concern than divining the future: finding his mentor, Buster Smith. We know that Smith had finally written Charlie, which must be how the younger man knew to turn up at

Smith's apartment on 135th Street and Seventh Avenue. Answering the front door, the older man knew something immediately: the boy had obviously been whipped down by his travels. This wasn't the spoiled young man Smith had known, who had almost always taken care to be neat and alert when he sat next to Smith on the bandstand at the Antlers Club in the West Bottoms, awed and warmly affectionate. His looks brought back to Smith the hard, dark memory of those Blue Devil days in Virginia, which left the band worn out, covered with dirt and coal dust, and fearful of the Eastern Seaboard.

Charlie needed a meal, a bath, and two or three days of sleep—that much was obvious—but he wasn't at all fearful. Being in Smith's company again enlivened him at the same time that it calmed him down. Charlie's legs may have hurt and his shoes may have cut into his swollen insteps, but sitting there with Buster Smith was as soothing as a hot bath and a good meal. After finally arriving in this notorious city of endless strangers, he was glad to feel the human presence of one of the best parts of home.

Then there was the town itself. Like everyone else who listened to the radio, went to the movies, or thumbed through a magazine, Charlie knew about New York's harbors, lined with big cargo ships and ocean liners; its huge parks; the bright glare of its nightlife; and its spunky little mayor, Fiorello LaGuardia, famous as a cartoon character for everything from accompanying the police on raids to smashing slot machines to reading the funny papers, eventually and endearingly, to young and old over the radio.

The Negroes in Harlem had another level of style, Charlie saw, and the concrete forest of buildings in lower Manhattan, even more impressive than in Chicago, almost took his breath away. There was a look in the eyes and faces of New Yorkers, a pace and syncopation to their walk, that seemed to rise with urbane fire during the busi-

ness day, then stretch into the gathering places of the evening, the deep points after dark when the sheer presence of so much humanity adds an electric hum to the air. The city's feeling was at once elegant and smart-alecky, as sharp as stainless steel and jagged rust.

This hard-boiled urbane sensibility transcended all the superficial categories of prejudice and privilege, even as it recognized a harsh human fact: that no amount of fine form and style, sophistication and gallows wit, optimism and good Samaritan ways, could forever hold the blues at bay.

Ever ready, this was a place of boundless appetites, a city that demanded eight newspapers to keep up with its story, three major league baseball teams to thrill it, and rapid transit above the ground, on the ground, and under the ground to get it where it was going.

The Big Apple was always in need of something new in order to realize itself, another set of cultural release valves to manage its ever-looming pressures. And the artistic fecundity that manifested itself in New York in these years grew partly from inspiration, partly from desperation. Like every professional musician who played dance halls, Charlie knew that New York's Broadway shows provided the songs that got people humming across the nation and around the globe. Anyone who went to the movies saw how often the era's romantic comedies, its tales of high society and down-low gangsters, and its ethnic melodramas were set in the metropolis on the Hudson.

The city had the best dance halls in America, the biggest movie theater in the world, and the longest chorus line anyone had ever seen, not to mention the best restaurants and clothing shops. And just a few subway stops away was Wall Street, where fortunes were made and broken.

It was simple. If you wanted to become a movie star, you went

west to Hollywood. If you had any other kind of serious career in mind, you went to New York. Starring roles weren't available to Negroes in those years, but there was plenty of room in show business for those who had the playing and composing skills, or who were tall, tan, and terrific enough to find work and make careers for themselves on bandstands, in Tin Pan Alley, or on the stages, which welcomed as much dancing and singing glamour from Negroes as the conventions of the time could bear.

Now Charlie Parker was here, with a roof over his head and Buster Smith standing by him in full support. He knew nothing about how the New York music scene functioned, other than what he'd heard by word of mouth, or dreamed as he listened to broadcasts or studied recordings. But he had no doubt that he was in the right place. Addie Parker's son would take Manhattan if given the shot.

AS CHARLIE WAS surprised to discover, Buster Smith wasn't exactly feeling the same way about New York. He was doing a little writing for Basie, working around a bit, but the Professor of Kansas City still hadn't managed to create the kind of impact in this town as he had back home. New York was full of so many good musicians, and there was so much going on, that it was easy to get passed over. A talented player could find little gigs here and there, but if you wanted to break out, you needed to get with a successful band, or put your own group together.

The Professor seemed as though he was waiting for something to happen—something that wasn't arriving as quickly as he expected. He'd never been much for jamming all night and running the streets, and that kept him from rising in the uptown or downtown pecking order. But neither was he a beggar or a complainer.

He was solid as ever, as a player and as a friend. He encouraged Charlie to get out there on the town and find out what he could do. He invited him to sleep at the apartment during the day, when Mrs. Smith was at work, and even let him use his alto for gigs whenever it was available—which was plenty these days. Since the Professor spent his time hanging out with old Basie over at the Woodside, or talking with some of the other Kansas City guys, that gave Charlie the run of the place.

Seeing how Buster Smith was faring, Charlie realized that he'd have to make some changes to his own plans. It was obvious that good things didn't come to you automatically in New York City. He wasn't thinking about starting a group of his own, not yet; his hope was that Smith would start a band and ask Charlie to join, giving him his toehold in New York and a steady living. In truth, Charlie wasn't even thinking that hard about earning a living—all he really wanted was to play—but he knew he'd have to find some kind of money somewhere, which put a splash of dread in the game. There it was. So what? Nothing in New York could be any worse than the hunger, the cold, and the anxiety of that long, rattling railroad trip east.

And there was more: here in New York, Charlie was surrounded by a quality of Negro life and excitement that he'd never witnessed before. In all of this man's Harlem, and all of this Manhattan, there had to be something for him. All he needed was a chance to prove himself, to let everyone know that he was serious now, that the lazy boy was gone. Not that many people in New York knew who he'd been, of course. But it was still true: the guy who walked the streets with Junior Williams back in Kansas City, talking about what he wanted to do, was in the country's fastest game now. He had shown them in Kansas City. He'd gotten his respect in Chicago. New York couldn't be all that different.

The Professor's apartment was close to everything. There were jamming clubs and hangout bars up the street, a block away, and then more a few blocks over from there. Once he got cleaned up and a little rested, some food in his stomach and a pat on the back from Buster Smith, Charlie hit the streets. He started moving around, looking and saying nothing, trying to notice how musicians related to one another and what to expect from Harlem life. He saw the terrible look on the faces of those who lived in the streets or who had been taken all the way down by alcoholism, but he also saw how well dressed people were in Harlem; he would have to pull himself up to something like their standards. He had snuck out of Chicago with some of Goon Gardner's duds and a pocketful of money he'd gotten pawning Goon's clarinet. But now Goon's clothes were the worse for hoboing wear and the money was gone with the wind.

This was no town for a ragamuffin. It didn't take Charlie long to discover that the night spots where the big-timers hung out—on 133rd Street, known as the Jungle—were off-limits to guys like him. Before you could get in where Billie Holiday, Lester Young, Coleman Hawkins, Chu Berry, Roy Eldridge, and those kinds of people gathered, you needed more than some talent and some enthusiasm. The staff was genial, but they meant serious business, and the people who went in were groomed and polished and smelling good, musicians or listeners, Negroes or whites.

Charlie wandered through this obvious capital of Negro America with the same acute curiosity that had driven him from club to club with Rebecca as a boy back in Kansas City, peering into doorways, trying to glimpse what those people were doing in there. The high-style stratum of Harlem nightlife looked like it rose up off the pages of fashion magazines. He spotted big-time musicians coming out of barbershops and beauty parlors, driving down the streets in their cars, standing in front of the Woodside, or coming

out of the YMCA. And he saw the Negro upper crust: respectable types such as teachers, doctors, real estate agents, lawyers, politicians, beauticians, chefs, morticians, and owners of restaurants, bars, and what have you. He was savvy enough to pick out the well-to-do hustlers, the ones with an extra pound of ice in their eyes and the swagger that barely concealed the violent confidence of a dirty boxer.

Charlie watched them all as he walked and walked the boulevards and neighborhoods of Harlem. He would take up a nonchalant position up the block from some passing spectacle, moving along if the block was too clean or if some local doorman started after him with a bat, telling him to get wherever the hell he was going. It was easier on the big streets, like Seventh Avenue and Lenox Avenue, where the action was nonstop. Through it all stood Charlie, watching in silence, wondering how long he'd remain in this strange exile. As he later told Jay McShann, one day he stood out in front of the Savoy Ballroom in his shabby clothes, a nickel and a nail in his pocket, and realized that he felt as happy as it was possible for him to feel.

AS ONE WHO hailed from a wide-open town, Charlie soon began to learn how things went in the uptown underground, in that haze where the hustlers, pimps, and gangsters made their livings. There were bloody stories connected to some of the rooms where jazz was played, and some of them led to the Negro numbers runners who made policy gambling part of the Harlem culture.

One such establishment, not far from Charlie's base of operations, was the Turf Club, at 111 West 136th Street. It was a fancy restaurant with a gambling game upstairs, both of them run by a fleshy West Indian named Casper Holstein, the inventor of the very

numbers racket that Dutch Schultz had bloodied and kidnapped his way into control of, knocking Negroes from the top for good.

The Dutchman reigned over the numbers until 1935, when he was given a finalizing lead nightcap after promising to kill New York's syndicate-busting state prosecutor, Thomas E. Dewey. In the wake of Schultz's murder, LaGuardia redoubled his pressure on the Sicilian, Jewish, and Irish lawbreakers who operated different levels of the syndicate, lording it over the docks, the prostitution and drug trades, and the gambling underworld, along with scattered smuggling and hijacking operations.

As shrewd as they were brutal, Lucky Luciano and Meyer Lansky, who steered the executive branch of the underworld, knew that the little mayor did not toady to thugs. The only way to survive was to work around him.

Fiorello LaGuardia, in short, was no Tom Pendergast.

One of the disreputable rooms was also one of the first places where Charlie Parker started feeling comfortable—socially, at least. It was Monroe's Uptown House on 134th Street and Seventh Avenue, just a block from Buster Smith's apartment. The room functioned as a homemade salon and barroom business office for its owner, Clark Monroe, a hustler all the way to the molecules. Almost six feet tall and handsome, light-brown-skinned, sporting such finely straightened hair that you might wonder if it actually grew out of his head like that, Monroe was always walking with glossy shoes, in impressive suits, surrounded by women. Clark Monroe was living that nighttime highlife—a luxury he'd inherited from Barron Wilkins, the room's former owner.

Tales still floated around about Wilkins, who'd been a big deal in the twenties, when Harlem was in vogue. He ran a joint that catered to the light and the damn near white as well as to those sometimes vivacious, sometimes corny, sometimes voyeuristic Caucasians who

cruised uptown in their limousines, hot to mix their champagne tastes with the hotsy-totsy rhythm and the decadence-for-sale of darkest Harlem. All his customers, his money, his girlfriends, and his intimate expectations, however, weren't enough to save Barron Wilkins. He was gummed up in so many shadow empires that, when he was murdered by a Negro pimp named Charleston, some said it was done on a syndicate contract. His room remained largely unused until Monroe took it over.

Clark Monroe had no such violent fate coming. He was a smooth type who could get just about anything anybody wanted, or could call someone to take nearly anything an itinerant but efficient thief brought in and help sell it to the readiest buyer. Monroe collected a little at both ends of such deals, fencing hot dresses, silverware, overcoats, watches, jewelry, and plenty else, all of it presented with enough finesse to prevent the uninitiated from discovering that some low-life trade was taking place nearby them.

Monroe enjoyed lording it over the night in his joint, where he would stroll in after midnight looking every inch the potentate ready to get all the jobs done. He had a real love for the music, and a real affection for musicians, though he didn't offer them much more than a place to play and some food to soak up the booze afterward. Still, if you wanted to better your musicianship and could swing, you were welcome in Clark Monroe's—even if your clothes were as substandard as Charlie Parker's.

Charlie soon found himself in the musical second line, the jam sessions where journeyman jazzmen got together late at night and played for a few dollars, over at Monroe's joint or up at Dan Wall's Chili House on Seventh Avenue between 139th and 140th Streets. At first he didn't do much more than stand around holding Buster Smith's alto case under his arm. Sometimes the musicians ignored him; other times they would ask him to unpack his horn. Then,

after waiting his turn, he would take off into the music, his good ear moving him through the tunes until he found an opening to showcase what was becoming his style, alternating breathless passages of fast notes and the long, sometimes mournfully shrill calls of his Kansas City blues heritage.

The response was neither encouraging nor the opposite. Most of the musicians just looked his way for a moment and then focused on the next one blowing a suitable style through the tune.

No matter what reaction his playing garnered on any given night, one thing is almost certain: given his empty pockets, Charlie made sure whenever possible to leave the bandstand soon enough to make it to Monroe's, where if you blew for a prescribed amount of time you would get free vittles. He knew how obnoxious it would seem to run in at the last minute, trying to get a meal after only a few notes; blundering through the after-hours etiquette could turn people against him, and sacrificing respect was one risk he couldn't afford to take. His awareness of social nuances, which showed in the way he carried himself, quietly made Charlie a welcome visitor at Monroe's kitchen, his full plate a symbol of his fringe membership in the circle he was cautiously attempting to join.

Charlie took good care of Buster Smith's horn and dutifully stayed in the streets until his mentor's apartment was free and he could get some rest. He routinely fell into a deep sleep there with his clothes still on, driving Mrs. Smith up the wall when she returned at the end of the day to see him dead to the world atop the covers, dirty shoes still on his feet. The boy was just strange, she thought; no amount of complaining could get him to undress. He couldn't even say why. But he was so sweet and charming that she forgave him every time.

When Charlie awoke, he would wash and get a bit of that good old home cooking under his belt as he told the Professor of his

Harlem adventures. In his pressed suit and polished shoes, drawing on his cigar the way he used to during those long afternoons he spent writing music in the Kansas City clubs, Smith assured Charlie that things would come around, that he had the talent—and the right kind of determination—to find whatever he wanted in New York.

What New York had to offer Charlie deepened his already great hunger to get more and more together with his horn. Even as his confidence grew, and he began to get noticed on the New York scene, the ever-present loner beneath his genial surface started to resurface. Jobs began to turn up, but he didn't always take them, lest they interfere with what he was working on. He would rather be broke and closer to sounding the way he wanted to than be earning some money—even if it prevented him from buying the clothes he needed to show up on a proper bandstand.

Charlie was also encountering some of the same resistance that Lester Young had when he came to New York six or seven years earlier. People were always telling him how to play and what he should do with his sound. Where Lester had been told his sound was too soft, Charlie was told that he needed to do away with that hard, ugly tone and cultivate one that was softer and rounder, prettier and more pleasing to the ear, like the plush, urbane, and sensuous tones that Benny Carter or Johnny Hodges had perfected. The guys he was spending time with—many of them second-stringers—told him what he should be listening to, around town and on records. Those guys, all of them intent on getting to the top themselves, or as close to it as possible, had plenty to say, lots of New York whys and wherefores, most of it delivered with neither restraint nor respect. Charlie listened and nodded, never arguing in defense of himself, but inside him a strain of resentment began to spread.

• • •

BIDDY FLEET WAS jamming with a little four-piece group when he first noticed Charlie coming into Dan Wall's Chili House. The spot was "mostly an eating place," with a large room in the back where musicians could play and "the manager didn't mind it." Charlie took the saxophone case he was carrying, put it down unopened, and just stood there saying nothing. For all Fleet knew, he could have been bringing in someone else's instrument and waiting for the owner to show up. Maybe the guys had asked Charlie to play out of curiosity; maybe they were looking for something to spark the kind of excitement all musicians hope for from the moment they leave their homes and head off to the evening bandstand. It was impossible to know.

Fleet was a stocky, dark-brown-skinned man with conked hair and a short body who wore a fine-fitting suit and shoes shining like a costly showroom car. He took to Charlie on the spot, noticing in his improvisations that the saxophonist was interested in things out of the ordinary, even if they were guaranteed to bother some people. The guitarist had become accustomed to the odd huff of criticism himself, harassed for strumming fancy chords that were unfamiliar to the bulk of Harlem jazz musicians, who were used to improvising off the melody and a bit of skeletal harmony.

Biddy Fleet didn't particularly care what those New York musicians thought, as long as it didn't get in the way of his employment. He was a veteran of the challenging Colonnade jam sessions down in Washington, DC, where titans like the burly Chu Berry and the elfin Don Byas came to the bandstand and blew through all twelve keys with tones as big as tobacco barns, slithering out highly sophisticated chords that either you could play or you couldn't. They

didn't mess around down there; the harder it was, the better they liked it. After finishing off an invention, they would stand in solemn repose or sit with their heads tilted as they listened, their eyes full of disdain or gravely appreciative corroboration.

Fleet considered himself a "symphony hound," which was a way of saying that he was impressed by the notes he heard in concert music, where the harmony was richer. As bassist Jimmy Butts said, "He was very knowledgeable about music, and he wouldn't hesitate to tell you what was right and what wasn't. He didn't do it in a nasty way, though. He was just sure and easy about it, on the calm side—but he would definitely tell you if you got out of line in that music. Oh, he would tell you."

Whenever Fleet plucked something Charlie didn't understand, the saxophonist would ask, without hesitation or embarrassment, "Would you please do that again?" He was a lean Kansas City kid with a good ear and a quick mind, Fleet remembered, as well as an increasing interest in playing intriguing, unexpected notes as he shifted from chord to chord. "Bird was playing when I met him, and sounding as the Bird sounds," Fleet said. "Bird wasn't satisfied with the way he'd been doing, and I imagine that's why he knew there had to be something else. See, Bird kept thinking."

This shared concern with breaking out of common territory brought them together for informal skull sessions, where they talked about the chords of certain tunes; often the guitarist would pull out his instrument and illustrate what he meant. To Fleet, it seemed as though Charlie was looking for someone to confirm what he was already hearing in his head, the thing that was the other side of both the unflappable authority of his Kansas City blues and the tunes he already knew how to get through.

The observant Fleet recognized that the saxophonist also felt alienated. "Bird seemed to have been disgusted with musicians who

at first didn't particularly care for his playing. They didn't like him at first. Some of them thought he was playing wrong, and I imagine it was horn players who knew something about the instrument. But to me, whatever he was doing, he could do it well, and that made him ace with me. The thing that I loved about Bird is this: he wasn't one of those who's got to write something down, go home, study on it, and the next time we meet, we'll try it out. Anything that anyone did that Bird liked, when he found out what it was, he'd do it right away. Instantly. Only once on everything. Nearly everything that I did that he was interested in, I'd show him once—he had it."

In particular, Fleet admired Charlie's dexterity. "He could do whatever he wanted to. He was with that horn. People talk about difficult fingerings and all that. There was no difficult fingering with Bird. Bird would blow it out of his horn—one, two, three, on the spot. Then he's got it; you don't have to go back over it. It's there forever. His main trouble when I met him, if it was any trouble, was ideas, because a lot of things that he wanted to do, he didn't know how to approach them harmonically. But once he found out . . ."

Charlie and Biddy were soon spending a lot of time together. In Biddy Fleet's company, Charlie Parker eased into another of the relationships that were so important to his development, getting with that one person who was either already doing what Charlie himself wanted to do or who was willing to join him in diligent pursuit. And as his time with Fleet took him further and further into the refinements and extensions of harmony, it also put Charlie in the company of a man who had similar interests outside of music.

Frank Wess remembers the guitarist as one of those rare people capable of fixing just about anything. "Biddy liked to figure out how mechanical things worked. He could take a light fixture apart and find out why the bulb wasn't working. Biddy was a bitch. He knew how to fix locks. Seemed like whatever it was, he could get

it back together. . . . You could say he was a natural handyman, just had the mind for it. Something break and Biddy was around, you can bet if it wasn't broken for good, I mean almost completely destroyed, he would get it back to working like it was supposed to. . . . The touch and the mind, he was born with it. It was a gift."

In Biddy Fleet, then, Charlie Parker had a buddy in New York with whom he could trade notes on the technological innovations and developments that were multiplying in the modern age— innovations designed to intensify industrial productivity; improve the speed and quality of aviation; make automobile travel safer, faster, and more luxurious; allow cinematographers to capture human skin tones and the colors of the world on film; and shift Americans toward an ever more comfortable life through the magic of home appliances, like the telephone.

That intellectual camaraderie gave the saxophonist another avenue of comfort as his studies deepened and his ambition broadened. Charlie's own skill at repairing various devices—which he would later put to memorable use when traveling with bands— may first have been picked up from Biddy Fleet and then enhanced by his own digital genius for feeling out the subtleties of balance, weight, and functional rhythm in things mechanical.

Neither of the two was in the musicians union, which meant they did their playing in the underground of jam sessions. They developed a body of songs that were harmonically challenging. "We would work on things like 'All God's Chillun Got Rhythm'— that had some funny changes in the bridge—and songs like 'Get Happy' or 'Nice Work If You Can Get It,'" Fleet said. "See, all of those difficult tunes was what we worked on mostly. Tunes that had been shunned by a lot of guys. A lot of good musicians just didn't care to play those tunes. We worked on 'Cherokee.' That was purposely shunned by most of the musicians because of the bridge."

Those "difficult tunes" also had a way of separating the wheat from the chaff, Fleet recalled. "You can use those hard tunes to get rid of the guys who can only play the blues all night. They can't mess with that stuff, and then you can keep right along working on what you want to get deeper into."

The world Biddy Fleet and Charlie Parker traveled together was no more than fifteen blocks wide. At the far end of their night travels, they might walk up the hill on 145th Street to a place on the corner of Saint Nicholas Avenue, then move on down to Dan Wall's, and end up at Clark Monroe's, where they might hang out until late enough in the morning for Charlie to go into Buster Smith's place and get some sleep. He had to wait until Buster's wife had left for work. Then he could get some sleep. That was about the only steadfast rule in the Smith household.

Sometimes Charlie spent time at Fleet's apartment, on 130th Street and Lenox Avenue. Then, when Fleet moved to the Park View Hotel on the corner of 110th and Lenox, "Bird used to come down there all the time. And that's how some of my family met Bird, and they thought he was a jolly type of fellow to be so great. However, I didn't see him as that great. I saw him as different."

During that period, Charlie had also started listening closely to alto saxophonist "Red" Rudy Williams, who held down a chair with the mighty Savoy Sultans, a unit notorious for its relentless ability to swing. On any given night, Charlie might ignore the radio until the Sultans came on. As Williams's alto sound surged out of the speaker, he would exclaim, "There's *Red Rudy*!" The guitarist was surprised: Williams was a straightforward player, nowhere near as adventurous as Charlie was, or wanted to be. But Charlie was starting to feel conflicted about his musical direction. He knew he wanted to play the different things he was hearing in his head, but he was also becoming dismayed and intimidated by the reception

he got when he played in public—especially at Monroe's. As Fleet remembered, "Bird would take his horn and go up to the mike or go out under the spot and play and play and play. But when he finished playing, the audience that used to applaud the different guys, you'd see one look at the other as if, 'Well, he's finished. Who else is going to blow?' No applause, not any at all."

Charlie took the blank stares personally. "Bird was hurt by the reception he got. Bird wanted to be liked. Everybody wants to be liked. No one wants to just be treated cold and nasty. But what Bird didn't quite understand then is that if you're going to try to please the public, you will never play your horn. I would say to him, 'You're doing all right. Don't worry about it. Don't worry about what people think.'"

Fleet did his best to pump up his new friend's confidence, but there were other musicians around him, too, and he felt equal pressure to respond to what they were telling him. Those other Harlem musicians were rock steady in their visions of jazz. They didn't like his sound, or what he was playing, and they were starting to get up in his face about it. As far as they were concerned, he needed to change his direction and get with the regular alto saxophone program as they knew it. He needed to slow down all those lickety-split passages, to stop playing those funny notes that didn't add up to a goddam thing.

"Sometimes I wonder if I should play like Rudy Williams," Charlie mused to Biddy Fleet.

Whatever conflicts he may have felt in such moments of weakness, though, when Charlie actually pulled out his horn he willfully became even more resolute. By now he was infusing his improvised lines with the harmonic connections he learned from Biddy Fleet, enhancing the lonely boy cry of his Kansas City blues with an effective intellectual detail. His playing grew fresher and fresher,

merging the primitive and the sophisticated in a way that matched many of the other artistic triumphs of the modern age. Filmmaker Jean Renoir thought that combining was central to the age; he would have enjoyed talking with jazz artists who could articulate the meaning of how their art had evolved.

Neither Charlie nor Biddy Fleet always knew the academic names for the harmonies they were playing, or for the spontaneous variations they were playing through them—a fact that would later convince some musicians who got close to Charlie that he was a kind of idiot savant, unaware of the ingredients of his art, manipulating them merely through intuition. Those people had it wrong. In truth, Biddy and Charlie were following their ears but in a very systematic fashion. They moved through their music note by note, increasing their technical command in much the same way that apprentice mechanics learn the workings of automobiles by lying under them for hours and learning part by part how the engines and transmissions are put together and what makes them function.

In particular, these two young musicians were following Biddy's yearning to give his harmonies more color, adding notes that dressed up the chords so they weren't "naked," as he said. By this point Charlie had learned the chords that were at the basis of his improvisations, but he would still have had to sit down to work out the specifics of how to work with those harmonies—a kind of analysis that was by no means beyond his capacity but that was happening very much on the fly. Charlie the progenitor was a man in a hurry, an authoritative player who threw out answers, right or wrong, with equal authority, and then went about his business, even his mistakes enlarging the enigma that surrounded him.

•　•　•

BIDDY FLEET ALSO noticed certain things about Charlie besides his determination to master his music. Beyond his joviality and his curiosity about all those newfangled tools and products, his young friend from Kansas City could also be surprisingly bold at unexpected times. Charlie might suddenly drop his shy western boy reserve and walk up to a woman he didn't know and begin a conversation with her. Those he approached weren't the typical young women hanging around in a joint, keen to make the most of a potential thrill at close quarters; they might be a little older, spotted on the street or alone in the hall of Fleet's apartment house. Somehow, whether it led anywhere or not, Charlie could get a woman to talk with him, not to ignore his unexpected advance, even smile at something he said. Once in a while, they even agreed to come hear him play.

One of the most mysterious things about Charlie during this period is that he seems to have had his drug addiction under control. No one remembers seeing him slip into the wild mire of theft, frustration, and disappearance that went with that old habit. He smoked his Camels, had a little wine or beer, and kept his head clear. The music was all he had serious time for. Now and then he took a menial job to make some pocket money, sweeping up nightclubs or washing dishes. It didn't matter to him as long as the job didn't get in the way of what he was working on. He spent his nights improvising on his horn, grabbing a few hours' sleep before reporting for work, or staying up if he was due at work early in the morning.

At some point, Biddy Fleet got a job working downtown in Greenwich Village, at a club called the Swing Rendezvous at 117 MacDougal Street. Charlie never came down to see him, but after Fleet got off work and took the train uptown to jam at Dan Wall's or Monroe's, the two would usually meet up, Charlie walking that

Kansas City Vine Street way, digging into the floor, pulling Buster's alto out of its case. One of those who saw Charlie play uptown in those days was Ben Webster, the great tenor saxophonist who would gain his fame with Duke Ellington. A big, handsome man, Indian-looking, known to rumble when he got too far into his cups, Webster almost swallowed the mouthpiece when he played, pushing it so far past his embouchure that his lip almost met the screw holding the reed in place. The tone his bulky frame could push through the tenor was elephantine, but he was beginning to put a smoothness to the other side of his shouting and growling style, alternating his pugnacious swing with a lyric, dreamlike whisper that could float the distance of a city block.

Webster was also from Kansas City, but, to Fleet at least, he didn't seem to respond to Charlie's playing. "Ben couldn't hear Bird at first. You can tell without a person saying a word: they're looking at you and wondering what you're going to do next, or why did you do what you are doing, or do you know what you're doing. . . . I could see that in the faces of a lot of musicians."

Whether or not Fleet was reading Webster's reaction correctly, the very fact that he noticed Charlie was meaningful. Many of the musicians who worked in the upper echelon bands of the jazz world were also volunteer scouts on the lookout for new talent. One morning, after they finished playing, Fleet walked Charlie up to his dishwashing job at Jimmy's Chicken Shack, on the hilly part of 145th Street at Saint Nicholas. Charlie told him, "I'm trying to decide if I should go to an audition for Duke Ellington's band this morning." Fleet, who knew little of the New York circles Charlie traveled through when the two of them weren't together, was caught off guard by the news.

Such an audition probably wouldn't have been for a permanent seat; Ellington's alto players of that period, Johnny Hodges and

Otto Hardwick, would remain in place until 1946. But every band has a moment when a regular member becomes ill, mysteriously wanders off for a short period, or has pressing personal business that briefly takes him away from music. Anyway, Biddy wasn't that interested in big bands; few of them used guitarists in any kind of featured role, Charlie Christian's sublime place with Benny Goodman being the rare exception.

"I'm supposed to go," Charlie finally said, "but I'm not." Then he spent the rest of the morning scraping the leavings of the previous night's meals from the plates amd watching the clock tick past his first opportunity to move from obscurity into the highest side of the Negro big time.

Why would Charlie Parker pass up an opportunity to join Duke Ellington's band? In both artistry and public attention, no one exceeded Ellington. Yet that doesn't seem to have tempted Charlie. If his claim about the audition was true—if he wasn't just making it up to impress Biddy Fleet as he was wont to do now and then to elevate his image—Charlie may just have had a difficult time imagining how what he was mining out of his imagination, his horn, and his studies with Fleet could have been compatible with the language of Ellington's improvisers. And given his sensitivity, if he were rejected by a body of musicians so universally admired, it could have wounded him as deeply as he'd been back at that Kansas City jam session when he stumbled through "Body and Soul," with Jo Jones throwing a cymbal on the floor in exasperation and disgust.

Charlie may have feared having to answer the exquisite tone of Johnny Hodges with his own, more strident sound, which had come under so much criticism from those New York Negroes. He may also have realized that his music would demand more improvising leeway than he was likely to get in a jazz orchestra so filled with star soloists. And he would have known that touring with Ellington

would have meant parting with Biddy Fleet, the one player who was totally sympathetic to his musical research, giving him support he couldn't find among other musicians. Whatever the reason, Biddy himself was startled when he realized that Charlie had skipped the appointment. "The average musician would say, 'Man, I'd like to play with Duke!'" he chuckled years later.

After Charlie finished his work at Jimmy's, the two men walked over to 135th Street and Lenox and eased into a place on the corner where they could get a mug of root beer and a hamburger for seven cents. Charlie seemed as relaxed as ever, talking about the music they'd played the night before, at home in their two-man homemade laboratory of discussion, practice, and performance.

AT SOME POINT during this period, Charlie moved out of Buster Smith's apartment. He started hanging out at the Woodside Hotel, where the liveliness and variety of the New York jazz scene always put an exciting spin on things. He didn't actually have a room—he was just floating around—but a bright and well-trained piano player named Rozelle Claxton, who knew Charlie from Kansas City, introduced him to his fellow members of the touring Ernie Fields band; thereafter, Charlie was able to bum a place on the floor, on a couch, or in a chair. ("Carrying the stick," they called it.)

Living in the Woodside gave him another chance to move further into that aspect of the city, just as he was doing in the after-hours world of jam sessions, even in the menial restaurant and nightclub jobs that gave him a more thorough sense of how things worked: how professional cooks got ready for business; how memory was everything when it came to being a good waiter or waitress; how, no matter how good the night in a restaurant might be, an evening of fat tips and receipts also meant the filth and the disorder

of dirty dishes, bathrooms, and floors after the doors were closed and all the customers had gone home. Some were hired because they were willing: standing up to the mess made them essential. No good room could make it without them. Charlie's father had embodied the truth that the luxury of good service was nothing to be ashamed of; for a busboy, the end of a shift—with all external filth removed—was an unnoticed sunrise of pride.

Trumpeter Jerry Lloyd told Robert Reisner that he met Charlie through fellow trumpeter Benny Harris while the saxophonist was staying at the Woodside. Lloyd took his new friend to jam at MacDougal's Tavern down in the Village. "I got Bird one of his first jobs in New York," Lloyd recalled. "He was desperate. Some days he'd go without eating. I got him a job in a joint called the Parisien Dance Hall." It was a taxi-dance establishment.

Decades later, Claxton laughed loudly as he remembered how people's opinions of Charlie changed when they heard him play. "One time he asked one of Ernie Fields's alto men to let him play his horn. . . . So the guy let him play his horn, and he was shocked because Parker played so much stuff! Maybe he didn't have anywhere to stay, but I mean he knew how to play alto saxophone! . . . Man, that horn had never been played like that before!"

Claxton's recollections reveal much about how information moved from place to place, musician to musician, in those days. Born in 1913 in Bartlett, Tennessee, near Memphis, he was one of eight children from a highly musical family. His mother and father played by ear, but the Claxtons made sure that their four boys and four girls learned music formally. The Claxton children all played and sang in the choir at First Baptist Bartlett, where Rozelle's parents were deacon and deaconess. For six years Rozelle studied concert piano under three different teachers.

He described his most important instructor:

Mrs. Georgia Woodruff is the one who was respon-
sible for my developing my left hand. She was play-
ing at the church in Memphis, you know, Central
Baptist. Her father was the minister, the Reverend
T. D. Rogers. I studied classical music with her, and
also the jazz part; because she was able to do that,
too, play both of them—play and sing. She was very
talented. She just had talent enough to play the jazz,
to go into the theaters, the Pantages Theater and
the Palace. She played the organ for silent movies. A
lot of guys from New York used to come down there.
They had stage shows, and those guys were playing
the stride style like James P. Johnson. So she picked
up on it, and she taught it to me.

Woodruff also taught Claxton how to use minor seventh and
dominant seventh chords and their harmonic extensions:

Well, I mean, naturally, playing those classical
things you played all those different kinds of har-
mony anyway. Well, the classical things, most of it's
in triads. But she added the IV, V harmony to it, the
major and minor sixth chord, or then the major and
minor seventh chord. Well, you get all those tones
in classical music, but they are in triad form for
the most part. So when you play the IV, V, *and* add
the IV, V in jazz, the chord sounds full. . . . After the
seventh, you played a ninth, then the eleventh, the
augmented eleventh and the thirteenth.

Woodruff's ear was so good that when she heard a device Art
Tatum used—modulating up a half step, then resolving his impro-

visation back into the original key—she taught that to Claxton as well. After performing under Jimmie Lunceford at Manassas High School, Claxton went to Kansas City in 1933, where he worked with the band of Clarence Davis, the trumpeter who played and roomed in the Ozarks with Charlie Parker. At one point, W. C. Handy used Davis's group when he came through Kansas City, and encouraged Claxton to leave for New York. Young, dumb, and plumb in love with a local girl, Claxton remained.

Claxton met Charlie Parker in one of those 1937 jam sessions when things were changing. The two worked together in Harlan Leonard's band not long before Charlie finally hoboed the hell out of there. During one session, somewhere in 1938, Claxton used Tatum's shrewd technique. "How do you do that?" Charlie asked, his eyes gleaming in wonder. "Would you please do that again?" Claxton taught him how it worked, and before long the half-step shift became a permanent tool in Charlie's approach.

Now, in the summer of 1939, the two were reunited in New York—Claxton an employed professional, Charlie still a scuffling vagabond looking for his niche. Charlie told Claxton about the musicians in New York who impressed him, young guys who were getting it together in the Harlem sessions. They talked about the hierarchy among piano players: Tatum first, of course, though Charlie was just as interested in Teddy Wilson, who was influencing many Manhattan piano players. But Charlie's greatest admiration was reserved for the saxophone players: first Lester Young, then Ben Webster and Herschel Evans, Basie's other tenor man.

When Charlie left the Woodside, he found himself a place downtown in the Stuyvesant High School area, renting a space where he could sleep and practice. Whose horn he had or how he got it is a mystery. The son of the woman who was his landlord recalled to jazz scholar Phil Schaap that Charlie gave his name as Charles

Christopher Parker, an expansion that Rebecca Parker had never heard from Charlie or his mother. (The affectation may have been a way of saluting his lineage: Christopher was the middle name of his grandfather on his father's side, Peter Parker.) He got a job washing dishes in the Stuyvesant area but did all of his playing up-town, gradually turning ears in his direction.

By late 1939, Charlie was playing with more confidence. There is some mythic talk that, while working at Jimmy's Chicken Shack, he listened at close range to Art Tatum, the harmonic grand master of jazz and the most startling virtuoso the music ever produced, who had a long engagement there. Biddy Fleet never heard Charlie mention studying Tatum in person, but like every player familiar with the pianist, they were both in awe of Tatum's approach: his unusual impositions and resolutions of harmony, his complex conception and sparkling execution.

Tatum had astonishing rhythmic imagination, perfect time, and absolute swing. His playing combined the digital fluidity of European masters like Liszt and Chopin, the honky-tonk and barrel-house line that led to ragtime, and the hotel and cocktail sound of sentimental ditties and Tin Pan Alley standards. In his book *Stomping the Blues*, Albert Murray observed that jazz musicians used Tin Pan Alley as a kind of folk source, and that idea was never better illustrated than in Art Tatum's playing. He remade popular songs into miniature American concerti, arrived at through a style built upon Earl Hines and the Harlem kings of stride such as James P. Johnson, Fats Waller, and Willie "The Lion" Smith. Given Charlie's appetite for fresh approaches, if the alto saxophonist had been lucky enough to watch Tatum in action nightly at Jimmy's Chicken Shack, Biddy Fleet would surely have heard all about it.

Another player casting a large shadow in New York at the time was Coleman Hawkins, who'd just returned to the States after five

years abroad, where he had lived the life of a celebrity unencumbered by race. Across the water he did what was not always possible in the United States. Yes: driving fast cars, skiing, and coupling up with pretty women, no matter what hair textures or skin colors were involved. Slick and strong enough for whatever New York had to offer, Hawkins was out to reclaim his title as the king of the tenor saxophone from innovative upstarts like Chu Berry and Lester Young, that tall yellow demon who had perpetually bested him during a December 1933 jam session at the Cherry Blossom with his light, melodic fluidity, sailing up as he extemporized. But that was then and that was all right: this returning innovator, the man who had given the tenor saxophone its position in jazz, had something for them, *all of them.*

On October 11, 1939, Hawkins recorded a version of "Body and Soul" that succeeded in simultaneously rattling and inspiring his fellow musicians. To the surprise of everyone—and despite the fact that Hawkins never quite stated the tune's familiar melody—the recording became a big hit, the force of his saxophone line making an enormous impact without ever resorting to familiarity, gimmicks, or simplification. In one three-minute recording, Hawkins had given his horn a wholly new identity, drawing on Art Tatum's sophisticated arpeggiation but repurposing it in the service of his own frontier mind.

"Body and Soul" was the talk of the town. It was one of those marvelously odd moments in American aesthetic history, a burst of complex invention that managed to capture the public imagination. It was everywhere—on record and on the radio, crooning triumphantly through windows, walls, and doorways all over Harlem. And it was a subject of ongoing analysis among musicians, who argued fiercely over whether Hawkins was gaining new ground or leading them all into a bog of inaccuracy.

None of this was lost on Charlie Parker. The style he was in the midst of forging, through constant practice and contemplation, certainly drew on Hawkins and Tatum, as well as Lester Young, Buster Smith, Chu Berry, and Roy Eldridge. Yet it went beyond the fusion of such different influences: the sharp edge of his sound, his bubbling rhythmic intensity, and the aggressive velocity of his technique conspired to create something fresh that was inspiring talk very different from when he'd first arrived in Harlem. He was starting to get work on bandstands—paying jobs!—and to attract a tight circle of younger musicians who recognized that there was something to what he was doing. Charlie Parker was starting to get with the groove of New York, and the Big Apple was beginning to get with him. It was peeling pleasantly, sweet and tasty. His dream was closer than ever.

IN THE SPRING of 1940, a young trumpeter named Joe Wilder traveled down to Annapolis, Maryland, with a band from Philadelphia called the Harlem Dictators. Annapolis was on the circuit then, and people from Washington, DC, and Baltimore would go there to hear the bands at two hotels, the Washington and the Wright. The crowds were thick, and sometimes you might see a handful of white people out there listening or dancing, but the dominant ethnicity by far was Negro American. Wilder was on vacation from Philadelphia's Mastbaum School, a home to other players, including clarinetist Buddy DeFranco and trumpeter Red Rodney. Years later he couldn't recall which hotel his band worked in, but he remembered that Pearl Bailey was also on the bill, singing and doing comedy, though still unknown to the greater world.

During the day, the musicians would get together and jam. Wilder went to one of the sessions and learned that the musicians

working the other hotel were employed by a showman known as Banjo Burney Robinson, as part of a large revue of singers, dancers, and instrumentalists. Burney was about the size of Count Basie, but his reputation was far different: Burney was known for taking revues out on the road from New York, paying everyone in full the first week, coming up with half the money and a story the second week, and then disappearing with all the money at the end of the third week. (Biddy Fleet had a trick for getting even with those kinds of bandleaders: he would steal the sheet music for the first-chair parts from the saxophone, trumpet, and trombone books—leaving no one to play the melody and thus making it virtually impossible for the band to play the arrangements.) For the moment, though, things were looking good in Annapolis. Banjo Burney had uniforms for his instrumentalists and costumes for the singers and dancers. It was a very professional-looking outfit. And one of the guys in his band was Charlie Parker.

When Joe Wilder first encountered Charlie, he was struck by the way the young man played the saxophone: thrusting the horn straight out, not holding it to the side or with any of the posing associated with the big boys of the instrument. No visual sauce, no extras, just a deadpan stare that earned him the nickname "Indian." He "reminded [them of] the cigar store Indians that you used to see in front of the tobacco shops . . . because he held it right in front of him and he had features somewhat like an Indian."

There was no derision to Charlie's nickname, however. Charlie was the highest-ranking combatant in Banjo Burney's orchestra, and when things got especially hot in a jam session, someone would say, "Go get Indian." Then it was off to find him, practicing somewhere but always ready to step into the tempo, the key, and the harmony, and to put something down so rough that victory had to come his way.

Joe Wilder remembers "Indian" Parker's first appearance at those jam sessions in Annapolis: "Most of us were somewhat awestruck by him, you know. He was something. . . . I mean, he did things and played with such clarity and freedom that it was sort of unheard of. We had guys who could play. There were fellows in the band that I was in who played extremely well. But even they were amazed by what Charlie Parker played. He just had it. . . . His development of ideas was different than what most of us had heard or even attempted, because he was doing a lot with an approach to harmony that most of us had never even thought about. *It wasn't bebop. He was just swinging. But his interpretation was completely different.*"

The two bands, the Harlem Dictators and Banjo Burney's organization, stayed in Annapolis for three weeks, and during that time Wilder noticed something remarkable about how Charlie practiced. Charlie was "a very likable person and a very intelligent guy," he recalled, but he was always working on that saxophone. In those days, most musicians focused their practice on certain areas of the music, sticking to a limited number of keys. Charlie was different.

"He was practicing every day," Wilder said, "and he would practice diligently. Whatever he played in one key, he would play in all the other keys. No matter how difficult the figure he was playing, he would practice it in every key. And that's where, apparently . . . not apparently—that's how he developed that dexterity that he had, where keys meant nothing at all to him." In those long practice sessions, Wilder says, he heard some foreshadowing of the harmonic devices that later distinguished bebop.

There was another young alto saxophone player who was turning heads in those Annapolis jam sessions. His name was Oswald Gibson—the musicians called him "Little Gib"— and he was working with a seven-piece group down from Philadelphia under the leadership of pianist Jimmy Golden. Frank Wess, who lived in

Washington, DC, and had yet to start playing professionally, came to Annapolis after school to hang around the musicians and hear the fireworks at the jam sessions. Of the encounters between Indian and Little Gib, Wess says, "They both sounded very much alike. Yeah, very much alike. . . . You know, the music progresses, wherever it is, at about the same rate, and you have the same thing going on in a lot of different towns. Some towns get together faster than others."

Charlie and Little Gib had never met before. "It was just coincidence that they played so much alike," Joe Wilder says. But his assessment of the two saxophonists, contrasted with Wess's, shows how differently two musicians can hear the same events.

"Some of the guys felt that it came out kind of even, because this little guy Gib was quick, too," Wilder remembered. "He was fast, you know. He didn't have the musical knowledge that Charlie Parker had, but he had some of the same facility. On that basis, he was sort of able to keep up with Charlie, where the rest of us, I mean, we were dragging our feet. We had never heard things that fast, although I knew some guys like John Brown in Philadelphia, who later played with Dizzy's big band . . . who could play like that. But still, they weren't Charlie Parker. Charlie was an exception."

The trumpeter Idrees Sulieman, then known as Leonard Graham, was there as well. He recalled musicians saying to Little Gib that he played everything that Indian played, to which Gib answered, "Yeah, but he played it *first*."

How could Charlie Parker have felt about Oswald Gibson? Had he ever expected to find himself blowing against another young player, someone he'd never heard of, from a town he'd never been in, who was working toward the same kind of instrumental command? If we believe Joe Wilder's account, Charlie may well have discerned the difference between his own musical knowledge and

Gibson's. Yet Gibson's presence may have inspired Charlie to work even harder, given his pride and competitive nature. Charlie loved having buddies to practice with, but no one remembers him practicing with Little Gib. They battled in the jam sessions and went their separate ways.

CHARLIE KEPT IN touch with his mother—as he always would—letting her know how he was faring, now and then charming her out of a small loan to get him from one day to the next. So Addie Parker must either have known where he was living in New York or had heard from him when he was down in Annapolis with Banjo Burney. However it happened, his mother contacted him in May with bracing news: his hard-drinking, freely wandering, nightlife-living father had been murdered at the hands of some street woman. Her angel child, her favorite son, had better pack right up and come on home for the funeral.

Charlie returned to Kansas City by rail. This time he had a ticket, but his heart was no lighter than on the gloomy night he'd left, around eighteen months ago, nearly a year before Coleman Hawkins had his Negro community hit with "Body and Soul." The town was far different now. He could hardly recognize it.

A year ago, on May 22, 1939, Tom Pendergast had been sentenced to fifteen months in prison after pleading guilty to income tax evasion, the same charge that brought down the mighty Capone. The many thousands of wide-open Kansas City days and nights were gone, victim of an overdose of the brand of honesty that made it hard for musicians who depended on the nightlife to survive. What a moment: just as Charlie was getting with the New York groove, his erstwhile dissipation behind him, mastering his horn and earning some respect for it, bloody murder pulled him back into the

K.C. blues. Luck was hard to come by—and, when you got it, it never lasted long enough to get a goddam thing done all the way right.

REBECCA HAD BEEN through a whole heap of homemade hell since Charlie took it upon himself to disappear from town: *poof.* She and Addie Parker were at odds most of the time. It was ugly and it was strange. Rebecca thought her mother-in-law was "in the arts," a hoodoo woman, especially after Parkey took little baby Leon and walked him around the house in a circle, saying, "Now he won't ever leave home." The satisfaction in Addie's voice and eyes gave Rebecca an ominous chill.

Rebecca kept silent, but she watched every little thing Addie Parker did with a growing combination of fear and resentment. She could see that Addie was gradually trying to reduce Leon's affection for his own mother. She wanted that boy all to herself—as if, having failed to hang on to Charlie Sr. and then to her own son, she could start all over again with the next generation. Her ways always revealed her mind.

Addie Parker wasn't a naturally warm person—Rebecca had known that for a while now—but she was so warm with Leon, so sweet, paying so much attention, cooing to him all the time, making him laugh and giggle. Oh, she put a light in that child's eyes. Yes, she did. If she could get that boy, baby Leon, he would replace Charlie the father and Charlie the son. And if Charlie the son came back after this long, long time away—and stayed back—her world would be perfect, son and grandson under her control. That son of hers and that baby would have everything they wanted; they would need for nothing that was within her power to bring home. Addie Parker knew how to spoil people and command them at the same time.

All this business with Parkey, and Rebecca's other feelings about the father of her child, kept her in an emotional and psychological whirl. She still loved Charlie; she could remember how he looked, his strong body and its reddish-brown tone, the way it felt when they were together and everything was going along right, the sound of his voice, that lost look he could have, or that happy look, or that look that showed how much he cared for her. She remembered how he would pull himself together, little by little, and take her out riding in Parkey's old Ford. Of course, she also remembered the many ways he had broken her heart, first into big pieces, and then into smaller and smaller ones. There was no way to forget the surprises that came from the inky world he lived in and couldn't cut loose from, the sudden violence—even the way the two of them silently communicated their mutual fear and unhappiness. It was a lot for a young girl to carry around.

By and by, Rebecca began missing her own mother and the atmosphere of the home she'd once known, when things had made sense and there was no constant feeling of insecurity darkening the sky. Rebecca didn't know where she was going; she didn't know what was going to happen to her and her child; she had no idea where Charlie was or what he was doing. Now he was gone, giving the crabs to other girls who didn't know he wasn't clean. Just as easy, he could have picked up some harsher disease from those street women. He could be dead, for all she knew. One thing was sure as death itself: if Addie Parker was in contact with him but didn't feel like telling her, there was no way Rebecca was ever going to find out.

Rebecca's problems with Parkey finally reached their most difficult plateau when her mother-in-law demanded that she divorce Charlie in absentia and make a choice: either prove she had a means of support or turn over baby Leon to his grandmother.

Rebecca was dumbstruck. Now Parkey was going to put the white court people in their family business? That was another slap: Rebecca meant nothing to her now that Charlie had left, even though Parkey had promised him that she'd take care of his wife and his baby on the day that her saxophone-playing son had hopped a rattler and disappeared from Kansas City. Well, Addie Parker didn't lay down in love to get pregnant with Leon, and she didn't lay down in labor to let him loose in the living world. Rebecca's will was not gone, not hardly. She might have felt broken inside, but her anger was the equal of everything else she felt. If she had stood up to her own mother for Charlie, she could stand up to Charlie's mother for her own son.

When Addie forced the matter into court, that simplified everything; her betrayal scraped away all of Rebecca's hesitation. She would have to get away from Addie Parker, to get her son out of that cold hoodoo woman's shadow. Rebecca acquiesced to the divorce—and she was overwhelmed, almost humiliated, with gratitude when her own mother offered herself as guaranteed support for Leon.

All the rancor in 1516 Olive cooled off then, replaced by a low-grade resentment on both sides. One part of her life was closing down. When the day finally came, her brother, Winfrey, drove up and said, "Come on, Rebecca, I'm taking you home."

"Home," she recalled decades later. "It felt like, to me, like the most beautiful word I ever heard anyone say."

REBECCA MOVED TO her family's new home in Leeds, Missouri, about a ten-minute drive from Kansas City. In May 1940, her mother came to Rebecca and said, "Becky, Charlie's at the door."

She went to the door and talked with Charlie on the porch. This young man looked good, very good. He was still lean, but he had a

new coating of seriousness in his eyes. There was more man than
boy standing there. There was also a kind of sadness to him, an-
other cut of pain, something like the way he'd looked the day he
carried their miscarried second baby to the bathroom, in a pan
given to them by Dr. Thompson, and flushed it away. Yes, she still
knew him, God help her. She knew that young man who was rising
out of the skin of the boy she had fallen in love with. Still, she could
tell something was wrong with Charlie that day—wrong as a back-
ward seven. She was right: his father had been stabbed to death
with a pair of scissors, and Charlie had come back home for the
funeral. Poor Charlie: his father, always an invisible ghost to him,
was finally gone for good.

He visited with Rebecca for a while, trying to piece their mar-
riage back together. He tried to explain himself to her: everything
he had done, he said, he had done either because he didn't un-
derstand the meaning of his actions or because he had to take a
chance on his talent. He had suffered out there, hopping trains,
starving, wearing his shoes until his feet swelled up so big they
almost busted out of the leather. It wasn't easy, but Charlie was
getting much closer to his own way of playing, and even some of
the guys back east, who'd never heard of him, were beginning to
respect him. He had put the drugs and the liquor behind him. Now
all he wanted was to have his wife and son back. Rebecca had to
know that he loved her, and that he loved Leon, and it must be ab-
solutely clear that the three of them were supposed to be together
under one roof.

Well, many things were clear, all right, but her moving back in
with him into that woman's house on Olive Street was not one of
them. She still loved Charlie: she could feel it just looking at him,
and more so because of the new power and confidence that had
replaced his old, unearned, childish arrogance. Rebecca could see

he wasn't high, and he looked rested, so she believed him when he said he'd conquered the needle and the bottle. But up under all of the rioting emotions of attraction, and the seductive attraction of his voice, she still felt in her heart an absolute lack of confidence that the two of them could work out their troubles. As good as he looked, as sweet as he spoke, as serious as he obviously was, she could still feel the turmoil within Charlie.

As she sat and talked with him, Rebecca heard herself saying, "No, Charlie," over and over again.

After realizing he couldn't convince her himself, Charlie said to her mother, "Mrs. Ruffin, please make Rebecca come back to me."

"Charlie," she said, "I didn't put you together, and I didn't take you apart. That's between you and Becky."

"All right, Mrs. Ruffin." It went no further. Charlie left.

What happened after that was remembered quite differently by Rebecca and her sister Ophelia in interviews conducted decades later. Ophelia claimed that, even though things were hard between Charlie and Rebecca, and despite the animosity between her sister and Mrs. Parker, Becky was always trying to get back with Charlie. Rebecca claimed that she broke off things with Charlie for good in East Saint Louis in 1939, when he was with Billy Eckstine's big band and a young, enthralled Miles Davis was there listening. Though Rebecca insisted on the story, her timing was impossible: Davis didn't intersect with the Eckstine band until 1944, when he was just graduating from high school. All Ophelia remembered about those later years was that Rebecca was so crazy about Charlie that she tried over and over to get him to do right, to take care of her and Leon.

What Charlie did with himself after Rebecca refused to leave her mother's home is very clear. He went right back into Addie Parker's house, no longer a boy but a young man who had traveled and had

an even stronger sense of what he wanted to do. Perhaps seduced by the comfort of 1516 Olive, Charlie didn't go back to New York, not right away. There in his mother's house he didn't have to worry about clothes, food, paying to get his saxophone fixed, cab fare—anything. All he had to do was walk through that door and he was the crown prince of the kingdom.

But that didn't mean that he had changed his ways. Charlie was now a full-fledged night person. He loved being in the streets, playing until everyone was worn out, pulling a nice new lady next to him, listening to other people's tales, and spinning his own—about Chicago and New York and how exciting everything was. To hear Charlie tell it, if you hadn't been to Harlem, you hadn't been anywhere. And as he lingered in the easy comfort of his hometown, the discipline he had developed in New York went lax. The Charlie Parker who studied diligently with Biddy Fleet was replaced by the wild one who'd preceded him in Kansas City—addiction and all.

Charlie's return to drugs was apparently assisted by Tadd Dameron, who was hated by Lawrence Keyes, leader of the Deans of Swing and one of Charlie's first musical employers in Kansas City. Keyes hated that Negro from Cleveland for pulling his buddy back down into that snake pit from which so few escaped. Dameron, a composer and an arranger as well as a middling pianist, was a curious man looking for new things to do in music. A romantic, he had been thrilled by the hugely orchestrated melodic scores of Hollywood, the music of Duke Ellington, and the songs of Tin Pan Alley's bigger talents, like George Gershwin and Cole Porter. He also claimed to have studied chemistry, and he knew a lot about the various intoxicants that could derange the senses into a state of euphoria, about potions and powders that were designed to relieve pain but had begun to assume their primary role as a form of illegal recreation.

Charlie met Dameron in Harlan Leonard's band, which he rejoined now that he was back in Kansas City. Leonard still disliked him, but Charlie could play even better now—everybody knew it—and Leonard was able to forgive him his shortcomings because of what he brought to the bandstand. When that saxophone was in his mouth, the band lifted up, the men playing beyond their usual level of skill, pulled along by the hot, lean sound of his daredevil inventions. With Charlie Parker standing there, still as a wooden statue, sweat puddling at his feet, the rhythm section swung harder, the brass and reeds kicked out their parts with more edge and fire, and the whole sound coalesced into a Kansas City storm.

Harlan Leonard could see the boy still wasn't taking care of himself, or taking care of business. He came to work when he felt like it, and when he did get there he looked like an unmade bed. To Leonard's point of view, Charlie's gift was misplaced. It should have gone to a much better man, not this knuckleheaded mama's boy who seemed to delight in the way his fellow band members sided with him against the leader.

As Biddy Fleet noted, Charlie preferred being loved to being hated; he was grateful for the support of his fellow musicians. But nothing anyone thought about his quirks and vacillations meant much to him, so long as no one's conclusions got in the way of his concentration. He was too busy working on his horn and having a good time to be bothered by what some second-level guys had cooking in their brain pans. The world out there was much larger than the provincial minds that surrounded him, and he had already passed some tests in that wider world. His rump was in Kansas City, but his dreams were back in New York.

There was a high-minded, contemplative side to Charlie, too, a habit of wondering how things would feel if the world were vastly different. As fascinated as he was by innovation and invention, he

was more intrigued by the inspiration behind the invention—by how some human mind thought of each new idea. He recognized that thought was a pure thing not impeded by social circumstance. It had independent power. A C scale was a C scale, no matter who played it or why, which gave those notes—any notes—a spiritual quality. That was why the bandstand was such a sacred place, and why it would have been difficult to ascertain much about the social conditions of the 1930s while listening to the Negro musicians of Charlie's era. They didn't evade life when they performed, whether in public or private; they entered its condition of freedom through their craft, discipline, and inspiration. In the pure universe of musical tone, they were able to express themselves as exactly who they were, not as the limited icons that others, black or white, might mistake them for.

Charlie Parker, no matter how highly talented, was not greater than his idiom. But his work helped to lead the art form to its most penetrating achievement. Jazz, as a performing art, is about navigating a landscape in which spontaneous creation whizzes by in layered stacks, and about creating a fresh and continual response to that landscape. The music is about more than merely making something up; as drummer Max Roach often said of playing jazz, it is about creating, maintaining, and developing a design.

Today we might call this multitasking, but at its most fundamental level, it is about victory over chaos, about achieving and maintaining a groove that meets the demands of melodic, harmonic, rhythmic, and timbral inventions in milliseconds. During his most satisfied bandstand experience, Charlie Parker knew what every talented jazz musician has, before and after: how to listen and hear, instant by instant, and how to respond with aesthetic command to that instant, gone now and never to return.

Trumpeter Bobby Bradford once said that whenever people

heard jazz, and understood how the elements within it were lining up and working in coordination, its emotional and intellectual power was strong enough to convince them that they had been dreaming. Maybe that was what the brain taught us: that a dream team could make its art by dreaming together—mutualizing Apollo and Dionysus—until nothing but the fact of their instruments separated the players from one another.

Charlie Parker was another dreamer, ready to enter that large and mutual dream.

Epilogue

In the 1980s, on a visit to Chicago, I met the saxophonist Joe Daley at Joe Segal's Jazz Showcase, a venue then in the Empire Hotel, a building where musicians from out of town could take rooms and play the job downstairs. Daley and I stood on the rug outside the club shortly before it opened for business and talked about what he had seen there in the late forties, when Parker came to Chicago. Daley was struck by the effect Charlie's music had on local musicians and listeners alike, who sometimes reacted as though they were at a revival.

At one point in our conversation, we were joined by another saxophonist. He was a stranger to me, but he joked easily with Daley, who clearly respected him as a friend, and as one who knew the lore of jazz through his own eyes. He said his name, but I did not write it down and don't remember it today. He surprised me: I thought I was aware of all the respected alto and tenor players in town, but he said enough about music—including some insightful things about Lester Young's fingering—that I was convinced he knew what he was talking about.

A few minutes later, the saxophonist made a comment that sur-

prised me even more. He claimed he had seen Charlie Parker in a "soundie"—a kind of proto–music video, five or ten minutes long, that was popularized in the early 1940s. In the film, he said, Charlie was playing not a saxophone, but a clarinet, as a section player in a big band. At first he said the band was Harlan Leonard's—and Charlie is known to have played with Leonard's band in 1939 and 1940—but I questioned what he told me, because he said the soundie was a film nobody else he knew had ever seen. Daley hadn't seen it either, but he knew the man well enough that he took the story seriously.

Like Gene Ramey, anyone who spends time investigating the life of Charlie Parker must come to terms with the mysteries that decorate his story. What we know of Charlie's life during the months between his departure from Kansas City in early 1939 and his return from New York in 1940 remains fragmentary despite the work of many scholars. His itinerant lifestyle can make him seem more a movie character—a figure caught in glimpses, in jump cuts and slow dissolves—than a flesh-and-blood human being. He was leading a busy and productive life, full of adventure, arrogance, and humbling discipline, including the discovery and conquest of himself. The fact that he'd managed to break his drug habit, for a while at least, seems to have given him a strength that must have helped his optimism, though it could not have extinguished his despair.

His chameleon ability—not to change color, but to fit in very quickly through mimicry—allowed him to be as comfortable in the backwoods, with its rustic flavors and ways, as he was in the city, amid that middle-class-to-upper-crust milieu his father, Charlie Sr., had evoked when speaking to his son about the people he and his fellow porters treated to fancy service on the trains. And we

know he learned to emulate skills with an intensity that made his personality as rubbery as his facial features.

Charles the younger seemed able to remember voice patterns, accents, and dialects as accurately as he did pitches. He could summon the notes of the human landscape and reproduce them as clearly and accurately as he could the notes and phrases of songs and the way they were harmonized. None of this made him superhuman, but it prepared him to handle unexpected emergency, to retain an ingratiating resourcefulness that complemented what he was learning in his trade as a bandstand improviser. We do know that Charlie surfaced in Chicago before Jay McShann arrived in January 1939, and then again in the spring of 1940. Could he have appeared in a soundie on that second trip? Perhaps he held on to Goon Gardner's clarinet along with his clothes; perhaps some other musician got him the clarinet job and lent him the instrument. We know he learned the licorice stick back in his hometown days, from his school band instructors. Certainly by then his digital memory was so swift and strong that this young guy, both timid and brazen, was capable of getting prepared to play a dance band book in a couple of hours.

It was on one of these stints in Chicago that he first encountered Bob Redcross, who became a longtime associate. Redcross may have been a hustler, but he was a principled one who prided himself on giving a sucker an even break and on his ability to make fast friends with a peer—even that skinny kid from Kansas City who walked up out of nowhere and cadged a cigarette, standing there talking after the smoke was lit, his leg crooked like the out-of-towner that he was.

Redcross and the stranger soon found they had a connection. It was the kind of intellectual curiosity that brought them together

as friends who had both feet in the jazz world, though they found themselves taking distinctively different paths through pages of books, newspapers, and magazines. Their literacy and curiosity often coaxed them into music quite different from jazz, and into museums that cost nothing but provided plenty. Some of those public institutions were more than ready to make a pair of young Negroes feel like interlopers, but Charlie and Bob were too optimistic to let that distract or discourage them.

"Over the years," Redcross told me years later, "Charles and I would get to something like an art museum—like when he was having a ball with that painter Gertrude Abercrombie. But in the early times we just wanted to discuss things that interested us, smoke a little, drink a little, and listen to as many records as I was willing to play until Charles fell asleep, or I did. Then it started all over the next day. It was that wild and crazy in one room, because men with intelligence and energy, and a lot to explore, know how to keep busy. It wasn't that we were bored to tears; we were always on the lookout for things that were informative and could make us think deep and distant thoughts."

The earliest recording of Charlie Parker, the first document we have of his playing, is sometimes said to have been captured by Clarence Davis, though Bob Redcross also claimed responsibility for all of Parker's earliest recordings. Whatever the case, one thing is certain: the player is Bird. It is a four-minute solo recording of the young saxophonist playing two songs, "Honeysuckle Rose" and "Body and Soul." Parker fans have since come to know the performance as "Honey and Body." Many have assumed it was recorded in May 1940, but it may have been made earlier—which would make some sense of how Parker sounds on the recording, much closer to 1939 than some have suggested.

The recording is a fleeting moment in time made memorable by

technology, discernible through a haze of popping and hissing, an audible window screen against which his face is pressed. In those four minutes, we hear Charlie Parker confronting himself, confronting both what he knows and what he is still trying to work out. He stands alone, keeping time in his body, maintaining tempo all by his lonesome, with no audible measurement from a metronome or a drummer, a guitarist, a bassist, or any other rhythm player. In usual jazz circumstances—regardless of style, from New Orleans jazz to last week—the featured player is constantly responding to the inventions of others, all aesthetic notions in motion, all attention acutely on one another. On "Honey and Body," though, there is no band. Not at that moment, not on that recording. There is only Charlie Parker.

This—the sound of the moment before ignition—is what people have long hoped to find in searching for recordings by Buddy Bolden, the New Orleans cornet player thought to have brought together enough functional understanding to begin jazz, or to get so close that others knew what to do. In Bolden's case, we have no voice of the dead; we have only a photograph, Bolden with his band, in his playing context, handsome and charming but as still as written notes on manuscript paper. We can only surmise that he is holding closed a secret, invisible box, waiting to pull something out that will allow him to turn the world around.

Charlie's recording is more intimate than even the extended solo breaks and extraordinary single-note improvisations of Louis Armstrong's "Laughin' Louie," recorded a few years earlier in a raucous 1933 big band studio session for RCA. "I'm going to do a little practicing," Armstrong says before leaping into his marvelously controlled and heartfelt performance. But this was a commercial record, intended for the public. Charlie's private recording is different. It is an audible diary passage, among the earliest evidence

we have of a major jazz artist appraising himself with the looking glass of a private recording, preserved by luck and discovered through the army of collectors that was beginning to mature at the same time Parker did. He surely intended it only for himself, probably not valuing or even remembering it for long.

Parker delivers the two songs through a series of statements, each evolving into the next, following the logic of group improvisation, but through a solo voice. The single line is removed from its context, divorcing the listener from any sense of how small a slice of the story is truly being revealed. He is like an actor on an empty stage, trying to drive himself through an entire play alone, while still reacting to every other part. His silent costars are the ghosts of jazz, living or dead, remembered exactly or partially or imaginatively. Most of all, he is alone, as he had always been. He is the concentrated history of his art, an ambitious journeyman with an appetite for personal greatness whose special abilities never settled for recapitulation but ushered his own identity forth along with everything he heard on the bandstand, in the audience, through the radio, or spinning around on the turntable.

We know already how much of Charlie's knowledge came from Buster Smith, his professorial mentor, as they practiced far away from the roar of the crowd, or sat not more than one chair away onstage at the Bottoms, or upstairs at the private smokers, where the good times rolled as decadently as they could. We know how he studied the silken mysterious lyricism of Lester Young, heard nightly during his recent boyhood in the backyard of the Reno, among the musicians, the whores, and the hangers-on like himself, all of them awed by the sailing surprise of Lester's imagination.

We know what he got from the recordings and broadcasts of that rough tenor taskmaster called Chu Berry, whose fast, combative passages argued with and against the chords, twisted them out

of shape, made a yowled getaway at the peak of a heated passage—with the kind of tempered hysteria that was more about expression than loss of control, as Charlie himself surely wanted it to be. Even when hysteria crept up on him, it melted away when he shook at it with the censer of his saxophone, the transformed rattle used to purify the ritual, the brass tamer in one body: the hellfighter made with twenty-two keys, a mouthpiece, a reed, and a bell. But all of that was still not enough.

Wherever he was, in whatever room playing whatever horn, owned by him or not, Charlie Parker was in a condition of confrontation. That was inevitable. By now he knew, deeper than his marrow, what all serious artists realize: that no matter how great and perfect a major creator is at a moment of sublime delivery, there are always limitations. No one person is perfect enough to conjure what another person feels as he tries to express what is inside. Parker, the young talent, was beginning to realize that no established genius, however rough, tough, and dreamily hypnotic, could hear what he was hearing. Perhaps what he heard was actually his and his alone.

That must have been almost as frightening as the moment when Charlie sat in on "Body and Soul" up on Jimmy Keith's bandstand, naively running the changes of "Honeysuckle Rose" and "Up a Lazy River." Those mistakes got him thrown off the bandstand because—as he later put it—there was "no kind of conglomeration" that could make those chords match what the band was playing. So he got off the stand in defeat, showered down with derision. But from that point on, he pledged to learn how, to unlock the genie that was hidden somewhere in his soul.

He had always sensed it was there, that genie, despite the lack of available proof. It was as real as the spirit in the tale of Aladdin, but it had to reveal itself to a boy in Kansas City with a funny-shaped

head. And he knew there was nothing magic about it, though the masters could make their work sound that way. He could *learn* it if he was willing to *work* hard enough. Well, as that first recording reveals, he now had the genie by the foot and was trying to pull it out.

"Honey and Body" was a kind of test flight. Armstrong and the others had been as real as the Wright brothers; they had proven, through recording technology, that human beings had the ability to fly through their minds, to spy upcoming notes within themselves and harness them instantaneously as personal statements, within the context of mutual improvisation in which cohesive magic arrives through empathy and the art of the invisible—music—is ultimately made to shine like Klondike gold. But this was a new kind of aerodynamics.

We know nothing about how Charlie Parker arrived in the room where he recorded that day, how long it took him to get ready for his saxophone, how much time elapsed before it was ready for him, prepared to stand up under his enthusiasm. Yet we can picture him: Standing or seated, in dark glasses or none, eyes open or closed, at the perfect angle to see through a glass darkly. He blows without hesitation, lurching forward with pure lyric power. Swing and control of time are already there. No prisoners taken and none demanded. He sees the music clearly and knows what he must do with it. It comes to him in an unfinished outline, and he proves himself in private, not for that moment alone, but for all time. A whole leg spins audibly on the turntable. It is Charlie Parker, indisputably stepping through the air and waiting for the other limb to drop.

Acknowledgments

This book is dedicated first to Emma Bea Crouch and her husband, James Crouch, each of whom embodied and evoked, through the tone of their memories, what first hooked and fascinated me about the art of jazz and the world out of which it came during the Depression years of the 1930s. What Richard Schickel calls "the American vastness" inhabited their memories of the clothes, the automobiles, dance halls, the trains, the movie houses, the sense of style, and the contempt for all limitations, coming from within or without, arriving as a distinctively graceful way to live, or—way down at the other end—as an ongoing vulnerability to the delusional.

My mother's grandfather was from Madagascar; he arrived on a Portuguese sailing ship in 1863 and heard the percussive war music of General Grant's cannon shelling Vicksburg, Mississippi. Jumping ship, he met a Choctaw woman whom he married before moving to Arkansas and later to east Texas. He was remembered as tall, jet black, with slanted eyes and hair down to his shoulders; he and his wife must have made a somewhat unique couple. My father described his grandfather as a redheaded Irishman who owned a

plantation in Atlanta, Georgia. This cluster of bloodlines has led me to the conclusion that I, like many others, am an all-American guy: part African, part Asian, part Choctaw, and part Irish.

While my mother had a sensibility that lived on the bright side of the street, my father preferred the darker side. He was well acquainted with the hustling ethos, and he was prison victim of his belief that he was much less naive or square than workaday people, who could tell him nothing about the bright lights, the big city, and the nefarious ways things went on the back streets. In the end, however, a good-looking domestic worker, or maid, breathed much more free air than this roustabout criminal who spent most of my childhood behind bars, convinced he would not mess up that way again, until he found himself serving another sentence.

The rest of their family introduced that American vastness to me in weddings and funerals, long hopeless loves, bad marriages, and the periodic brass rings of a life that may sometimes have been a merry-go-round, but tended at moments to reshape itself into a roller coaster. Through all of the joy, all of the sorrow, and all the bittersweet half-steps, I came to recognize that jazz was always, or could be, a looking glass through which to see and express life in its multi-various forms and the infinity of its feelings, articulated in the transcendent beat of blues and swing.

I can reconnect with my entire family, all of my neighborhoods, everything I've ever done or imagined, whenever I hear any jazz band heat up and "put the pots on," showing how well it can struggle for joy together. No art says "I want to live" better or more forcefully than jazz. From the whisper, to the mysteriously artful noise, to the exultant and affirmative cry or scream, ever unwilling to be held down, every page of this book is a testament to that.

• • •

ACKNOWLEDGMENTS

THIS BOOK WAS begun more than three decades ago, and has benefited from layers contributed by all manner of people in or out of the arts, seeking to help or clarify things about what they knew, or thought they knew, about Charlie Parker and his world. I am most deeply appreciative of the time, feeling, memory, and understanding of those who were Charlie Parker's first loves, his earliest friends, and those who knew and worked with him as a young man and an evolving professional within the mythical and epic context of Kansas City. That midwestern town was a combustible and joyous compression of American history and modern life.

Beginning in 1981, I started formally interviewing people who had known the young Charlie Parker, and whom I came to know over many conversations and further interviews far into the next decade. I learned much about Parker's meaning to musicians through many, many conversations with trumpeter Bobby Bradford, a forty-year friend, one of the most intelligent men I have had the benefit of knowing. Bradford knew Parker's first wife, Rebecca Ruffin, and introduced me to her. By then she was living in Pasadena; she had not been interviewed and was eager to talk about that point in her life. Later, in Kansas City, I got to know her younger sister, Ophelia, the baby, along with Parker's bandleaders, his many friends, and others, all of whom gave this tale heft—though only after the narrative had been absorbed, sifted, and weighed against the misreadings, distortions, and willful fantasies that some others have paraded forward as fact. Some of the greatest revelations about Parker were provided by Rebecca, and by what Ophelia saw of their secret romance and quicksilver marriage to Charlie.

Then there were the musicians who knew, befriended, inspired, and collaborated with Charlie Parker in his earliest years—chief among them Gene Ramey, Buster Smith, Jay McShann, Orville

Minor, and Oliver Todd, five aces in the flesh, all of whom I interviewed at length on tape, and had many informal but informative conversations with as the years passed. These were estimable men who knew all of the Kansas City fact and lore, understanding many of the varied meanings of that era and how far that brief time actually was from what is believed, or even documented, all these years later. Jo Jones, in particular, helped me understand how Negroes negotiated the pressures of corruption and deadly criminals while maintaining their aesthetic, social, and human desires, whether general or specific. Those who knew Charlie Parker as the little boy who lived across the street, ready to pull pranks on hobos and neighbors come Halloween, or who performed with him in a local band, included Edward Reeves, Sterling Bryant, Julian Hamilton, Fred Dooley, Junior Williams, Earl Coleman, and Harry "Sweets" Edison, who all supplied atmosphere and detail. Insight into the McShann band's first visit to the Savoy Ballroom, and the responses of the audience, the Savoy staff, and fellow musicians, came from Panama Francis, Gus Johnson, John Tumino, Chubby Jackson, Biddy Fleet, Frank Wess, Rozelle Claxton, and Joe Wilder. Further contributions came from Mary Lou Williams, Buddy Tate, Lawrence Lucie, Kermit Scott, Jimmy Heath, Walter Bishop, Jr., Jackie McLean, Walter Davis, Jr., Michael James, Bob Redcross, Phil Schaap, and Billy Eckstine, and many others, the chorus of voices necessary to put flesh and bone on legend, or wings, when they fit.

One of my most intellectually substantial friendships has been with Loren Schoenberg, a musician and educator who knows how to lead a band, how to teach a class, and how to run a nonprofit, none of which is easy to do. I have benefited from his feelings for the music, his writing, and his range of subtle insights. My best

friend, Wynton Marsalis, has been an ever-growing compendium of musical accomplishment with a large appetite for knowledge. I met him when he was seventeen and have discussed every aspect of the arts and human life with him almost daily for more than two decades. WM was a match with Ralph Ellison, Albert Murray, and Saul Bellow, three men who were always ready, willing, and able to treat me to inspiring, informative, and loquacious exchanges, often as bawdy as learned, each believing it was of the utmost importance to stay acquainted with the street. As Armstrong said, "It's all life." That is the perfect way to describe the fluid, insightful contributions of Max Roach, perhaps the grandest drummer in the history of Western percussion, and an imposing raconteur with a multitude of facts at hand. Right behind him, as a raconteur and great teller of unheard stories full of illuminating detail, was Philly Joe Jones, one of the grand masters of "the hang," a sublime and masterful teacher. And the quality writer Tom Piazza and I talked for three decades about Armstrong, Ellington, Basie, Lester Young, jazz itself, cinema, American and world literature, and Parker, whom he always held in a high, invincible place.

At Mosaic Records, thanks to Michael Cuscuna and Scott Wenzel for essential and speedy help. Invaluable help in providing photographs and documents came from Donna Ranieri at the Frank Driggs Archive, newly housed at Jazz at Lincoln Center, and from Llew Walker at the website www.birdlives.co.uk, also a valuable source of details on Charlie Parker's life. Thanks to them, and also to the Miller County Museum, Miller County, Missouri, for its photos of Musser's Ozark Tavern, and the Kansas City Library for the photo of the Antlers Club, originally seen on John Simonson's blog http://paris-of-the-plains.blogspot.com.

At HarperCollins, my working team has included my editor,

ACKNOWLEDGMENTS

Calvert Morgan; his assistant, Kathleen Baumer; jacket designer Milan Bozic; managing editor Keith Hollaman; and publicist Gregory Henry. We were brought together by my agent, Georges Borchardt. I thank them all, and the many others not mentioned by name, who made such demands on my sensibility and intelligence.

Sources

Besides the in-person interviews noted in the Acknowledgments, other sources consulted in research for this book include:

Armstrong, Louis. *Satchmo: My Life in New Orleans*. Boston: Da Capo, 1986.

Baker, David N., ed. *New Perspectives in Jazz*. Washington, D.C.: Smithsonian Institution Press, 1990.

Basie, Count, with Murray, Albert. *Good Morning Blues: The Autobiography of Count Basie*. New York: Da Capo, 2002.

Bergreen, Lawrence. *Capone: The Man and the Era*. New York: Simon & Schuster, 1996.

Blesh, Rudi, and Janis, Harriet. *They All Played Ragtime,* New York: Oak Publications, 1974.

Burroughs, John. *Public Enemies: America's Greatest Crime Wave and the Birth of the FBI, 1933-34*. New York: Penguin, 2009.

Bushell, Garvin. *Jazz from the Beginning*. New York: Da Capo, 1998.

Calasso, Roberto. *La Folie Baudelaire*. Translated by Alastair McEwen. New York: Farrar, Straus and Giroux, 2012.

———. *Tiepolo Pink*. New York: Knopf, 2009.

SOURCES

Caplan, David. *Questions of Possibility: Contemporary Poetry and Poetic Form.* New York: Oxford University Press, 2005.

Cardullo, Bert, ed. *Jean Renoir: Interviews.* University Press of Mississippi, 2005.

Crouch, Stanley. *Considering Genius: Writings on Jazz.* New York: Basic Civitas, 2007.

Dary, David. *Cowboy Culture: A Saga of Five Centuries.* Lawrence, KA: University of Kansas Press, 1989.

Dexter, Dave. *Jazz Cavalcade: The Inside Story of Jazz.* Whitefish, MN: Literary Licensing, 2011.

Douglass, Frederick. *Narrative of the Life of Frederick Douglass an American Slave.* New York: Bedford/St. Martins, 2002.

Driggs, Frank, and Chuck Haddix, *Kansas City Jazz: From Ragtime to Bebop—A History.* New York: Oxford University Press, 2005.

Du Bois, W.E.B. *Dusk of Dawn: An Essay Toward an Autobiography of a Race Concept.* Piscataway, NJ: Transaction Publishers, 1983.

———. *The Souls of Black Folk.* Mineola, NY: Dover Publications, 1994.

Durham, Philip, and Jones, Everett L. *The Negro Cowboys.* Bison Books, 1983.

Ellison, Ralph. *Living with Music: Ralph Ellison's Jazz Writings.* Robert O'Meally, ed. New York: Alfred A. Knopf, 2002.

Flaubert, Gustave. *Madame Bovary.* Translated by Lydia Davis. New York: Viking Press, 2010.

Fletcher, Tom. *100 Years of the Negro in Show Business.* New York: Da Capo, 1984.

Gelernter, David. *1939: Lost World of the Fair.* New York: HarperCollins, 1996.

Gentry, Curt. *J. Edgar Hoover: The Man and the Secrets.* New York: Penguin, 2001.

Giddins, Gary. *Celebrating Bird: The Triumph of Charlie Parker.* New York: Birch Tree Books, 1987.

Hughes, Langston. *I Wonder as I Wander; An Autobiographical Journey.* New York, NY: Hill and Wang, 1956, 1999.

SOURCES

Johnson, Stephen. *Burnt Cork: Traditions and Legacies of Blackface Minstrelsy.* Amherst & Boston, MA: University of Massachusetts Press, 2012.

Jones, Papa Jo. *Rifftide: The Life and Opinions of Papa Jo Jones.* Edited by Paul Devlin. Minneapolis, MN: University of Minnesota Press, 2011.

Katz, William Loren. *The Black West: A Documentary and Pictorial History of the African American Role in the Westward Expansion of the United States.* New York: Touchstone, 1996.

Lincoln, C. Eric. *The Black Muslims in America.* Grand Rapids, MI: Wm. B. Erdmans, 1994.

Lloyd, Craig. *Eugene Bullard: Black Expatriate in Jazz-Age Paris.* Athens, GA: University of Georgia Press, 2006.

Marquis, Donald. *In Search of Buddy Bolden: First Man of Jazz.* Baton Rouge, LA: Louisiana State University Press, 2005.

Matera, Dary. *John Dillinger: The Life and Death of America's First Celebrity Criminal.* Boston: Da Capo, 2005.

McBride, Joseph. *Searching for John Ford: A Life.* New York: St. Martin's, 2001.

Morgenstern, Dan. *Living with Jazz.* New York: Pantheon, 2004.

Oliver, Paul. *Blues Fell this Morning: Meaning in the Blues.* Boston, MA: Cambridge University Press, 1990.

———. *Conversations with the Blues.* New York: Horizon Press, 1983.

Piazza, Tom. *The Guide to Classic Recorded Jazz.* Iowa City, IA: University of Iowa Press, 1995.

———. *Why New Orleans Matters.* New York: Harper Perennial, 2005.

Pierson, William Dillon. *Black Yankees: The Development of an Afro-American Subculture in Eighteenth-Century New England.* Amherst, MA: University of Massachusetts Press, 1988.

Porter, Lewis, ed. *A Lester Young Reader.* Washington, DC: Smithsonian Institution Press, 1991.

SOURCES

Reisner, Robert, ed. *Bird: The Legend of Charlie Parker*. New York: Da Capo, 1962.

Rich, Doris. *Queen Bess: Daredevil Aviator*. Washington, DC: Smithsonian Institution Press, 1995.

Roosevelt, Eleanor. *My Day: The Best of Eleanor Roosevelt's Acclaimed Newspaper Columns, 1936-1962*. David Emblidge, ed. Boston: Da Capo, 2001.

Russell, Ross. *Bird Lives*. New York: Da Capo, 1996.

———. *Jazz Style in Kansas City and the Southwest*. New York: Da Capo, 1973.

Smith, Willie "The Lion," *Music on My Mind*. New York: Da Capo, 1978.

Southern, Eileen. *The Music of Black Americans: A History*. New York: W. W. Norton, 1997.

Stearns, Marshall. *Jazz Dance*. Boston: Da Capo, 1994.

Tolland, John. *The Dillinger Days*. Boston: Da Capo, 1995

Vail, Ken. *Bird's Diary: The Life of Charlie Parker 1945-1955*. London: Castle Communications, 1996.

Wallis, Michael. *Pretty Boy: The Life and Times of Charles Arthur Floyd*. New York: W. W. Norton, 2011.

Ward, Geoffrey. *Unforgivable Blackness: The Rise and Fall of Jack Johnson*. New York: Vintage, 2006.

Webb, Walter Prescott. *The Great Plains*. University of Nebraska Press, 1981.

Weil, Simone. *War and the Iliad*. New York: New York Review Books, 2005.

Woideck, Carl. *The Charlie Parker Companion*. New York: Schirmer, 1998.

———. *Charlie Parker: His Music and Life*. Ann Arbor, MI: University of Michigan Press, 1998.

Page

5-36: This account of Charlie Parker's arrival in New York with the Jay McShann Orchestra was reconstructed from interviews with McShann, Gene Ramey, Oliver Todd, John Tumoni, Panama Francis, and others. McShann's memory for dialogue was especially useful.

19: The image of "knives being thrown at the audience" belongs to trumpeter Johnny Carisi, as told to Loren Schoenberg.

19: Charlie Parker's nickname "Bird," short for "Yardbird," is the subject of continuing and probably irresolvable speculation. Some believe that "yardbird" was slang for an unreliable person. Jay McShann told Robert Reisner that "yardbird" was the saxophonist's slang for chicken, one of his favorite meals. Once, McShann recalled, when the car Charlie was traveling in hit a chicken in the road, he shouted to the driver: "No, stop! Go back and pick up that yardbird." The bird was brought back to the hotel and cooked up for the band. Reisner, *Bird,* 150.

20-21: Panama Francis and Gene Ramey, taped interviews, 1981.

22-27: Ramey, McShann, Ralph Ellison, and John Tumoni in interviews and in conversation.

27: Oliver Todd, taped interview, 1981.

28: Jay McShann, taped interview, 1981.

29: Orville Minor, taped interview, 1981.

30-36: Ramey, Howard McGee, Jay McShann, taped interviews. Also drew on conversation with Chubby Jackson, the Blue Note, New York, NY.

37-42: For background material on the Great Plains, I drew on Walter Prescott Webb, *The Great Plains*; William Loren Katz, *The Black West*; Philip Durham and Everett L. Jones, *The Negro Cowboys*; and David Dary, *Cowboy Culture*.

42-43: Rebecca Parker, taped interviews, 1981, and untaped conversations throughout the 1980s. Addie Parker told Robert Reisner that Charles Sr. "was playing and singing on the vaudeville stages around Kansas City" when they met. Reisner, *Bird,* 159.

SOURCES

43: Addie Parker's maiden name appears variously as "Boxley" or "Boxely," or "Boyley," "Bayley," or "Bailey." See Giddins, *Celebrating Bird,* 26.

44: Addie Parker to Robert Reisner, in *Bird,* 159.

44-46: Edward Reeves, taped interview, 1981.

47: Addie Parker to Robert Reisner, in *Bird,* 163.

48-49: Edward Reeves and Sterling Bryant, taped interviews, 1981.

50-51: Edward Reeves, Rebecca Parker, Ophelia Ruffin Handy, taped interviews, 1981. Rebecca's age is difficult to pin down; to the author and other interviewers (see Giddins, 34) she gave her birth year as 1920, though Addie Parker told Robert Reisner that she was several years older (Reisner, 158ff).

52: Ophelia Ruffin Handy, taped interview, 1981.

53: Rebecca Parker, taped interview, 1981.

54-57: Rebecca Parker, ibid.

60: John Tumino, taped interview, 1981, and later conversations.

60-61: Bushell, *Jazz from the Beginning.*

62: Oliver, *Blues Fell This Morning,* 5.

63: Emma Bea Crouch, untaped conversations.

63: Wallis, Michael. *Pretty Boy,* 226.

64-65: Edward Reeves, taped interview, 1981.

66-67: Burroughs, John, *Public Enemies,* 51ff; Gentry, *J. Edgar Hoover,* 168ff.

68-70: Rebecca Parker, taped interview, 1981

77: Ophelia Ruffin and Rebecca Parker, taped interviews, 1981.

78: The rumor may be apocryphal. See Caplan, *Questions of Possibility,* 9, 141–2.

80-81: Ralph Ellison, untaped telephone conversation.

80-82: Rebecca Parker, taped interview, 1981; detail of the forty-five-dollar alto comes from Addie Parker to Robert Reisner, in *Bird,* 166.

83: Edward Mayfield, Jr. to Robert Reisner, in *Bird,* 142; Julian Hamilton, taped interview, 1981.

85: Harlan Leonard quoted in Russell, Ross, *Jazz Style in Kansas City and the Southwest.*

87: Marshall Stearns and Jim Maher, radio interview with Parker, 1953. Slightly differing transcriptions appear in Woideck, *The Charlie Parker Companion,* 93, and at http://www.plosin.com/milesAhead/BirdInterviews. html#500500. The interview itself is available on *New Bird — Rare Live Recordings & Interviews,* Swan Records/The Orchard, 1999/2010.

88: Addie Parker to Robert Reisner, in *Bird,* 162.

89-90: Fred Dooley, taped interview. 1981. Lawrence Keyes told Robert Reisner that his first band was called the Deans of Swing (*Bird,* 129). However, in *Kansas City Jazz: From Ragtime to Bebop—A History,* Frank Driggs and Chuck Haddix present contemporary evidence suggesting that, when Charlie Parker was a member in the summer of 1935, Keyes's original band was called the Ten Chords of Rhythm (or simply the Chords of Rhythm, after expanding to twelve pieces). Driggs and Haddix, 164-5.

91-92: Ophelia Ruffin Handy, taped interview, 1981.

93-94: Rebecca Parker and Oliver Todd, taped interviews, 1981.

100-1: Billy Eckstine, conversations at Blue Note, New York, NY, 1985.

102-4: This account draws on Ward, *Unforgivable Blackness.*

104: Hughes, *Autobiography,* 315.

104-09: Rebecca Parker, taped interview, 1981.

105: Charlie's union card, reproduced at http://www.birdlives.co.uk/index.php/ adolescence.html, shows that he paid his first union dues just seven days before he proposed to Rebecca (though the Bird Lives site gives the number as four). The original marriage certificate, completed by hand (reproduced at http://www.birdlives.co.uk/index.php/adolescence.html), gives Charlie Parker's age as "under twenty-one" and Rebecca's as "over eighteen." Giddins reproduces a 1961 typewritten copy (*Celebrating Bird,* 43).

114: Jean Renoir, in *Jean Renoir: Interviews,* 164.

114: Earl Coleman, taped interview, 1985.

116: Hermann Broch, "The Style of the Mythical Age: On Rachel Bespaloff," in *War and the Iliad* by Simone Weil and Rachel Bespaloff, 109.

119: Bushell, *Jazz from the Beginning*, 25.

119: Bob Redcross, taped interview at Blue Note, New York, NY, 1985.

121-22: Gene Ramey, taped interview, 1981

123-26: Southern, *The Music of Black Americans*; Crouch, *Considering Genius*, 217.

127: Johnson, Stephen. *Burnt Cork: Traditions and Legacies of Blackface Minstrelsy*, 98.

130-31: Blesh and Janis, *They All Played Ragtime*, 38.

131-32: Harry "Sweets" Edison, interviews about Kansas City and Lester Young, 1985 and thereafter.

132-36: Marquis, *In Search of Buddy Bolden*, 19.

138-40: Bushell, *Jazz from the Beginning*; Russell, *Jazz Style in Kansas City and the Southwest*, 40.

141: Gene Ramey on Page "balancing" the rhythm section, taped interview, 1981.

142-43: Basie and Murray, *Good Morning Blues*, 120.

143: Oliver Todd, taped interview, Kansas City, 1981.

145: Hammond, John. "Kansas City: A Hotbed for Fine Swing Musicians— Andy Kirk and Count Basie's Elegant Music Spoils City for Out-of-Town Name Brands." *Down Beat*, September 1936.

146: Oliver Todd, taped interview about Charlie Parker and Robert Simpson.

147: Lawrence Keyes and Rebecca Parker, taped interviews, 1981.

148: Clarence Davis, Gene Ramey, taped interviews, 1981.

151: Ellison, *Living with Music*, 60.

151-54: Gene Ramey, on the night he and Countess Johnson heard Charlie Parker humiliated by Jo Jones, taped interview, 1981.

155: John Jackson, telephone interview, 1981.

157-59: Lester Young, final interview, 1959. Available in Porter, *A Lester Young Reader,* 173.

160: Eddie Barefield, taped interviews, conducted at his home in the Bronx and at the Village Vanguard, New York, 1981 and thereafter.

160-61: Frank Wess, interview about Lester Young and the 1930s jam sessions, New York, NY, 1985.

163-72: Clarence Davis and Rebecca Parker, taped interviews, 1981.

165: The "woman piano player" Davis mentions was likely George Lee's sister, the singer Julia Lee.

180-81: Clarence Davis, taped interview, 1981.

182: Roy Eldridge, conversations, New York, NY, 1985-90.

184: Horowitz anecdote: Loren Schoenberg, conversation.

186: Gene Ramey, taped interview, 1981.

187: Gazzaway, Don. "Buster and Bird: Conversations with Buster Smith," *The Jazz Review,* 1960.

188-93: Buster Smith, taped interview, Dallas, 1981.

193: Russell, Ross. *Jazz Style in Kansas City and the Southwest,* 80.

194-95: Ralph Ellison, conversations.

196-98: Buster Smith, taped interview, 1981.

198-99: Ralph Ellison, conversations.

200-202: Buster Smith, taped interview, 1981.

202-203: Buster Smith, taped interview, 1981.

203: Although Ira Alexander "Bus" Smith was actually Bennie Moten's nephew, the bandleader treated him like his little brother, and the idea stuck. "Bennie kept referring to me as his kid brother, so I legalized the name Moten," he recalls in an interview quoted in Driggs and Haddix, *Kansas City Jazz*, 94.

203-204: Jay McShann, taped interview, 1981.

204: Orville Minor, interview, 1981.

205: Orville Minor, interview, 1981.

206-207: Oliver Todd, interview, 1981.

210: As he worked on refining his own bracing, vibrato-free tone, Parker must have been affected by Smith's sound. In his September 1936 *Down Beat* article about Kansas City, John Hammond singled Smith out: "his technique is unlimited and his tone quite free from the cloying quality which colored alto men took over from the Lombardo tribe." Quoted in Driggs and Haddix, *Kansas City Jazz*, 145.

211: Orville Minor, interview, 1981.

212: Doris Parker, interviews, New York, NY, 1985–2000.

213: Clarence Davis, interview, 1981.

213: Gene Ramey, interview.

214: Buddy Jones to Robert Reisner, in *Bird*, 124.

214-16: Doyle, Sir Arthur Conan. *The Sign of Four*, in *The Complete Sherlock Holmes*. New York: Doubleday.

216: Buster Smith, taped interview, 1981.

217: Gene Ramey, interview, 1981.

218: Orville Minor on "smokers," interview, 1981.

219-21: Jay McShann, interview.

222-23: Gene Ramey, interview, 1981; Jay McShann, interview, 1981.

226: Clarence Davis, taped interview, 1981.

227: Tommy Douglas to Robert Reisner, in *Bird,* 82-3. Parker was likely closer to seventeen years old when he played with Douglas.

227: Jay McShann, interview.

228: Gene Ramey, interview.

229-236: Rebecca Parker, taped interview, 1981.

237-241: Jay McShann, interview.

241: Harlan Leonard in Russell, *Jazz Style in Kansas City and the Southwest,* 174.

242: Gene Ramey, taped interview, 1981.

243-45: Junior Williams, interview, 1985.

245-46: Buster Smith, interview, 1981.

247-248: Gene Ramey and Jay McShann, interviews, 1981.

249: Addie Parker, quoted in Reisner, *Bird,* 163.

249-52: Buster Smith, taped interview, 1981.

253-55: Rebecca Parker, interview, 1981.

265: Rebecca Parker, interview, 1981.

268: A former Cotton Club dancer, interviewed for *Village Voice* article about *The Cotton Club,* a film by Francis Ford Coppola, 1984. The dancer recalled traveling to Chicago, where he saw Louis Armstrong at a gangster club in Cicero, IL.

269: Doris Parker, interview, 1985.

270: Junior Williams, taped interview.

271: For detail on Chicago crime in the 1930s, I consulted Tolland, *The Dillinger Days;* Matera, *John Dillinger*; and Bergreen, *Capone.*

272: Lincoln, C. Eric. *The Black Muslims in America.* Grand Rapids, MI: Wm. B. Erdmans, 1994.

277-79: Bob Redcross, interview, New York, NY, 1985.

278-79: Billy Eckstine, taped interview, New York, NY, 1985

280-81: Dexter, Dave. *Jazz Cavalcade: The Inside Story of Jazz*. Whitefish, MN: Literary Licensing, 2011; Billy Eckstine, interview, 1985

283: Jacques Butler, interview.

283-84: Roosevelt, Eleanor. *My Day,* 34.

285-86: For this account I drew on Gelernter, *1939*.

286: Walter Davis, Jr., interview, New York, NY.

287: Buster Smith, interview, 1981.

291-92: Jay McShann and Doris Parker, interviews, 1981 and thereafter.

292: For a colorful portrait of Harlem at the time, see Smith, *Music on My Mind*.

292-98: Biddy Fleet on Charlie Parker, interview; Frank Wess on Biddy Fleet, interview; both 1985.

303: Charlie's intense study sessions with Biddy Fleet have become the stuff of legend, but some particulars of that legend seem to have been altered in translation. In a 1949 article, Michael Levin and John S. Wilson quoted Charlie as saying that, during that period, "I kept thinking there's bound to be something else," another approach to the music that he wanted to play. "I could hear it sometimes, but I couldn't play it." Levin and Wilson themselves described the breakthrough in these words: "Charlie suddenly found that by using higher intervals of a chord as a melody line and backing them with appropriately related chord changes, he could play this thing he'd been 'hearing.'" As Carl Woideck has noted, however, the influential 1955 book *Hear Me Talkin' to Ya* presented that line as a direct quote from Charlie: "I found that by using the higher intervals of a chord as a melody line and backing them with appropriately related changes, I could play the thing I'd been hearing." (See Woideck, *Charlie Parker: His Music and Life,* 16. Woideck notes the possibility that the authors of *Hear Me Talkin' to Ya* were working from Levin's and Wilson's interview notes, but that seems remote.) The

quote has been passed on for generations as a kind of key to Bird's music, but at least one highly knowledgeable musician says that the line about intervals "does not make sense" as a way to describe Parker's breakthrough. In an email to the author, Wynton Marsalis observes that "Louis Armstrong, Coleman Hawkins, Art Tatum and others [also] played on the upper intervals of chords. What Charlie Parker did has happened perhaps only once in Western music. After figuring out how to double the velocity of the shuffle rhythm, which no one before him had done, he heard his improvised melodies at high speed and was able to hear Tatumesque harmonies at that velocity on a single note instrument! This can be heard in Chopin and Lizst, but they are considered light composers. Bird aspired to make melody on a heavyweight level, not just 2-5-1 arpeggios, or he would be in that line with Tatum and Hawkins. He is not. He is on the melodic level with Armstrong, which to me, makes Charlie Parker one of the two greatest players in the history of jazz and western music."

308: Jerry Lloyd to Reisner, in *Bird,* 137-8.

308-10: Rozelle Claxton, interview, 1985.

310: Phil Schaap, conversation.

313: Joe Wilder, interview.

316: Idrees Sulieman, taped interview, 1985.

318-22: Rebecca Parker, interview, 1981.

323: Lawrence Keyes, interview, 1981.

325-26: Bobby Bradford, conversations.

329-30: Bob Redcross, taped interview, New York, NY, 1985. See also Woideck, *Charlie Parker,* 68, 250.

Index

A

Abercrombie, Gertrude, 330
Africa, 124–25
Allen, Red, 182
Anderson, Buddy, 11
Anderson, Marian, 283
Annapolis, 313–17
Antlers Club, 205–6, 210, 216,
 218–19, 257, 267, 287
Armstrong, Louis, 30, 38, 98, 99, 117–
 19, 140, 145, 157, 160, 181–85, 198,
 222, 268, 272–73, 278, 331, 334
Aspects of Negro Life (Douglas), 173
Attucks, Crispus, 48

B

Bailey, Pearl, 313
Balaban and Katz Circuit, 5
Balanchine, George, 239

Bales, Walter, 237–40
Barefield, Eddie, 62, 145, 156, 160,
 211
Barnet, Charlie, 32
Basie, Bill "Count," 12, 20, 24, 26–27,
 35, 62, 141, 142–46, 149–52, 158–
 61, 179, 186, 193, 198–200, 202,
 204–5, 229, 237, 239, 241, 248–51,
 274, 281, 289, 290, 310
 Orchestra of, 16, 85, 60
bebop, 100, 140, 227, 315
Bechet, Sidney, 140, 184
Beckett, Fred, 242
Beiderbecke, Bix, 160
Bennett, Gwendolyn, 79–80
Bergreen, Laurence, 271
Berry, Leon "Chu," 27, 62, 155, 183,
 185, 198, 224, 232, 242, 244–46, 253,
 255, 291, 297, 312, 313, 332–33

Birds with Human Souls (Rowland), ix

Birth of a Nation, 73–75, 284

Blake, Fanny, 43

Blesh, Rudi, 130, 131

Blue Devils, 24, 85, 140–43, 145, 149, 158, 186, 187, 191–204, 209, 250, 287

blues, 16, 60–62, 103, 113, 117, 118, 138, 139, 150–51, 263–64, 276, 277

"Body and Soul," 87, 246, 306, 317, 330–34

Bolden, Buddy, 133–36, 331

Bonnie and Clyde, 63, 68

Bowes, Major, 152

Boxley, Hattie Lee, 106–7, 164, 236

Boyd, William, 72

Bradford, Bobby, 325–26

Braud, Wellman, 140

Broch, Hermann, 116

Broken Blossoms, 74

Bronson, Art, 158

Brown, John, 316

Brown, Piney, 64

Brown, Walter, 27, 29, 35

Bryant, Sterling, 48, 49, 51–52, 87–89, 105, 179, 232, 257

Buchanan, Charlie, 13, 14, 22, 25, 26, 32

Buffalo Soldiers, 41–42

Burney (Robinson), Banjo, 314, 315, 317

Burns, Tommy, 97

Bushell, Garvin, 60–61, 119, 137–38

Butler, Jacques, 283

Butts, Jimmy, 298

Byas, Don, 62, 297

C

Cabeza de Vaca, Álvar Núñez, 38

Calloway, Cab, 100, 245, 279

Capone, Al, 117, 271–72, 317

Carter, Benny, 62, 183, 224, 253, 296

Caruso, Enrico, 222

"Cherokee," 30, 32–34, 300

Cherry Blossom, 69, 123, 149, 312

Chicago, 267–68, 272

 Capone in, 117, 271–72

 conflict between Irish and blacks in, 272

 Great Migration and, 275–77

 jazz style of, 117, 118, 122

 Local 208 in, 273–74

 Parker in, 270–81

 Parker's move to, 253–57, 265, 267–70

Christian, Charlie, 306

Churchill, Winston, 78

Civil War, 41, 73, 76, 125, 127, 128, 133, 140

Claxton, Rozelle, 307–10

Clayton, Buck, 205, 241

Coleman, Earl, 113

Coleman, Ermir, 193

Colman, Ronald, 244

Considering Genius (Crouch), 123, 124

Cooper, Al, 23

Coronado, Francisco Vásquez de, 38–40

Cotton Club, 98–99

Crouch, Emma Bea, 63

Cullen, Countee, 78

Culliver, Freddie, 83–84

D

Daley, Joe, 327–28

Dameron, Tadd, 323–24

Daniels, Ernest, 164, 165

Dan Wall's Chili House, 294, 297, 301, 304

Daughters of the American Revolution (DAR), 283–84

Davis, Alonzo, 83, 84, 86

Davis, Clarence, 106, 148, 163–65, 180–81, 184, 209, 226–27, 268, 310

Davis, Miles, 322

Davis, Walter, Jr., 286

Deans of Swing, 89–90, 93–94, 147, 221, 323

Dee, Jesse, 189, 191

DeFranco, Buddy, 313

Depression, Great, 6, 48–49, 55, 63, 64, 66–68, 70, 130, 142, 200–202, 239, 270

Desmond, Paul, 87

Dewey, Thomas E., 293

Dexter, Dave, 280

Diamond, John, 126, 131

Dillinger, John, 42, 63, 68, 271

Dirty Legs, 34

Dodds, Baby, 117, 119

Dodds, Johnny, 119, 138

Dooley, Fred, 89–90

Dorsey, Bob, 6–7

Dorsey, Jimmy, 156, 211, 224

Douglas, Aaron, 173

Douglas, Tommy, 62, 226–29, 243, 252, 255

Down Beat, 145, 280

Doyle, Arthur Conan, 214–16

Durant, Will, 278

Durham, Eddie, 15, 62, 141–43, 193, 197–98, 200

E

Eckstine, Billy, 100–101, 222, 278–79, 322

Edison, Harry "Sweets," 131–32

802 Girls, 34

Eldridge, Roy, 30, 181–85, 198, 209, 224, 245, 255, 268, 291, 313

Ellington, Duke, 20, 35, 72–73, 76, 98–102, 104–5, 118, 119, 139, 279, 305–6, 323

 Parker passes up audition with, 305–7

Ellison, Ralph, 24, 80–81, 151, 194–95, 199, 210

Enois, Leonard "Lucky," 7, 25

Estevan (slave scout), 38–39

Evans, Herschel, 27, 62, 205, 245–46, 310

F

Fields, Ernie, 307, 308

Fleet, Biddy, 297–307, 311, 314, 323, 324

Fletcher, Tom, 120–21

Floyd, Pretty Boy, 63, 66–68

Floyd, Troy, 190

Foster, Stephen, 222

Foxx, Redd, 34

Francis, Panama, 20–21, 26, 28

G

Gale, Charles, 13

Gale, Moses "Moe," 13, 35

Gardner, Goon, 280, 291, 329

Gazzaway, Don, 187

Geraldine (paramour of Parker), 170–72, 229–30, 233, 257

Geronimo, 262

Gershwin, George, 323

Gibson, Andy, 26

Gibson, Hoot, 72

Gibson, Oswald, 315–17

Gillespie, Dizzy, 29, 34, 101, 227

Golden, Jimmy, 315

Goldin, Marie, 106, 164

Gone with the Wind, 73, 284

Goodman, Benny, 205, 225–26

Gould, Chester, 67

Gray, Harry, 274

Great Migration, 275–77

Great Plains, The (Webb), 40

Green, Freddie, 144

Greer, Sonny, 99, 101

Griffith, D. W., 72–75, 100, 284

H

Hamilton, Julian, 83–84

Hammond, John, 145–46, 159, 186, 204, 205, 250

Hampton, Lionel, 35, 99

Handy, W. C., 310

Hardwick, Otto, 305–6

Harlem, 12–13, 20, 28, 252, 287, 290–92, 295–96

 Cotton Club, 98–99

 Dan Wall's Chili House, 294, 297, 301, 304

 Monroe's Uptown House, 18, 293–95, 301–2, 304

 Savoy Ballroom, 8–9, 13–14, 16–17, 20–35, 292

 Turf Club, 292–93

 Woodside Hotel, 12, 14–16, 18–20, 250–51, 290, 291, 307–8, 310

Harris, Benny, 308

Hawkins, Coleman, 19, 23, 24, 30, 62, 155, 159, 182–85, 198, 245, 291, 311–13, 317

Hawkins, Erskine, 35

Henderson, Fletcher, 20, 24, 159, 182, 184, 185, 198, 245, 273

Hibbler, Al, 27, 29

Hines, Earl, 273, 311

Hite, Les, 21

Hitler, Adolf, 283

Hodges, Johnny, 19, 62, 89, 224, 253, 296, 305–6

Holiday, Billie, 16, 291

Holstein, Casper, 292–93

"Hometown Blues," 35–36

"Honeysuckle Rose," 330–34

Hoover, J. Edgar, 66, 67

Hopkins, Elmer, 223

Horowitz, Vladimir, 184

horses, 39–40

Hughes, Langston, 78–79, 104

I

Ickes, Harold, 284

Indians, 38–41, 263

In Search of Buddy Bolden (Marquis), 133, 134, 136

Intolerance, 74

"I, Too" (Hughes), 78–79

J

Jackson, Andrew, 43

Jackson, Chubby, 31–32

Jackson, John, 89, 90, 155

James Boys, 63, 262

Janis, Harriet, 130, 131

jazz, 61–62, 116–17, 123, 127, 139, 156, 177, 195, 303, 325–26

bebop, 100, 140, 227, 315

Chicago, 117, 118, 122

Kansas City, 69–62, 116–17, 122–23, 125, 137–46

natural vs. trained musicians in, 241–42

New Orleans, 117, 118, 122, 132–35, 144–45, 196

rhythm section in, 144

Jazz from the Beginning (Bushell), 119, 138

Jazz Style in Kansas City and the Southwest (Russell), 85, 139, 193–94

Johnson, Bud, 62

Johnson, Frank, 123, 125, 128

Johnson, Gus, 7, 25, 242

Johnson, Jack, 76, 96–98, 102–4, 121

Johnson, James P., 185, 309, 311

Johnson, Margaret "Countess," 152–54

Johnson, Pete, 15, 16, 60

Jones, Buddy, 214

Jones, Jo, 141, 144, 149–50, 153, 154, 205, 306

Joplin, Scott, 130–32, 135–36

Jordan, Louis, 158

Juba, Master, 126–27, 131

Julius (neighbor), 55–56, 232

K

Kansas, 39

Kansas City, 6, 42, 52, 59–60, 67, 161, 317

(Kansas City continued)

 jazz style of, 69–62, 116–17, 122–23, 125, 137–46

 lawlessness in, 63–68

 as music town, 137

Kansas City Massacre, 65–67

Keith, Jimmy, 86, 94, 333

Keyes, Joe, 149

Keyes, Lawrence, 82, 84, 88, 89, 93–94, 147, 323

Kirk, Andy, 12–13, 15–16, 60, 146, 152, 159

Kolax, King, 279

Kynard, Ben, 89

L

LaGuardia, Fiorello, 287, 293

Lansky, Meyer, 293

"Laughin' Louie," 331

Laughton, Charles, 244

Lazia, 64, 66–68

Lee, George E., 220–23

Lee, Julia, 223

Leonard, Harlan, 16, 60, 85–86, 241–43, 252, 310, 324, 328

Lewis, Ed, 241

Lindy Hoppers, 34

Lloyd, Jerry, 308

Logan, Eli, 242

Louis, Joe, 76, 95–96, 100–104, 283

Luciano, Lucky, 293

Lunceford, Jimmie, 20, 310

M

Madden, Owney, 99

Maher, Jim, 87

Marquis, Donald, 133, 134, 136

Mayfield, Edward, Jr., 83

McDaniel, Hattie, 284

McGhee, Howard, 32

McKay, Claude, 78

McNeil, Crackshot, 192

McShann, Jay "Hootie," 7, 17, 19, 23–31, 35, 43, 203–4, 219–21, 223–26, 228, 237–43, 248, 252, 280, 292, 329

 Bales and, 237–40

 Orchestra of, 1, 8–17, 20–36, 60, 118, 248

 Parker hired by, 246–47

 Parker's meeting of, 241–43

Miley, Bubber, 145, 182

Millinder, Lucky, 9, 20–21, 26, 28, 118, 229

 Orchestra of, 9, 20, 26, 28, 32, 33, 35

Minor, Orville "Piggy," 11, 12, 18, 27, 29, 118, 203–6, 209–11

minstrelsy, 67, 73–75, 84, 98–101, 120–21, 126–27, 130, 244

Mitchell, Razz, 23–24

Monk, Thelonious, 34

Monroe, Clark, 18, 293–94

Monroe's Uptown House, 18, 293–95, 301–2, 304

Morton, Jelly Roll, 140, 141, 283

Mosley, Snub, 242

Moten, Bennie, 62, 85, 138–40, 142–43, 149, 186, 199, 200, 202–3, 221, 241, 250

 death of, 145, 202–4

Moten, Bus, 203

Murray, Albert, 142

Music of Black Americans, The (Southern), 123

Murray, Albert, 311

Musser, Clarence, 163–64, 167, 180, 185, 206

N

Nash, Frank "Jelly," 65–66

Nelson, Baby Face, 63, 68

New Orleans, 271

 Black Codes in, 134–35

 jazz style of, 117, 118, 122, 132–35, 144–45, 196

New York City, 10–12, 14, 16, 139–40, 161, 287–89

 Parker's arrival in, 285–87, 289

 Smith in, 286–87, 289–91, 295–96, 301, 307

 Smith's move to, 250–52, 270

 see also Harlem

New York World's Fair, 285–86

Niza, Marcos de, 38–39

No Way Out, 75

O

Oliver, Joe "King," 98, 117–19, 138, 139–40, 145, 158, 272–73, 278

Oliver, Paul, 62

100 Years of the Negro in Show Business (Fletcher), 120–21

"One O'Clock Jump," 26, 249

Original Amateur Hour, The, 152

Owens, Jesse, 283

P

Page, Oran "Hot Lips," 15, 60, 62, 141–43, 145, 149, 150, 193, 200

Page, Walter, 15, 62, 85, 138, 140–41, 144, 149, 152, 192, 193, 196, 200, 202, 226

 Blue Devils of, *see* Blue Devils

Parker, Addie (mother), 43–45, 47–49, 51, 53–55, 68, 70, 76–78, 82, 83, 86–88, 92, 105–7, 148, 155, 164, 165, 167–72, 212, 214, 230–36, 247, 249, 264, 317, 318–20, 322–23

 and Charlie's leaving Kansas, 254, 318, 320

 Leon and, 318

Parker, Charlie:

 arrival in New York, 285–87, 289

 in automobile accident, 164, 212

 birth of, 42, 44

 in Chicago, 270–81

(Parker, Charlie continued)

childhood of, 43–49

drug use of, 17–18, 30, 164, 169–71, 212–17, 227, 229–33, 235, 242, 246–48, 256, 257, 285, 304, 321–23, 328

family background of, 42–43

first club gigs of, 27

moves to Chicago, 253–57, 265, 267–70

practice schedules of, 87–88, 315

saxophone chosen as instrument of, 82

saxophone mouthpieces and, 228–29

saxophone screw lost by, 146–47

Sherlock Holmes mysteries enjoyed by, 214–16

technological innovation as interest of, 286, 300, 304, 324–25

westerns enjoyed by, 70–72

Parker, Charles, Sr. (father), 42–45, 48, 106, 264, 308, 318, 328

death of, 317–18, 321

Parker, Doris (third wife), 212, 269, 270

Parker, Francis Leon (son), 232–33, 236, 244, 249, 253, 254, 256, 285, 318–22

birth of, 231–32

Parker, John "Ikey" (half-brother), 43–46, 48, 55, 106

Parker, Peter Christopher (grandfather), 42–43, 311

Parker, Rebecca Ruffin (first wife), 50–57, 59, 63, 68–71, 76–78, 81–83, 88, 91–95, 104–9, 116, 147–48, 164–72, 185, 229–36, 244, 249, 256–57, 264, 285, 311, 318–20, 322

Charlie divorced by, 319–20

Charlie's leaving of, 253–56

Charlie's marriage to, 104–5

Charlie's visit to, 320–22

Francis's birth and, 231–32

Geraldine letter and, 170–72, 229–30, 233

loss of second child, 233–36, 257, 321

move back with family, 320–22

pregnancies of, 167, 230, 231, 233–35

Pasler, Bus, 205–6, 218

Payne, Felix, 64

Pearl Harbor, 7

Pendergast, Tom, 6, 16, 42, 59, 64, 65, 68, 161, 163, 164, 267, 293, 317

Poitier, Sidney, 75

Porter, Cole, 213, 323

Pretty Boy (Wallis), 63

Q

Queen City Concert Band, 131

R

ragtime, 61, 123, 128–32, 135, 137

railroads, *see* trains

Ramey, Eugene Glasco, 7, 11, 21, 22, 24, 25, 30, 31, 33, 121–22, 152–55, 186, 223, 242, 246–49, 280–81, 328

Redcross, Bob, 119–20, 277–79, 329–30

Reeves, Edward, 44–46, 48, 50, 64–65, 87

Reisner, Robert, 47, 82, 83, 214, 227, 249, 308

Reno Club, 148–55, 161, 186, 204–6, 239, 249, 332

Renoir, Jean, 113, 303

Roach, Max, 325

Rodney, Red, 313

Rogers, T. D., 309

Roosevelt, Eleanor, 16, 283–84

Roosevelt, Franklin D., 8, 16, 284

Ross, James, 86, 94

Rowland, Beryl, ix

Ruffin, Daddy, 49–52, 55

Ruffin, Dorothy, 50, 53

Ruffin, Fanny "Birdy," 49–54, 57, 59, 69–70, 76–77, 89, 91–94, 105, 230, 234, 319, 320, 322

Ruffin, Octavia, 50, 53, 77, 93–94

Ruffin, Ophelia, 50, 52, 54, 77, 91–92, 256, 322

Ruffin, Rebecca, *see* Parker, Rebecca Ruffin

Ruffin, Winfrey, 50, 53, 77, 92, 320

Rushing, Jimmy, 62, 141–43, 149, 179, 200

Russell, Ross, 85, 139, 140, 193–94, 241

S

sampling, 286

Savoy Ballroom, 8–9, 13–14, 16–17, 20–35, 292

Savoy Sultans, 23–24, 35, 301

Sax, Adolphe, 61

saxophone, 61–62

Schaap, Phil, 310–11

Schmeling, Max, 95, 96, 102–4

Schultz, Dutch, 293

segregation, 76, 80, 129, 196

Sign of Four, The (Doyle), 214–16

Simpson, Robert, 88–89, 94, 107, 147, 150, 163

death of, 147–48

slavery, 38, 124, 127, 129, 130, 133

Underground Railroad and, 262, 264

Smith, Bessie, 138

Smith, Buster, 60, 62, 141, 145, 149, 150, 155, 156, 186–93, 195–206, 209–13, 216–17, 219–21, 223–28, 240–43, 245, 249–52, 255, 256, 267, 274, 313, 332

move to New York, 250–52, 270

in New York, 286–87, 289–91, 295–96, 301, 307

Smith, Carl "Tatti," 149

Smith, Jabbo, 182

Smith, N. Clark, 85–86, 140, 241

Smith, Tab, 228–29

Smith, Willie "The Lion," 89, 185, 311

smokers, 218–19

Sousa, John Philip, 132

Southern, Eileen, 123

Southwest, 41–42

spook breakfasts, 218, 257

Stearns, Marshall, 87

Stewart, Dee, 223

Stewart, Rex, 24

Stomping the Blues (Murray), 311

Story of Philosophy, The (Durant), 278

Sulieman, Idrees, 316

Swing Rendezvous, 304

T

Tatum, Art, 38, 155, 184–85, 309–13

They All Played Ragtime (Blesh and
 Janis), 130, 131

Thompson, Big Bill, 118

Thompson, J. R., 234–35, 321

Tin Pan Alley, 289, 311, 323

"To a Dark Girl" (Bennett), 79–80

Todd, Oliver, 27, 88, 89, 94, 107, 115,
 143–44, 146–47, 206–7, 209

Towles, Nat, 6

trains, 43, 129, 261–65
 riding on boxcars, 201,
 255–56, 269–70

Trent, Alphonso, 149, 190

Trumbauer, Frankie, 156, 157, 160,
 211

Tumino, John, 22, 25, 26, 60

Turf Club, 292–93

Turner, Joe, 60, 61, 223

U

Underground Railroad, 262,
 264

Unforgivable Blackness (Ward), 104

V

Valentino, Rudolph, 222

Victoria, Queen, 125

W

Waller, Fats, 109, 185, 200, 251, 311

Wallis, Michael, 63

Ward, Geoffrey, 104

Ware, Efferge, 223

Washington, Booker T., 85

Washington, Jack, 27, 62, 149, 150,
 241

Webb, Walter Prescott, 40

Webster, Ben, 27, 62, 158, 305, 310

Wess, Frank, 161, 299–300, 315–16

West, Wild, 37–38, 42, 43, 126, 161
 Parker and, 70–72

Wheatley, Phillis, 78

White, Voddie, 189

Wilder, Joe, 313–16

Wilkerson, George, 164

Wilkins, Barron, 293–94

Willard, Jess, 103

Williams, Bert, 119

Williams, Cootie, 35, 118

Williams, Fess, 100

Williams, Junior, 243–45, 270, 290

Williams, Mary Lou, 152

Williams, "Red" Rudy, 301, 302

Wilson, Dick, 62, 158

Wilson, Teddy, 310

Woideck, Carl, 330

Woodruff, Georgia, 309–10

Woodside Hotel, 12, 14–16, 18–20,
 250–51, 290, 291, 307–8, 310

World War I, 275

World War II, 8, 283

Y

Young, Lester, 16, 27, 30, 62, 145,
 149–50, 155–61, 179, 181, 185, 186,
 193, 195, 198, 200, 202, 205, 211,
 241, 242, 245–46, 248, 252, 253,
 255, 270, 291, 296, 310, 312, 313,
 327, 332

Young, Willis, 157

Z

Zephyr (neighborhood girl), 56–57,
 92

About the Author

Stanley Crouch has been writing about jazz music and the American experience for more than forty years. He has twice been nominated for the National Book Critics Circle Award, for his essay collections *Notes of a Hanging Judge* and *The All-American Skin Game*. His other books include *Always in Pursuit, The Artificial White Man*, and the novel *Don't the Moon Look Lonesome*. His writing has appeared in *Harper's, The New Yorker, Vogue, Downbeat, Partisan Review*, the *New Republic*, the *New York Times*, and elsewhere. Since 1987 he has served on and off as artistic consultant for jazz programming at Lincoln Center and is a founder of the jazz department known as Jazz at Lincoln Center. He is also executive vice president of the Louis Armstrong Educational Foundation. A recipient of a MacArthur Fellowship, he is a member of the American Academy of Arts and Sciences and a regular columnist for the New York *Daily News*.